PRAISE FOR

The Man Who Made Vermeers

An Amazon Best Art Book of the Year
A National Award for Arts Writing finalist
An Edgar Award nominee for Best Fact Crime

"The case of Han van Meegeren, the boldest modern forger of Old Masters (as far as we know), is a grand yarn of twisty deceit, involving prestigious dupes and scads of money, with a sensational trial at the finish. . . . *The Man Who Made Vermeers: Unvarnishing the Legend of Master Forger Han van Meegeren*, by the writer and artist Jonathan Lopez, brings hard light to Van Meegeren's machinations and (very bad) character."
— PETER SCHJELDAHL, *The New Yorker*

"It's hard to imagine improving on Lopez's gem of a tale."
— CHRISTOPHER KNIGHT, *Los Angeles Times*

"I can say with authority that Jonathan Lopez's *The Man Who Made Vermeers* makes for a terrific read, even by flashlight as you lay on top of sweat-soaked sheets wishing you'd thought to buy a battery-operated fan before [Hurricane] Ike struck." — DOUGLAS BRITT, *Houston Chronicle*

"Here is a serious, funny, ironic, informative study of a delicious scoundrel that reads like a novel." — DON FRY, *Virginia Quarterly Review*

"Jonathan Lopez deftly reveals that the man who made the fake Vermeers was quite a fake himself." — JEAN GRAHAM, *Newark Star-Ledger*

"An engrossing read . . . Lopez does a wonderful job depicting the pre-World War II art world, in which American millionaires like Andrew Mellon proved particularly easy pickings. He also gives a vivid depiction of the crafty and corrupt Van Meegeren." — JIM FEAST, *Brooklyn Rail*

"Has added a good deal to our understanding of the story."
— JAMES FENTON, *New York Review of Books*

The Man Who Made Vermeers

JONATHAN LOPEZ

The Man Who Made Vermeers

UNVARNISHING THE LEGEND OF MASTER FORGER HAN VAN MEEGEREN

MARINER BOOKS
HOUGHTON MIFFLIN HARCOURT
Boston New York

First Mariner Books edition 2009
Copyright © 2008 by Jonathan Lopez

www.hmhbooks.com

Portions of this work were published in slightly different form, chapter
two as "Gross False Pretences" in *Apollo*, December 2007; chapter three
as "The Early Vermeers of Han van Meegeren" in *Apollo*, July/August
2008; and chapters four and seven in Dutch as "De meestervervalser en de
fascistische droom" in *De Groene Amsterdammer*, September 29, 2006.

Library of Congress Cataloging-in-Publication Data
Lopez, Jonathan.
The man who made Vermeers: unvarnishing the legend
of master forger Han van Meegeren/Jonathan Lopez.—1st ed.
p. cm.
Includes bibliographical references and index.
1. Meegeren, Han van, 1889–1947. 2. Art forgers—
Netherlands—Biography. 3. Painters—Netherlands—Biography.
4. Vermeer, Johannes, 1632–1675—Forgeries. I. Title.
ND1662.M43L67 2008
759.9492—dc22 [B] 2008005727
ISBN 978-0-15-101341-8
ISBN 978- 0-547-24784-7 (pbk.)

Text set in Fournier MT
Designed by Linda Lockowitz

Printed in the United States of America
DOC 10 9 8 7 6 5 4 3

For Laura

Contents

INTRODUCTION • *A Liar's Biography* • *1*

CHAPTER ONE • *The Collaborator* • *11*

CHAPTER TWO • *Beautiful Nonsense* • *21*

CHAPTER THREE • *The Sphinx of Delft* • 52

CHAPTER FOUR • *Smoke and Mirrors* • 72

CHAPTER FIVE • *A Happy Hunting Ground* • *100*

CHAPTER SIX • *The Master Forger and the Fascist Dream* • *124*

CHAPTER SEVEN • Sieg Heil! • *143*

CHAPTER EIGHT • *Goering Gets a Vermeer* • *166*

CHAPTER NINE • *The Endgame* • *186*

CHAPTER TEN • *Swept Under the Rug* • *221*

EPILOGUE • *Framing the Fake* • *243*

ACKNOWLEDGMENTS • *249*

ENDNOTES • *257*

SELECT BIBLIOGRAPHY • *295*

PICTURE CREDITS • *317*

INDEX • *323*

The Man Who
Made Vermeers

INTRODUCTION

A Liar's Biography

AT THE END OF WORLD WAR II, shortly after the liberation of Amsterdam, the Dutch government threw wealthy artist Han van Meegeren into jail as a Nazi collaborator, charging that he had sold a priceless Vermeer to Hermann Goering during the German occupation. In a spectacular turn of events, Van Meegeren soon broke down and confessed that he himself had painted Goering's Vermeer. The great masterpiece was a phony.

While he was at it, Van Meegeren also admitted to forging several other pictures, including Vermeer's famed *Supper at Emmaus,* the pride of Rotterdam's Boijmans Museum, a painting once hailed by the prominent art historian Abraham Bredius not merely as *a* masterpiece, but indeed "*the* masterpiece of Johannes Vermeer of Delft." When the news got out, it made headlines around the world, and the forger became an instant folk hero. In widely reported interviews at the time, Van Meegeren claimed to be a misunderstood genius who had turned to forgery only late in life, seeking revenge on the critics who had scorned him early in his artistic career.

An ancient grievance redeemed; a wrong put right. It was a wildly appealing tale back in 1945, and indeed it remains quite

seductive today. In the Netherlands, where Van Meegeren is still a household name, the story of the wily Dutchman who swindled Hermann Goering continues to raise a smile.

But the forger had one more trick up his sleeve: his version of events turns out to have been extravagantly untrue.

LIKE MANY OTHERS, I was originally drawn to Han van Meegeren by the sheer cleverness of what the man had accomplished. Yet, in pondering his story over the years, I found that much of it simply didn't add up. How could anyone's first attempt at art forgery have yielded so large, complex, and distinctive a composition as *The Supper at Emmaus*? As I delved deeper into the subject, I gradually came to understand that Van Meegeren had not been a meek and downtrodden artist on a quest for personal vindication, but rather a truly fascinating crook who had plied the forger's trade far longer than he ever admitted—his entire adult life, in fact—and with astonishing success. Through interviews with the descendants of Van Meegeren's partners in crime and three years of archival research in the Netherlands, the United States, Great Britain, and Germany, I learned that Van Meegeren worked for decades with a ring of shady art dealers promoting fake old masters, some of which ended up in the possession of such prominent collectors as Andrew Mellon and Baron Heinrich Thyssen. All the while, Van Meegeren cultivated a fascination with Hitler and Nazism that, when the occupation came, would provide him entrée to the highest level of Dutch collaborators.

Art fraud, like other fields of artistic endeavor, has its own traditions, masters, and lineages. When Van Meegeren entered the world of forgery, he joined a preexisting culture of illicit commerce that had thrived in Europe and America for years and would continue to thrive throughout the first half of the twentieth century, a time when the market for old masters was booming thanks to a growing number of buyers ready to dedicate their newly made

industrial fortunes to the collecting of fine pictures. Not only was Van Meegeren an important player in an elaborate game of international deception in the 1920s and 1930s, but some of his disreputable associates later put their expertise to work laundering stolen Holocaust assets in the same way they had laundered fake pictures—through the art trade. Although Van Meegeren himself stuck mostly to the sale and promotion of forgeries, he and his circle offer a case study in opportunism: for during the war, they operated at various points along the gray scale of collaboration—from gray, to grayer, to truly dark—as they cashed in on the Nazi takeover.

Just how big an operation was the early, unknown phase of Van Meegeren's career? About as big as art fraud gets. The picture swindles with which Van Meegeren was involved during the 1920s were remarkable both for their financial scale and for the numbers and types of people involved. The following incident, never before disclosed, offers a glimpse of Van Meegeren's unlikely team of accomplices.

In the spring of 1928, Van Meegeren, then thirty-nine years old and just coming into his own as a forger, paid a discreet two-week visit to London, where he stayed with a friend by the name of Theodore Ward. An industrial chemist who specialized in the technology of paint, Ward was also an avid collector of old masters, particularly still lifes by Dutch Golden Age artists like Willem Kalf and Abraham van Beyeren. He bought, sold, and traded such pictures; he haunted the salesrooms at Christie's and Sotheby's; and hardly a single item of quality ever came through the galleries of Bond Street without attracting his inquisitive eyes. Ward later donated his still lifes to the Ashmolean Museum at Oxford in memory of his wife, Daisy. Today, the Ward collection is generally recognized as one of the most comprehensive of its type in the world.

Inspired by his boundless zeal for Holland and its artistic achievements, Ward had even created an ersatz seventeenth-century Dutch interior in the parlor of his Finchley Road townhouse. With

the distinctive black and white stone floors, rustic ceiling beams, and sturdy oak furniture typically found in pictures by De Hooch, Vermeer, and Metsu, the Ward residence looked almost like a stage set awaiting costumed performers to enact familiar scenes from the history of art—a woman reading a letter, a sleeping servant, the mistress and her maid. Such an artificial atmosphere can only have delighted the visiting Van Meegeren, whose line of work entailed a very similar type of historical fakery.

The interior of Ward's Finchley Road residence

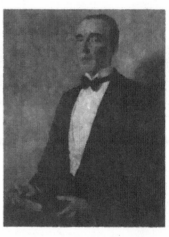

Portrait of
Theodore W.H. Ward, 1928

While in this strange fantasy environment, Van Meegeren painted Ward's portrait. Shown wearing a red velvet smoking jacket, cigar duly in hand, Ward looks, in the finished image, much the way members of his family often described him: sophisticated, self-assured, even a tad superior. In 1997, Ward's son gave the portrait to the Ashmolean, sending with it a note in which he recalled, across a distance of seventy years, Van Meegeren's frequent visits, throughout the 1920s, to the old house in the Finchley Road. "Van Meegeren was very amusing," he remembered fondly, "because my father was aware of his tendency to paint under another name—and quite successfully! It was then an open joke between him and my father and mother."

But Ward's son left out the best part. For, at approximately the same moment that Van Meegeren was immortalizing Theodore Ward on canvas during that 1928 visit, an employee of Ward's—a confidence man by the name of Harold Wright—was negotiating to sell a fake Frans Hals in the London offices of the world's most powerful art dealer, Sir Joseph Duveen. And the intrepid Mr. Wright had every reason to think that he would succeed: just a few months earlier, he had sold Duveen a fake Vermeer, *The Lace Maker*, at a price equivalent to millions of dollars in today's money. Of course, both the "Hals" and the "Vermeer" were works by Han van Meegeren.

Although criminal, Van Meegeren's career during the Roaring Twenties had an undeniable charm: the *haut monde* atmosphere, the conspiratorial strategizing, the blithe spirit of prosperous times. And Van Meegeren himself, at this point, was not unpleasant to know. With his small, birdlike frame constantly aflutter

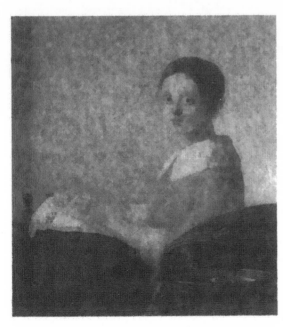

The Lace Maker, forgery in the style of Vermeer, ca. 1926

and his irreverent sense of humor on full display, the surreptitious forger made for lively company: he was outgoing, outspoken, and ostentatiously playful about leading a secret life. His alcoholism was still under control: the truly destructive binges, the incoherent, gin-fueled tirades that would eventually frighten off many of his friends, had not yet begun. Indeed, the young Van Meegeren socialized easily with both the upper crust of Dutch society, who provided him with portrait commissions, and the denizens of the shadow world where he made his real money. He was a man of parts back then, and many of them were genuinely appealing.

It was also during these years that Van Meegeren, still very much an apprentice in the business of forgery, began to learn his trade—and not only the technical bits, but the intellectual demands as well. He was to discover, first and foremost, that a fake doesn't necessarily succeed or fail according to the fidelity with which it replicates the distant past but on the basis of its power to sway the contemporary mind. Although the best forgeries may mimic the style of a long-dead artist, they tend to reflect the tastes and attitudes of their own period. Most people can't perceive this: they respond intuitively to that which seems familiar and comprehensible in an artwork, even one presumed to be centuries old. It's part of what makes forgeries so seductive.

Van Meegeren put this principle to work early and did so with notable style and grace, although, at the time, even he was probably unaware of his anachronisms. Van Meegeren's lovely Vermeer-esque girls from the 1920s resemble, on the one hand, the genuine article, but on the other, the highly fashionable portraits that the forger was doing under his own name at roughly the same moment. To the eyes and expectations of the day, what could possibly have been more appealing, on a subliminal level, than an art deco version of Vermeer's delicate aesthetic? Indeed, Van Meegeren's *Lace Maker* looks as though she would gladly cast aside her labors and fox-trot the night away if only someone would ask her.

Yet, Van Meegeren never owned up to these delightful early fakes. Was it a lingering sense of loyalty that stayed the forger's tongue about schemes involving multiple partners and associates in the art market's underworld? To some extent, that's probably the case. All of the forgeries to which Van Meegeren did ultimately confess were made during the final phase of his career, when he was working without a net—orchestrating the swindles by himself; finding his own middlemen; secretly directing negotiations; and pocketing the bulk of the money. But it would be naive to think that honor, even in the dubious form of honor among thieves, was an overriding concern for Van Meegeren. The primary reason he kept quiet about the length and extent of his career in forgery was that after getting arrested at the end of the brutal German occupation, he wanted to be perceived as something other than a seasoned professional criminal who had exploited the circumstances of war simply to make money. He reinvented himself as the bane of cultural snobs and Nazi tyrants alike. And in the zeitgeist of the immediate postwar era, that was a *very* good thing to be.

Clever though this myth making was, Van Meegeren did himself an enduring biographical injustice with his bogus revenge-fantasy explanation for his life and career. His motivations were, in reality, considerably more subtle and complex. And the true story of his metamorphosis from painter to forger turns out to offer a poignant evocation of his inner conflicts: for it was not the cruelty of the critics that doomed Van Meegeren's legitimate artistic aspirations, but rather Van Meegeren himself. Seduced by the easy money and thrilling gamesmanship of his initial forays into forgery during the 1920s, the young Van Meegeren, slowly but surely, lost his sense of calling. Rather than soldier on, throwing his full energy into painting his own pictures in his own name, he allowed an essential part of who he was, the genuine artist, to wither on the vine. It was a Faustian bargain, one whose consequences included a chronic drinking problem, a failed first marriage, and a series of

tawdry affairs. Moreover, as the chip on Van Meegeren's shoulder grew, so too did his taste for fascist politics.

This, of course, was the biggest thing that the forger was covering up in 1945. Strange though it might seem in view of the Goering episode, Han van Meegeren really was a collaborator. His interest in Nazism went back to the very toddler stage of the movement: as early as 1928, five years before Hitler assumed power as chancellor of Germany, Van Meegeren could be found parroting selections from *Mein Kampf.* Fleecing Hermann Goering was just an ordinary business transaction, not a political statement. Van Meegeren truly believed in the fascist dream. After the war, that was a big problem.

Today, Van Meegeren's affection for the Nazis is the biographical roadblock that makes it virtually impossible to conceive of the forger as a hero in any conventional sense. But putting moral questions temporarily aside, what is truly intriguing about Van Meegeren's turn toward Hitlerism is that it dovetails so neatly with his growing success as a forger. Although an inner anger may initially have pointed Van Meegeren down the road toward the politics of resentment—and this factor cannot be discounted—for a forger, the appeal of fascism, in its full Nietzschean mode, ultimately goes far deeper than mere soreheadedness. What is a forger if not a closeted Übermensch, an artist who secretly takes history itself for his canvas, who alters the past to suit his present needs?

Oddly enough, it makes perfect sense, viewed in that light, that the three greatest European art forgers alive during the Second World War—Van Meegeren with his false Vermeers; Jef van der Veken, the Belgian forger of Van Eyck; and Icilio Joni, the master of the fake Italian Primitives—were all avowed fascist sympathizers. They were, to be sure, archopportunists. But on a more profound level, the logic of might makes right and the dream of the will to power captured the imaginations of these cunning men who reveled in their ability to rewrite the textbooks of art.

Indeed, Van Meegeren's later Vermeer forgeries push this mentality to its logical extreme. Beginning with his *Supper at Emmaus* of 1937, Van Meegeren created a fictitious biblical phase of Vermeer's career, flattering the intellectual vanity of art historians who had theorized that the great seventeenth-century master, known to have painted one biblical scene in his youth, might well have produced more. Yet, the mischief didn't end there. Looking closely at *The Supper at Emmaus,* does it come as any surprise that it was conceived in the afterglow of Van Meegeren's visit to the 1936 Berlin Olympics? The magniloquent solemnity of this picture has little precedent in the work of Vermeer, but it certainly does echo the volkisch Aryan propaganda imagery of the era, which presented an idealized vision of life in Germany's

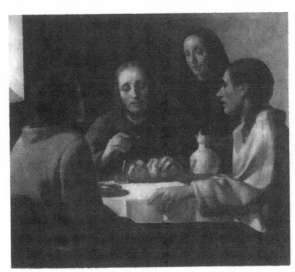

The Supper at Emmaus, forgery in the style of Vermeer, 1936–1937

rural heartland. Fitting in all too well with Van Meegeren's chosen world view, *The Supper at Emmaus* may actually have captured, in its very falseness, a certain middlebrow reactionary strain of prewar culture better than any "real" artwork ever could.

As a forgery, *The Supper at Emmaus* is now a defanged cobra: nobody visiting it today at the Boijmans Museum, in Rotterdam, where it is still a source of popular curiosity, could ever be fooled by the tendentious conceit that made it seem so timeless, yet so hauntingly up to date, back in 1937. But when seen for what it really is, *Emmaus* remains captivating. Part dream, part lie, this elaborate fake is a subterranean landmark in European intellectual history—an artifact uniquely evocative of a period in which the power of major leaders was often based on malicious fabrications. As such, it makes a relatively straightforward fraud like Van Meegeren's 1920s vintage *Lace Maker* look like child's play.

Indeed, the aesthetic and intellectual distance between these two works neatly describes the path Van Meegeren travelled during the course of his career. In a sweet confection like *The Lace Maker*, Van Meegeren amiably portrayed a seventeenth-century maiden in the guise of a coquettish flapper, as he casually messed about with the chronology of taste. But it was this very aspect of art forgery that Van Meegeren would seize upon, refine, and build into something truly dark and potent in his later life. For although Van Meegeren was certainly an accomplished forger in the technical sense, the greatest deceptions he pulled off actually had less to do with his prowess as a visual artist than with his use and misuse of history. This was the case when he reached back into the past to insert a modern, reactionary "Vermeer" into the canon of Western art; and, after the war, when he projected his self-exculpatory myth forward into the future. In both instances, he knew precisely how to seize on the zeitgeist and turn it to his own ends; to match what people wanted to hear with what he wanted them to believe.

What follows, then, is a liar's biography, the story of a man whose deceptions, fueled as they were by the spirit of his times, shine a light back on that distant era today.

CHAPTER ONE

The Collaborator

THEY CAME FOR HIM on May 29, 1945. Shortly after 9:00 in the evening, Lt. Joseph Piller walked over to Keizersgracht 321 from his nearby headquarters on the Herengracht. An armed soldier was by his side. They had a car at their disposal—one of the few working vehicles in the city—but tonight they had no intention of using it. They planned to conduct Han van Meegeren to Weteringschans Prison on foot, marching him through the streets at the point of a gun.

It was cool and damp in Amsterdam; it had rained on and off all day. Complete darkness had settled upon the city: there were no street lamps, no house lights, no bright points of illumination shining down from apartment windows. The electricity and gas had been shut off throughout the Dutch capital for months. Having promised to lead occupied Holland into a glorious new era under his rule, Hitler had instead plunged it back into the age of the candle and the kerosene lantern. Even with the Germans now defeated, the power grid wouldn't be up and running again for weeks; gas service wouldn't return to normal until the winter.

And of course there had been other, more serious indignities visited upon the Dutch people that could never be set right at all.

Knocking on the front door of Van Meegeren's home, an elegant, centuries-old burgher's residence, Lieutenant Piller announced himself as an officer of the provisional military government, or *Militair Gezag*. Once the introductions were dispensed with, matters took their natural course. The silver-haired Van Meegeren, a small man with a theatrically large presence, expressed complete bewilderment at Piller's inquiries into Hermann Goering's seemingly looted Vermeer. And

Keizersgracht 321, Amsterdam, residence of Han van Meegeren

with regard to the five other biblical Vermeers that Lieutenant Piller had traced back to him, Van Meegeren was likewise unable to provide further particulars. Piller then asked how, exactly, Van Meegeren had gotten so rich amid the widespread deprivations of the war. "He said that he had sold a group of Flemish Primitives prior to the outbreak of hostilities," Piller noted in his statement for the case file, "and that it was in this way that he had come by his money." Having already interviewed enough people to know better, Lieutenant Piller wasted no time informing Van Meegeren that the game was over.

As Van Meegeren later described it, he remained stoic and inscrutable throughout the mile-long journey to the Weteringschans. If true, this was no mean feat: collaborators on their way to jail were often jeered at or accosted by angry bystanders, even

at night, now that curfews had been abandoned. In the three weeks since the end of the war in Europe, the public humiliation of quislings had become victory's sideshow. Thousands of German-friendly Dutchmen were being led off to prison all across the country, sometimes one by one and sometimes in large groups,

Han van Meegeren, 1945

stumbling along with their hands clasped behind their necks, their faces frozen with fear.

During the war, the Germans had used Weteringschans Prison as a way station for Amsterdam Jews picked up in night raids, or *razzias*. Anne Frank's family had been kept there before being sent on to the death camps. Located just a stone's throw from the Rijksmuseum, in the center of the city, it was a convenient place for the Gestapo to take care of the record keeping so important to their far-flung apparatus of murder. Resistance leaders had also been held at the Weteringschans; some had been tortured there; some had been put to death. That this hulking, high-walled, nineteenth-century jail was now filling up with the Nazis' friends and helpers was a kind of poetic justice—inadequate, to be sure, but gratifying nonetheless.

When they finally arrived at the prison, Lieutenant Piller gave Van Meegeren one last chance to tell the truth, instructing him to write down the names of the people who had provided him with the Vermeers.

"They tried to get me to talk," Van Meegeren later recalled, "but they did not succeed."

His stubbornness earned him a stay in solitary confinement. The guards shut him away sometime after 11:00 that night—and Lieutenant Piller, for his part, would have been content to let Van Meegeren rot in the Weteringschans forever.

JOSEPH PILLER WAS neither a professional soldier nor an expert in the history of art. He didn't understand the full details of Van Meegeren's case, and many of his assumptions about what had occurred would later turn out to be wrong. But Piller approached this matter, like everything else he was working on in those chaotic days just after the Liberation, with a sense of passion and purpose. "It was clear that I didn't like collaborators," he later remarked. "Too much had happened in my life to be kind to people like that.

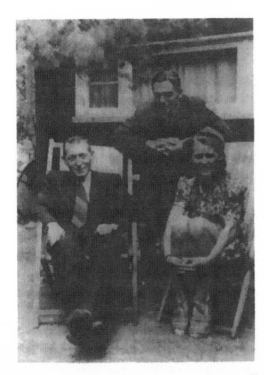

Joseph Piller and his
wife with the British
agent Dick Kragt
(standing), ca. 1944

I was more extreme then. I was young and had witnessed many
deaths, and I hated anyone who had worked with the Germans."

A self-described "simple Jewish boy," Joseph Piller had been
living happily in Amsterdam until May 1940, when the Germans
invaded the Netherlands. He soon found it expedient to take ref-
uge in the countryside with his wife and infant daughter. A skinny
twenty-six year old, a garment worker by trade, Piller had no prior
experience with rural life, but he made the most of his time among
the farms and fields of the tiny village of Emst. He joined the local
Resistance and set to work finding hiding places for Jewish children
from the cities: locating reliable farmers who could take on young
"guests"; procuring false identity papers and ration cards through
clandestine channels; raiding German storerooms for supplies; and
keeping a constant eye out for the unwelcome attention of informants.

This network was fully established and running smoothly when the admirable Piller suddenly found himself with additional responsibilities one day in 1942, when a British secret agent named Dick Kragt fell from the sky bearing special orders from London. Kragt had parachuted into the Netherlands on a mission to rescue Allied airmen shot down over occupied territory—to hide them, protect them, and then spirit them across the front lines to safety. And, together, Kragt and Piller proceeded to do just that, time and again, over the next two and half years, expanding the Underground's existing operation to accommodate the new assignment.

By the time he came face to face with Van Meegeren, Piller had been awarded an officer's commission in the newly reconstituted Dutch army. Indeed, he had assumed a leading role in investigating the goings-on at Amsterdam's famed Goudstikker gallery. A Jewish-owned business, the gallery had been taken over shortly after the invasion by one of Hermann Goering's henchmen, a Bavarian banker named Alois Miedl. Known throughout the war years as the go-to man for German opportunists visiting the conquered Dutch capital, the chubby Miedl whiled away his evenings with the fast set of young Nazi officials who congregated at the bar of the sumptuous Amstel Hotel; he threw dinner parties for the likes of Ferdinand Hugo Aus der Fünten, the SS Hauptsturmführer in charge of transporting Dutch Jews to the death camps of Eastern Europe; and when VIPs came to town from Berlin, Miedl proudly led them on tours of the storerooms of looted Jewish valuables—silverware, furniture, porcelain, watches, wedding rings, children's toys. Lieutenant Piller, as he informed Allied investigators at the time, was convinced that Miedl had turned the Goudstikker gallery into a front where looted art got laundered into cash to finance the Nazis' Abwehr espionage ring. Given Miedl's well-timed escape to the safety of Falangist Spain toward the end of the war, such a theory seemed more than credible. Piller was after big game: spies, informers, the hidden financial workings of the Third

Reich. It was in the course of looking into these matters that he happened upon the Van Meegeren case.

"I discovered that a painting had passed through Miedl's hands depicting Christ and the Adulteress, attributed to Johannes Vermeer," Piller stated in a later deposition. "Miedl bought it for 1.65 million guilders and then sold it to Hermann Goering. By interviewing various middlemen I realized that this work must have come from the artist Han van Meegeren . . . Speaking to various other people, I soon discovered that a total of six paintings by Johannes Vermeer had appeared on the market since 1937 and that these also had come from the aforementioned Van Meegeren. I then went to Van Meegeren for an explanation."

But Van Meegeren was clearly not the type to explain. The man was a collaborator—Piller was quite sure of it—and like all collaborators, Van Meegeren had covered his tracks. Although Piller could link him to the Vermeers through various dealers and straw men, the trail went cold from there. The experts whom Piller consulted said that these particular Vermeers were part of a special cycle of paintings, unusual for their biblical subject matter. It was thought that Vermeer might have painted them to decorate a *schuilkerk*, a hidden Catholic church, during the Reformation. If these pictures had originally belonged together, then it stood to reason that Van Meegeren and his accomplices might have looted all of them from a single collection. But which one, where—and who else was involved?

On June 11, 1945, Piller transferred Van Meegeren from the Weteringschans to a nearby interrogation facility on the Apollolaan. There, Piller and his men questioned Van Meegeren for an entire day, around the clock, without pause. Van Meegeren admitted to nothing: when asked a question, he would either turn away and face the wall or else answer with an elaborate non sequitur.

Piller then decided to try a more aggressive tactic. He told Van Meegeren that the Allies had tracked down Miedl in Spain—which,

in fact, was true. Piller then suggested that Miedl was prepared to testify under oath that Van Meegeren had come to the Goudstikker gallery with the sole intention of doing business with highly placed Germans, a threat that Piller invented out of thin air. If Van Meegeren refused to divulge the names of his accomplices, Piller could still get him for trading with the enemy—even without an admission of guilt—on the basis of Miedl's supposed testimony.

Piller asked Van Meegeren one last time where Hermann Goering's Vermeer had come from.

"He turned to me," Piller recalled, "and he said: 'I did it. I painted it.'"

For perhaps the first time in his life, Han van Meegeren was being entirely honest. And to Joseph Piller's everlasting astonishment, he found himself believing Van Meegeren's confession almost immediately. "I was sure of it," Piller later observed. "Van Meegeren had done it. It was completely in keeping with human nature. He was someone who felt misunderstood by everyone involved with art. He wanted to show the world what he could really do . . . After twenty-four hours of questioning, once you came to understand his psychology, it made perfect sense."

Indeed it did. And suddenly, Joseph Piller, who had just come through his own five-year David-and-Goliath struggle, saw something in Han van Meegeren that he rather liked.

LIEUTENANT PILLER HAD no doubts at all about Van Meegeren's claims, but some of the art experts involved with the case remained skeptical. In particular, the notion that Vermeer's *Supper at Emmaus* was actually a modern fake struck them as distinctly difficult to believe. Consequently, Piller's remarkable discovery remained a closely guarded secret while an investigation was conducted to determine if Van Meegeren was telling the truth. During this waiting period, Piller got to know his peculiar prisoner somewhat better and grew to admire him immensely. The young lieutenant was

charmed by Van Meegeren's track record of outsmarting the powerful and the learned. And he was quite sure that his faith in the forger's story would, in due course, be vindicated.

But then, on July 11, 1945, the newly legal Dutch Resistance paper *De Waarheid*—The Truth—ran a front-page story that cast Piller's entire theory of the Van Meegeren case into doubt. In Berlin, a young correspondent named Jan Spierdijk had toured the ruins of the Reichschancellery, the once-majestic headquarters of the Nazi government, where sprawling heaps of debris now sullied the marble floors. Walking through Hitler's abandoned personal library, just off the Reichschancellery's central offices, Spierdijk had come across an enormous book of Han van Meegeren's drawings, with a handwritten inscription on the inside cover. The inscription said, in German, "To my beloved Führer in grateful tribute, from H. van Meegeren, Laren, North Holland, 1942."

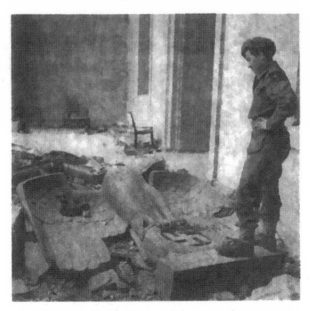

British soldier amid the ruins of
Hitler's Reichschancellery in Berlin, July 1945

Called *Teekeningen 1*, the book contained reproductions of Van Meegeren's art paired with verses by the Nazi poet Martien Beversluis. "If any doubts may have persisted about the political sympathies of Mr. Van Meegeren," the hard-line editors of *De Waarheid* intoned in a boldfaced sidebar to Spierdijk's article, "this report has expunged them."

Reading this article, in his bustling office on the Herengracht, Lt. Joseph Piller can only have shaken his head in disbelief. In light of the evidence, Piller had to ask himself afresh a question whose answer he had thought he already knew. Who *is* this Han van Meegeren?

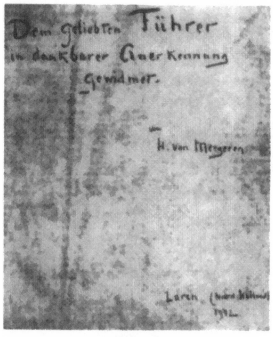

"To my beloved Führer in grateful tribute,
from H. van Meegeren, Laren, North Holland, 1942"

CHAPTER TWO

Beautiful Nonsense

LET'S RETURN TO BERLIN for a moment. Not the bombed-out disaster area that Jan Spierdijk visited in the summer of 1945, but the glittering and spectacularly corrupt Berlin of the mid-Weimar period. Having weathered the First World War, failed uprisings of the left and right, and a crushing bout of hyperinflation, the German capital was, by the late 1920s, booming again, thanks to a massive influx of funds from foreign investors. Real estate prices had shot through the roof, and enormous construction projects seemed to be popping up everywhere. A brand new underground train line rumbled between the Alexanderplatz and the northern suburbs, to the immense satisfaction of the many city officials who had bought property along the route. Tourists flocked to town for the nightlife. And why not—there was something for everyone, at least everyone who liked sex. With little access to the enormous sums bloating the high end of the economy, a surprising number of ordinary Berliners made a living selling the only desirable commodity they possessed. Provocatively dressed *Kontroll* girls worked the Friedrichstrasse all night long; the transvestite floor show at the Silhouette Cabaret couldn't be beat; and even if you

just wanted a bit of quiet recreation back in your hotel room, the weekly *Nachtkultur* magazines listed hundreds of possible companions, both male and female, categorized according to their talents and specialties. Some even worked in teams: husband and wife, mother-daughter, dominant and submissive.

Babylon on the river Spree—that's what stunned foreigners called it—and it was in this cosmopolitan setting that young Englishman Harold R. Wright showed up in 1927 with a framed oil painting and dreams of untold wealth. A mystery man then as now, Wright is not the sort of figure one normally encounters in history books. There is only one known photograph of him: prematurely bald with a beaky nose and an anxious smile, he appears thin and rangy, like a scarecrow dressed up in a baggy suit. A bit player in the international art world, Wright makes his first appearance in the records of Christie's London auction house in 1924, buying and selling paintings in partnership with Theodore Ward—he of the Dutch-style sitting room in the Finchley Road. Then just twenty-six years of age, a minor employee in Ward's paint business, Wright seems to have tried his best to emulate his boss, adopting the lofty persona of a gentleman amateur, someone who dealt in pictures merely as an amusing pastime. He started calling himself "Captain Wright," and while he had no legitimate claim to that title, it wasn't an arbitrary pretension. The son of a Nottinghamshire iron worker, Wright had dutifully served in the trenches of World War I. He never rose above the rank of private, but during one particularly bloody week of 1916, he ended up in command of his unit, earning both a commendation and a temporary commission in the process. As a result, he seems to have passed himself off as a full-fledged officer for the rest of his life. Both his courage and his presumption would serve him well on his mission in Berlin.

It was toward the end of June that Wright brought Han van Meegeren's *Lace Maker* to the Kaiser Friedrich Museum, a

majestic building at the tip of Spree Island, so close to the water's edge that, at a distance, the museum's ornate dome seemed to rise dramatically out of the river itself. Claiming to have found the picture in an Amsterdam antique shop, Wright presented *The Lace Maker* for the expert consideration of Dr. Wilhelm von Bode, director-general of the Prussian state museum system. This was not unusual: Bode received a constant stream of visitors asking for his opinion with regard to the attribution of artworks, and for a fee, he was only too happy to render his judgment. Indeed, during the great inflation of 1921, Bode and his colleagues at the Kaiser Friedrich had been besieged by as many as a hundred people each week desperate to turn family heirlooms into hard currency on the international market—a sort of mirthless precursor to *Antiques Roadshow*. Moreover, Bode was already acquainted with Wright, who had brought other pictures to the Kaiser Friedrich. Yet, ordinary though the circumstances were, the outcome of the meeting was remarkable: on June 27, 1927, after careful reflection, Bode issued a written certificate declaring *The Lace Maker* to be a "genuine, perfect, and very characteristic work of Jan Vermeer of Delft." Explaining his reasoning, Bode wrote, "Not only has it got the true Vermeer charm as to lighting and coloring, but at the same time there is extraordinary fascination in the expression of the face, still half that of a child."

So impressed was Bode with this discovery that he asked Wright if *The Lace Maker* could be exhibited for a few months in the rotunda of the Kaiser Friedrich Museum. "Generally speaking, the Ministry is not desirous of such loan exhibits," Bode explained in a letter to Wright, "but in honor of a Vermeer—especially one which, up to the present, has been completely unknown—we shall be glad to make an exception."

Wright graciously consented to Bode's request. After all, in Berlin, a town where a lot of pretty girls were up to no good, *The*

Lace Maker would have no trouble hiding in plain sight. The picture would go on view at the end of August.

WHEN HE WASN'T BUSY hoodwinking Wilhelm von Bode at the Kaiser Friedrich Museum, Harold Wright could generally be found in The Hague, which, during the 1920s, was Han van Meegeren's base of operations. On paper, at least, Wright worked as the manager of a subsidiary branch of Theodore Ward's paint company located in suburban Leidschendam, just outside The Hague proper. The administrative duties involved in running the Titanine Verf en Lakfabriek would not appear to have been all that taxing: Wright evidently spent most of his time either playing golf—at which he excelled—or else hanging around with the artist and picture restorer Theo van Wijngaarden. Van Wijngaarden had a reputation for "finding" the signatures of great masters on old paintings that were previously unsigned as well as for other equally questionable business practices. It was in Theo van Wijngaarden's atelier at Sumatrastraat 226, behind the offices and storerooms of a firm of house painters, that Han van Meegeren labored to churn out brand new old masters from approximately 1920 to 1932—first as Van Wijngaarden's employee, then as his partner.

Ideal for a forger in training, The Hague in those days was a supremely stylish venue for mischief and artifice of all types. In a nation whose great wealth and enduring prosperity derived from a flinty tradition of toil and thrift, The Hague stood out for its atmosphere of leisure and unapologetic opulence. It was "the city of beautiful nonsense," in the words of a then-popular guidebook for in-the-know visitors, "a place to linger, to walk, to gossip, to flirt, to dance, and to do nothing for most of the time." Home to the royal family, the Dutch parliament, and a lively cultural scene, The Hague was not a commercial center in the mold of Amsterdam or Rotterdam but a playground for the elite—as well as for

Han van Meegeren,
ca. 1918

those with elitist pretensions. Men who could have stepped right
out of a Jeeves-and-Wooster story strutted about town with mon-
ocles cocked under their eyebrows, spats strapped to their shoes,
and walking sticks firmly in hand. Indeed, more sober-minded
Dutchmen often rolled their eyes at the seemingly endless capac-
ity of Hagenaars to posture and pose—a set of behaviors neatly
summarized by the term *Haagse Bluf.* In time, a dessert by that
name would become a popular treat for young children: made of
raspberry meringue, it looks extremely rich, but it's really just a
puff of sweetly flavored air.

Although Han van Meegeren was not from The Hague origi-
nally, he had adapted quite easily to the spirit of the place. Born
in 1889, the third of five children in a middle-class Catholic fam-
ily, Van Meegeren had grown up in provincial Deventer under the
yoke of a stern schoolmaster father, who packed the budding artist

Portrait drawing
of Willem van
Konijnenburg

off to study architecture at Delft Technical University in 1907.
When the young Van Meegeren neglected his schoolwork to paint
and draw, he heard the predictable paternal complaints, which
grew much louder when, in 1911, twenty-two years old and still a
student, Van Meegeren got his Protestant girlfriend, the shy Anna
de Voogt, pregnant. Van Meegeren's father, outraged, would not
consent to the pair getting married until Anna, the daughter of
a mixed marriage between a Dutch colonial administrator and a
beauty from the East Indies, agreed to raise her progeny as good,
church-going Catholics. Eking out a living as an assistant draw-
ing instructor at Delft, Van Meegeren struggled to support Anna,
their son Jacques, who was born in 1912, and daughter Pauline,
born in 1915. But when Van Meegeren left his job—the only steady
employment he would ever have—and moved with Anna and the

A photo of Anna van Meegeren, ca. 1919, by H. Berssenbrugge, who specialized in "artistic" photo portraits processed to look like paintings

Costume party at the Haagse Kunstkring, ca. 1930

children to The Hague to pursue an artistic career full time, he was like a caged bird suddenly set free.

It was then 1917, and while war raged elsewhere in Europe, Van Meegeren was at liberty to focus on matters of art and pleasure, for neutral Holland—which profited by trading with both sides in the conflict—stood as a contented oasis unto itself. Once settled in The Hague, Van Meegeren started rubbing elbows. He applied and was accepted for membership in the Haagse Kunstkring, a social club for creative types, including painters, writers, musicians, and actors. In addition to sponsoring shows and performances by its members, the Kunstkring also hosted speaker's evenings, costume parties, cabaret nights, talent competitions, and other light, entertaining get-togethers. At such events, Van Meegeren often showed off his skills by making photo-realistic charcoal sketches of important guests, particularly those whom he wished to impress—like Willem van Konijnenburg, The Hague's most successful and best connected artist, who, in Van Meegeren's portrait drawing, comes across as a singularly distinguished individual. With his knack for flattery, Van Meegeren would eventually become a sought-after portraitist for the well to do, not only in The Hague but throughout the Netherlands. And yet, while commissioned portraits and gallery sales of his figure studies and genre scenes provided a fair income—far more than most young artists ever made—it wasn't enough for Van Meegeren, who quickly found himself in possession of expensive tastes and bad habits, among them a roving eye.

It was a problem born, to some extent, of matrimonial disillusionment. Initially, Van Meegeren had tried to include Anna in his explorations of the high life, but these outings had served mostly to underscore the couple's increasingly divergent temperaments. An old photograph tells the story. In it, the demure Anna, preparing to attend a costume ball with her husband, wears a fanciful outfit that Van Meegeren designed for her in an Egyptian style by way of

Cecil B. DeMille. Her sad eyes, downturned mouth, and faraway gaze are not those of a carefree party goer. Anna, in fact, generally preferred to be at home with the children, leaving Van Meegeren to cast about for a woman with a more adventurous attitude.

It wasn't long before he began to take an interest in the flirtatious actress wife of his good friend Carel Hendrik de Boer. An art critic, De Boer was one of Van Meegeren's earliest supporters in the public sphere: he had devoted a full-length article to the up-and-comer back in 1916, declaring him "a painter destined to walk the path of acclaim" after seeing his work in a small group show. Oddly, the friendship between Van Meegeren and De Boer seems not to have suffered once the affair started. The two men even set up shop giving art lessons together to society girls—De Boer lecturing on theory and Van Meegeren teaching the rudiments of

Johanna de Boer,
ca. 1920

life drawing. Indeed, Van Meegeren was a fixture at the De Boer residence during this period, often sketching and photographing Johanna. According to the recollections of a playmate of one of the De Boers' two children, Johanna looked "very pretty" posing in diaphanous garments, while De Boer—"a timid man"—busied himself with his work.

As an older member of Van Meegeren's social circle recalled in an unpublished letter from the 1970s, Johanna de Boer was everything Van Meegeren could have wanted in a woman: "She conducted herself very provocatively. Nowadays if a girl were to lay down naked and drunk on a billiard table we might think nothing of it . . . but back then it was really scandalous." Indeed it was: the affair went on for years and eventually wrecked the artist's home life. While continuing to live with Anna and the children, Van Meegeren, who already maintained a separate art studio, proceeded to rent a pied-à-terre in the center of town for his assignations. Although the complaisant Carel does not appear to have raised any objections, long-suffering Anna ultimately sought the comforts of another man and divorced Van Meegeren, who then married Johanna—although not before fitting in a few other dalliances in between. It took him five years to get around to tying the knot.

Considering the nature and extent of these extramarital pursuits, Van Meegeren very likely turned to forgery, at least at first, as a way to underwrite his immoderate lifestyle. Johanna was not a cheaply purchased plaything. Although her acting career consisted mostly of supporting roles in drawing-room comedies, her materialistic ambitions were legendary among her friends, one of whom recalled her jesting, Mae-West style, that she preferred the kind of bank account "with a lot of zeroes in it." And much like giving drawing lessons with Carel de Boer—or taking on occasional commercial illustration work, which Van Meegeren also did

during this period—forgery was a well-travelled path to extra income for struggling artists in the Netherlands.

THE BEST INDICATIONS are that the forging of Dutch old master paintings began during the era of the masters themselves. Toward the end of his life, the artist and writer Arnold Houbraken (1660–1719) published a three-volume chronicle of the Dutch art world called *De Groote Schouburgh*—The Great Stage—where he noted that it was not unusual at that time for dealers in possession of valuable pictures to keep "various young painters at work copying these pieces." True, before the advent of mechanical reproduction, there was a legitimate trade in faithful, handmade copies—marketed as such—but it seems that dealers sometimes increased their profits by selling copies as the real thing, carefully choosing buyers who were unlikely to be acquainted with whoever had bought the original. There are many instances of such pictorial mitosis in old provenance records, and to some extent, this disreputable practice even continues today. During the 1990s, the New York dealer Ely Sakhai secretly commissioned copies of his Gauguins and Renoirs, selling the genuine masterpieces in the United States and the duplicates in Asia for roughly equal prices. He was convicted of fraud in 2004.

Due to modern advances in disseminating news and information, selling doubles of valuable pictures is now a much more difficult proposition than it was during the seventeenth century, an issue Sakhai no doubt had ample time to ponder in the course of his three-and-a-half-year prison sentence. Purely duplicative forgery was, in fact, already quite problematic by Van Meegeren's era. During the nineteenth century, with the growth of public museums, art history had come together as a rigorous academic discipline, and scholars had dedicated themselves to sorting out what was real and what was imitation—an error-prone process, but one that successfully rooted out thousands of old copies. As meticulous

lists of authentic pictures by the major masters were compiled, it became easier for experts to keep close tabs on the whereabouts of important items. Under the circumstances, dealers whose Rembrandts had a tendency to develop twins earned bad reputations very quickly. By the beginning of the twentieth century, influential galleries with good names in the trade had far too much to lose to become involved with the chicanery of copying.

Not that this impulse toward honesty overwhelmed everyone in the art world. A new breed of unscrupulous dealer had begun to appear on the scene in the years just before the turn of the century, employing new methods to prey upon unwary customers at the priciest end of the market. Claiming not to be dealers at all, these so-called gentleman amateurs derived much of their cachet from appearing to be above commerce. They collected pictures for the love of art—or so they said—but they could always be persuaded to sell select items to people deemed worthy of owning fine things. Just like the handful of true aesthetes who really did offer pictures without an eye to profit, these dishonorable "gentlemen" might gain a client's trust by selling a genuine masterpiece or two. But then they would begin palming off forgeries or fraudulently restored old pictures sporting false signatures. The Italian art historian Gianni Mazzoni, one of the leading authorities on turn-of-the-century forgery, has shown that some such dealers acted as impresarios, directing the efforts of modestly remunerated hired hands who made the fakes to order.

Aristocratic titles and impressive addresses seem to have been helpful in creating the illusion of leisure essential to the gentleman amateurs' success. The "Baron" Michele Lazzaroni did quite well selling ersatz Italian masterpieces—in theory, works by early Renaissance painters like Crivelli, but, in reality, ruined old pictures repainted, completely or in part, by skilled artisans in Lazzaroni's employ. The Belgian dealer/collector Emile Renders did much the same with the art of the Flemish Primitives. Teaming up with a

talented Brussels-based picture restorer (and sometime forger) named Jef van der Veken, Renders purchased dozens of second-rate old pictures in terrible condition, which Van der Veken "repaired" imaginatively in the style of Van Eyck and Petrus Christus. Although Renders was thought to have some of the world's finest Flemish paintings in private hands—and he did have several excellent pieces—for the most part, what he had was a chateau filled with Van der Vekens, any of which he would have been happy to sell at a good price. In addition to these so-called hyperrestorations, Van der Veken also produced outright forgeries for dealers even less scrupulous than Renders, but by inventing new compositions rather than reproducing existing ones, Van der Veken usually evaded the attention of experts intent on debunking copyists.

Jef van der Veken tended to limit his mischief to the works of fifteenth-century artists who had painted in egg tempera, and he had good reasons for doing so. It had become very risky, for technical reasons, to forge or "fake up" the art of later generations of painters, like the seventeenth-century Dutch masters, who had worked in the more versatile medium of oil paint. Legitimate art restorers had discovered, sometime in the mid-nineteenth century, that highly concentrated alcohol could be used to remove old, discolored varnish from paintings without damaging the underlying image, and in the ensuing vogue for cleaning pictures with alcohol, a fascinating side benefit of the procedure soon came to light: it was a great way to unmask fake oil paintings. Although alcohol has almost no effect on oil paint that has had time to harden thoroughly—which can take over a hundred years—it dissolves new oil paint quite easily. Tempera, which dries very hard, very quickly, is not susceptible to the solvent action of alcohol in the same way, so Jef van der Veken, Emile Renders, and Baron Lazzaroni were fairly safe promoting their contrived fifteenth-century wares. But the alcohol test posed a serious problem for anyone hoping to sell a modern fake as a product of Golden Age Holland, for it was extremely difficult to

use tempera or any other traditional, fast-drying artists' colors to mimic the buttery brushstrokes and soft glow of oil paint. So long as a fake seventeenth-century masterpiece had to be painted in oils, it could only be sold to a customer too unsophisticated to test it—a factor that tended to be a drag on profits.

Indeed, during the early years of the twentieth century, forging the Dutch masters was, more often than not, a rather down-market endeavor, geared toward duping the casual buyer who thought he was getting a bargain in a flea market or some other unlikely spot. Paintings by major artists like Rembrandt and Frans Hals would have been far too conspicuous for such purposes. Therefore, swindlers who promoted fakes in this manner tended to commission forgeries of somewhat lesser items, like the popular tavern scenes of Adriaen van Ostade or the game-and-fowl still lifes of Jan Fyt. If real, such works would certainly have been valuable, although not breathtakingly so. The Hague seems to have been a center for this type of trickery. One day in 1910, Wilhelm Martin, the director of the Mauritshuis—the royal picture gallery—went for a stroll through the city and was surprised to find a series of crude Van Ostades for sale at very cheap prices in a grocer's window. Certain that these pictures were fraudulent, Martin bought one and carried it back to the Mauritshuis's restoration studio, where he doused it with alcohol. The image soon dissolved into a puddle of muck. Martin wrote up the incident with a word to the wise: real old masters are not to be found amid the fresh fruit and vegetables at the local market.

Luckily for Han van Meegeren, he never had to waste his talents on such nickel-and-dime deceptions. In or around 1920, he teamed up with—or more accurately, was recruited by—the remarkable Theo van Wijngaarden, a picaresque figure whose experience and resourcefulness gave him a leg up on amateurish operators who promoted fakes of the type so easily exposed by Wilhelm Martin.

Although Theo van Wijngaarden once admitted in a newspaper

The art dealer Leo
Nardus, ca. 1914

interview that he couldn't write more than a few halting lines with-
out help, a lack of formal education hadn't stopped him from get-
ting ahead in life. Born in Rotterdam in 1874, the son of a plasterer,
Van Wijngaarden had worked as a housepainter during his youth;
he also did wallpaper hanging, decorating, and odd jobs such as
repairing broken windows and furniture. Industrious and clever,
he managed to avoid following in the footsteps of one of his older
brothers, a petty thief with a careless habit of winding up in jail.
Teaching himself how to paint and draw—primarily landscapes
and flower studies—Van Wijngaarden got his introduction to the
world of high art working as a "restorer" and confidential business
assistant for the fabulously dishonest dealer Leo Nardus, one of
the most colorful figures in the history of the art world, although a
man little remembered today.

Theo van Wijngaarden's name has barely made it into the history books, but Nardus's has been intentionally expunged from them—largely because so many wealthy collectors wished to forget that they had ever met the man. Hailing from a prosperous family of Utrecht antique dealers, Nardus had apprenticed in the picture trade in Paris with the distinguished firm of Bourgeois Frères. His greatest commercial success, however, came not in Europe but in the United States, where he was a frequent visitor during the 1890s and early 1900s. Fluent in four languages, a champion swordsman, and an internationally known chess master, Nardus was a highly charismatic individual, and he used his charm to devastating effect in his business dealings. Taking advantage of America's newly rich industrial millionaires, who had only just begun collecting art, Nardus made millions selling old copies that would have been unmarketable in Europe; newly made fakes, which Americans didn't know to probe with alcohol; and, most astonishingly, an array of utterly undistinguished antique-shop pictures that he attributed, with a twirl of his handlebar moustache, to great artists such as Vermeer, Velázquez, Rembrandt, Turner, Botticelli, Raphael, and Leonardo da Vinci. Many of these ill-favored things can be found today in the storerooms of museums in Philadelphia, Washington, and other cities along the Eastern seaboard. Often the curators have no idea why their Gilded Age benefactors would ever have bought such awful paintings.

Nardus's perfidy was only unmasked in 1908 when the Philadelphia streetcar magnate P. A. B. Widener noticed that the three Vermeers Nardus had sold him weren't included in a recent book on the artist written by the renowned Dutch art historian Cornelis Hofstede de Groot. Having purchased a total of ninety-three paintings from Nardus over the previous fourteen years, Widener soon invited Hofstede de Groot to come to America to assess the "Nardus Pictures." Apparently suspecting what lay in store, the Dutchman did not come alone: he brought with him the well-known

English critic Roger Fry, the German connoisseur Wilhelm Valentiner, and the great American expert on Italian painting Bernard Berenson, then living in Florence. Duly assembled at Lynnewood Hall, Widener's imposing 110-room mansion just north of Philadelphia, the experts informed Widener that only a scattered few of the pictures he had gotten from Nardus were genuine masterpieces. The vast majority had been sold under what Widener later described in a distraught private letter as "gross false pretenses," with the entire collection worth roughly 5 percent of what Nardus had charged for it. These paintings were a very far cry from the fine group of genuine old masters that the Widener family would eventually assemble—after recovering from the Nardus fiasco—and donate to the National Gallery of Art in Washington, D.C.

By the time the day of reckoning at Lynnewood Hall came around, Leo Nardus was safely back in Europe, and he suffered almost no direct consequences from his actions. Although he was rumored to have painted some of Widener's more questionable pictures himself, Nardus was never prosecuted or publicly exposed in any way, mostly because the wealthy Americans he had duped feared humiliation of the emperor's-new-clothes variety. There was, however, a great deal of gossip about Nardus within the picture trade, and although he continued selling art in Europe after his American adventures, he often had to hide behind front men due to his bad reputation. Such arrangements seem not to have crimped his lifestyle: the story in Theo van Wijngaarden's family is that Leo Nardus was so rich, he ate his meals from golden plates using golden utensils.

Prompted in part by legal proceedings brought by a wife whom he had abandoned in France, Leo Nardus left the Netherlands shortly after the First World War, retiring to a seaside palace in Tunisia. With his primary employer suddenly gone, Theo van Wijngaarden was obliged to make a living on his own in The Hague, carrying on with roughly the same sort of work that he

had previously done for Nardus. According to gossipy newspaper accounts from the time, Van Wijngaarden's activities included deceptive restoration, adding false signatures to old pictures, and copying valuable items that came through the atelier. Such petty chicanery probably paid the rent, but the real challenge for Van Wijngaarden, as his granddaughter, a professional portraitist, explained to me, was learning to work *in de trant van*—in the style of the old masters. Although Van Wijngaarden possessed an indisputable gift for color harmony and a wonderful feeling for the texture and physicality of paint, he labored under significant limitations as an artist that made it very difficult for him to produce high-quality forgeries in an extemporaneous mode. He had never truly mastered the depiction of the human figure at close quarters; his few known portraits show only a rudimentary understanding of facial anatomy; and even his landscapes tended to be at their best when the more exacting details were omitted or left unresolved. A skilled restorer, Van Wijngaarden could make even the newest of pictures look perfectly old, but to carry the business of art fraud to the next level, he had to find better forgeries to work with than anything that he could create on his own.

What Van Wijngaarden needed was a star pupil, and he found one in Han van Meegeren. Precisely how they met is not clear, but one of Van Meegeren's closest companions in the social whirl of The Hague, an amateur dealer named A. H. W. van Blijenburgh, had once been associated with Leo Nardus and may well have furnished the introduction. (Van Blijenburgh had been one of Nardus's fencing partners, competing actively in both the epée and the saber.) We can fix the date at which Van Meegeren began work at the Sumatrastraat to sometime before 1921 due to a piece of lore handed down in the Van Wijngaarden family. It was at this point that Theo van Wijngaarden's son Willy, then finishing art school, was invited to join in the production of fakes—but declined to do so. A promising painter, far more skillful than his father, Willy

had grown up partially estranged from the disreputable Theo, who had walked out on the family years earlier. Willy informed Theo that he didn't want to be "made into a Frans Hals," and also indicated that he didn't care to spend time in the company of Van Meegeren, whom he considered arrogant.

Theo van Wijngaarden may have been especially eager to recruit his son around this time because the forgery business seemed to be on the verge of a boom: Van Wijngaarden had just figured out a way around the dreaded alcohol test. Working by trial and

Theo van Wijngaarden, *Self-Portrait,* ca. 1907

error, he had invented a medium for traditional artists' pigments that successfully mimicked the physical appearance of oil paint but dried quickly and resisted softening with alcohol. The Van Wijngaarden family still has the book that "Old Theo" used as a guide during his research. This was no complex scientific tome, but rather, in keeping with Van Wijngaarden's artisanal roots, an instructional volume on painting techniques and materials, printed in large type and in very simple Dutch, intended for use by house-painters. Based on the extensive underlinings and occasional hand-written notes in the margins, it seems that Van Wijngaarden at first attempted to adapt milk-based casein paint as a substitute for oils, but while this would have dried rock hard, it just didn't have the right look. Ultimately, it was gelatin glue—a water-borne emulsion of bonemeal—that proved to be the perfect vehicle: when properly prepared, it had the body and smooth texture of oil paint, yet, once dry, was completely impervious to alcohol.

With Theo van Wijngaarden still working out some of the technical issues related to the gelatin-glue medium—for instance, it turned many pigments an unpleasant shade of gray—Van Meegeren's earliest efforts at the Sumatrastraat probably entailed a measure of hit-and-miss experimentation. Likewise, much of Van Meegeren's initial work with Van Wijngaarden may have consisted not of outright forgery but of the sort of deceptive overrestoration for which Van Wijngaarden's shop was already well known.

Although fraudulent restoration is not as blatantly criminal as full-blown forgery—someone like Baron Lazzaroni, for instance, could always claim that his Italian Primitives were at least partly real—the line between the two practices is actually quite thin, as both usually begin with genuine old pictures. Forgers reuse panels and canvases from period paintings to ensure that their creations will have what is called "age crackle." They strip away the orig-inal image using sandpaper or caustic soda but leave the under-lying ground layer intact. When painted over, the characteristic

crack pattern contained in the old, hardened ground will telegraph through to the new surface, giving the forgery virtually the same craqueleur as a picture that has been dry for centuries. The cracks can then be accentuated by darkening them with dirt, ink, graphite, or other foreign matter to complete the illusion of age. Such tricks of the trade were Van Wijngaarden's specialty: according to his family, he kept jars of rusting nails and rotting leaves buried in the backyard to provide suitable muck for the process.

Unfortunately, whatever out-and-out fakes may have emerged from the partnership between Van Meegeren and Van Wijngaarden during the period from 1920 to 1921 are known to us only through rumor—primarily comments made years later by Van Meegeren's children—but interestingly, all of the rumors center on works by Frans Hals, for whom Van Meegeren, with his sense

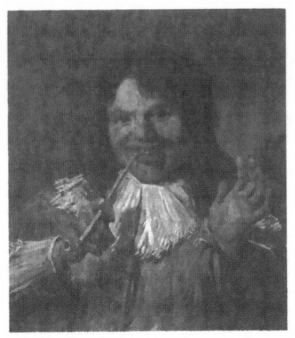

The Boy Smoking, forgery in the style of Frans Hals, ca. 1922

of flash and dazzle, had a natural affinity. Indeed, the first readily documentable forgeries by Van Meegeren (ca. 1922) show just how effortlessly the artist adapted his skills as a society painter to the production of Hals-style rascals. In *The Boy Smoking* for instance, Van Meegeren improvised freely in the style of Hals—forgery at its most complex and inventive—and after only two years on the job, this was quite an impressive accomplishment.

Of course, crafting a plausible old master was just the first of many steps involved in the business of high-end art forgery. In order to sell an ersatz painting for the price of a true master-piece, a market, a buyer, a credible front man, and a tale explaining the picture's origins had to be in place, and these variables often proved to be difficult to control. From a forger's perspective, the most lucrative solution would have been to introduce the fakes to wealthy customers directly, without the protection of middlemen. This was, more or less, the model that Leo Nardus had employed, but Nardus's American adventures had caused a backlash in the art world, subtly changing the rules of the game for future swindlers. The day of reckoning at Lynnewood Hall had cemented the reputations of Hofstede de Groot, Bernard Berenson, and the other major experts as the ultimate arbiters of quality and authenticity. Thereafter, it became virtually impossible to sell a major painting to a major collector without first obtaining a signed attribution from one of the top authorities in the field—for Italian works, Berenson; for Dutch ones, Hofstede de Groot or Harold Wright's victim, Wilhelm von Bode; for the Flemish Primitives, the great Max Friedländer; and so on down the line. Likewise, in the post-Nardus era, wealthy Americans had become extremely wary of buying pictures from any but the most reputable galleries: in practice this meant that Joseph Duveen—the dealer of choice for the very richest of the rich—acted as the gatekeeper to the high end of America's ultralucrative art market, along with a handful of other figures like Nathan Wildenstein and the Knoedler brothers.

"Gentleman" dealers like Baron Lazzaroni could, and did, continue to do business. But now they had to work much harder: they had to dupe experts into attributing second-rate or fraudulent paintings and then dupe big dealers like Duveen into buying the merchandise. The doors to places like Lynnewood Hall were now permanently closed to charming interlopers.

Given all of the complications that working with an end buyer would have entailed, most forgers were content to sell their wares for quite modest sums to the type of dealer who knew exactly what he was getting and who was prepared to take the risks involved with promoting the fakes upward through the art market's food chain. According to his memoirs, the great Italian forger Icilio Joni, whose spurious Siennese Primitives frequently fooled Bernard Berenson, worked for a whole parade of "gentleman" dealers, including some Americans, who came to Italy expressly looking for fakes. From a forger's point of view, such an arrangement was attractively safe, and there are indications that, at least in the first year of their partnership, Van Wijngaarden and Van Meegeren may have availed themselves of this uncomplicated tactic. For instance, one of Leo Nardus's old business partners, a semilegitimate dealer and collector named Van Gelder, acquired a very dubious Frans Hals *Boy with a Flute* during this period: it answers to the description of one of the rumored early Van Meegeren fakes, and today is not considered genuine by the leading experts on Hals.

Laundering fakes through Van Wijngaarden's existing contacts in the trade would have offered a straightforward means of making a living, but having conquered the alcohol test, Van Wijngaarden and Van Meegeren were soon tempted to sell their works for really big money at auction by asking friends to pose as the owners of record. This idea may well have suggested itself to Van Wijngaarden because Leo Nardus had often used intermediaries, particularly in order to obtain certificates of expertise from the upright Hofstede de Groot. And yet, while asking friends to sell fakes did provide

a measure of anonymity, the gambit was still quite risky. It could only work if no doubts were ever raised about the picture's authenticity or origins, but most forgeries do tend, sooner or later, to prompt questions. Moreover, trying to con respectable people into taking part in a criminal conspiracy is, as Van Meegeren discovered, a difficult trick to pull off.

Consider, for instance, an incident that occurred at the baronial estate of Molecaten outside Hattem in the eastern Netherlands. Van Meegeren had made a very favorable impression on Baron van Heeckeren van Molecaten in 1924 by painting two stunning portraits of the baron's sons, Eric and Walraven. Indeed, one can easily understand the rave reviews: the round-format portrait of young Eric, in particular, is wonderfully fresh, direct, and evocative—an example of Van Meegeren's very best work. The following year, Van Meegeren paid a return visit to Molecaten and, while there, painted a formal, three-quarter-length portrait of the baron, ostensibly as a gesture of friendship. Posed in the bright red uniform of the local *Ridderschap*—a fraternal order of and for the aristocracy—Baron van Heeckeren van Molecaten looks every inch the fine Dutch nobleman that he was. It wasn't until Van Meegeren finished the painting, though, that he really got to work: casually mentioning that he had a few "old pictures" that he was planning to sell at auction, Van Meegeren asked if he could say that they had come from the manor house at Molecaten. The answer was an emphatic "no," and the good baron distanced himself from the artist from that point forward.

Even when Van Meegeren succeeded in getting people to go along with his plans, the results were not always ideal. In 1923, he talked an old school chum by the name of H. A. de Haas into acting as a straw man in the sale of a fake Frans Hals called *The Laughing Cavalier*—and everyone nearly got caught. De Haas, an engineer who had belonged to the same Catholic student group as Van Meegeren at Delft, had a wife and five children to support, which

Portrait of Eric Baron van
Heeckeren van Molecaten, 1924

Portrait of E. W. Baron van
Heeckeren van Molecaten, 1925

may have left him susceptible to dubious financial propositions. As De Haas later recalled, he was invited to the Sumatrastraat one day by Van Meegeren, who asked him to place *The Laughing Cavalier* in an upcoming sale in the Frederik Muller auction house, a friendly favor for which there would be a handsome commission. What excuse Van Meegeren gave for requesting De Haas to act as the seller isn't clear. Nor is it clear whether De Haas, whose home was adorned with a half dozen oil paintings by Van Meegeren, actually believed that *The Laughing Cavalier* was by Frans Hals—although the picture did have a signed certificate of expertise. Theo van Wijngaarden had brought *The Laughing Cavalier* to Cornelis Hofstede de Groot—the self-same connoisseur who had seen through Leo Nardus back in 1908. Hofstede de Groot approved *The Laughing Cavalier* enthusiastically. He also approved *The Boy Smoking* during the same visit. Indeed, he liked it so much that he later decided to buy it for his own collection, deducting the cost of his thousand-guilder-per-picture "honorarium," or fee for expertise, from the 30,000 guilder purchase price.

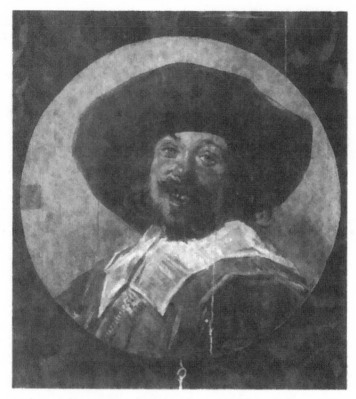

The Laughing Cavalier, forgery in the style of Frans Hals, ca. 1922

As planned, De Haas brought *The Laughing Cavalier* to Amsterdam, and the salespeople at Muller's found the work quite seductive. They immediately located a private purchaser who was willing to pay fifty thousand guilders for it—approximately fourteen years' salary for the average man—thus obviating the need to place the picture in a public sale. But this was only good news until it wasn't: within a year, the buyer returned in a state of high outrage, saying that a technical examination had shown *The Laughing Cavalier* to be of indisputably modern manufacture. After reviewing the facts, the house of Muller concurred, refunded the purchase price, and then brought suit against De Haas for fraud. When De

Haas tried to squirm out of it, saying that he had "purchased" the picture from Theo van Wijngaarden, Muller's simply added Van Wijngaarden's name to the lawsuit.

The court case, which dragged on for two years, became a sensation in the papers, as the famously chilly Hofstede de Groot steadfastly maintained—laboratory evidence be damned—that *The Laughing Cavalier* was a genuine Frans Hals. He argued that science had no place in the examination of pictures and that a connoisseur's judgment should be considered sacrosanct. He even wrote a brief pamphlet called "The Eye or Chemistry"—*Oog of chemie*—to publicize his views. But with the technical evidence plain as could be, Hofstede de Groot's zealous defense of *The Laughing Cavalier* found virtually no support among other experts. Although Theo van Wijngaarden had gone to the trouble of procuring an old panel for the forgery, it was not nearly old enough: the original preparatory ground layer on the panel contained zinc white, a pigment not invented until the nineteenth century. And Van Wijngaarden's gelatin-glue medium, while good enough to pass the alcohol test, didn't hold up so well under more rigorous inspection: it turned spongy when soaked in water—something that oil paint, alas, would never do.

Even Hofstede de Groot, science averse though he was, knew that oil paint shouldn't absorb water, and the paradox apparently troubled him. In *Oog of chemie*, he describes asking Theo van Wijngaarden for an explanation of this phenomenon during a visit to the atelier on the Sumatrastraat. Not missing a beat, Van Wijngaarden responded that he had treated *The Laughing Cavalier* with a special cleaning solvent that made oil paint behave just as though it had a water-based medium. To demonstrate how the process worked, he then plucked a seemingly very old painting from the walls of the atelier, rubbed it down with an unidentified liquid, and voilà, this picture too was suddenly susceptible to softening with water. Never suspecting that Van Wijngaarden had simply

used another gelatin-glue fake for this alchemistic game of show and tell, Hofstede de Groot walked away satisfied.

Indeed, in a newspaper interview conducted at the height of the controversy, Hofstede de Groot openly scoffed at all the rumors surrounding *The Laughing Cavalier* and its possible origins. "The gossip going around about it being painted by Nardus or Van Meegeren is absurd," he said. "They should wish that they could paint that way." Hofstede de Groot was clearly right to rule out his old nemesis, Leo Nardus, who was long gone from the Netherlands by that point. But with regard to Van Meegeren, what could the man have been thinking? It seems astonishing that, with the talk of Van Meegeren's involvement known to him, Hofstede de Groot still failed to reach the obvious conclusion—although

Cornelis Hofstede de Groot in a 1923 oil portrait, artist unknown

perhaps he ultimately did sense that all was not right with *The Laughing Cavalier*. In what many perceived as a face-saving maneuver, Hofstede de Groot dramatically put an end to the lawsuit in 1926 by agreeing to purchase the painting for his own collection at the full fifty thousand guilder price tag.

As a result, the House of Muller dropped all charges before a verdict could be reached, and Hofstede de Groot never had to admit that he had been wrong about the picture. Still, the damage to his reputation was considerable—and it wasn't just his aesthetic acumen that got called into question but his personal integrity as well. For even though Hofstede de Groot had never been accused of any complicity in the swindle, his longstanding practice of charging fees for his certificates came off as a form of corruption, at least in the eyes of his many critics.

Supplying certificates of expertise had evolved into Hofstede de Groot's main source of income in the years following the Nardus incident at Lynnewood Hall. With so many dealers now needing to guarantee the authenticity of their pictures, Hofstede de Groot wrote hundreds of certificates every year, using preprinted forms to make the work go faster. His fees ranged from as little as thirty guilders for attributing paintings of relatively low market value up to a thousand guilders for masterpieces. Clients who wanted Hofstede de Groot to travel abroad to look at their paintings had to pay an additional 500 guilders per day—with the clock ticking from the moment he left home until the moment he returned. When one London dealer complained about these high costs, the great expert replied, "I am so much wanted everywhere that if I took less I would never be at home, always en route, and that is not the aim of my life." Poverty wasn't his aim either. By the 1920s, Hofstede de Groot had made enough money to move from fairly modest quarters on The Hague's Heeregracht to a palatial limestone mansion on the Lange Voorhout, the city's most prestigious address. To those inclined to take a jaundiced view, the notion that economic

self-interest might have clouded Hofstede de Groot's judgment in the case of *The Laughing Cavalier* was hard to dismiss.

And yet, while that perception was not entirely unfair, it missed the underlying irony of Hofstede de Groot's situation. This very proper Dutchman had gotten into the business of selling certificates in order to stem corruption in the art market, not to capitalize on it. Clearly, Hofstede de Groot wanted to make money, but integrity lay at the heart of his enterprise, and the last thing he would have wanted to do was tarnish his reputation by passing a fake. Having established himself as judge and jury in the realm of Dutch old master paintings, however, Hofstede de Groot had become a prime target for forgers and swindlers, who had adapted their tactics to the changing realities of the picture trade.

When Han van Meegeren was in full grandstanding mode after the Second World War, he would claim that he had set out to make fools of the world's art experts because they had scorned his work in his own name. But the men who were tricked into attributing Van Meegeren's fakes over the years had nothing to do with the fate of the forger's legitimate artistic aspirations. They weren't journalists; they didn't review gallery shows; and they had no influence over the contemporary art scene. Van Meegeren duped them because he had to: they represented his only path to the high end of the art market. They were, simply put, part of his business model.

And publicly embarrassing Hofstede de Groot was very bad for business. The uproar surrounding *The Laughing Cavalier* cast an unwelcome light on what was meant to be a game of shadows. However convenient it may have been to attempt a really big score right in their own backyard using De Haas as a front man, Van Meegeren and Van Wijngaarden soon fell back on a safer and more traditional forger's arrangement. They would hide behind an experienced but ethically challenged art-world operator who took over the work of selecting the middlemen and orchestrating

the sales, and who may even have decided which artists would be faked and which subjects portrayed in the forgeries.

This new setup was never exposed in Van Meegeren's day—it has remained a secret for eighty years—but a web of clues and circumstantial evidence allows us to trace the operation's outlines. It's a murky story, and that should be taken as a measure of the scheme's overall success. Whereas the failure of *The Laughing Cavalier* attracted legal scrutiny and newspaper coverage, the next stage of Van Meegeren's and Van Wijngaarden's efforts generated publicity of a very different kind—praise for newfound Vermeers.

CHAPTER THREE

The Sphinx of Delft

WHEN VAN MEEGEREN admitted to being a forger in 1945, he claimed to have focused on Vermeer because the Delft master's work provided a universally recognized standard of excellence against which to measure one's own painterly prowess. "I picked one of the five greatest artists who ever lived," Van Meegeren declared—helpfully adding that he considered Leonardo da Vinci, Michelangelo, Rembrandt, and Frans Hals to be the other members of the quintet. The way Van Meegeren told it, he was looking for the grandest *succès d'estime* that a forger could possibly achieve, and Vermeer seemed like a suitably big name for the job. But, like virtually everything else Van Meegeren ever said, his comments on this issue have to be taken with a grain of salt: for it wasn't a list of art history's top stars that led him to his preferred object of emulation. On the contrary, there were practical, business-minded factors of supply and demand that made Vermeer an especially tempting target for forgers and swindlers, as Vermeer was then an art-historical enigma waiting to have the blank spots in his career filled in.

Dead for centuries, his paintings dispersed and mostly unknown, Johannes Vermeer had emerged during the latter half of

the nineteenth century as one of the art world's biggest celebrities. By Van Meegeren's day, Vermeer's works commanded prices on par with the very finest masterpieces of Rembrandt, but when the French writer Théophile Thoré had begun publishing essays about Vermeer's sun-filled interiors and limpid figure studies in the 1860s, few connoisseurs outside Holland had heard of the artist's name. Indeed, even *in* Holland it was possible, during that period, for great works by Vermeer to go completely unrecognized: in 1881, the collector A. A. des Tombe purchased perhaps Vermeer's most iconic painting, *The Girl with the Pearl Earring,* for all of 2½ guilders at a small auction in The Hague. It was a remarkable find—and also an inspiration. For as Vermeer's reputation grew, people naturally began to wonder what else might be waiting to be discovered. With only about thirty of Vermeer's pictures then known, it seemed logical that more would eventually turn up. And over the years, a few did. *The Woman with a Balance,* for example, was rediscovered in 1911; and *The Girl with the Red Hat* in 1925. However, by the time Harold Wright palmed off Van Meegeren's bogus *Lace Maker,* in 1927, the age of miracles was over. There were no more genuine Vermeers left to be found—although no one realized it at the time.

As the great German expert Max Friedländer once put it, art dealers of the 1920s lulled themselves to sleep at night dreaming about Vermeer. Discovering a picture—any picture—that might be accepted as a Vermeer was the interwar art world's equivalent of the quest for the Holy Grail. Dealers all across Europe pestered great authorities like Bode and Hofstede de Groot to attribute a multitude of minor seventeenth-century paintings to Vermeer—portraits, landscapes, still lifes, interiors, religious scenes, whatever they could find. Theodore Ward's brother Albert sent so many inquiries of this kind to Hofstede de Groot that the Dutchman simply took to scrawling *Niet op gereageerd*—"not answered"—atop Albert's incoming missives. Although trying to attribute

pictures by lesser hands to great painters was a standard art dealer's gambit, in the case of Vermeer, it was actually quite difficult to pull off. Whereas Rembrandt, for example, had a workshop full of assistants whose paintings could sometimes be taken for the master's, Vermeer, who inspired no known school of disciples, did not. Credible near-Vermeers were not easily found, leaving the fondest hopes of many a treasure hunter to languish unfulfilled.

Turning this atmosphere of wishful thinking to their advantage, some of the picture trade's more creative operators soon enlisted the help of forgers to furnish the market with all the works that Vermeer didn't paint but that collectors still hoped he had. And it wasn't just Van Meegeren and his associates who tried their hands at this game. There was a Jazz Age explosion of bogus Vermeers. Some were outright fakes; others were seventeenth-century pictures deceptively "restored" to resemble Vermeer's style. During the 1920s, Joseph Duveen bought at great expense no less than four newly discovered Vermeers—none of which was genuine. One of them, *The Girl with a Kitten,* although legitimately old, had been so thoroughly repainted that the image disintegrated when Duveen's people cleaned it with alcohol, leaving the horrified Duveen scrambling to recoup his money. Another, a sauced-up seventeenth-century picture of a very French-looking boy, was called into question by outside experts soon after Duveen, believing the painting to be by Vermeer on the basis of Hofstede de Groot's attribution, sold it to New York financier Jules Bache in 1922. The other two pseudo-Vermeers that Duveen bought, *The Smiling Girl* and *The Lace Maker,* both by Van Meegeren, were sold with great fanfare to the Pittsburgh banker Andrew Mellon, who later donated them to the National Gallery of Art in Washington, D.C. They hung there through the 1960s as authentic works by the master's hand.

Duveen's bad luck with Vermeers seemed to know no bounds. Perhaps even more embarrassing than buying four duds, Duveen

A seventeenth-century
French painting
attributed to Vermeer
by Hofstede de Groot
and sold by Joseph
Duveen to the financier
Jules Bache

flatly turned down the only real Vermeer he was offered during
this period, *The Girl with the Red Hat*. Not that he thought it was
a fake: his in-house advisors had simply convinced him that it
was "too small" to be of interest. Knoedler & Co. promptly ac-
quired the picture and then sold it for a handsome sum to Andrew
Mellon, who at least had one real Vermeer to keep his fakes com-
pany. Duveen's fear of little pictures did, at least, save him from
purchasing the weirdly miniature, five-by-seven-inch Vermeer
forgery known as *The Young Woman Reading*, which some have
claimed was made by Jef van der Veken, although that attribution
is considered extremely unlikely for stylistic and technical reasons
by the top authority on Van der Veken today. Others have sug-
gested Van Meegeren as the work's author, although that suspicion
too seems quite doubtful. After Duveen passed it up, Wildenstein
& Co. acquired it and then sold it to the twice-unfortunate Jules
Bache, who, ever eager to possess a Vermeer, never got one.

The Young Woman Reading, forgery in the style of Johannes Vermeer by an unknown artist, ca. 1926

Regardless of who may have made it, *The Young Woman Reading* deserves a moment's further attention because it was brought to market by a well-known art-world insider, suggesting a great deal about how the Vermeer swindles of the 1920s actually worked. This picture was "discovered" in a Dutch private collection by the art historian and dealer Vitale Bloch, who brought it to his mentor, Wilhelm von Bode, for attribution. A sophisticated man with flexible morals, Bloch developed an extremely bad reputation during the Second World War: although nominally Jewish, the Russian-born Bloch arranged to be declared an "honorary Aryan" by the Nazis and proceeded to make a very comfortable living in occupied Holland by acquiring paintings for the Reich on a commission basis. Looted Jewish art was found in Bloch's private collection at the time of his death in 1975, and the archives of various major galleries indicate that Bloch peddled paintings with false and fabricated provenances for many years after the war. In that light, it is hardly surprising that one elderly Jewish art dealer in the Netherlands, a

concentration camp survivor, told me bluntly, "Vitale was a dirty dog." Bloch's long history of double dealing has led to considerable speculation: most notably, the distinguished Dutch art historian A. B. de Vries once suggested that the unsavory Dr. Bloch might have acted as the "spiritual director" of a complex criminal conspiracy going back to the 1920s.

De Vries had no hard evidence to back up his suspicions, but he may have been on to something. Certainly, Vitale Bloch played a questionable role in authenticating some of Van Meegeren's wartime "biblical" Vermeers; moreover, the stylistic evolution of Van Meegeren's earliest Vermeer forgeries—three charming pictures of young women—suggests that one or more dishonest insiders supervised their creation. Each of these fakes improves subtly on the last, guided, it would seem, by a nuanced awareness of Wilhelm von Bode's developing tastes and opinions. At this stage of his career, Van Meegeren, still new to the ways of the international art market, probably did not have the requisite background to pull this off by himself. But other people involved with the Sumatrastraat forgery ring were ideally positioned to help guide the forger's efforts—people with an expert knowledge of the Vermeer literature and a close understanding of Bode's reasons for accepting or turning down specific paintings.

Although several mid-level German dealers were mixed up in these schemes—and Vitale Bloch may well have been working with them—the evidence indicates that the true *éminence grise* behind Van Meegeren's early fake Vermeers was Theodore Ward, who provided the crucial link between Berlin's seamy culture of art world intrigue and Theo van Wijngaarden's Dutch fake factory. Why point the finger at Ward? To begin with, the frequent movements of Ward's employee, Harold Wright—from London, to Germany, to the Netherlands—dovetailed very conveniently with the needs of the forgery business, if not necessarily with the demands of Ward's paint company. When Wright was handling

paperwork related to the attribution of pictures that he and Ward bought at Christie's in 1924 and 1925, he operated out of Ward's London office in Piccadilly; when he was negotiating to sell pictures in Berlin in 1927, he was ostensibly the manager of a small paint factory Ward owned in Bremen; and in 1928, when people in the art world began to suspect that Wright was a "clever, dangerous, and tricky man," he hastily relocated to The Hague to run Ward's distribution office there, later expanding it to a full-fledged production facility. It is highly improbable that Wright, a junior employee, would have had such latitude to decide his postings, changing job descriptions at the drop of a hat. These decisions, however, would certainly have fallen under the purview of Ward himself.

Moreover, Ward had years of experience buying and selling pictures in England, Holland, and Germany, going back to the beginning of the century. Aside from assembling his own collection, Ward also acted as a private dealer; his brothers Albert and Rudolf operated a London gallery for about a dozen years; and Ward seems to have known a great deal about the less honest aspects of the art world. For instance, when a picture of his disappeared under suspicious circumstances, Ward stated in a letter, "At a very wild guess, I would say that it was stolen by two men who do odd jobs for one of the dealers in the St. James's district." He described the suspects as being "about 35–40. Medium height. Stoutish. Jewish or semi-Jewish appearance. Speaking with a foreign accent, but only slightly so. They wear usually dark or grey overcoats."

Then, of course, there was the Berlin connection. Theodore Ward had lifelong contacts in Germany: although British by birth, Ward was of German extraction, spoke German fluently, and had studied for a time at Heidelberg. In his adventures as a *marchand-amateur*, he often sent artworks to Berlin for sale through local dealers and galleries. And looking at the various transactions involved in the promotion of Van Meegeren's early fake Vermeers,

it is apparent that they were orchestrated by someone who was keenly aware of how the Weimar art world worked. Indeed, several fairly notorious Berliners were called upon to help carry out the schemes. For instance, one of Van Meegeren's fake Vermeers, *The Smiling Girl*, was presented to Wilhelm von Bode for attribution in 1926 not by Harold Wright but by a German army officer turned art dealer named Walter Kurt Rohde, who was later implicated in a plot to forge Bode's certificates of expertise.

Likewise, after Harold Wright got Bode to approve *The Lace Maker*, the initial contacts to sell the picture to Joseph Duveen were set up through a chain of German dealers that began with Hans Wendland, an extremely shady character who later became a key figure in the Nazis' art looting apparatus. Although the Nazis kept the best artworks they confiscated from the Jews of Europe as trophies for the Reich, many items deemed either second rate or degenerately modern were passed off to private dealers like Wendland, who then sold these stolen Holocaust assets through clandestine channels in occupied Europe, or, in some cases, on the legitimate art market in neutral Switzerland. As it happens, Theodore Ward's brother Rudolf, although technically a British subject, was also suspected of trading in art of dubious origins from his base of operations in occupied Paris, where he came under the direct protection of the SS and was said, by Allied military intelligence, to have "worked consistently throughout the war in the German interest."

Interrogated by Allied investigators after the war, Rudolf Ward, Hans Wendland, Vitale Bloch, and other dealers who had capitalized on the Nazi takeover consistently denied any personal wrongdoing, but often provided damning information about associates. Although the evidence is consequently fragmentary, one gets the impression that these men functioned as part of a loosely affiliated network of independent operators who occasionally joined forces to pull off major transactions. And it would appear

that the roots of this ad-hoc system of illicit trade actually reach back to a period decades before the war, when many of the same figures participated in the shell game of promoting and selling fakes.

But why, in the 1920s, would a prosperous businessman like Theodore Ward have gotten involved with anything as disreputable as a forgery ring? To judge from what is known of Ward's character, malice and envy probably had a great deal to do with it. Despite several generous gestures in his declining years, such as giving his Dutch still lifes to the Ashmolean Museum, Theodore Ward was known, even in his own family, as a man with a chip on his shoulder. Ward considered himself a true connoisseur of pictures, but budgetary constraints generally forced him to limit his purchases to minor masters and lesser genres. As a result, he seems to have cultivated an elaborate disdain for wealthier collectors who could afford whatever they wanted but lacked a profound knowledge of art. Once, during a trip to New York, Ward wrote to acquaintances in England condemning the permanent collection of the Metropolitan Museum on precisely those grounds: "Several of the Rembrandts are of no great age and should, to use an American expression, be 'debunked.' It serves them right for wanting only big names." Apparently, Ward could be equally high-handed in his day-to-day behavior. The noted Dutch art historian Fred Meijer relates that, on one occasion, while eating lunch at the Ritz in London, Ward expressed his displeasure with the quality of the soup on offer by ostentatiously carrying his bowl across the dining room and emptying it in the street outside.

Much though Theodore Ward may have enjoyed expressing contempt for the world at large, it would be naive to discount the importance of greed as a motive for his involvement in the Vermeer forgeries. Although Ward was well-off, he was not truly rich—at least not initially—and his family had, over the years, known its economic ups and downs. Ward's father had gone bankrupt in the

shipping business around the turn of the century and was, at one time, wanted by the police in connection with an incident of petty theft. What's more, the paint business, though successful, was a property Ward owned with many partners, including brothers, uncles, cousins, and a sizeable group of outside investors. In 1936, the entire company—the factories, equipment, land, and other assets—was valued by Price Waterhouse at £53,000. By way of comparison, Joseph Duveen paid a total of £56,000—roughly $3.75 million in today's money—for *The Lace Maker* and *The Smiling Girl,* and it was all in cash. The potential profits from promoting fakes were big enough to tempt a great many people. And it would appear that Ward, over time, grew curiously richer than the other members of his family: he drove a Rolls-Royce doctor's coupé, filled his closets with what his nephew derisively described as "a hundred pairs of shoes," and developed a marked fondness for the Riviera. He ultimately retired to Cannes, where he lived his final years in the Mediterranean sunshine, far from the Finchley Road townhouse where he had welcomed Han van Meegeren time and again in the 1920s.

DEVISING AND PROMOTING fake Vermeers involved a steep learning curve. In 1924, while the *Laughing Cavalier* scandal was boiling over in The Hague, Harold Wright brought the first of Van Meegeren's Vermeer forgeries to Berlin, and Wilhelm von Bode shot the painting down immediately. This picture seems to have been *The Girl with the Blue Bow,* which was later reintroduced successfully through London, after Bode's death, with a certificate written by Bode's younger disciple Wilhelm Valentiner. Given that Bode continued to receive Wright at the Kaiser Friedrich, he most likely did not reject this putative Vermeer as a fake but rather as a work that was simply not by the master—and with so many people trying to hit the Vermeer jackpot, there's no reason to think that this near miss would have struck Bode as an unusual

or suspicious occurrence. It's also fairly easy to see why he might not have wished to authenticate the painting.

One obvious barrier to accepting *The Girl with the Blue Bow* as a work of Vermeer, questions of quality aside, is that it comes across as a conventional commissioned portrait, a type of picture that Vermeer simply did not paint—despite the widely held belief among twentieth-century art dealers that he really ought to have done so. Indeed, looking at *The Girl with the Blue Bow* from today's vantage point, it resembles nothing so much as the children's portraits that Van Meegeren painted for Dutch patrician families throughout the 1920s. It has far more in common with Van Meegeren's portrait of young Cornelia Françoise Delhez—with her endearing saucer eyes and button nose—than with, for instance, Vermeer's *Girl with the Pearl Earring*. And it's not just that the wonderfully impossible eyelids that Vermeer finessed in *The Girl with the Pearl Earring* remained forever beyond Van Meegeren's capabilities. (Van Meegeren tried and failed any number of times to mimic them in his Vermeer forgeries.) Vermeer's familiar masterpiece is in fact conceived in a fundamentally different way from *The Girl with the Blue Bow*. In a tour de force of stagecraft, Vermeer presents his turbaned mystery woman with a characteristically Baroque sense of drama evident even in the very torsion of her pose. One could easily imagine her as part of a larger genre scene: her face implies a story. The Dutch would call this sort of picture a *tronie*—we might call it a character study—and if one were to categorize Vermeer's known close-up images of faces, all of them would lie somewhere in the terrain between the *tronie* and the full-fledged genre scene. None is a frontal portrait head shot in the manner of *The Girl with the Blue Bow*.

Yet, even though Vermeer didn't paint portraits per se, *The Girl with the Blue Bow*, with its soft modeling and liquid, *pointillé* highlights was a valiant, indeed clever, attempt to expand the limits of the master's oeuvre through the power of forgery and thus

The Girl with the Blue Bow, forgery
in the style of Vermeer, ca. 1924

Johannes Vermeer, *The Girl
with the Pearl Earring,* ca. 1665

*Portrait of Cornelia
Françoise Delhez,* 1924

subtly rewrite the pages of art history. The list of Vermeer's known works was so small and the pictures so familiar that to find a way into the canon, a forger had to create not merely a "characteristic" image but one that speculated about the unknown pathways of Vermeer's art. The more that the forger's conceit resonated with the attributing expert's own imagined narrative of Vermeer's motives and development, the more likely the picture was to win the wished for nod of approval. Had Bode accepted *The Girl with the Blue Bow,* the attribution might well have paved the way for further fake Vermeer portraits. To his credit, Bode didn't take the bait with *The Girl with the Blue Bow.* But forgery being a business of trial and error, this simply meant that Bode would be presented with a different art-historical puzzle the next time around.

Van Meegeren's second attempt at a Vermeer, *The Smiling Girl,* was virtually tailor-made to suit the sensibilities of Wilhelm von Bode. A *tronie* rather than a portrait in the manner of *The Girl with the Blue Bow,* this new forgery not only hinted, through the model's amused expression, at a narrative anecdote, but the specific subject of that anecdote would have been immediately apparent to Bode. The features of the model in *The Smiling Girl* unmistakably echo those of the inebriated female figure in Vermeer's *Girl with a Glass of Wine,* a genre scene depicting a young woman courted by an overeager suitor who plies her with drink. As it happens, *The Girl with a Glass of Wine* was a picture familiar to Bode from his earliest youth: it was the pride of his native

The Smiling Girl, forgery in the
style of Vermeer, ca. 1925

Johannes Vermeer, *The Girl with a Glass of Wine*, ca. 1660

Braunschweig, the very first Vermeer that he had ever seen. The resemblance between the two pictures was a clue that Bode could hardly have missed. The notion that a lost Vermeer like *The Smiling Girl* might have been manufactured expressly for him to rediscover seems, for better or worse, not to have entered his mind.

Bode may well have been distracted by another selling point of *The Smiling Girl*: its scent of intrigue. The picture had been brought to the Kaiser Friedrich by a woman who said that she was not the owner but was acting in his service. Once Bode authenticated the picture, the amateur dealer Walter Kurt Rohde suddenly appeared on the scene, saying that he had just acquired the "Vermeer" and intimating that it had been smuggled out of Bolshevik Russia by the still un-named original owner, presumably a white émigré. With so many dispossessed Tsarist noblemen working as bellhops and waiters all across Berlin, the story probably sounded

less preposterous then than it does now—and apparently it captured Bode's imagination. An archmonarchist with a pronounced operatic streak in his character, Bode decided that he, personally, would help arrange the picture's sale. Losing no time, he contacted the offices of Duveen Brothers to announce that a new Vermeer had been discovered at the Kaiser Friedrich. The picture, Bode promised, would be offered to no one else.

Unlike Hofstede de Groot, who was never quite at peace morally about playing the role of the paid expert, Bode reveled in being an art-world insider. He had worked hand in glove with dealers his entire career, trading favors to get the artworks he wanted for his beloved Kaiser Friedrich Museum, using his power to give or withhold certificates as leverage, and occasionally taking great pleasure in cutting off dealers who displeased him. Although Bode was a genuine scholar who took his work attributing pictures quite seriously, he nonetheless enjoyed being in the thick of things, and it seems that his love of the limelight sometimes got the better of him. In this instance, unwittingly duped by a fake, Bode proceeded to promote it in the marketplace.

Financial considerations may also have played a role in Bode's actions. Like most Germans, Bode had lost virtually every pfennig he possessed during the great inflation of 1921–1923, when the value of the mark dropped, in the course of about eighteen months, from an initial exchange rate of two marks to the dollar to an astonishing low point of four million marks to the dollar. Anyone who had money in the bank, anyone who owned government bonds, anyone relying for income on a pension or annuity was left destitute. This is what led more than fifty thousand female residents of Berlin to seek alternate employment turning tricks for foreign sex tourists—and many people in the art world perceived similarly scandalous behavior on the part of Wilhelm von Bode in the attributing of pictures. In a pot-and-kettle letter written to a London dealer during this period, Hofstede de Groot decried Bode's

declining standards: "If a dealer or owner of a picture knows how to talk to Bode, he can get every picture testified by him. He is now often asked not to date his written opinions as there is less importance attached to the later ones than to the former ones. I am told that there are also endorsements by him from which the date has been cut off for this reason."

As it happens, by the time *The Smiling Girl* was discovered, the great art dealer Joseph Duveen was well aware that Bode was hard up for money. In fact, Duveen had very quietly done what he could to help. When Bode had been forced to auction off virtually every art book he owned to pay for basic living expenses after the inflation hit, Duveen dispatched two employees to the sale, instructing them to bid against each other and drive up the prices. At the end of the day, Bode found himself with an unexpected windfall, while Duveen ended up in possession of a great many costly volumes that he really didn't need.

Duveen, however, was not the type of person to allow sentimentality to intrude on matters of business, and in consequence, he was quite cautious when he heard about Bode's new Vermeer. Although he did not make the week-long journey from New York

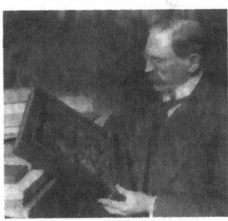

Joseph Duveen Wilhelm von Bode

to Berlin to inspect *The Smiling Girl* in person, Duveen was eager to have the picture examined by his own representatives. Soon, Duveen's nephew Armand Lowengard, who managed the Paris branch of the firm, and Edward Fowles, head of the London office, were on their way to the Kaiser Friedrich. In due course, they informed Duveen via cable that the picture was disappointingly "wanting in color." However, they were quite convinced that it was "by the master." With representatives of Knoedler & Company suspiciously lurking about in Berlin—despite Bode's assurance of secrecy—Lowengard and Fowles advised Duveen to make a prompt purchase, as the painting was "too good to allow others to obtain."

Nonetheless, Duveen held off buying the picture until it could be seen by one more person: Frederik Schmidt-Degener, the director of the Rijksmuseum, whom Duveen kept secretly on retainer to confirm the attributions of Dutch paintings. An employee of the Dutch state, Schmidt-Degener was prohibited from turning his office into an art-market empire à la Bode—there were no certificate seekers to be found queued up outside the Rijksmuseum—but in exchange for discreet payments, he offered his expertise on a private basis to Duveen, who valued Schmidt-Degener's opinion precisely for its seeming disinterest. It was only after Walter Kurt Rohde brought *The Smiling Girl* to Amsterdam, where Schmidt-Degener gave it his approval, that Duveen's Dutch bankers paid Rohde the agreed-upon sum of £18,000, or about $1 million in today's money. Schmidt-Degener was so pleased with *The Smiling Girl* that he even requested permission to bring it to The Hague so that he and Wilhelm Martin could compare it to *The Girl with the Pearl Earring* at the Mauritshuis. Favorably impressed, the two museum men would have been shocked to know that a few months earlier they could have witnessed the creation of Duveen's latest acquisition less than a mile away on the Sumatrastraat. And so would Duveen—who, in addition to paying Rohde's asking price

and Schmidt-Degener's fee for expertise, also sent a generous £600 "present" to Wilhelm von Bode for alerting the firm to the picture's existence in the first place. As Edward Fowles put it, Bode could "be very useful to us in keeping us informed of the different pictures which are turning up daily in Germany." If an exclusive arrangement was what Fowles had in mind, however, he would soon be disappointed.

When Harold Wright showed up the following summer with *The Lace Maker*, Wilhelm von Bode once more sprung into action. Attributing the picture was probably a fairly simple matter: not only was *The Lace Maker* clearly by the same hand as *The Smiling Girl*—that freshly anointed masterwork—but it also conformed to a written description of a missing Vermeer that had been sold at auction in 1816 and had never been seen again. When it came to marketing the picture, Bode remained eager as ever to lend a hand, but he didn't contact Duveen directly this time. Instead, he actually made Duveen's life more difficult by offering to let Wright exhibit *The Lace Maker* at the Kaiser Friedrich, essentially giving him advertising space. Indeed, Wright successfully used the imminent public display of the new Vermeer as a bargaining chip to conclude a fast and lucrative deal with Duveen, who wanted to acquire *The Lace Maker* before any of his competitors had a chance to see it.

Duveen was initially alerted to the picture's existence by his longtime friend Leo Blumenreich, a legitimate Berlin dealer, who had been tipped off by Hans Wendland. The highly illegitimate Wendland not only acted as Wright's representative during the sales negotiations but also received a hefty £1,200 commission under the table from Duveen for directing *The Lace Maker* the firm's way. It is not clear whether Wilhelm von Bode was aware of Wendland's involvement in the deal. Bode was not especially fond of Wendland, whom he had fired from the Kaiser Friedrich staff in 1906 for stealing antiquities from a museum-sponsored

archaeological dig and selling them on the open market. Strangely, though, the two continued to consult quite politely over paintings, with Bode providing Wendland with numerous certificates of expertise even after this falling out.

Just as he had *The Smiling Girl*, Joseph Duveen bought *The Lace Maker* without first seeing it in person. Armand Lowengard was quite taken with the picture when he saw it in Bode's offices at the Kaiser Friedrich, and a deal was reached quickly—so quickly, in fact, that Frederik Schmidt-Degener did not even have a chance to get to Berlin from Amsterdam to offer his opinion. An escape clause was therefore built into the contract. Harold Wright agreed to accept a nonrefundable deposit of £1000, with the understanding that the remainder of the purchase price would be paid into his bank account within ten days. If Schmidt-Degener should find fault with the picture, Duveen's loss would be limited to the deposit. In return for this magnanimous gesture on Wright's part, the House of Duveen was obliged to acknowledge that Wright offered no warranty of any kind regarding *The Lace Maker* or its attribution. Indeed, in his formal letter of acceptance, Wright referred to the painting simply as "my picture, painted on canvas, showing a young lady making lace, which you accept on your own authority as a work of Jan Vermeer of Delft."

When Schmidt-Degener arrived at the Kaiser Friedrich Museum on September 1, 1927, he had no trouble at all locating *The Lace Maker,* for it had been placed on public display, as promised. Hence, it was amid a teeming crowd of onlookers in the museum's grand rotunda that he first caught a glimpse of the forty-first known Vermeer. There was excitement in the air. And it didn't take long before Schmidt-Degener was excited too. He promptly rushed off to the telegraph office and wired Duveen. CONSIDER VERMEER UNDOUBTFUL AND AUTHENTIC WORK, he proclaimed. CHARACTERISTIC AND STRIKING ACHIEVEMENT. Although Schmidt-Degener did see a few flaws in the picture's physical condition, most notably a

couple of spots that needed retouching, such matters were only to be expected in a delicate object hundreds of years old. BEAUTIFUL ACQUISITION, was his final verdict. THANKS CHEQUE. REGARDS, DEGENER.

And with that, the deal was done. Duveen instructed his London branch to deliver the remaining £37,000 balance due on *The Lace Maker* to Wright's bank in London. Precisely how much of this money made its way into Han van Meegeren's pocket is uncertain, but the forger does seem, at the very least, to have gained a wealth of knowledge from the events leading up to this triumphant outcome. Collaborating with Theodore Ward and the men in Berlin—seasoned art-world operators working at the most sophisticated levels of intellectual and psychological persuasion—Van Meegeren had succeeded in crafting a string of fakes designed not only to look like plausible Vermeers but also to appeal to the sensibilities of a particular expert and to fit preexisting ideas about lost examples of the master's work. This was a complete course in swindle. And Van Meegeren evidently internalized the lessons he had learned, for in time, he would be able to replicate such impressive results almost entirely on his own.

CHAPTER FOUR

Smoke and Mirrors

DURING THE 1920S, forgery was still just a sideline for Van Meegeren, who also enjoyed a successful public career, most notably as a portraitist working for a socially exclusive clientele. Indeed, by the middle of the decade, he was the artist of choice for the patrician Liberal State Party of the Netherlands. Not only did Van Meegeren design the party's campaign posters at election time, but he painted portraits of the party's leaders, their well-to-do supporters, their wives, their children—and the *Liberalen* accepted him happily into their orbit.

A posh group whose main concerns were individual freedom, secular values, and the protection of private property, the *Liberalen* had once been the ruling party of the Netherlands but had fallen into a steady decline after the adoption of proportional voting in the early years of the twentieth century. They were increasingly boxed in by the Socialist movement on the left and the religiously affiliated conservative parties on the right. But in terms of class, cachet, and refinement, they were still very much at the top of the heap, furnishing an attractive model for Van Meegeren's social strivings. In an impressive display of *Haagse Bluf*, the young,

upwardly mobile Van Meegeren, flush with cash from his work with Theo van Wijngaarden, managed to fit in quite nicely with the party's biggest names. The party chairman, H. C. Dresselhuys, once described Van Meegeren admiringly at a public ceremony as "one of our best contemporary artists, far more motivated by sympathy for our principles . . . than by any desire for material gain."

Masquerading as a gentleman, Van Meegeren occasionally got some of the finer points wrong—contemporary photos show him wearing chalk-striped, doubled-breasted suits with peaked lapels, starkly at odds with the more somber attire of his Liberal friends—but at his best, Van Meegeren could summon up sufficient charm to overcome such miscues. As the socialite Tettie Maduro once summed it up in a personal letter fondly recalling her portrait sittings with Van Meegeren, "That man was a genius."

Indeed, Van Meegeren's poise shows through clearly in his artwork. The most famous image Van Meegeren ever produced under his own name dates from this period, and it is a veritable tribute to the understated elegance that characterized the Liberal elite. A delicate pencil drawing of young Princess Juliana's pet deer from the Royal Menagerie in The Hague, it is known as the *Hertje van Van Meegeren,* or "Van Meegeren's Fawn." Widely reproduced, this dainty little picture became a popular symbol of affection for the royal family, a patriotic icon perfectly suited to a nation whose monarchism

Het Hertje van Van Meegeren, ca. 1922

is as discreet and low key as its monarchs. Upon seeing the *Hertje* at its original public exhibition, the reviewer for The Hague's Liberal-aligned daily newspaper exclaimed enthusiastically, "Such brittle grace. Such aristocracy. It is splendid!"

Van Meegeren's closest connection within the Liberal Party establishment was member of Parliament Gerard A. Boon. Just a few years older than Van Meegeren, Boon, an attorney in private life, was a rising star in Dutch politics. An electrifying speaker, known both for his confident public persona and his rugged good looks, Boon projected an almost palpable sense of moral authority on the issues he cared about most. He zealously championed the women's rights movement in parliament throughout the 1920s and later earned widespread respect for his impassioned antifascist oratory. In 1933, less than one year into Hitler's reign, Boon declared, "Every country must follow the form of government that it chooses for itself, but Germany has to realize that the entire civilized world will stand against it until the shameful mistreatment of its small Jewish minority comes to an end." Referring to the hopes of homegrown fascist agitators who advocated a totalitarian regime for the Netherlands, Boon would ask simply, "Could anyone imagine something less Dutch?"

Van Meegeren would later exploit these high-minded beliefs by drawing the unsuspecting Gerard Boon into an astonishingly devious scheme that both appealed to and subverted Boon's antifascist sympathies. This wouldn't happen until 1936, but even fairly early on it should have been

Member of Parliament
Gerard A. Boon

clear to Boon that his own politics were quite different from Van Meegeren's. In 1928, using the money from the sale of *The Lace Maker*, Van Meegeren founded and financed an ultrareactionary arts magazine called *De Kemphaan*, or "The Fighting Cock," which served, during its relatively obscure three-year run in The Hague, as a forum for ideas far more strident than anything the genteel Gerard Boon would ever have allowed himself to be associated with. In his harshest contributions, Van Meegeren denounced modern painting as "art-Bolshevism," described its proponents as a "slimy bunch of woman-haters and negro-lovers," and invoked the image of "a Jew with a handcart" as a symbol for the international art market. He explained the "spiritual sickness" of modernism as follows:

> There is no art which attracts so many parasites and prose-lytes as painting. Under the flag of a few drunken madmen and a few art-anarchists, they smear their colors on canvas and shut the mouths of anyone who might protest with a flood of made-up terms meant to sound like philosophy or psychology. With cheap material—their inner spirit—they cover fine linen. The product becomes accepted as a demonstration of "sensitivity" by those around it, fearful to be seen as "insensitive" themselves.

Van Meegeren seems to have been as prone to imitation in writing as he was in painting, for his arguments are suspiciously similar in content, wording, and style to those of a then little-known Austrian writer—a tormented artist himself—who had offered a like-sounding antimodernist harangue in 1925:

> One feared to be called "uncomprehending" by these madmen and swindlers, as if it were shameful not to understand the productions of spiritual degenerates or slick con-men. These apostles of the "one true faith" in the cultural realm had a very

easy means to present their madness as great art: everything that seemed idiotic or crazy they explained as a representation of their "inner state of mind," which was really just a cheap way of shutting up any protest beforehand.

The writer was Adolf Hitler; the book, *Mein Kampf.*

IN DESCRIPTIONS OF Van Meegeren culled from the comments and reminiscences of people who knew him, the one epithet that inevitably comes up is "actor." Throughout his life, Van Meegeren behaved like a performer on a stage, moving from one role to the next as it suited his mood or purposes: the high-minded artist, the bohemian playboy, the splenetic reactionary, the heroic forger out to show the world what he could really do. This penchant for shape shifting was, of course, a convenient trait in a man who made his living through subterfuge and deceit. But Van Meegeren's self-fashioning did not begin as a sinister or pathological enterprise. At the outset, trying on various masks and attitudes was simply an innocent and conventional response to a challenge faced by every young artist: the search for a creative identity.

Traditionally, the learning process started with emulation. During his childhood in Deventer, Van Meegeren took his first lessons in painting and drawing from a local artist named Bartus Korteling, who specialized in moody, sentimental landscapes. Eager and amiable, Van Meegeren soon adopted this manner as his own. Once he moved to Delft for his architectural training and was free to spend his spare time in museums—the Mauritshuis in The Hague was just fifteen minutes away by train—Van Meegeren supplemented Korteling's tutelage with a close study of the Golden Age masters, whose works he sketched and copied with steady determination. In 1913, while still a student, Van Meegeren won a gold medal in a university-wide drawing competition with an interior view of the St. Laurens church in Rotterdam—a performance based heavily on the work of the nineteenth-century artist

Interior of the St. Laurens Church, 1913

Johannes Bosboom, with nods to seventeenth-century painters like Saenredam and De Witte.

Nostalgic, conservative, and executed in a borrowed style, this elaborate aquarelle might seem like a harbinger of fakes to come, but imitative efforts of this type were a standard phase in the training of any aspiring painter in Van Meegeren's day. Designed to cultivate proficiency while leaving questions of originality temporarily on hold, such exercises, whether assigned or self-imposed, were intended not merely to honor tradition, but to lead to bigger and better things. Novices, according to theory and custom, were supposed to find themselves by learning from, mimicking, and

ultimately surpassing the accomplishments of bygone days. And the young Van Meegeren actually showed every sign of being the kind of painter who could synthesize an affinity for older styles into something new and personal—just as he should have.

Indeed, by the time Van Meegeren had his first solo show in 1917, at the Pictura exhibition hall in The Hague, he was clearly trying to assert himself as his own man. He filled the gallery with a wide range of contemporary subjects—women with parasols walking through the dunes at Scheveningen, horse-drawn carriages on cobbled city streets—and his technique, particularly in oils, had a pleasing freedom and looseness about it. These works, while hardly cutting edge, were entirely in step with trends that were current in The Hague, but best exemplified by artists just slightly older than Van Meegeren, such as Willem de Zwart, Floris Arntzenius, and Willem van Konijnenburg. If Van Meegeren was still a little bit behind the times in the Pictura show, it was only by a half generation. And as the many favorable reviews of the exhibition clearly demonstrated, this wasn't a bad thing. "Here we have a truly fresh young talent who isn't looking for success along dangerous pathways," said the critic for the *Nieuwe Courant*, approvingly. "I predict he shall find many admirers." Indeed, the press generally portrayed Van Meegeren as a respectful beginner who, with continued application and hard work, might well carry the great Hague School tradition—with its golden tones and scenes from daily life—forward into the future.

When he entered the world of forgery around 1920, Van Meegeren stumbled on the road to artistic maturity. He didn't drop his legitimate career, but he never managed to distill a profound and distinctive personal vision, an intense marriage of style and content through which he might have expressed himself powerfully in his own name. Slowly but surely, the imitative logic of forgery condemned Van Meegeren to a state of arrested development in which artistic role playing—completely divorced from its

legitimate purpose as a tool for growth—became an end in itself. The more adept Van Meegeren grew at imagining his way into the creative concerns of long-dead painters, the more his work as a "real" artist in the contemporary world began to appear eccentrically derivative and shallow.

The problem developed in stages over a period of years, but it was already becoming apparent in 1922, when Van Meegeren had his second solo show, a grand affair occupying both floors of the Biesing Gallery on the Molenstraat. A step backward both in terms of career development and artistic trends, the exhibition consisted entirely of narrative scenes taken from the Old and New Testaments. In the swanky, silver-martini-shaker world of The Hague during the Jazz Age, this was a somewhat odd choice of subject matter. And the Baroque theatricality that Van Meegeren affected in these paintings only made the whole undertaking seem even more peculiar. The attenuated poses, calculated figure groupings, and dramatic lighting effects were so clearly inspired by other sources that, at times, it appeared as though Van Meegeren were simply riffing on art history and using the Bible as a pretext for a flashy display of virtuosity. For instance, *Christ Preaching in the Temple*, like most of the Biesing pictures, is exquisitely painted—it features buttery impastos, a masterful sense of design, and color harmonies that make the red and yellow garments of the Hebrew acolytes practically leap off the wall—but here, as in the companion piece, *The Tribute Money*, done in tempera, one gets the distinct impression of witnessing an artificial scene taking place in a theater, a piece of high-concept stagecraft with no genuine feeling behind it at all. Although these pictures aspire to a great deal, they seldom rise above the level of mere illustration, establishing the characters and setting the story in motion but saying very little about either.

Almost a decade after his prize-winning drawing of the St. Laurens Church, Van Meegeren had clearly made vast strides

Christ Preaching in the Temple, ca. 1922 *The Tribute Money*, ca. 1922

technically—solving complex compositional problems with ease—but, on a deeper level, he had gotten nowhere: he was still conceiving his work in terms of challenges and projects specifically associated with the precedents of previous centuries, while bringing little of his own to the subjects he painted aside from skillful brushwork. Van Meegeren's problem wasn't merely that he was a stylistically conservative artist trying to make a go of it in the modern era; he wasn't obliged to adopt cubism or fauvism or any other -ism to succeed. Van Meegeren possessed all the technical prowess he might have needed to become, for instance, the Edward Hopper of the Netherlands: he simply didn't possess the vision. Whereas Hopper had a way of seeing the world through his art that was utterly personal, Van Meegeren had only a carefully honed appreciation for the achievements of the past. Just like Van Meegeren's early student work, the Biesing pictures still have all the earmarks of performances, demonstrations of skill,

rather than expressions of a deeply felt individual sensibility. And while such exercises were appropriate and acceptable in a beginning artist, for one in his mid-thirties, they were a cause for real concern.

The newspapers took note. The reviews of this show, although filled with praise for Van Meegeren's painterly élan, generally expressed total bewilderment at what the artist thought he was up to. The critic from *Elsevier*—who wondered what had become of the earlier Van Meegeren, the purveyor of "sweet anecdotal scenes"— found this sudden attempt at biblical gravitas not only a tad grandiose but also hard to square with Van Meegeren's growing reputation as a fashionable man about town. "To portray the Bible one must have a spiritual inclination in that direction," he wrote. "Otherwise, one gets only pictorial gallivanting, which I don't begrudge anyone, but it has no profound meaning." Another reviewer, the influential Just Havelaar, started out by giving Van Meegeren high marks for ambition and hard work—"It is immediately apparent that this still-young man has mastered drawing, painting, and composing groups and multiple figures as few others in our country have done"—but he ultimately found the pictures lacking any sense of spiritual depth or "inner creative-life." Havelaar, who prized sincerity above all else in art, earnestly suggested that a choice of subject matter more in keeping with Van Meegeren's true nature—for instance, the story of Don Quixote—might have yielded better results. Keying in on the broad humanity of Cervantes's magnum opus, Havelaar probably intended no insult by this comment. But given that Van Meegeren was, in effect, tilting at windmills in his attempt to be the Rembrandt of the twentieth century—valuing, as did Quixote, the past over the present and seeking to relive a distant age—the recommendation was painfully à propos.

The greater irony, however, and a poignant one, was that Van Meegeren, widely and correctly recognized as a bon vivant, also

harbored a well-informed affection for the Bible. Although an astonishingly bad Catholic during his adult life, Van Meegeren had been steeped in an atmosphere of intense religiosity in his youth. His parents were deeply devout; his uncle was a priest; and his cousin was chairman of the Dutch League for the Promotion of Large Families—De Nederlandse Bond voor Grote Gezinnen—an anti-birth-control organization. Indeed, despite his subsequent moral failings, Van Meegeren never entirely lost touch with his early Catholic cultural roots. True, employing the Lord's image in the commission of grand larceny did constitute a rather serious transgression, but even when he was painting his fraudulent biblical Vermeers, he seems still to have drawn upon the lingering remnants of his faith. "The texts of the Bible are so clear, so completely human," he jotted in a sketchbook during that period. "Faith in the figure of Christ—believed in from childhood—the most beautiful thing to paint." Adding, in a curiously parental-sounding exhortation to himself, "Read the Bible before painting, and then keep reading while at work, 20 or 30 times per day: stick with it."

Seen in this light, the Biesing pictures begin to assume a measure of tragic grandeur, even taking into account their strange artificiality and anachronistic ambitions. For they show Van Meegeren—a man with an unhappy marriage, a scandalous mistress, and a budding career in crime—trying to reconnect with his origins, and failing badly in the attempt. With his identity both as an artist and as an individual growing increasingly confused, Van Meegeren made an effort, with these biblical narratives, to hold on to a piece of himself. But compelled to communicate through a scrim of allusions encompassing everything from Rembrandt to Gustave Moreau, he could only bring forth what *De Groene Amsterdammer* called "biblical theater for an actor, and by an actor." Indeed, by tapping into the bedrock of his religious upbringing, Van Meegeren discovered that

he had very few spiritual values to express, and no truly personal language with which to express them.

The Biesing show, muddled and half realized though its contents were, represented the high watermark for Van Meegeren's ambitions as an artist in his own right. He would not attempt such a major public statement in his legitimate career again until he reinvented himself as a Nazi artist during the German occupation. Years later, after he was unmasked as a forger, Van Meegeren claimed that the critical response to his biblical narratives had been so brutal, so vicious that he was no longer able to exhibit his work, leaving him embittered and bent on revenge. The truth, however, was that he thwarted his own development. The critics, while hardly enthusiastic about the Biesing pictures, were not out to get Van Meegeren, and the show itself was not an outright disaster; in fact, most of the paintings found buyers. If Van Meegeren had put the same level of ingenuity into his own art that he put into his career on the Sumatrastraat, he might yet have realized the potential implied in his early work, even after the setback at Biesing. But having painted himself into a corner creatively and intellectually, Van Meegeren chose the easiest available solution to his problems. He simply withdrew—into forgery in the private precincts of the Sumatrastraat and into immaculately cultivated pretensions in his public life and career.

For a while, this arrangement seems to have provided Van Meegeren with a reasonably satisfying compromise. Indeed, in the period from 1923 to 1928, Van Meegeren not only produced some of his most charming forgeries—his Vermeer girls and Frans Hals rogues—but enjoyed one of the most serene eras in the "normal" side of his split existence as well. After divorcing in 1923, Van Meegeren was unencumbered by wife or children—Anna, provided with a generous settlement, took young Jacques and Pauline to live first in Paris and then in the Dutch East Indies for several

years—and Van Meegeren was free to pursue his evolving role as a gentleman of means and taste, portraitist to the cream of high society, and loyal supporter of the Liberal State Party. It was an elaborate sham, but, in many ways, a pleasant one. And temporarily, it even paid dividends for Van Meegeren's art.

Little though Van Meegeren would have liked to admit it, his society portraits of the mid-1920s were vastly superior to any of his more ambitious efforts in his own name. The painting of stylish and flattering likenesses was, of course, a big comedown for an artist who had wanted to measure himself against the old masters in biblical pictures a meter high. But Van Meegeren seems to have benefited from the discipline that this fairly narrow project entailed: for it freed him from the conceptual bombast and overwrought art-historical allusions that marred so much of his other work. As a portraitist, Van Meegeren was never quite able to evoke the kind of emotional depth or interior drama that John Singer Sargent or even, at times, William Orphen had been capable of revealing in their sitters; however, drawing inspiration from the cool restraint and simple dignity of the Dutch upper classes, Van Meegeren's portraits from his "Liberal Party Period" give a wonderful evocation of the sitters' elevated social milieu without ever lapsing into rococo extravagance. For instance, looking at Van Meegeren's oval portrait of Marie Vriesendorp from 1926, one can well imagine that the girl's wealthy banker father was delighted by the results. Indeed, with her porcelain skin and captivating eyes, the young Miss Vriesendorp appears to be the very image of loveliness itself.

Of course, it wasn't just the sitters who were posing in these portraits: Van Meegeren was too, via his public persona as an artist. Playing off the old-fashioned gentility that he admired in the well born and the well to do, Van Meegeren began to adopt an air of aristocratic nostalgia, presenting himself as the upholder of artistic tradition, as the living embodiment of time-honored cultural

*Portrait of Marie
Vriesendorp,* ca. 1926

verities in a changing world. Not coincidentally, Van Meegeren's best fakes from this period show evidence of the same preoccupations. For example, works like *The Girl with the Blue Bow* and *The Lace Maker* draw much of their appeal from their wistful, honeyed sense of longing after a bygone age. Indeed, putting aside their deceptive aims, these early "Vermeers" seem very much of a piece artistically with Van Meegeren's best society portraits, evoking virtually an identical mood of timeless grace.

Although Van Meegeren seems to have derived genuine enjoyment from all of his recherché posturing, the act was apparently not without its frustrations. Pretending to be something you aren't, day after day, can become exhausting. And at times, Van Meegeren understandably wanted to blurt out the truth, if only for the sake of his pride.

For instance, even as the case of *The Laughing Cavalier* was heading to trial, a portrait sitter happened to compliment the

Halsian panache of Van Meegeren's brushwork. According to the sitter's later recollections, Van Meegeren responded that the resemblance was more than casual; after all, it was *he* who had painted *The Laughing Cavalier*. Indeed, considering that the rumors about his involvement in the swindle were widespread, Van Meegeren may well have made other comments along these lines during the press uproar. However, once the police received an anonymous letter saying that *The Laughing Cavalier* was just the tip of the iceberg and that there was, in fact, a forgery ring working at the very highest levels of the art world with "a well-known painter from The Hague" at its center, Van Meegeren apparently began to think better of such idle boasting. Although a police investigation never materialized, Van Meegeren seems to have held his tongue after this aspect of the storyline appeared in the newspaper.

As he moved from strength to strength as a forger, though, Van Meegeren grew increasingly disenchanted with the way he was perceived, or misperceived, by his peers. And with some justification. Known in public as the inoffensively traditionalist court painter to the patricians of The Hague, Van Meegeren was, in reality, one of the most successful artists alive in Europe when Joseph Duveen bought *The Lace Maker* in 1927. Not even Picasso could have sold a single canvas for £38,000—or even a quarter of that. Moreover, Van Meegeren had risen to the top in a field of creative endeavor so radical that it went beyond cutting edge to criminal. Yet, only his closest confidantes knew that he had painted *The Lace Maker,* and *The Smiling Girl* before it. This was a bitter pill for a man like Van Meegeren, who had craved a public triumph in the Biesing show. And while, in the pages of fiction, Sir Percy Blakeney may have been perfectly content to act like a fop in order to hide his secret adventures as the Scarlet Pimpernel, Van Meegeren, in figuring out how to cope with his own double life, did not choose to play the fool. Instead, he found an outlet for

his resentments in *De Kemphaan,* where he posed as a strutting rooster, pecking away at everything that annoyed him, and looking for a fight.

De Kemphaan CAME OUT of a milieu entirely different from either the Liberal State Party, with its deluxe sense of ease and forbearance, or the raffishly amoral world of Theo van Wijngaarden's Sumatrastraat atelier, where a man did what he had to do to make a dishonest guilder. In its attitudes and arguments, as in the social background of its contributors, *De Kemphaan* was emphatically a product of the reactionary element in what the Dutch would call the *keurig* middle class—*keurig* meaning, in this context, "decorous" or, more precisely, "exhibiting correct and proper taste." This was the teachers-and-preachers atmosphere in which Van Meegeren had grown up. And although Van Meegeren's propriety-minded father would certainly not have approved of *De Kemphaan*'s over-the-top, hectoring style, the magazine gave Van Meegeren a symbolic link back to the stern parent whom he had perennially disappointed. That link was Jan Ubink, the man Van Meegeren appointed as *De Kemphaan*'s editor.

A constant presence around the Van Meegeren household back in Deventer, Ubink had, in fact, been a favorite pupil of Van Meegeren's father, who taught French and history in a specialized academy for boys planning careers in education. A big-brother *cum* role-model figure for Van Meegeren, Ubink had been an academic star at the Rijkskweekschool voor Onderwijzers, the sort of student who was clearly destined to succeed in his chosen profession and perhaps even achieve distinction in the public sphere. And by the time he took up the reigns of *De Kemphaan,* Ubink had worked his way up through the ranks of teaching to become the headmaster of an elite state-run grammar school in The Hague, a plum position, all the while developing a side career as a writer.

De Kemphaan, 1928, cover illustration
by Van Meegeren

Jan Ubink, photograph
ca. 1910

He produced a weekly column for *De Sollicitant,* a free newsletter distributed to educators; contributed occasional opinion pieces to magazines and newspapers interested in culturally conservative criticism; and penned a succession of plays and stories, many of them with religious thematic content.

Ubink was also a fellow traveller at the fringes of the nascent fascist movements popping up in the Netherlands, as they had in most European countries, in the wake of Mussolini's march on Rome. Yet, although Ubink flirted with fascism throughout virtually his entire adult life, he never quite consummated the relationship. Indeed, while many of his closest friends joined Holland's first organized fascist party, the Verbond van Actualisten, upon its founding in 1923, Ubink, a prudent man with a position as a public servant, thought better of it. To be sure, he maintained cordial relations with the founder of the Actualisten, Alfred Haighton,

with whom he sometimes shared shots of gin and lengthy chats about the state of Dutch culture; but the narcissism of small differences being a very strong force in his life, Ubink rather considered himself above Haighton's brand of bare-knuckles politics, which included sending street fighters to break up socialist rallies. The cerebral Ubink, a Hagenaar to his fingertips, preferred to vent his spleen on an almost purely theoretical plane.

To cite but one example, Ubink was a founding officer and one of the most vocal promoters of an oddball pressure group known as the League of Dutch Playwrights—De Bond van Nederlandse Toneelschrijvers—which advocated purging alien influences from the stages of Holland. As a matter of political principle, the Bond contended that no theatrical group presenting works translated from a foreign language should receive government support. But if promoting domestic talent might seem like a perfectly reasonable policy objective for struggling Dutch writers, the Bond's idea of what constituted real "Dutchness" was unfortunately not based solely on linguistic considerations—as the only Jewish member discovered to his dismay before hastily resigning. The reactionary, crypto-bigoted agenda of the Bond—still couched in outwardly unobjectionable terms during the 1920s—later became abundantly clear during the Second World War, when the Bond adopted a vociferously anti-Semitic line and received direct financial support from the occupation government to help stamp out "foreign degeneracy" in Dutch cultural life—meaning Jews, leftism, and anything self-consciously modernist. Johanna de Boer's cuckolded husband, Carel, who sometimes fancied himself a playwright, was also a member of the Bond; during the war, he too showed his true colors, acting as chairman of the cultural affairs division of the fascist National Front party.

This was the ugly road to collaboration and disrepute that the clique around Van Meegeren's *Kemphaan* would follow when

totalitarian rule became a reality. But *De Kemphaan* itself belonged to a different era: the early, amateur years of right-wing thinking in the Netherlands. In 1928, when *De Kemphaan* first appeared, fascism was still a tiny fringe movement in Van Meegeren's homeland; the nightmare of the Nazi invasion lay far in the future; and Hitler was just a provincial rabble-rouser, living in Bavaria, with very little international visibility. Although most of its writers ended up as Nazi sympathizers during the war, *De Kemphaan* did not advocate fascism per se. And aside from Van Meegeren's oblique remarks about "Israelites" running the art market, it seldom contained any overt anti-Semitic content. So, what was this strange, proto-fascistic art magazine called *De Kemphaan* really about?

Taken at face value, the main intellectual objective behind *De Kemphaan* was to define, purify, and carry forth the cultural tradition that had once made the Netherlands great. This theme is touched upon in virtually every article that ever appeared in *De Kemphaan*'s pages: Van Meegeren elaborated on it with regard to the visual arts; Ubink applied it to literature; and other contributors took it up in connection with music, philosophy, history, and the state of higher education. And if you didn't look too closely at the details or probe the logic of the arguments, this was a seemingly public-spirited, patriotic enterprise. Although the whole ultra-Nationalist tenor of the magazine was slavishly copied from foreign models—particularly the Italian fascist press, the propaganda beginning to emerge from Hitler's Nazi movement in Germany, and the cultural critiques of the burgeoning Action Française—*De Kemphaan*'s stated intention was to allow the Dutch to know themselves. In issue after issue, preaching exclusively to the converted—of whom there were few—*De Kemphaan* exhorted the people of the Netherlands to reclaim the greatness they had known during the Golden Age and leave behind their modern identity as

the "wee cheese and bread folk" of Europe. At times, the project even inspired Van Meegeren to verse:

> The spirit of your people is great, O Holland!
> Look back to your glorious past,
> Which lives on between the meadow and the sea,
> And which, across the passing centuries,
> Prepares to bloom anew!

Although *De Kemphaan* offered many tendentious theories to explain why Dutch culture had attained such distinction during the glorious seventeenth century, the most interesting and important among them was certainly Jan Ubink's. A Catholic chauvinist, Ubink devised an idiosyncratic interpretation of Golden Age society, grounded, to some extent, in history, but thoroughly colored by ethnic pride. For instance, while the conventional wisdom might point to the rise of Calvinism, Spain's defeat in the Eighty Years' War, and the success of the East India Company as the forces behind Holland's blossoming, Ubink thought that there was another, far more compelling factor to consider. Noting that even by the middle of the seventeenth century, half of the Dutch population was still Catholic, Ubink suggested that the Protestant merchant class "did not represent the whole nation, but merely a part of it, and by no means the largest or most important part." This, as far as Ubink was concerned, was the secret key to understanding the culture of the Dutch Golden Age: "On the outside it appeared to be Calvinistic and modern, but inside, it retained a profoundly medieval orientation." Indeed, Ubink's hero was the seventeenth-century poet Joost van den Vondel, the Dutch Shakespeare, who had famously converted to Catholicism late in life, showing, as Ubink put it, that he "knew the right direction." For Ubink, it was the residual influence of medieval Catholicism that had shaped the very spirit of the Dutch people—the *volk*.

As an explanation of Dutch seventeenth-century life, Ubink's theory is debatable, but when seen as a reflection of the intellectual circle in which Han van Meegeren moved in the late 1920s, it is highly illuminating: for this was the blueprint of *The Supper at Emmaus*. Although Van Meegeren's *Emmaus* exploited an existing art historical theory—that Vermeer, having married into a Catholic family, might have done Catholic religious paintings—it also had a politico-intellectual program behind it. With his biblical Vermeers, Van Meegeren would offer a masterful proof that a latent "medieval orientation" did indeed lurk inside the heritage of the Golden Age, and much as in the case of Joost van den Vondel, at the very highest levels of artistic creativity. Moreover, in offering this proof, the forger not only extended *De Kemphaan*'s argument about the essential nature of "Dutchness" into visual form but ingeniously insinuated it into the fabric of art history. Van Meegeren would not actually hit upon the pictorial vocabulary necessary to realize his biblical Vermeers until the thirties, but the first glimmers of the idea behind the whole project clearly occurred in 1928, with Jan Ubink and *De Kemphaan*.

In many ways, Ubink was Van Meegeren's idea man, his collaborator in turning forgery from a straightforward money-making endeavor à la Theo van Wijngaarden into an art form with a deeper purpose. While Ubink was probably not privy to the concrete planning for *The Supper at Emmaus*—Van Meegeren was living in France by the time he painted it—he seems to have been aware of Van Meegeren's secret life during the *Kemphaan* days. As early as 1930, for instance, Ubink wrote a well-received three-act play entitled *The False Madonna* about a fake religious masterpiece sold to the Louvre with a certificate obtained from Wilhelm von Bode. (The underlying message was that the age and authorship of the picture were petty concerns compared to the eternal truths of beauty, creative struggle, and religious belief.) More importantly, though, in the pages of *De Kemphaan* itself, Ubink worked hand in

hand with Van Meegeren to pound out—between the lines—an elaborate theory of the fake and the real that offered a surreptitious moral justification for what Van Meegeren was already up to on the Sumatrastraat.

De Kemphaan's constant refrain was that the Netherlands had been led astray by modernity. Sinister, foreign, un-Dutch influences had poisoned the established cultural values of the nation, and as a result, the Dutch *volk* stood in peril of losing its identity. To set the situation right, *De Kemphaan* wanted to toss the defilers of tradition, at least metaphorically, into the *Ketel*—a medieval cauldron "in which purveyors of false coins were scalded and cooked alive." Clearly, there was no point in arguing with such "degenerates," or even in engaging with them: they and their ideas simply had to be liquidated—boiled in oil. Indeed, what the world needed, according to Jan Ubink, was a more militant version of the nineteenth century's most controversial philosopher. "Friedrich Nietzsche was able to profit by plucking the spiritual values of his time out of circulation and then using the power of his genius to stamp new material out of the old," Ubink declared, continuing with the metaphor of coinage. "Lucky Nietzsche! The spiritual values back then may have been confining, worn, and limited, but at least they still [contained] real gold and silver." In contrast, wrote Ubink, the ideas of the modern world were coins of lead—worthless and *fake*—counterfeits foisted on an unsuspecting public by intellectual con men.

And it was no secret who the culprits were in this vast conspiracy, for *De Kemphaan* kept track its of enemies in every field of creative endeavor, enumerating the apostates who had betrayed the culture of the Netherlands. With regard to the visual arts, for instance, Van Meegeren traced the descent into chaos back to Vincent van Gogh, whose work he lambasted on more than one occasion as "finger-painting" and whose writings and correspondence he denounced as muddle-headed, self-involved theorizing. Indeed,

in *De Kemphaan,* Van Meegeren excoriated both Van Gogh and Paul Gauguin for throwing open the doors of Holland's creative life to the "international art communism" being promoted by intellectuals abroad, thus making the subsequent work of Dutch modernists like Kees van Dongen and Piet Mondrian—figures much derided in the pages of *De Kemphaan*—all but inevitable.

As chance would have it, in 1928 Van Gogh's name became inextricably linked in the public mind with art forgery and the larger question of artistic validity. In January of that year, a minor dealer in Berlin had been caught selling phony Van Goghs. The dealer in question, Otto Wacker, had offered a total of thirty-three fakes in the style of the modern Dutch master, successfully selling some of them to major galleries and collectors. A preliminary police investigation indicated that Wacker's brother, a painter and aspiring modern dancer, had produced these forgeries, building up Van Gogh's characteristically crusty surface with the help of fast-drying plaster of Paris. In the initial hearings, however, Wacker steadfastly maintained that the "Van Goghs" were genuine and that they had come from the collection of an unnamed Russian nobleman. (Comparing this cover story to that used in selling *The Smiling Girl,* one begins to sense a certain unimaginative consistency in the tales told by various forgers and forgery rings.)

Van Meegeren had a field day with the Wacker case, as it gave him an opportunity to engage in two of his favorite pastimes— schadenfreude and sophistry. He produced a series of articles for *De Kemphaan* in which he expressed simultaneous delight and horror at the idea of anyone bothering to fake the works of Vincent van Gogh—whose art, by *De Kemphaan*'s standards, was intrinsically worthless. Pictures that looked like "the disordered scrawlings of a child or an idiot" could simply not be considered real art: the forged Van Goghs were, by this logic, neither more nor less fake than the genuine ones.

What, then, of forging old masters? No fool, Van Meegeren certainly didn't "out" himself in the pages of *De Kemphaan*, but his parsing of the issues in the Wacker-Van Gogh case offered an interesting sub-rosa rationalization for his own picture swindles, past and future. If there were, as Van Meegeren playfully asserted, not thirty-three but rather "175 fake Van Goghs,"—that is to say, the entirety of Van Gogh's oeuvre reproduced in a recent book on the artist—why couldn't there be fifty or a hundred *real* works by Vermeer? Given that Van Gogh and Gauguin had, as Van Meegeren said, "annexed the pages of art history" with their "art-anointing language," couldn't Van Meegeren justifiably turn the tables, reopen the history books to a point before the modernists came along, and then add to the great tradition as a true artist should? As Jan Ubink had put it, there was no point in even engaging with the ideas or arguments of modernity; not even Nietzsche could have made anything valuable out of such stuff. The important issue, in the upside-down world of *De Kemphaan*, was not forgery, as such, but the extent to which art was faithful to the essential spirit of the Dutch *volk*.

Indeed, throughout the run of *De Kemphaan*, Van Meegeren toyed with the conceit that the masters of the Dutch tradition were still alive and working, inspiring each other—and him—to new and greater achievements. He addressed several open letters to artists long dead, and in 1929, when the Royal Academy in London held a comprehensive exhibition on the history of Dutch art, Van Meegeren wrote an imaginative essay in which Rembrandt, Vermeer, Frans Hals, and company dropped by after hours to review the show. (In general, they approved, but they ventured a guess that the works in the room at the end—the ones signed "Vincent"—had been done by the spoiled infant son of one of the show's wealthy organizers.) Given that his own Vermeer-style forgery *The Smiling Girl* was on display, Van Meegeren seems to have been unable to resist making light of Vermeer's unusual

status as the "new" old master, whose works were still being dis-
covered. Van Meegeren addressed Vermeer directly in terms that
sound suspiciously like a soliloquy:

> They think that you are a bit of a lazy bones, making only
> 41 paintings in 23 years. As if you could help the fact that 30
> years ago you were unknown and mistaken for Metsu. Things
> have gone crazy with you now, though. There was a time one
> couldn't even borrow money against one of your paintings,
> but who knows how much they might bring in at the pawn-
> broker's shop today. And whenever one of them seems to be
> lost they try with all kinds of "schemes" to reclaim it.

There were, of course, only forty-one Vermeers if you counted
the fakes, and the "schemes" involved in rediscovering lost mas-
terpieces were hardly a mystery to Van Meegeren. Like much of
what Van Meegeren wrote for *De Kemphaan,* this was a coded
communication, a sardonic aside whose only real audience was
Van Meegeren himself. In his humor, as in his work as a forger,
it would seem that Van Meegeren derived his greatest amusement
from leaving the rest of the world in the dark.

DURING THE RUN OF *De Kemphaan,* Van Meegeren was less in-
volved with his Liberal Party friends than he had been earlier in
the twenties, but the magazine did not make him persona non grata
with the elite—largely because they paid it no attention. Flying
under high society's radar, *De Kemphaan* was mostly overlooked
by Van Meegeren's Liberal Party acquaintances, and those who
did notice seem to have perceived it merely as a passing fancy,
part of some obscure and quite trivial art-world argument. This
is not to say that *De Kemphaan* could ever have gotten a nod of
approval from people who took good manners quite seriously: al-
though the Liberal Party newspaper in The Hague didn't devote
much coverage to *De Kemphaan,* the culture page did once note,

with a tone of mild scolding, that Van Meegeren delivered up his "mocking fantasies" in that peculiar monthly from time to time.

The main impact of *De Kemphaan* wasn't on Van Meegeren's standing with the broad-minded *Liberalen*, for whom he had always been something of a rare bird, but rather with his peers in the artistic and creative subculture of The Hague, particularly at his beloved Haagse Kunstkring. With his scathing, self-financed magazine and his steady output of articles denouncing new trends in the arts as subversive and degenerate, it's little wonder that Van Meegeren developed a reputation for being *scherplippig*, or "sharp-tongued," among other members of the Kunstkring. Indeed, as the strident tone of Van Meegeren's writings began to characterize his behavior in daily life, people outside the narrow realm of *De Kemphaan* increasingly shied away from him for fear of ending up embroiled in nasty, pointless arguments. His rising alcohol intake—gin being his tipple of choice—may have exacerbated these problems. By the early thirties, Van Meegeren and Johanna had fallen into a routine of "antisocial" drinking, reportedly making a spectacle of themselves at Kunstkring parties on more than one occasion. As an acquaintance of his later put it, "Van Meegeren could at times be quite amusing due to his biting and cynical sense of humor—but only up to a certain point, and that was the point of drunkenness." Indeed, when Van Meegeren had a few too many, he tended to become sarcastic, mean-spirited, and personally insulting.

In 1932, these confrontational tendencies landed Van Meegeren in a protracted and acrimonious public dispute with the other members of the Kunstkring, a quarrel that changed the course of his life. The trouble began in the spring of that year when a seat opened up on the governing board. The more conservative members of the board, led by Jan Ubink, lobbied hard for Van Meegeren to be named to the vacant position. Noting that the Kunstkring had taken on substantial debts in planning its move

to a new headquarters, Ubink suggested that the wealthy Van Meegeren, once appointed to the board, might be inclined to help out financially. There was even talk of Van Meegeren being put in charge, of his being made not just a member of the board but its chairman. Indeed, in a feeble and farcical echo of the political campaign going on at that very moment across the border in Germany, Ubink declared that what the Kunstkring needed in such difficult times was "a mighty leader"—*een krachtige leider*—who could instill order amid the chaos and set the institution back on a healthy path to growth. The overheated rhetoric of the Hitler versus Hindenburg election had, it seems, spilled over on to one of the smallest and least likely stages conceivable.

As news of these plans spread, the junior members of the Kunstkring organized a revolt. Having heard quite enough of Van Meegeren's opinions to know what the ill-tempered artist was all about, they drew up a petition and threatened to resign en masse if Van Meegeren were allowed to have his way. They complained that he would "not be objective enough to deal fairly with varying sensibilities," and in this line of reasoning they seem to have found some highly sympathetic ears on the board. Acting strategically, two board members, not aligned with Ubink, took it upon themselves to contact the primary benefactor from whom the Kunstkring had borrowed the money to fund its operations, and they asked if he would be willing to forgive the debt in return for a selection of works by member artists. The individual in question, a well-known Dutch art connoisseur living in retirement in Monaco, agreed without further ado; he had, after all, made the loan in a spirit of generosity in the first place. Ubink's financial wedge issue was thus completely neutralized. And with little else to recommend Van Meegeren—except perhaps his potential for sowing unintentionally productive discord—his candidacy was easily and successfully blocked.

Feeling thwarted and quite genuinely humiliated, Van Meegeren took the Kunstkring incident hard. Indeed, he resigned his membership in disgust. A letter from the board acknowledging Van Meegeren's resignation—probably drafted by Ubink—expressed regret at the painter's decision, noting that "this shall certainly be a great loss as you represent a spirit in the artistic world that is sadly dying out."

The dustup at the Kunstkring is often cited as the reason for Van Meegeren's decision to move abroad: by the end of that year, he and Johanna had left the Netherlands and taken up residence on the French Riviera. In later life, Van Meegeren himself alternately confirmed and denied the idea that embarrassment over the problems at the Kunstkring compelled him to leave town. And although it does seem likely that this was one of the factors in the move, other matters might also have played a role. On the personal side, Van Meegeren's father had died earlier that year, putting a decisive end to any possibility of redeeming what had always been a deeply troubled relationship. On the business front, certain developments in Van Meegeren's work with Theo van Wijngaarden on the Sumatrastraat also would have made the change of scenery not only expedient but, indeed, quite appealing.

Curiously, even after moving to the Riviera, Van Meegeren continued to be involved, in a roundabout way, with one of the key players in the Kunstkring matter. The wealthy benefactor who was willing to be so flexible about the money the Kunstkring had borrowed, the man who ultimately doomed Van Meegeren and Ubink's efforts at a Kunstkring putsch, was none other than Abraham Bredius, the great scholar of Dutch seventeenth-century painting who would eventually authenticate *The Supper at Emmaus* and declare it to be Johannes Vermeer's greatest masterpiece.

CHAPTER FIVE

A Happy Hunting Ground

HAVING VISITED THE RIVIERA frequently on vacations, Van Meegeren and Johanna faced no great adjustments settling there permanently. In the sunny village of Roquebrune, close by Monaco's border, they rented a spacious villa on a hillside with a view of the Mediterranean. They already knew the rhythms of life in the area and had even discovered a few bits of local culture that appealed to their tastes. Van Meegeren, for instance, was fond of the regional newspaper, *L'Eclaireur de Nice et du Sud-Est*, whose art correspondent, Camille Mauclair, was a rabid reactionary. Indeed, Mauclair, later a vocal cheerleader for Nazism and anti-Semitic cultural politics under the Vichy government, had been the object of frequent praise in the pages of *De Kemphaan*.

In opting to spend his self-imposed exile just a stone's throw from Monte Carlo, Van Meegeren clearly wasn't fretting over expenses. Nor did he need to. Although he wasn't nearly as rich as he would eventually become, he had already earned enough money during his dozen-year adventure as a forger in The Hague to set aside a tidy nest egg. Precisely how much is hard to say, as the formula for dividing the spoils between Van Meegeren, Theo van

Wijngaarden, and their various English and German associates is not known. But Van Meegeren's share from the sale of *The Lace Maker*, for instance, had certainly been quite substantial: it had allowed him to bankroll *De Kemphaan* even as he slacked off in his work as a portraitist. He accepted only a handful of paid commissions during his last years in Holland.

Moreover, it wasn't just the money from *The Lace Maker* that he had brought with him to the Riviera but the proceeds from the sale of other fakes as well. Van Meegeren hadn't given up on forgery after Harold Wright's 1927 triumph in Berlin. On the contrary, he had continued to plug away at his work on the Sumatrastraat with all the diligence that he failed to apply to his legitimate career. And to understand why Van Meegeren really left The Hague and began a new life abroad, it is important to look beyond the story of the Kunstkring. For Van Meegeren didn't relocate to Roquebrune simply to lick his wounds but to cash in on an opportunity that had presented itself in the course of his experiments with Theo van Wijngaarden.

THE YEARS FROM 1927 to 1932 had been a period of constant adaptation for Van Meegeren and his comrades in the business of art fraud. Due to changing circumstances, they had been only intermittently successful: for every fake that went well, others failed, and none was an unqualified triumph as *The Lace Maker* had been.

For example, Van Meegeren's very first forgery after *The Lace Maker*, a Frans-Hals-style portrait, failed disastrously in the marketplace, putting an end to Harold Wright's career as a straw man in the process. In February 1928, just six months after selling *The Lace Maker*, Harold Wright had reintroduced himself to Joseph Duveen's European representatives and let them know about his latest find. But things got off on the wrong foot from the very start. Whereas a newly discovered Vermeer, in its extreme rarity, could

inspire endless amounts of wishful thinking in the House of Du-veen, a Frans Hals allowed for a much more measured appraisal, there being many more known works by the master's hand, as well as centuries' worth of old copies and imitations floating around on the market. Indeed, Joseph Duveen's nephew Armand Lowengard offered only a lukewarm assessment when he examined Wright's new picture in Berlin. "We have nothing to criticize about the qual-ity of the picture," Lowengard reported back to Duveen in New York. However, the portrait was not, Lowengard thought, worth £15,000. The subject, a bearded man wearing a wide-brimmed black hat, struck him as "somewhat dark and gloomy looking."

At a distance of three thousand miles, Joseph Duveen was will-ing to be a bit more optimistic. "Nothing more saleable," he wrote back to Lowengard, endorsing further negotiations. Wright was then asked to bring the Hals portrait to London so that Duveen's people there could examine it. As it happens, Van Meegeren also made the journey to the British capital at that same moment, this being the visit during which he painted Theodore Ward's portrait in the pseudo-Dutch sitting room. Although the forger's trip may have been made in anticipation of another big payday at Duveen's expense, it probably evolved very quickly into a strategy session.

Duveen had sent photos of Wright's painting to Frederik Schmidt-Degener at the Rijksmuseum, and it wasn't long before Schmidt-Degener wired back to say that the picture was noth-ing but a pastiche of two existing Frans Hals portraits. Suddenly, memos began to fly between the various offices of Duveen Broth-ers, describing Harold Wright as a "clever, dangerous, and tricky man." Indeed, Duveen found himself wondering about an issue that ought to have been on his mind from the very start. WHAT IS PICTURE'S HISTORY? he demanded to know in a telegram to Low-engard. WHENCE CAME IT? CERTAINLY NOT FROM SKIES. Duveen did not end up buying the Frans Hals. Nor, in fact, did anyone else, for both it and Harold Wright soon disappeared—seemingly

from the face of the earth. Wright beat a hasty retreat to The Hague, where he kept an extremely low profile, and the Hals portrait never resurfaced on the market.

When the smoke cleared, Duveen was not sure exactly what to make of Harold Wright's activities. He didn't jump to the conclusion that Wright had been selling fakes, but the whole situation certainly gave him cause for concern. Even though Duveen often bought pictures without first seeing them in person, relying upon experts both inside and outside his firm to guide his purchases, he presented himself in public as the art world's supreme authority on matters of aesthetic value. He schooled his clients to believe that truly important pictures could be purchased only through him and that his opinions with regard to art were virtually infallible. "To establish that kind of absolutism took unremitting vigilance and unremitting ingenuity," Duveen's biographer S. N. Behrman once wrote. "Duveen's name must be inseparably associated with not just great works of art but the greatest, and he would allow nothing to tarnish this glittering trademark." The very notion of a scandal or controversy surrounding one of his pictures was surely something Duveen wished to avoid. And as the twenties gave way to the thirties, even though *The Lace Maker* and *The Smiling Girl* remained on Andrew Mellon's walls unchallenged, Duveen and his staff became increasingly wary when it came to new Vermeers.

The House of Duveen was, in fact, never duped by a Van Meegeren fake again, although more would be offered to the firm in the years to come. For instance, *The Girl with the Blue Bow*— the pseudo-Vermeer portrait that Wilhelm von Bode had rejected in 1924—was presented to Duveen's London office by an English front man named Charles Carruthers after Bode's death. Carruthers claimed that the picture had been in his family for as long as he could remember. But Duveen's office manager, Edward Fowles, turned down *The Girl with the Blue Bow,* saying he was not convinced of its authenticity, and considering that Fowles took the

unusual step of having the picture X-rayed, he probably doubted more than just the attribution. (The X-rays turned up no damning evidence; Fowles would have needed to test the picture's gelatin-glue medium to unmask the forgery.) After the defeat at Duveen's, *The Girl with the Blue Bow* was eventually brought back on the market after a round of laundering in an auction sale. Although the evidence is circumstantial, it appears likely that Theodore Ward orchestrated all of this. Auction house records indicate that Ward and his brothers had done frequent business over the years with the buyer who "acquired" the painting from Carruthers, a frame maker named Collings. Collings transferred *The Girl with the Blue Bow* to yet another party, who brought it to Wilhelm Valentiner for attribution. The picture was then sold as a certified Vermeer to a legitimate dealer and eventually found its way into an American private collection.

Even after this incident, Duveen Brothers had to remain on guard. Another previously unknown "Vermeer," this one depicting a girl dressed in antique costume, turned up in Berlin in August 1930 and was promptly brought to the attention of Armand Lowengard. A variation on *The Girl with the Red Hat*, it is sometimes known today as "The Greta Garbo Vermeer," as the face of the sitter bears a striking resemblance to movie posters for *Anna Christie* and *Wild Orchids*—an interesting and apparently effective subliminal appeal to the eyes of the 1930s, since the anachronism blended in completely unnoticed with the prevailing tastes of the day. The great connoisseur Max Friedländer, who had succeeded Bode as director of the Kaiser Friedrich Museum, wholeheartedly accepted this picture as a Vermeer when it was brought in for attribution, reportedly calling it "splendid." And although Friedländer was not a recognized authority on seventeenth-century painting—his area of specialization being the German and Flemish Primitives—he was not alone in his opinion. Wilhelm Martin of the Mauritshuis concurred in the attribution, as did Duveen's expert

of choice, Frederik Schmidt-Degener. However, this chorus of approval notwithstanding, when Armand Lowengard went to inspect the picture, his response was extremely guarded, indeed, almost gun shy. "This question is so difficult," he wrote to Duveen, "that I am thoroughly going into the matter before adopting a definite attitude." Lowengard and Duveen ultimately chose to do nothing. In the end, the Paul Cassirer Gallery, one of the better Berlin firms, arranged to sell the picture to Baron Heinrich Thyssen, for whom Max Friedländer had long served as a trusted advisor. Once so eager to beat out the competition for *The Lace Maker,* Duveen was content to let this new Vermeer simply pass him by.

Given that Van Meegeren never confessed to painting Baron Thyssen's Vermeer, it seems fair to ask why this picture has so often been ascribed to him. In 1952, Van Meegeren's son, Jacques, announced to the Paris press that Miss Garbo was one of his father's efforts. In and of itself, the younger Van Meegeren's word actually means very little: having grown up largely estranged from his father, Jacques van Meegeren spent much of his later life trying to cash in on a story that he really didn't know. Indeed, on other occasions, he claimed pictures for his father's oeuvre that possessed clearly documented provenances going back over a hundred years. With the Garbo Vermeer, though, Jacques seems to have been on the right track, for in its appearance and conception, this "Vermeer" mirrors a stylistic shift that occurred in Van Meegeren's legitimate work during this period, as the artist moved from the rounded volumes and curling brushstrokes seen in his best portraits of the early twenties, to the more angular style on display, for instance, in Theodore Ward's portrait, done just a few years later. Likewise, there is also fairly compelling documentary evidence of Van Meegeren's authorship of the Garbo Vermeer. In an art book, formerly the property of Han van Meegeren and now held in the archives of the Boijmans Museum in Rotterdam, it seems that the forger proudly signed his name below a photographic reproduction

"The Greta Garbo Vermeer"—known more formally as *The Girl with a Blue Hat* or *The Girl in Antique Costume*—shown here in a printed reproduction with Van Meegeren's handwritten annotations

of Thyssen's picture and annotated it elsewhere "Vermeer? No. Han van Meegeren."

Interestingly, Van Meegeren also jotted down that Thyssen's Vermeer had been discovered in "+/– 1931." As Van Meegeren doesn't seem to have made these notations until around 1939, his haziness about the exact timeframe of the sale may have been due to a fading memory, but it could also indicate that he was rather far removed from the process of marketing this picture in Berlin.

With Harold Wright out of action, the Greta Garbo Vermeer was likely passed off through a network of third parties, much in the way *The Smiling Girl* had been before it. Perhaps Hans Wendland played a role, as he had in the handling of *The Lace Maker*. Indeed, given that Max Friedländer both authenticated and helped market the picture, Wendland's involvement seems quite probable. Although Friedländer was a man of great rectitude, the seedy Wendland was one of his closest friends. Moreover, Friedländer was often accused of allowing his personal feelings to blind him when it came to giving certificates to people he liked. In any event, the Thyssen sale did not go through until sometime after March 1931; and if Van Meegeren shared in the spoils, he would have received his money a bit later still, which could explain the lack of specificity in his recollection of the relevant dates.

It would appear that Van Meegeren played a rather more direct role, however, in the marketing of his next fake Vermeer, *The Gentleman and Lady at the Spinet*, which popped up in The Hague in July 1932. Significantly, this was the first time that Van Meegeren had attempted to introduce a forgery in the Netherlands since the 1923–1926 brouhaha over *The Laughing Cavalier*. There was an extremely good reason why he was once again willing to take the risk of operating so close to home: he had a completely foolproof fake on his hands—scientifically speaking.

A breakthrough for Van Meegeren, *The Gentleman and Lady at the Spinet* was painted not with Theo van Wijngaarden's artisanal gelatin-glue medium but with a modern wonder product—Bakelite. A forerunner to postwar thermoplastics, Bakelite was used during the twenties and thirties to make everything from telephone handsets to brightly colored costume jewelry. Industrially, Bakelite-based paints were sometimes used in baked-on spray coatings, particularly when a hard, tough finish was desired. And that same toughness was what made Bakelite so appealing for forgery: when fully dry, Bakelite was impervious to just about

The Gentleman and Lady at the Spinet, forgery in the style of Vermeer, ca. 1932

anything. The alcohol test would have had no effect on a Bakelite fake. And unlike gelatin glue, Bakelite didn't soften in water either. Indeed, a film of hardened Bakelite behaved almost exactly like an oil-paint surface hundreds of years old. By grinding period-appropriate pigments into liquid Bakelite and then using the resulting mixture on recycled seventeenth-century canvases, Van Meegeren was suddenly able to create fakes that virtually no scientist could have proved fraudulent, at least not using the methods ordinarily employed in the conservation laboratories of the 1930s. In short, Van Meegeren had hit the technological jackpot.

It's quite likely that Van Meegeren was alerted to the virtues of Bakelite by Theodore Ward. Not only was Ward a recognized expert in the chemistry of paint with numerous patents to his name, but Ward's company appears to have used Bakelite in some of its products. (They had branched out into the fabrication of synthetic

radio casings in the early 1930s.) Yet, while Ward may have given Van Meegeren the basic technical tip, it was Van Meegeren himself who had to adapt Bakelite for use as an artist's material. Van Meegeren's mentor, Theo van Wijngaarden, would not have been able to provide much beyond a measure of encouragement. Although Van Wijngaarden had been able to make gelatin glue simulate the consistency and handling characteristics of oil paint with uncanny precision, such a feat was extremely difficult to achieve with runny, sticky Bakelite.

Formed by mixing carbolic acid and liquid formaldehyde, Bakelite is very similar, both in its chemical and working properties, to the two-part epoxy resins commonly available in hardware stores today, the main practical difference being that Bakelite requires the application of heat to harden. In his earliest Bakelite fakes, Van Meegeren appears to have hit upon a painstaking technique whereby he would apply small touches of the pigmented Bakelite mixture to his canvas and then quickly pounce the surface with a large, dry brush—called a blender—to smooth out the paint before the Bakelite became too tacky to work with. Only after building up his image through this tedious process did he finally add a few well-placed, briskly applied brushstrokes, giving the work at least a superficial sense of verve. The whole production then had to be "cooked"—really just warmed for a lengthy period—in a makeshift oven constructed out of plywood, and heated with either sterno, a sun lamp, an electric coil from a toaster, or, less probably, gas cylinders, depending on which of the many contradictory descriptions one believes.

Although scientifically impressive, the initial results of these experiments were visually rather awkward. For instance, *The Gentleman and Lady at the Spinet* has a very cold and rigid appearance, completely different from Van Meegeren's normal painting style, and also wholly unlike the soft and luminous effect that one would expect in a real Vermeer. Indeed, *The Gentleman and*

Lady at the Spinet presents a weirdly "precisionist" vision of the Delft master's work: all the forms have sharp outlines and all the volumes are defined by fastidious gradations of light and shade. Although Van Meegeren here offers up a learned pastiche of elements cribbed from known compositions by Vermeer—the stone floor, the woman's dress, even the landscape painting hanging on the wall in the background—on the subtler level of the artist's touch, something has definitely gone wrong. Unable to employ his usual freely brushed technique due to the limitations of his new materials, Van Meegeren seems to have fallen back on his early architectural training, conceiving *The Gentleman and Lady at the Spinet* almost as if it were a mechanical drawing exercise.

Wrapped up in his struggles with the new Bakelite medium, Van Meegeren may have been blind to these shortcomings, but other people were not: *The Gentleman and Lady at the Spinet* prompted strong murmurs of disapproval almost as soon as it appeared on the market. This new Vermeer was said to have come from the collection of a reclusive old family who had entrusted their prized masterpiece to one J. Tersteeg for the purposes of effecting a sale. A writer and publisher who travelled in the same circle as Van Meegeren's friend Jan Ubink, Tersteeg was one of the founding officers of the Verbond van Actualisten, the first organized fascist party in the Netherlands. Although it is not known whether he was a witting or unwitting accomplice in selling *The Gentleman and Lady at the Spinet*, Tersteeg did have a measure of credibility in the art world, as his father had managed the Dutch branch of the Paris-based Goupil gallery for many years. From Tersteeg, the picture passed into the hands of the Katz gallery, a Dutch firm, which then sold it to the German banker Fritz Mannheimer for an undisclosed sum. Prior to setting up the Katz-Mannheimer deal, however, Tersteeg had sent *The Gentleman and Lady at the Spinet* to Budapest, presumably for consideration by

another buyer; at that time, representatives of the Paris firms of Wildenstein and Kleinberger were summoned to have a look at the new Vermeer. They turned it down—recognizing it as completely fraudulent.

The Gentleman and Lady at the Spinet did come with a certificate of expertise, having been authenticated for Tersteeg by the aging Dutch art expert Abraham Bredius, the generous benefactor who had given the Kunstkring easy terms on the payment of its loan just four months prior. Although Bredius had long been an important figure in the Dutch museum world and, earlier in the century, had published his archival research quite actively, he had never been as heavily involved with the sale of certificates as either Hofstede de Groot or Wilhelm von Bode. Indeed, he had occasionally criticized both men for getting too close to the trade—a criticism that was fairly easy for Bredius to make, as his family had, for many years, owned a sizeable munitions factory, making him a very wealthy man. Yet, while Bredius had little need for money, on some level, he had always envied the power that his two greatest colleagues in the connoisseurship of seventeenth-century Dutch art had wielded. With both Bode and Hofstede de Groot dead, Bredius seems to have sensed an irresistible opportunity to step into their shoes and play at being an art market pooh-bah in his declining years.

By all appearances, Van Meegeren painted *The Gentleman and Lady at the Spinet* with Bredius firmly in mind. One of Bredius's greatest coups as a connoisseur had been his discovery of Vermeer's *Allegory of Faith*, which he purchased for his own collection after spotting it as a work of the master in 1899. The tapestry-weave curtain used as a framing device in *The Gentleman and Lady at the Spinet* is copied almost literally from *The Allegory of Faith*, a fact that Bredius duly noted in attributing the picture. Likewise, *The Gentleman and Lady at the Spinet* also resembles *The Allegory*

of Faith in its overall stiffness and inertia, which probably nobody other than Bredius would have considered positive. Indeed, *The Allegory of Faith* is easily the least-loved work in Vermeer's oeuvre: when Bredius had wanted to cash in on the picture by selling it on the American market, Joseph Duveen turned it down flat, noting that "the subject is rather against it." After Duveen's rebuff, Bredius ended up selling his Vermeer through the somewhat less prestigious Kleinberger gallery; he still made a tidy fortune from the deal, but the idea that his Vermeer hadn't been up to Duveen's lofty standards left Bredius feeling insulted, and he was apparently determined to use *The Gentleman and Lady at the Spinet* as a means of exacting revenge.

It was Bredius's long-held opinion that most of the Vermeer discoveries of the 1920s had been bogus. He had even twitted Duveen with such assertions from time to time. As Duveen's London office manager, Edward Fowles, later recalled, Bredius "had continually warned me that they were making fake Vermeers." And in October 1932, Bredius went public with those suspicions. Proudly announcing the discovery of *The Lady and Gentleman at the Spinet* with a scholarly article published in the *Burlington Magazine*, the bible of the old-master market, Bredius stated frankly that the art world's lust for fresh Vermeers had provided forgers with "a happy hunting-ground for their activities." He denounced several 1920s-vintage Vermeers as fakes, including Duveen's *Smiling Girl*. He also ridiculed as

Abraham Bredius, ca. 1925

Johannes Vermeer,
The Allegory of Faith,
ca. 1672

woefully misattributed the "obviously French portrait of an ob-
viously French boy" that Duveen had sold as a Vermeer to Jules
Bache in 1923. Oddly, the possibility that his own new find—"a
very beautiful authentic Vermeer"—might be an even bigger dud
seems not to have occurred to Bredius. But the picture had, of
course, been made specifically to appeal to his sensibilities.

When Joseph Duveen got wind of Bredius's comments, the
sound of a small explosion might well have been heard in the vi-
cinity of Fifth Avenue and 56th Street in New York City. BREDIUS
ARTICLE BURLINGTON MAGAZINE VERY INJURIOUS TO US, Duveen
exclaimed in a telegram to Edward Fowles, who was in Paris at
that moment. HIS NEW DISCOVERY MUST BE DISCREDITED SOME-
HOW. Almost immediately, Fowles wrote back to Duveen, com-
miserating and saying that Bredius was still "bitter" against the
firm because of *The Allegory of Faith*. Fowles promised to look into

the matter of the new Vermeer further and, by the end of the week, he reported back to Duveen with welcome news:

> Wildenstein informs me that they know the "Burlington" Vermeer, as it was offered to them at the beginning of September. In their opinion the picture is quite modern and not even worth anything . . . Old Wildenstein considers the matter very serious as he foresees an attempt by Bredius to force himself into the Dutch picture market by raising controversies . . . He considers it inexcusable that a so-called expert should pass such an obvious fake.

It would seem that experience had taught Nathan Wildenstein to banish any fond hopes when it came to mysterious Vermeers. *The Gentleman and Lady at the Spinet,* despite its many faults, was certainly no worse a picture than the dreadfully fake *Young Woman Reading* that Wildenstein had found so appealing back in 1927. But by 1932, Wildenstein had become a far warier man. Not only had the Great Depression brought an end to the go-go atmosphere of the twenties, but Vermeer-mania wasn't exactly what it used to be either. Rumors about fakes were circulating in London and Berlin, prompting revisionist scholars to take a hard look at works like *The Young Woman Reading* that had been hailed during the boom. As doubts were cast on many such "Vermeers," the dealers who had handled them faced potentially embarrassing questions. Although Wildenstein was probably quite content with the profits from *The Young Woman Reading*—he had sold it to Jules Bache for $134,000—he had certainly never intended to sell a fraudulent painting. Wildenstein had been fooled, plain and simple, and that was nothing for a great art dealer to be proud of.

Convinced though he may have been that the new Vermeer was "modern and not even worth anything," Wildenstein had no desire to expose Bredius's mistake. There was nothing to be gained by airing the art market's dirty laundry in public, for there

was no telling where such an exercise might lead. Ultimately, even the hot-headed Duveen came around to this way of thinking, at least after a little prodding from Edward Fowles. "We would advise that you keep out of any controversy over the matter of the Vermeer, as if we slam the picture, we may lose Mannheimer as a client," Fowles stated in a letter to Duveen. "In any case, we hear it is common talk in Berlin that the picture is wrong, so it is bound to come [out] sooner or later." And in a nod to the possible skeletons lurking in the firm's own closet, Fowles astutely pointed out that all of the Vermeers sold by Duveen Brothers were "well-defended" by Schmidt-Degener. There was, hence, no need to rise to Bredius's bait regarding *The Smiling Girl*. Although still fuming mad, Duveen reluctantly agreed that the best course was to do and say nothing.

Some of the bloom had clearly come off the rose in the Vermeer swindle business. And yet, while the likes of Duveen and Wildenstein could no longer be duped by *pointillé* highlights or doe-eyed maidens clad in seventeenth-century garb, Van Meegeren hardly needed to cast aside the palette and mahlstick and call it quits. Smaller, but nonetheless quite important European firms could still serve as possible marks for the forger's product line. Not having been stung yet, they were still inclined to give the benefit of the doubt to newly discovered Vermeers turning up on the market. And aside from having the potential to generate large profits, a fresh example of the Delft master's work would have been very appealing to certain firms from the standpoint of pride and competitiveness. After all, second-tier dealers always enjoyed demonstrating their ability to handle pictures as great and significant as those sold by the mighty Duveen.

For instance, the Dutch firm of Katz, which bought *The Gentleman and Lady at the Spinet*, was just such an up-and-coming gallery—one whose aspirations sometimes outstripped its competence. With good connections among wealthy Jewish collectors in

Germany, Switzerland, and the Netherlands, the brothers Nathan and Benjamin Katz had, over the years, carefully built up their father's antique business, eventually branching out into the riskier but more lucrative field of old-master paintings during the 1920s. According to a now-elderly art dealer in The Hague who knew the Katz brothers well—and liked them immensely—they were natural-born salesmen who could "sell anything to anybody" by sheer force of personality, and usually at substantial prices. Merchants first and foremost, the Katz brothers were not great connoisseurs of art, particularly not in the beginning. And in making acquisitions, they often relied on the recommendations of paid advisors who combed the markets in London, Paris, and Berlin, figures such as the German art historian Kurt Erasmus and the Franco-Russian picture scout Georges Isarlo. Likewise, regarding the physical condition of paintings, the Katz brothers always made sure to consult with their in-house picture restorer—who was, as it happens, none other than Theo van Wijngaarden's son, Willy van Wijngaarden.

Even as a young man, Willy van Wijngaarden had wanted nothing to do with the sale or manufacture of forgeries: he had turned down his father's offer to join the family business back then, and his resolve to follow the high road through life hadn't softened with time. Now older, with a wife and two small children to support, Willy had been forced to put aside his hopes for a career as a painter, making his living, instead, tending to pictures for art dealers, working first with the firm of Asscher-Koetser in London and then with the Katz brothers back home in the Netherlands. According to his daughter, Willy truly adored the Katz family: although not Jewish himself, he was a frequent guest at his employers' Sabbath dinners. Yet, despite both good intentions and first-hand knowledge of the ways of forgers, Willy was unable to prevent the Katzes from being landed with quite a few fakes. Aside from *The Gentleman and Lady at the Spinet*, there was also a

mysterious Frans Hals that was denounced by an expert as a modern forgery made with *kunsthars*—synthetic paint—a few years after the Katzes acquired it. Likewise, *The Girl with the Blue Bow* passed through the Katz Gallery on its travels from the salesrooms of London to its final resting place in America.

Just like everyone else, Willy was fooled by these forgeries. But at some point, based either on something that he noticed in pictures that came up for consideration or, more likely, by nosing around his father's business operations, Willy seems to have gotten a better sense of what was going on. By the mid-1930s, Katz had stopped buying forgeries. And when Vermeer's biblical works began to appear on the market, Willy van Wijngaarden was well aware that they were not by the master. Willy's daughter can remember vividly that her father told her, just before the war, that he was certain—absolutely certain—that the first and greatest of the biblical Vermeers, *The Supper at Emmaus,* was a fake. And he also had a pretty good idea of who had painted it.

The fact that Van Meegeren had so conspicuously skipped off to France might well have signaled to Willy van Wijngaarden that the forger was up to something big. But Willy is unlikely to have had any more detailed information upon which to base his suspicions than that. In leaving, Van Meegeren had cut ties with Willy's father and everyone else involved with the Sumatrastraat forgery ring. Working on the Riviera, Van Meegeren would return to the simpler and, for him, far more profitable option of painting a fake and finding a single front man to sell it. Bakelite had made this possible. Although *The Gentleman and Lady at the Spinet* may have caused Duveen and Wildenstein to grumble, there was no risk of it dissolving in water the way *The Laughing Cavalier* had, back in 1923.

VAN MEEGEREN SPENT his first few years in France refining his technique with the Bakelite medium. Settling into the rented villa in Roquebrune with Johanna, Van Meegeren proceeded to set up

Woman Playing the Lute,
forgery in the style of
Vermeer, ca. 1933

a forgery studio in a well-lighted room upstairs. In due course, he produced two new Vermeers—*Woman Reading Music* and *Woman Playing the Lute*—as well as a rather wooden looking *Portrait of a Man* in the manner of Terborch. He never tried to sell any of these pieces. They represented only a very minor improvement over *The Gentleman and Lady at the Spinet*, retaining much of that picture's paint-by-numbers aesthetic. But Van Meegeren did make progress. He eventually turned out a rather good Frans Hals, a variation on the famed *Malle Babbe* in Berlin. The Hals, a dramatic advance technically over the other early Bakelite fakes, is executed in a direct and muscular style. And yet, although it appears quite convincing in photographs, on close inspection, it still has a strangely flat and dead surface, the attempts at thickly applied, bravura brushstrokes resembling nothing quite so much as melted cake icing. Like the previous near-miss fakes of this period, the Hals was never placed on the market. But after the Hals, Van Meegeren produced two Pieter de Hoochs—*Interior with Drinkers* and *The Card Players*—both of which were quite passable fakes,

Malle Babbe, forgery in the style of Frans Hals, ca. 1935

capturing something of De Hooch's fine, yet tentative touch. Although Van Meegeren did not try to put them into circulation right away, he would eventually do so, and with great success.

In the meantime, though, having mastered the recalcitrant Bakelite medium, Van Meegeren embarked on an ambitious new project. Beginning in the autumn of 1936, and continuing for the next seven years, he would produce six fake Vermeers on religious themes. Unified in both subject and style, and presenting a sustained argument about the hidden pathways of Vermeer's artistic development, these forgeries were quite unlike any Van Meegeren had previously created. They were also very unusual Vermeers.

Although Vermeer is best known for his genre scenes, it is generally acknowledged that, at the very beginning of his career, he produced two large and not terribly good narrative compositions—*Diana and Her Companions,* which depicts a story from mythology, and *Christ in the House of Martha and Mary,* a biblical history painting. Writing about these two pieces of juvenilia in 1921, the great English critic Roger Fry posited that "Vermeer

Johannes Vermeer, *Christ in the House of Martha and Mary*, ca. 1655

began with the ambition of painting ideal scenes in the grand style and in accordance with Latin ideas of design, [but] gradually resigned himself to the narrower scope and smaller scale of typical Dutch genre."

This assessment seems to have been quite correct, but in Van Meegeren's day, with dealers, experts, and collectors constantly on the lookout for more Vermeers, hope lingered that the artist hadn't put aside his early ambitions quite as soon as Fry suggested. For instance, Wilhelm von Bode had authenticated a biblical scene, *The Parable of the Unmerciful Servant,* as a work of Vermeer in the early 1920s, although the picture never gained wide acceptance with other experts (virtually everyone but Bode ascribed it to the school of Rembrandt). Nonetheless, given that Vermeer was known to have married into a Catholic family, it did seem quite plausible that Catholic patrons might have supported his production of religious paintings, perhaps intended to decorate a *schuilkerk,* or hidden church, where Dutch Catholics gathered to practice their forbidden religion during the Reformation.

Van Meegeren began his biblical series, fittingly, by painting a picture about a miraculous reappearance. *The Supper at Emmaus* presents an episode from the Gospel according to Luke, in which Christ, having risen from the dead after the crucifixion, reveals his identity to two of his followers over a meal at a humble inn. Although the Emmaus story had been painted by many artists over the centuries, it was most closely associated with Caravaggio, who, quite importantly for Van Meegeren's purposes, was known to have exerted a strong influence over Dutch painters working in an Italianate manner during Vermeer's time. In his two known versions of the subject, Caravaggio had focused, with typical theatricality, on the astonishment expressed by Christ's companions when they finally realize that it is the Lord who sits in their midst. Such demonstrative emotion being almost impossible to imagine in the quiet and understated world of Johannes Vermeer, Van Meegeren wisely chose to present the calmer prelude to this climactic moment, showing Christ just beginning to bless and break the bread in a tell-tale echo of the Last Supper.

By imitating the sense of suspended action that pervades Vermeer's paintings, Van Meegeren gave *The Supper at Emmaus* a crucial measure of credibility as an example of the master's "missing" biblical period. Bolstering this conceit, Van Meegeren also filled his *Supper at Emmaus* with stylistic and technical references to Vermeer. Some of these are fairly obvious, such as the inevitable *pointillé* highlights and extravagant use of expensive ultramarine blue—the trademark pigment that gives Vermeer's daylight its cool, crisp tone. More subtly, Van Meegeren copied the pose of the disciple at the far right from Vermeer's *Astronomer* and then stitched it seamlessly into the new composition. Many of the items arrayed on the table—the silver platter, the glasses, and the earthenware jug with the pewter top—are also appropriated from genuine Vermeers, such as *The Music Lesson*, at Windsor Castle, and *The Girl Asleep*, in the Metropolitan Museum of Art. Van Meegeren

purchased period examples of these props in antique stores, keeping the objects around his home as models and, perhaps, to set an appropriate seventeenth-century mood for his labors. Even the heavy, hooded eyelids of Christ and the innkeeper, certainly Van Meegeren's strangest borrowing, hearken back, in an exaggerated form, to the standing figure of Martha in Vermeer's *Christ in the House of Martha and Mary.*

What's peculiar about *The Supper at Emmaus,* at least when you look at it closely, is that it appears also to draw inspiration from several sources completely unrelated to Vermeer or even to Golden Age Holland. For instance, the stylized, almost Gothic, severity of Christ's head has no precedent in the Delft master's oeuvre: it seems far more in keeping with the work of the late-

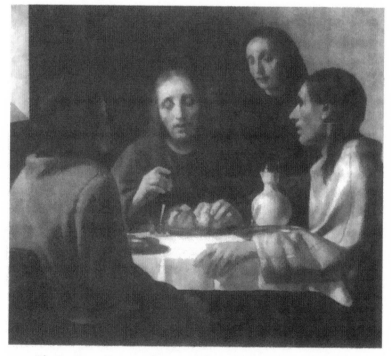

The Supper at Emmaus, forgery in the style of Vermeer, 1936–1937

Albrecht Dürer, *Self-Portrait at Age Twenty-Eight,* ca. 1499, also known as the "Self-portrait as Christ"

fifteenth/early-sixteenth century German artist Albrecht Dürer. Specifically, Dürer's iconic *Self-Portrait at Age Twenty-Eight,* also known as the "Self-Portrait as Christ," strongly prefigures the rectangular face, massive nose, exaggerated lips, and long, limp hair seen in Van Meegeren's depiction of the Lord. Even the pronounced and anatomically unusual creases that frame the mouth of Van Meegeren's Christ echo the dark shadows cast by the moustache in Dürer's self-portrait, almost as though Van Meegeren had reproduced the shading while omitting the facial hair.

Why would Van Meegeren have lifted material from the most German of German artists in creating a new masterpiece by Vermeer? As it happens, there's good reason to believe that, when Van Meegeren painted *The Supper at Emmaus,* things Germanic were very much on his mind.

CHAPTER SIX

The Master Forger and the Fascist Dream

VAN MEEGEREN BEGAN *The Supper at Emmaus* shortly after returning from an extended trip to Berlin. He and Johanna had attended the Olympic Games, which, that particular year, were as much a celebration of the Fatherland as they were a sporting event. Indeed, the 1936 Summer Olympics had provided Germany with a grand opportunity to showcase its national traditions for the appreciation of visitors from around the globe. As an accompaniment to the Games, for instance, the German Olympic Committee mounted a sprawling indoor-outdoor exhibition titled "Deutschland" that presented an overview of Germany's contributions to the arts and sciences, as well as important artifacts from German history, including a copy of Martin Luther's *Ninety-five Theses,* a Gutenberg Bible, the original manuscript of *Mein Kampf,* and thousands of other objects spread out across 150,000 square meters of display space.

There was also a large contemporary art show—the German Reich Art Exhibition—which might well have held some interest for Van Meegeren due to the particular stylistic tendencies on display. The show presented prize-winning works from a competition

open to entrants from all of the Olympic nations; however, with the judges handpicked by the Nazi regime, the selected exhibitors turned out to be mostly German artists of the type that Hitler generally applauded. A former art student himself, Hitler had strong feelings about aesthetics and had never been shy about sharing his ideas. He had devoted almost an entire chapter of *Mein Kampf* to the evils of modern art and Dadaism, providing arguments and ammunition to like-minded people across Europe, including Van Meegeren, who had closely paraphrased this diatribe in the pages of *De Kemphaan*. After attaining power, Hitler openly persecuted artists who worked in "degenerate" styles but lavished official patronage on those whose images reflected the *Volksgeist*—the essential spirit of the German people. As he proclaimed in his 1935 Reich's Party Day oration, "We shall discover and encourage the artists who are able to impress upon the German State the cultural stamp of the Germanic race. . . . They are the expressions of the soul and the ideals of the community." For the most part, this directive yielded rather prosaic results—countless paintings and photographs of blond, blue-eyed farm girls amid the meadows and streams of Germany's bucolic countryside. More impressively, though, Leni Riefenstahl employed these same tropes in the beginning of *Triumph of the Will*, where she presents thousands of robust lads and squeaky-clean maidens gleefully setting forth from the four corners of the nation to attend the Nuremberg Rallies, a stirring tribute to the unity of the German nation.

Van Meegeren, who had always been a stylistically conservative artist, evidently developed a strong interest in *Volksgeist* themes and imagery over the years. Although this trend would not become readily apparent to the outside world until Van Meegeren revitalized his career in his own name during the war years, a latent volkisch sentiment is already present in *The Supper at Emmaus*, with its Germanic take on a simple rural repast. Van Meegeren himself seems to have put his finger on this covert connection when

he reimagined his greatest Vermeer as a blatant *Volksgeist* image in his circa-1942 oil painting *Mealtime at the Farm*. He presents the same composition with the same overtly spiritual mood but transforms the central figure of Christ into a sturdy country matron surrounded by a dozen respectful children of various ages. *Mealtime at the Farm*, moreover, isn't just *a* picture: it's a type of picture. In Nazi Germany one could have found hundreds of similar images, all of them extolling the virtues of German mothers who produced healthy offspring for the Fatherland. So much value did the Reich place on maternity that a new civilian medal, the *Mutterkreuz*, was created for fecund wives like the one shown wearing her badge of honor in a 1940 photograph by Nazi Party propagandist Liselotte Orgel-Köhne. In the early years of the Reich, such depictions of Aryan mother worship tended to be quite joyful, like Orgel-Köhne's photo; at the height of the war, a more somber tone prevailed, with all of the fighting-age men necessarily absent from the family gathering—as they are in *Mealtime at the Farm*.

The subtle affinity between Van Meegeren's biblical Vermeers and Nazi *Volksgeist* imagery did not end with *The Supper at Emmaus*, but rather continued straight through to the end of the series. For instance, the last of the biblical Vermeers, *Christ and the Adulteress*, the one that Van Meegeren sold to Hermann Goering in 1943, seems to lift its composition almost literally from a well-known 1940 painting by the Nazi artist Hans Schachinger, depicting a solemn Austrian family sending the man of the house off to the front. Van Meegeren's youthful adulteress simply takes the place of the similarly posed old woman in Schachinger's painting. In a more alarming parallel, Christ stands in for the departing Nazi soldier, who, in the eyes of the faithful, would probably have been seen as a sacrificial figure prepared to lay down his life for the greater good. By tapping into contemporary *Volksgeist* conventions, Van Meegeren was finally able to produce a group of biblical paintings unified in both sentiment and style—a goal that

Mealtime at the Farm, ca. 1942

A recipient of the *Mutterkreuz* and her family, photograph by Liselotte Orgel-Köhne, 1940

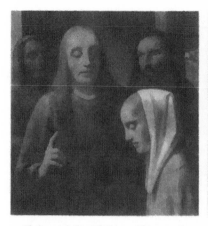

| *Christ and the Adulteress*, forgery in the style of Vermeer, ca. 1943 | Hans Schachinger, *Abschied*, 1940 |

had eluded him when creating the religious scenes that he exhibited under his own name at the Biesing show of 1922.

Much like Van Meegeren's early "high-society" Vermeer forgeries, the biblical Vermeers not only reflected the forger's own interests but also exerted a strong subliminal attraction on viewers steeped in the visual culture of the day. With both batches of fakes, it seems that many people were seduced by the illusion that Vermeer, a master for all times, had expressed himself in a way that was mysteriously up to date. In the case of the biblical Vermeers, though, certain individuals appear to have experienced an even deeper sense of identification, one that verged upon narcissism.

For instance, Hitler's personal photographer, Heinrich Hoffmann, considered himself a great fan and connoisseur of the so-called biblical period of Vermeer's oeuvre. Hoffmann was deeply impressed when he first saw *The Supper at Emmaus* at Rotterdam's Boijmans Museum in the late 1930s. A few years later, during the war, Hoffmann squabbled bitterly with Hermann Goering when the related picture, *Christ and the Adulteress*, appeared on the market. A newly discovered Vermeer of this high caliber, Hoffmann

maintained, should rightly go to the Führer himself. Ultimately, Hoffmann was outmaneuvered by Goering's minions and lost his chance at the picture. But it's hardly surprising that Hoffmann would have found so much to admire in a painting like *Christ and the Adulteress*: it shared the same underlying ethos as his own work. One of the originators of the Nazi aesthetic, Hoffmann not only took the official photos of Hitler used on postage stamps and currency but also published a parade of illustrated books with such stirring titles as *Hitler Builds Greater Germany*, *Hitler among the Youth*, *Hitler and His Mountains*, and the astonishingly popular *Hitler off Duty*. Whether Hoffmann showed the Führer embracing gleeful German children, or befriending hard-working German laborers, or just spending an idle moment relaxing with a pack of well-trained German Shepherds, the images always conveyed the same inner intensity, the same numinous aura, the same striving toward an ideal of German-ness.

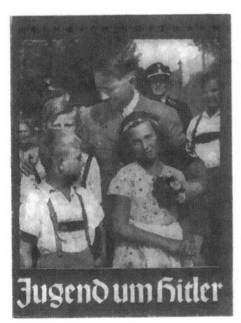

Hitler among the Youth, 1934

It would seem that Hoffmann's unwitting admiration for Van Meegeren's artistry did not go unreciprocated. Painting an elaborate portrait of his friend the Dutch pianist and conductor Theo van der Pas, in 1942, Van Meegeren produced a composition remarkably similar to a Hoffmann photograph showing Hitler dedicating a bust of the nineteenth-century Austrian composer Anton Bruckner at Walhalla, the Bavarian Hall of Fame and Honor at Regensburg. In Hoffmann's photo, the Führer proudly contemplates a room filled with Teutonic heroes immortalized in white marble, while, in Van Meegeren's rendition, Van der Pas receives inspiration at the piano from the disembodied spirits of Bach, Beethoven, Schubert, and Franz Liszt. Although it is difficult to say precisely how deliberate this borrowing was on Van Meegeren's part, it is quite clear that Van Meegeren and Hoffmann were working in the same magniloquent idiom—visually and intellectually—employing the authority of the past to flatter the vanity of the present.

Forgery granted Van Meegeren even broader latitude: his fakes actually altered the historical record in subtle ways, rather than just referencing tradition. Most pointedly, by fabricating a fictitious period of biblical history painting in Vermeer's career, Van Meegeren not only satisfied the art market's desire for more examples of the master's work but also reinforced the idea that Vermeer had operated in a Catholic milieu. Given Vermeer's towering reputation, a work like *The Supper at Emmaus* offered quiet support for Jan Ubink's notion that a latent Catholic influence lay at the very heart of Dutch Golden Age culture and could hence be considered essential to the spirit of the Dutch *volk*.

The biblical Vermeers also seem to draw on another strain of thought embedded in *De Kemphaan,* the idea that the Dutch and German traditions had been closely related historically and, in many ways, remained intertwined. Jan Ubink often gave thanks in *De Kemphaan* "for having been born Teutonic" and romanticized the cult of Wotan and the mythology of the Black Forest as

Portrait of Theo van der Pas,
ca. 1942

Hitler dedicating a bust
of Anton Bruckner at
Walhalla on June 6, 1937

if they were integral parts of Holland's native folklore. Likewise, the opinions Van Meegeren had published on the struggle between modernism and more conservative artistic trends had closely echoed arguments then raging across the border in Germany. This type of intellectual give and take between defining a pure national tradition and imitating successful models from other countries was

quite common to right-wing thinking across Europe in the prewar period. Mussolini's Italy had established the fascist paradigm, and as Hitler's power grew, Germany became an increasingly influential prototype. In the biblical Vermeers, with their borrowings from Dürer and Nazi *Volksgeist* imagery, the German past and the German present came together to cast a quintessentially Dutch artist in a subtly foreign light.

Was the Germanic tone of the biblical Vermeers the result of Van Meegeren's subconscious mind following ideas and images to their logical conclusions, or was it a calculating act of intellectual sabotage? In all likelihood, it was a bit of both. While Van Meegeren could hardly have plotted out every implication of his stylistic choices, *The Supper at Emmaus* represented such a dramatic shift in his art that it seems to have been more than just a casual experiment. As an acquaintance of his once put it, Van Meegeren was "the sort of man who liked to test the limits of what was acceptable, as a kind of provocation," and the chain of events after the forger's trip to the Olympics strongly suggests that he conceived of the biblical Vermeers in this spirit. For not only did he set to work on *The Supper at Emmaus* soon after his visit to Berlin, where Nazism and its cultural products had been so triumphantly on display, but the battle between fascist and antifascist politics played a crucial role in the way Van Meegeren brought his new Vermeer to market.

FATE WAS EXTREMELY KIND to Van Meegeren that summer. No sooner had he and Johanna returned to Roquebrune from Berlin than they received a call from an old friend—Gerard A. Boon, honorable member of Parliament for the Liberal State Party. Van Meegeren had fallen out of contact with Boon for a few years after moving to the Riviera, but Boon's wife, Bertha, had tracked the artist down in 1935, sending him a note to say that her mother—whom Van Meegeren had known and liked—had passed away. As

Bertha later recalled, she sent along several old photographs of her mother and asked if Van Meegeren would be willing to paint a memorial portrait. Van Meegeren had accepted the commission, and now that the Boons happened to be on vacation in nearby Cap Ferrat, they were curious to see the finished product.

Van Meegeren promptly dropped in on the Boons to deliver the portrait, but citing his deep respect and affection for Bertha's deceased mother, he refused to accept any payment, a gesture that Bertha found quite touching. Soon enough, Van Meegeren and the Boons began to catch up on the news of each other's lives. Times were not especially good for Gerard Boon in 1936. The Liberal State Party, with its appeals to humanism and moderation, was increasingly irrelevant in public affairs. Extremist fringe groups were gaining ground in the Netherlands: the Dutch National Socialist Party, a slavish imitation of Hitler's movement, had already won two seats in the Upper House—not a large number, but still infuriating for Boon, who had just as much contempt for the Dutch Nazis as he did for the German ones. And things would only get worse. Although Boon did not yet realize it, he would not have a platform from which to rail against the totalitarian movements of Europe for much longer. He was to lose his seat in Parliament in the general elections of 1937.

Van Meegeren had his troubles too, apparently. As he explained to the Boons, a problem had been weighing on his mind for some time, a most vexing problem. And in due course, he asked for a bit of help.

Van Meegeren claimed to be on friendly terms with an old Dutch family who lived in Italy and faced constant harassment from Mussolini's government. "They were confirmed anti-fascists and were being spied on by the black-shirts and their agents," as Gerard Boon would later recall the story. "The family was therefore in danger and they desperately wanted to emigrate to America." They needed to sell an important artwork from their

collection to raise money for the trip, but because of Italy's strict export controls they would never be able to bring it to market. There was considerably more to the tale as well—subplots involving abandoned castles, mystery women, and so many other embroidered details that Van Meegeren himself later admitted that he couldn't remember everything he told Boon. But the point of it all was ultimately quite simple: if Van Meegeren could arrange to smuggle the painting out of Italy, would Boon be willing to find a buyer?

Eager, as always, to do his part to support the antifascist cause, Boon agreed. About nine months later, acting on Van Meegeren's instructions, Gerard Boon brought *The Supper at Emmaus* to Abraham Bredius in Monaco for attribution. Without a doubt, this was the cruelest deception of Van Meegeren's career, an act of betrayal both personal and political to which the unsuspecting Boon was completely oblivious.

AT HIS HOME, the Villa Evelyne, in the foothills above Monte Carlo, Abraham Bredius was then enjoying a late-life revival in his career as an art historian, having just published a well-received catalogue of the complete paintings of Rembrandt, notable for eliminating some two hundred spurious works from the canon. As Bredius wrote, "It is the intention of this book to publish anew, subject to the most conscientious restriction, the complete oeuvre of Rembrandt's brush, which has lately been very considerably extended by additional attributions." By shrinking the Rembrandt corpus, Bredius had angered numerous art dealers and collectors, as well as colleagues who had vouched for the authenticity of the rejected paintings, but he had also provided the world with a clearer and more intelligent vision of Rembrandt's work.

Despite his earnest desire to root out mistaken attributions, Bredius had, however, already proven susceptible to Van Meegeren's

fakery in ascribing *The Gentleman and Lady at the Spinet* to Vermeer. And his longstanding involvement in the discussions surrounding Vermeer's two known religious paintings would make him a fairly easy mark when it came to *The Supper at Emmaus.* Not only had Bredius discovered and owned *The Allegory of Faith,* but he had been closely involved in the initial attribution of *Christ in the House of Martha and Mary,* Vermeer's only biblical narrative. Back in 1901, Bredius had travelled to England with Wilhelm Martin to have a close look at *Christ in the House of Martha and Mary,* then in the hands of a London dealer eager to have it confirmed as a work of Vermeer. The painting fascinated the two Dutch visitors, for in its overall style and handling, it strongly resembled the Mauritshuis's *Diana and Her Companions,* which, likewise, was very insecurely attributed at the time. Perceiving the faint signature "I V MEER" on *Christ in the House of Martha and Mary,* and noting certain stylistic similarities to the master's mature work, Wilhelm Martin was immediately inclined to ascribe both paintings to Vermeer. Bredius, however, disagreed, thinking the Italianate manner in which the pictures were composed completely uncharacteristic of Vermeer. Ultimately, though, it was Martin's opinion that won out in the scholarly community. And in time, Bredius had to admit his mistake. Both pictures truly were painted by Vermeer, and they have remained firmly attributed to him to this day.

Bredius was hardly the type to make the same mistake twice. By the time Gerard Boon presented him with *The Supper at Emmaus,* Bredius fully accepted that Vermeer had been influenced by Italian or Dutch Caravaggist sources, and Van Meegeren's fake simply reinforced that hard-learned lesson. Still, *The Supper at Emmaus* was a revelation, the sort of picture that forced one to see Vermeer completely afresh. Writing his certificate of expertise, Bredius expounded at length on the significance of his latest discovery:

This magnificent work of Vermeer . . . has been rescued—
thank God—from the oblivion where it languished for many
years, undamaged, just as it was when it left the artist's stu-
dio. The subject matter is nearly unique in his oeuvre, and it
expresses a depth of sentiment such as one sees in none of his
other works. When this masterpiece was shown to me I had
difficulty controlling my emotion. And such will be the case
for many who are able to behold this painting. Composition,
expression, and color all unite to form a whole of the highest
art, the highest beauty!

Soon thereafter, Bredius announced the news of this extraordi-
nary find to the general public with a major article in the *Burlington
Magazine*, declaring that *The Supper at Emmaus* was not merely *a*
masterpiece, but indeed "*the* masterpiece of Johannes Vermeer of
Delft."

Bredius, alas, fell right into Van Meegeren's trap. It was a tragic
moment, but perhaps more tragic still, Bredius remains posthu-
mously ensnared in that same trap today. Bredius's praise for *The
Supper at Emmaus* was so effusive that once the picture was finally
exposed as a fraud in 1945, the name "Bredius" became a byword
for nitwittery in art-historical circles, and his reputation has never
really recovered. Perhaps this reaction was understandable, but it
was also quite unfair.

Despite his periodic failings as a connoisseur, Abraham Bre-
dius was not a fundamentally stupid man. Certainly, he wasn't na-
ive when it came to the business of authenticating pictures, and he
had not approached *The Supper at Emmaus* with a wholly uncriti-
cal attitude. Indeed, in June 1937, when he first received Gerard
Boon's letter describing a hitherto unknown picture belonging to
a mysterious old family, he had been quite wary. Bredius didn't
know Boon. So, he wisely made inquiries with an attorney in The
Hague concerning Boon's "trustworthiness and integrity." The
lawyer's response was positive, just as it should have been, and

Bredius was soon describing Boon admiringly to acquaintances as "a member of the lower chamber of Parliament, a charming man." Indeed, had providence not furnished Van Meegeren with the perfect go-between in the earnest and personable Gerard Boon, things might well have turned out quite differently with *The Supper at Emmaus.*

Boon and Bredius got on famously. Members of the same class and culture, they ended up working together closely to bring *The Supper at Emmaus* to market, using all the social connections at their disposal to help matters along. When he wrote his certificate of expertise for *The Supper at Emmaus,* Bredius had immediately suggested to Boon that it would be advisable to find a wealthy Dutch buyer for it, as an artwork of such great national importance really ought to be retained in the Netherlands. Boon was not opposed to this idea, but with the interests of his imagined antifascist client in mind, he felt obliged to seek out the best price he could get: in October 1937, Boon transferred the picture to the vaults of Crédit Lyonnais in Paris, informing Duveen Brothers that this newly authenticated Vermeer could be theirs for £70,000. Edward Fowles and Armand Lowengard promptly came to inspect *The Supper at Emmaus* and, in due course, asked Boon for photographs, which were sent to Schmidt-Degener in Amsterdam. Lowengard ultimately declared that Duveen Brothers had no interest in the picture, because they did not believe it to be by the master's hand. Indeed, although Boon did not know it, Edward Fowles had cabled Duveen in New York with a far blunter verdict: PICTURE A ROTTEN FAKE.

Boon promptly wrote to Bredius in Monaco with the bad news about Duveen Brothers, leaving the elderly expert predictably outraged. Fearing, as he put it in his reply to Boon, that Duveen and Schmidt-Degener were "hatching a plot" against the picture out of personal spite, Bredius pushed forward with renewed determination in his plans to find a high-profile Dutch buyer. Having

already alerted Dirk Hannema, the
director of the Rotterdam's Boij-
mans Museum, that a new Vermeer
had been discovered, Bredius now
pestered Hannema with letters and
telegrams urging him to go to Paris
and meet with Boon. One of Bredi-
us's former protégés, Hannema was
not necessarily the keenest scholar
in the Dutch museum world, but
with ample connections among the
wildly rich "harbor barons" of Rot-
terdam, he was the one most likely

Dirk Hannema

to come up with the money for a major acquisition. And crucially,
he had a taste for big, splashy pictures. Indeed, although Hannema
did not make it to the vaults of Crédit Lyonnais until early No-
vember, he fell in love as soon as he saw *The Supper at Emmaus*,
later writing Bredius to say that Schmidt-Degener had been a fool
to condemn the painting on the basis of mere photographs. "Don't
worry yourself over such ill-formed opinions: the picture speaks
for itself!"

While Bredius tried to coax Hannema into making an offer,
Boon prudently continued seeking a buyer in the trade. Somewhat
bewildered after his experience with Duveen, however, he was ini-
tially unsure how to proceed. Nathan Katz wanted to see the pic-
ture, but Boon put him off with excuses—likely under instructions
from Van Meegeren, who, by this point, may well have feared the
inquisitive eyes of Willy van Wijngaarden. Eventually, a family
friend gave Boon the name of a dealer in Amsterdam, D. A. Hoo-
gendijk, who was known to be a straight shooter. In due course,
Hoogendijk came to see the new Vermeer in Paris, bringing with
him the financial backer of his firm, the wealthy tobacco merchant
Oscar Garschagen. Although, in the interests of protecting the

Italian family, Boon had to be cagey about the picture's origins, he was completely honest with Hoogendijk regarding the Duveen situation: he stated plainly that the picture had been turned down by Fowles and Lowengard, both of whom had cast aspersions on Bredius's attribution. This didn't bother Hoogendijk, who suspected that Duveen was gaslighting Boon in order to force down the asking price. Indeed, sensing in Boon's plight a golden opportunity, Hoogendijk and Garschagen offered to take *The Supper at Emmaus* on a consignment basis; no cash would change hands until the picture found a buyer, so the firm assumed no risks. For lack of a better alternative, Boon gladly accepted their terms.

At the end of November, *The Supper at Emmaus* was transferred to Hoogendijk's gallery in Amsterdam, where it received a cursory cleaning to remove some of the dirt and grime that Van Meegeren had smeared over a coat of murky, yellow varnish to simulate the patina of age. Meanwhile, Bredius and Hannema set to work convincing the Rembrandt Society—a private organization devoted to funding major acquisitions by public museums—to buy the new Vermeer for the Boijmans Museum. Bredius got Boon to drop the asking price down to £58,000 (or 520,000 guilders, as it was eventually paid out) in order to make the transaction more feasible. Even after the discount, this was still a staggering outlay—£20,000 more than Duveen had paid for *The Lace Maker* during the height of the boom years. Pitching in, Bredius made a poignant contribution to the purchase fund himself, donating the 12,000 guilder fee he had received for his certificate of expertise. Prideful though his motivations may have been in promoting *The Supper at Emmaus*, Bredius certainly didn't do it for the money.

Bredius was on the up and up in another regard too. He never misled anyone about the difference of opinion that existed regarding the picture's attribution. In the very first letter he wrote to the Rembrandt Society's board, he made the situation perfectly clear: "Schmidt-Degener and Duveen have said—without ever seeing

the picture itself—'Oh no, that's not a Vermeer; Bredius is old and washed up; he can't see anymore.'" On the whole, Bredius's candor seems to have made a good impression. The Rembrandt Society asked Schmidt-Degener to stop by Hoogendijk's shop and have a fresh look at the picture, letting him know they were quite serious about moving forward with the purchase. Perhaps getting caught up in the excitement of unfolding events—as he had when he went to see *The Lace Maker* in the rotunda of the Kaiser Friedrich Museum—Schmidt-Degener evidently had a sudden change of heart when he saw *The Supper at Emmaus* in person. He pronounced it to be a genuine Vermeer. And so, with Schmidt-Degener's blessings and the Rembrandt Society's money, on Christmas Day 1937, the deal was completed. *The Supper at Emmaus* would go to the Boijmans Museum, just as Hannema and Bredius had hoped.

Soon enough, though, Frederik Schmidt-Degener began to have second thoughts—not about the picture but rather about who should own it. He simply had to have *The Supper at Emmaus* for the Rijksmuseum, and he now decided that he was willing to give Vermeer's *Mistress and Maid with a Letter* to Hannema in order to get it. Knowing a picture with star power when he saw one, however, Hannema turned Schmidt-Degener down.

A gifted showman, Dirk Hannema unwittingly stage-managed the crowning moment of Van Meegeren's career in forgery: a lavish exhibition—"Four Centuries of Dutch Art"—in which *The Supper at Emmaus* took pride of place in the central gallery at the Boijmans Museum. It was a grand debut fit for a grand discovery. The painting's image was used on all the posters and promotional materials for the exhibition, while a special issue of the museum's bulletin featured an elaborate article, complete with diagrams, explaining how Vermeer's approach to the Emmaus story was vastly superior to Caravaggio's—the work of the Delft master being simpler, sparer, and, most importantly, more *Dutch*. Poetry was written in the painting's honor; plaudits poured forth from the press;

The Supper at Emmaus installed at the Boijmans Museum, 1938

but amid all the excitement and hoopla, no one seemed to notice that the new Vermeer hanging on the walls in Rotterdam was a subtle homage to Nazi image making. Of course, excitement and hoopla—welcome distractions during the grim economic situation of the 1930s—had kept a lot of people from seeing the scheming dictator in Berlin for what *he* was too.

It is said that Van Meegeren attended this exhibition, which ran from June through October 1938. Probably he did—certainly, he would have wanted to—but it's difficult to know for sure. There's no hard evidence that he left the Riviera during this entire period: his high school reunion was held the next summer in Deventer; he did not attend, but he did send an upbeat note to his former classmates informing them that he had won the lottery. Which, in a sense, he had.

Having cut out the middlemen who had facilitated his previous swindles, Van Meegeren got to keep all the proceeds from the sale of *The Supper at Emmaus*, save for the 10 percent commissions that went to Boon and Hoogendijk. Indeed, Han van Meegeren, the painter of Vermeer's biblical masterpiece, was suddenly one of the richest artists in the world. Soon enough, he and Johanna gave up their rental villa in Roquebrune and bought an even grander place of their own in Nice itself, called L'Éstate, which they furnished in lavish style. They also bought expensive clothes, threw parties, and spent money like water. Yet, while they had enough cash to last a lifetime, this pleasant idyll soon came to a close.

On September 1, 1939, England and France declared war on Germany in response to Hitler's invasion of Poland. The whole of Europe was set to become a battleground. And with the Riviera no longer seeming like such a safe, cozy hideaway, Van Meegeren and Johanna sensibly chose to return home to Holland, where they assumed they would be out of harm's way. Theirs, after all, had been a neutral nation in World War I, and the Dutch had every intention of staying out of World War II as well.

Hitler, of course, had other plans.

CHAPTER SEVEN

Sieg Heil!

ON THE AFTERNOON of May 14, 1940, Hermann Goering introduced himself to the people of Rotterdam by having his Luftwaffe bombers transform the city into a smoldering pile of ash and rubble.

The battle for Holland was by then in its fourth day. After an advance attack by paratroopers, the invading German army had raced across the border at lightning speed, driving the ill-prepared and poorly equipped Dutch defense forces westward into the big cities along the Atlantic coast. Balking at the prospect of protracted urban combat, General Schmidt, commander of the Ninth Panzer division, halted his tank advance on the outskirts of Rotterdam. Schmidt wanted help from above. Through the appropriate channels, a call went out to Goering in Berlin.

As commander in chief of the Luftwaffe, Goering had pioneered the use of terror bombing as a military tactic, employing it first in support of Franco's armies during the Spanish Civil War and again during the brutal Warsaw Blitzkrieg of 1939. Targeting civilians in densely populated areas had proven to be an extremely effective means of demoralizing the enemy. And the

Hermann Goering at the 1934 Reich's Party Day celebrations.

An RAF propaganda leaflet contrasting Goering's imagined reactions to the Luftwaffe's bombing campaigns early in the war and the Allies' later attacks on German territory

carpet-bombing raid on central Rotterdam was to be Goering's biggest show of force to date, an unforgettable demonstration of the power and will of the Reich.

A total of ninety German aircraft bombarded the city that day, delivering a payload of explosives so large that the resulting firestorm consumed over 26,000 buildings and rendered 80,000 people homeless. While the inferno raged out of control, the Nazi high command declared that Amsterdam and Utrecht would be next on the list, a statement intended, and understood, as an ultimatum. Defenseless against further airborne attacks, the Dutch had to choose between surrendering their country and seeing it

blown to bits. With the royal family and a group of key state officials safely evacuated by ship to London, where they hoped to continue the operations of the legitimate government in exile, the armed forces of the Netherlands formally capitulated to Hitler's Wehrmacht. By May 15, just five days after the initial invasion, it was all over: Hermann Goering's bombers had put an end to Dutch liberty.

In Rotterdam, 640 acres at the heart of the city had been burned beyond recognition. But all was not lost. Whichever way the wind had blown on the afternoon of the bombings, it had not sent the wall of flame in the direction of the sleepy neighborhood about a half mile south of the central train station where the Boijmans Museum was located. The museum survived the tragedy mostly unharmed. Moreover, the curators had prudently removed the greatest masterworks of the collection to a blast-proof air-raid shelter. Vermeer's famed *Supper at Emmaus* was perfectly safe.

LIKE EVERYONE ELSE living in the Netherlands during the occupation, Han van Meegeren had to adjust to the new order of things. Unlike most people, though, he seems not to have found the transition particularly difficult.

Consider the following incident. Within a year of taking power, the Germans decreed that every Dutch citizen over the age of sixteen would have to carry a set of tamper-proof identity papers. Along with fingerprints and a stamped photograph, this so-called *persoonsbewijs* was to include a special seal for Jews and other putative undesirables, marking out their second-class status. The *persoonsbewijs* program met with widespread resentment. When the day rolled around for Van Meegeren to be photographed and fingerprinted, he took the opportunity to send a message to the powers that be—a message of hearty approval. Living then in the chic Amsterdam suburb of Laren, where he and Johanna had settled after returning from France, Van Meegeren cheerfully

trimmed his moustache into a small square, donned a black shirt, and marched off to the town hall to have his picture taken in a pose whose grandeur and melodrama would have made Heinrich Hoffmann proud. Indeed, had a golden statuette been awarded for best imitation of Adolf Hitler on the registration queue that day, the forger would surely have won.

Fascistic fashion statements aside, though, Van Meegeren concealed his Nazi sympathies during the war as often as he displayed them. Drawing upon a lifetime of experience in fraud, he danced a deft collaborationist two-step, toning down his behavior and rhetoric around anyone who was likely to take offense. For example, a socialist-minded poet who met Van Meegeren a few times at parties in wartime Amsterdam was later shocked to discover that Van Meegeren had been anything other than a loyal Dutch patriot. "Whenever the topic of the occupation came up," the poet recalled, "he talked all 'anti' and made it seem like he was no friend of the Krauts." So long as he was just talking, Van Meegeren was all things to all people.

His actions, however, show him pursuing a specifically pro-German brand of opportunism. During the early years of Nazi rule in the Netherlands, Van Meegeren donated substantial sums to both the German Red Cross and the controversial Winterhulp, an organization billed as a relief agency but vehemently denounced by the Resistance as a militaristic slush fund. "The Winterhulp helps only the war," went one common graffito. "So don't give!" Van Meegeren also took part in Nazi-sponsored art exhibitions in the Netherlands and Germany, showing works like his volkisch-themed *Mealtime at the Farm*. At one such exhibition, his entry bore a public dedication to Hitler. And, in January 1942, in response to a collegial request from Ed Gerdes, the occupation government's art tsar, Van Meegeren produced a painting depicting a wool collection drive to benefit Germany's troops on the Eastern Front.

Van Meegeren, moreover, was not pressured into doing any of these things. He acted of his own free will with specific goals in mind. For instance, he made his initial donation to the Winter-hulp for the express purpose of establishing his bona fides with Ed Gerdes, who was to become his primary connection in the occupation government. A Nazi true believer and fanatical anti-Semite, Gerdes was Van Meegeren's neighbor in Laren and a figure roundly despised by most Dutch artists during the war: his official duties included promoting Nazi ideology in art and eradicating any trace of Jewish influence from the cultural life of the Netherlands. Relishing his broad powers of censorship, Gerdes even demanded that the editor of a biographical dictionary of Dutch painters designate the long-dead Hague School master Jozef Israëls as a "Jew artist," effectively sewing a yellow star onto history. With an eye toward the prestige that came with official recognition, Van Meegeren spent an inordinate amount of time playing up to Gerdes—and the effort paid off. For it was through Ed Gerdes's good graces that Van Meegeren was able to exhibit in the Fatherland, an honor reserved for artists with strong connections to the Nazi cultural establishment.

Ed Gerdes

However eager Van Meegeren was to ingratiate himself with the occupation regime, he never went so far as to join the Dutch Nazi Party—a step that would have been, for him, as useless as it was dangerous. Party membership represented the point of no return for opportunistic Dutchmen during the war: clear-cut, undeniable evidence of treason. As a member of the party, Van Meegeren would have had no room to equivocate about his allegiances; yet, unlike the average man, he would have gained nothing in return for losing that prerogative. Aside from expressing ideological zeal, the main reason people joined the party was to land cushy jobs in the occupation government. Dutch Nazi party members were, for instance, routinely installed as the mayors of towns and villages, putting a familiar face on German authority at a local level. But a conventional job, much less a bureaucratic one, had never been high on Van Meegeren's list of desires, and it certainly wasn't what he was after during the occupation. What Van Meegeren wanted from the Germans was something far more personal: a second chance at defining himself as an artist in his own name.

The possibility of having a successful public art career, complete with the imprimatur of state approval—finally, at the age of fifty-one—was the primary motivation in Van Meegeren's turn from secret Nazi sympathizer to active wartime collaborator. Inside the Reich's dominion, the Nazis had created a new European art world cleansed of any "degenerate" modern tendencies, opening up vast opportunities for an artist of Van Meegeren's tastes, interests, and intellectual preoccupations. And despite the social stigma that working with the Germans entailed, Van Meegeren did not intend to let those opportunities pass him by. He could become, at long last, an artist of his times, because times had suddenly changed in his favor.

Van Meegeren's collaborationist paintings and drawings allowed him to express openly the disturbing worldview that had

already crept into *The Supper at Emmaus*. For instance, in a meticulously detailed oil painting called *Arbeid*—or "Work"—Van Meegeren created a symbolic-heroic tribute to the fascist corporative state. Here, the spectral face of a master builder shines forth from the skeleton of a steel-frame building, rising from the black smoke of a bonfire and pointing the way to a church spire towering in the hazy distance. *Arbeid* was commissioned by Ed Gerdes to decorate the entry hall of the Dutch Labor Front—Het Nederlandse Arbeidsfront—a quasi-governmental Nazi organization responsible for assimilating the Dutch workforce into the Reich's economy and war effort. A perverse example of occupation rebranding, the Arbeidsfront was what remained of the prewar Association of Dutch Trade Unions after all the Jews, leftists, and other naysayers had been removed from the governing board and replaced by zealous functionaries dedicated to serving Germany's interests.

Like many of Van Meegeren's collaborationist images, *Arbeid* was an illustration of the *Volksgemeinschaft,* the Nazi ideal of a highly disciplined "community of the people," guided and unified by the wisdom of the Führer—a concept much in vogue among the forger's circle of friends. "In a dynamic society, every function has its proper role: commerce, industry, agriculture, also war," Jan Ubink proclaimed in a lecture before his reactionary comrades at the League of Dutch Playwrights just days before the German invasion. Noting that democracy was inefficient at regulating these functions, the former editor of *De Kemphaan* went on to suggest a better alternative: "In the so-called totalitarian nations, things are arranged differently. There, the parliamentary game is no longer played, but rather, according to the dictates of the categorical imperative, the state cultivates the free time of its citizens in ways that benefit the entire society." From its commanding location on the wall at the Arbeidsfront, Van Meegeren's painting actually went Ubink one better, situating labor and industry in the context

not only of the *Volksgemeinschaft* but also of the more aggressive *Wehrgemeinschaft*—or "war community." Stressing the shared burden of worldwide conflict, the *Wehrgemeinschaft* obliged patriotic citizens to harness their "social roles" to the Reich's triumphant struggle for military dominance.

Although Van Meegeren was perhaps the least qualified artist in Western Europe to hold forth on the topic of civic virtue, his incorrigible bad faith was probably quite helpful to him in painting *Arbeid*, a fulsome advertisement for a fraudulent cause. *Arbeid* successfully conjures up a sense of resolute struggle and exertion, while conveniently ignoring the grim reality of the Dutch wartime labor situation. No grand edifices like the one shown in *Arbeid* were constructed in the Netherlands during the occupation for the simple reason that the Nazi occupiers were busy plundering the nation's raw materials and transporting thousands of workers forcibly across the border to toil under duress in German factories.

Likely aware that the ideology behind works like *Arbeid* was abhorrent to most of his countrymen, Van Meegeren employed

Arbeid, ca. 1941

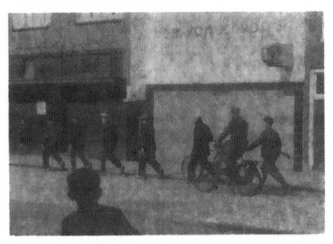

Dutch farmers from the province of Utrecht being rounded up
for work as forced laborers in German factories

imagery in his collaborationist pictures that was readily intelligible
as Nazi inspired but not so blatant in its implications that there was
no possibility for denial. There are no swastikas on display in Van
Meegeren's wartime oeuvre, no insulting caricatures of Jews, and
no identifiable German soldiers. And any Nazi symbols that do
pop up are generally of a type that could be explained away with
alternate interpretations. For instance, the death's head emblem of
the SS echoes the longstanding Dutch artistic tradition of signal-
ing the fleeting nature of life through representations of skulls and
bones. The pictures are obviously pro-German, but actually nail-
ing down the specifics entails following Van Meegeren through a
game of artistic hide and seek much like that involved in uncov-
ering a forgery. Although here what's at stake is not merely the
authenticity of an old-master painting but disloyalty and betrayal
in time of war.

Van Meegeren's veiled approach to the production of Nazi art
found its most interesting and outrageous outlet in *Teekeningen 1*,
a book of drawings that the forger-turned-collaborator published

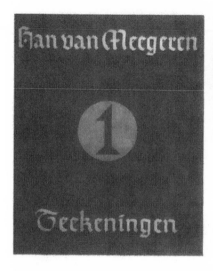

The *Wolfsangel* insignia of the
Dutch Nazi Party

Cover image of *Teekeningen 1*

in 1942. Clearly announcing its intentions, this folio-sized tome
featured a black cover with the title embossed in gold Gothic let-
tering and a large red circle containing the number "1"—black,
red, and gold being the ceremonial colors of the Nazi Party. In a
1976 letter expressing regret for his involvement in the project, the
book's Dutch publisher explained that Van Meegeren had incor-
porated the number "1" into the cover design not as a sequential
designation—no Volume 2 was ever envisioned—but as a surrep-
titious ideogram. Van Meegeren said that he intended the single
digit on a round field to look like a *Wolfsangel*, a Nazi hate em-
blem. The *Wolfsangel*, although German in origin, was the pri-
mary symbolic motif employed in the badges, flags, and insignia
of the Dutch Nazi Party. Indeed, *Teekeningen 1* resembled official
party publications so closely that the inscribed copy Van Meegeren
sent to Hitler must have looked quite at home on the shelves at the
Reichschancellery in Berlin.

Van Meegeren initially conceived the book as a promotional-
commemorative item for a major solo show that he mounted dur-
ing the war, with the approval of Ed Gerdes, who noted that Van

Meegeren seemed "to understand the new era." Many occupation government VIPs attended the exhibition's opening reception at the Mesdag Panorama in The Hague on January 12, 1942. Among those present that evening was Adolf Hitler's favorite Dutch Nazi, Meinoud Rost van Tonningen, one of the most powerful men in wartime Holland. As minister of finance under the occupation government, Rost van Tonningen oversaw the transfer of the Netherlands' gold reserves to the Reich and was, bar none, the single fiercest Dutch advocate of the German cause—far fiercer even than Anton Mussert, the titular head of the Dutch Nazi Party. Although it's impossible to say for certain, it was quite likely Rost van Tonningen who delivered Van Meegeren's signed presentation copy of *Teekeningen 1* to the Führer, for he was one of the very few people in the Netherlands—and certainly the only person in Van Meegeren's circle of acquaintance—who had any kind of face-to-face contact with the dictator in Berlin.

Why would such an important figure have gone to the trouble? Although he didn't know Van Meegeren well, Rost van Tonningen was quite friendly with the "coauthor" of *Teekeningen 1,* the Nazi poet Martien Beversluis, who wrote verses to accompany Van

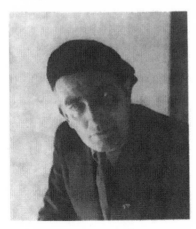

Meegeren's images in the book. Beversluis, an eccentric, hard-drinking ideologue who spent gin-soaked weekends with Van Meegeren and Johanna in Laren, was not only the most militant of Van Meegeren's close friends during the war but also the most foolhardy. While the timid Jan Ubink, for instance, advanced his career under Nazi rule simply by remaining noncommittal as he

Martien Beversluis

slipped into posts from which more principled journalists had been removed, Beversluis stormed the airwaves with fire-breathing propaganda broadcasts for the occupation government. A loyal member of the Dutch Nazi Party, he was named mayor of the town of Veere in the province of Zeeland, and received commendations for his fervor and efficiency in office. Ever ready to proselytize for the cause, Beversluis even wrote a children's book intended to instill the youth of the Netherlands with appreciation for their benevolent Führer.

In *Teekeningen 1*, Beversluis's poetry helped to clarify Van Meegeren's sprawling pictorial repertoire. In the drawing *Grain, Petroleum, Cotton*, for instance, Van Meegeren presents a soap bubble blown by an angular devil figure who reclines on the pages of an open book. Inside the shimmering orb—a traditional symbol of life's evanescence—sash-wearing dignitaries gather at a dais above a kick line of nude female dancers, oblivious to the fact

Grain, Petroleum, Cotton, ca. 1942

Snake and Fawn, ca. 1942

that they are being carted away by the skeletal figure of death. Inscribed in the bubble's surface are the Dutch words for the commodities named in the work's title. In Beversluis's accompanying text, we learn that the devil's book is the Old Testament, whose "hatred" has spawned a degenerate society prostrate before the powers of international finance. Only after a "fiery day of reckoning" will the benighted world see the light.

This apocalyptic vision takes on a more specifically Dutch character in an alarming image that appears near the end of *Teekeningen 1*. Offering a reprise of his most beloved work, Van Meegeren depicts Princess Juliana's pet fawn being ravished by an enormous black-speckled snake. The notion of "brittle elegance," once prized in *Het Hertje van Van Meegeren* by the Liberal Party press, has clearly been left far behind, along with any lingering royalist sentiment. Ripped from its context, this picture could perhaps be

read as a plea for mercy. But seen within the pages *Teekeningen 1,* where the purifying power of violence is glorified in plainly Nazistic terms, the murder of the fawn smacks of treason.

NOT ONLY DID the occupation reinvigorate Van Meegeren's work in his own name, but it also gave a tremendous boost to his career as a forger. Nazi conquest created substantial opportunities for those who could supply items that the Germans wanted, such as wood and coal for industrial purposes, or woolen goods for soldiers at the front. The war did remarkable things to the picture trade too, dramatically transforming both supply and demand. On the one hand, everyone in continental Europe was bidding up the prices of hard assets like gem stones and old-master paintings amid wartime restrictions on the convertibility and export of currency; and on the other, the Nazis were systematically looting vast quantities of art from Jews and others deemed to be enemies of the Reich. During the war, paintings of every variety could be sold easily and profitably, and it was not at all uncommon for items of dubious or unknown origins to show up on the market—factors that worked very much to Van Meegeren's advantage in selling his occupation-era Vermeers.

Indeed, Van Meegeren's ersatz examples of the Dutch national patrimony were much sought after in occupied Holland. Loyalists in the domestic cultural establishment desperately wanted to keep the Vermeers out of German hands and were willing to pay handsomely to do so; on the other side of the equation, high-level Nazis yearned to acquire trophy pictures like these, in part, for the sake of vanity, but also to validate, in a material way, the Reich's complete domination of Europe. Hermann Goering, in particular, was keen to get a Vermeer for his collection—largely due to an acute case of picture envy. While the Führer already had two Vermeers—*The Astronomer,* looted from the Rothschilds, and *The Allegory of Painting,* purchased under disputed circumstances

from the rightful owner—Goering had none. The search for an example of the Delft master's work became a matter of pride for Goering.

Although he couldn't access the state treasury to fund his acquisitions the way that Hitler could, Goering nonetheless possessed a very substantial fortune with which to pursue his adventures in art collecting. As the number-two man in the Nazi Party hierarchy after the Führer, Goering had enriched himself by means of graft, influence peddling, and the routing of lucrative government contracts to businesses that he personally controlled. As a result, he enjoyed a lifestyle of almost comical luxury. A former World War I flying ace, born into an influential family, Goering liked to play the part of the gentleman squire, dressing up in fanciful Tyrolean costumes and practicing longbow archery on the manicured lawns of his country estate, Carinhall, just north of Berlin. Named for Goering's deceased first wife, the Swedish Baroness Carin von Kantzow, Carinhall boasted an astonishing array of precious art objects, including nearly two thousand old-master paintings— some of them purchased, others looted, and still others given to Goering as gifts by people seeking government favor. As a collector, Goering had a weakness for showy, expensive items that were sometimes not of the highest quality; but still, he considered himself a great sophisticate. *Ich bin nun mal ein Renaissancetyp*, as he liked to say—"After all, I'm a Renaissance man."

Goering was an active participant in the Dutch art market virtually from the moment the dust cleared after the bombing of Rotterdam. Within days of the German victory, Goering's banker and financial advisor, Alois Miedl, went around to the major Jewish art collectors in the Amsterdam area and let it be known that they would be better off selling their possessions to him at fire-sale prices than letting the Gestapo simply haul everything away. That Miedl found a lot of takers for this seedy offer isn't surprising. An atmosphere of panic prevailed in the Jewish community

during the immediate aftermath of the invasion: more than 150 terrified Dutch Jews committed suicide in the week following the onset of hostilities. Working as Goering's representative, Alois Miedl acquired the entire four-teen-hundred-painting collection of the famed Goudstikker gallery for a cash payment made under extremely murky circumstances. A deal was struck with dubiously appointed representatives of the

Alois Miedl

absent owner—a Dutch Jew who had escaped with his wife and infant son, only to die in a freak accident en route to England. The Goudstikker's pictures went to Goering, while Miedl got to keep the family's real estate as well as the gallery itself. Thrown into the bargain was protection for Jacques Goudstikker's elderly mother, who had opted not to leave the Netherlands with the rest of the family. She would survive the war unharmed.

Despite his strong Nazi connections, Miedl, a German national who had lived and worked in Amsterdam since the early 1930s, enjoyed a fairly amicable relationship with the city's wealthy Jewish elite, largely because his wife, Dorie Fleischer Miedl, was Jewish herself. Dorie's heritage notwithstanding, during the war, the Miedls threw annual galas in their home in honor of Hitler's birthday. Dorie, who had been declared an honorary member of the Aryan race by the occupation government, personally led the toasts to the Führer's health, surrounded by some of the highest ranking members of the Amsterdam Gestapo, while Alois proudly stood by dressed in a black SS-style uniform.

As the occupation progressed, Miedl spun his Jewish connections into a devil-you-know protection racket, purchasing or taking into "safekeeping" all manner of Jewish assets—not just paintings but also bonds, stock certificates, even entire corporations—and reaping windfall profits in the process. Viewing the Holocaust mostly as a business opportunity, Miedl wasn't the Oskar Schindler of Amsterdam, but he did save more than a dozen Dutch and German Jews from death during the war—some for business reasons, some because they were members of Dorie's family, and others, seemingly, out of the goodness of his heart. Not everyone on Miedl's list, however, came out unscathed. Miedl employed two Jewish accountants to oversee his illegal trading activities on the black markets: toward the end of 1943, when he found that he no longer needed the services of Messrs. Einhorn and Danziger, Miedl chose to withdraw his protection, and the pair were promptly deported to Theriesenstadt, taking Miedl's business secrets with them to their graves. As one of Miedl's associates later remarked, the man was *sehr schlau*—very clever.

By building a personal empire, Alois Miedl was cheating the Reich out of its blood money, but Hermann Goering seems not to have minded, for Miedl knew how to get great artworks. Elsewhere in the Reich's conquered territories, the official Jewish-property registration apparatus took control of confiscated Jewish collections, so Goering was obliged to defer to Hitler when divvying up the spoils; indeed, that's why Goering couldn't obtain Vermeer's *Astronomer* from the Rothschild paintings seized in Paris. But by working with Miedl, Goering was able to acquire many of the very best Jewish-owned pictures in the Netherlands before the bureaucracy had time to get to work.

Indeed, due in part to Miedl's coercive buying activities, relatively few pictures of truly momentous cultural importance were ever confiscated outright by the Nazis in occupied Holland. Aside

from the Goudstikker pictures, there were, in fact, not many large blue-chip collections owned by Dutch Jews—certainly nothing like the Rothschild holdings in France—and on the whole, during the first twelve months or so of Nazi rule, an atmosphere of frantic deal making prevailed. For instance, the Katz brothers, the employers of Theo van Wijngaarden's son Willy, used their expertise and connections to help Hitler's representatives purchase a major Swiss collection that the Führer had long coveted; in return, thirty-five members of the Katz family were given exit visas to neutral countries, thus escaping the prospect of the concentration camp. Having done business with the Nazi regime left the Katzes open to criticism after the war, but given what was at stake, it is very difficult to question the prudence of their actions.

For those who possessed no bargaining chips, of course, there were no bargains to be struck. The Netherlands, once home to a thriving Jewish community, lost more Jews to the death camps per capita than any other nation in Europe. And with the lives went a great deal of property, including fine art objects as well as the everyday belongings of thousands of ordinary families. Most of the artworks confiscated from Jews in occupied Holland were several steps down from the level of quality that would have interested Goering, Hitler, or the German state museums and were therefore sold off. This was a subtly different endeavor from the Nazis' elaborate efforts to capture the world's great artistic treasures for the Reich. It was plunder for profit; commercialized pillage; the remorseless, workaday criminality of the Holocaust, carried out for the three-fold purpose of stealing from the Jews, obliterating all memory of their existence, and raising a bit of ready cash.

One of the few really large Jewish collections seized outright by the Nazis in the Netherlands was the decidedly mixed-quality trading stock of Leo Nardus, Theo van Wijngaarden's early mentor in the ways of art world fraud. Nardus, who had retired to Tunisia in the early 1920s, left his art collection behind, entrusting it

to the safekeeping of a well-to-do childhood friend, Arnold van Buuren, who had continued to sell individual pieces whenever good prices could be obtained on the Amsterdam market. In 1942, the Nazis arrested Van Buuren, who, like Nardus, was Jewish, and sent him to his death in a concentration camp. Confiscated as enemy property, Nardus's pictures were then carefully assessed and sorted by major figures in the Nazi art world. Alois Miedl had examined the Nardus collection prior to Van Buuren's arrest: finding only one item that he considered important enough for Goering— a copy of a Rubens picture—Miedl later reported that the collection consisted mostly of second-tier works incorrectly ascribed to first-tier masters, which sounds entirely plausible given Nardus's usual standards and practices.

Yet, even though these pictures were deemed unfit to please a Nazi potentate, they still had real monetary value. And precisely because they were *not* immediately recognizable landmarks of western art, they were ripe for laundering through the trade. Aside from the one item that Miedl had acquired for Goering, the remainder of these 156 paintings were sold off, many of them in an auction that appears to have been something of a sham, with several lots going for implausibly low prices to buyers only very haphazardly identified. Asked about the ongoing efforts to recover these works, most of whose whereabouts remain unknown, a representative of the Nardus family has stated that, even when items do turn up, legally reclaiming them can be quite difficult because of the intentionally deceptive alterations commonly made to pictures dumped onto the wartime market. Panels got cut down and canvases restretched to change their dimensions, and in some cases, the images themselves were retouched. The records of Allied property recovery investigators even note assorted instances of complete overpainting to facilitate smuggling. Although the Nazis could make up their own laws to justify the seizure of Jewish property, the professional middlemen who chose to handle these

pictures were fully aware that theft was theft, and took pains to cover their tracks.

We only know about the Nardus collection in detail because it was large enough to attract individual attention. But thousands of other moderately valuable nonmasterpiece paintings were confiscated from Jewish families throughout occupied Europe. And although there are fairly extensive records of pictures that were taken and scattered indications of how much was received when certain items were put on the market, the precise identifying details of the particular images often went unrecorded. Whereas vaunted Nazi record keeping can be extremely helpful in tracing the fate of pictures that were considered important enough to keep for the Reich, in the case of items destined for the marketplace, the records often served more to obscure the crime than to document it. And it should be said that some of the objects the Nazis chose to sell were quite fine, including minor works from world-famous collections. After the war, the art dealer Jacques Seligmann spent years trying to track down various bronze statues taken from his family's Paris gallery and auctioned off by the Nazis to people identified only by first name. Likewise, in 1941, several pictures looted from the great collection amassed by the Parisian Jewish Schloss family found their way to the Dutch art market through a pseudonymous buyer called "Buitenweg"—a real Dutch surname, which, as a common noun, happens to mean "back road." Due to the fact that an item from the Schloss collection was later found in the possession of the art expert Vitale Bloch, some have speculated that Bloch himself was the mysterious Buitenweg, although it seems unlikely that he could have been working alone.

Of course, Bloch hardly lacked for company in the less wholesome regions of the art world. Many of the same figures who had taken part in the Vermeer swindle business of the 1920s put their expertise to work dealing in looted Holocaust artworks once the Nazi kleptocracy took hold. Hans Wendland was one of the

biggest offenders in this line. The most important artworks that the Nazis sold during the war were the masterpieces of European modernism that they took from Jewish collectors and dealers like the Rosenberg family of Paris. Although top canvases by Picasso, Matisse, and Van Gogh were extremely valuable in most of the world's estimation, to the Nazis such pictures were "degenerate" and ripe for sale. Heedless of the risks involved in trafficking items so easily identified and traced, Wendland acquired several pictures out of the confiscated Rosenberg holdings and sold them on the Swiss market. Although most of Wendland's looting-related activities later proved extremely difficult to nail down with any great legal precision, the Rosenberg pictures left a paper trail that caused Wendland considerable trouble when he was finally arrested trying to flee Europe via Italy in 1946. Wendland was, however, not easily thwarted: admitting no wrongdoing or complicity, he stonewalled through four years of legal proceedings and eventually walked away a free man.

The Rosenbergs' hiding place for their pictures was revealed to the Nazis, in return for a large cash payment, by another figure who had been involved with the sale of dodgy Vermeers back in the Roaring Twenties, one Yves Perdoux. An associate of Wendland's, Perdoux had acted as the front man in the sale of the sauced up and heavily repainted portrait of a French youth that Joseph Duveen had purchased as a Vermeer in 1923 and then sold to Jules Bache. During the war, Perdoux worked as a Gestapo informer and was also implicated in the sale of looted assets. His office mate, Achille Boitel, was murdered by the French Resistance; and if Perdoux had suffered a similar fate, the loss to humanity would have been very small indeed.

In the Dutch wartime art world, as looted objects found their way back to the open market, both from within the Netherlands and from abroad, a strange atmosphere began to develop, one in which commerce and pillage cohabited, sometimes uneasily and

sometimes with disturbing nonchalance. Just as during the 1920s, when the biggest international galleries willfully suspended their disbelief at the notion of new Vermeers popping up one after another like toadstools, so too, during the war, many reputable dealers affected an air of incuriosity about what went on in their midst, a common failing in many fields of endeavor in occupied Europe. The really big Dutch dealers did not traffic in looted art: that was the province of thieves; smugglers; and disreputable, low-level operators. Generally, the better dealers also avoided accepting artworks of unknown provenance as payment in kind when doing business with major German buyers, Hermann Goering being particularly notorious for that type of bartering. But almost every top-drawer Dutch dealer remained quite eager to make money selling pictures to art-coveting Nazis, and the fact was that Nazi money was dirty no matter how you looked at it.

Aside from the obvious taint, doing business with the Germans on a grand scale was plainly contrary to the best interests of the Netherlands as a nation, for a warm commercial embrace gave the invaders clear reason to believe their presence in the country was welcomed. The Resistance press loudly denounced trading with the enemy, as did Radio Oranje, the voice of the Dutch government in exile, broadcasting nightly from London. After the occupation, dealers would claim that doing business with the Nazis had been the only way to put bread on the table amid the difficult circumstances of wartime. But millions of guilders changed hands in the Amsterdam market alone—fortunes were made buying and selling art during the war, not mere pennies put aside against adversity. Tacitly acknowledging this fact, many dealers would later say with a measure of pride that they had always made a point of overcharging their German customers, as if such price gouging were a patriotic gesture in support of the war effort. That such things were said with a straight face suggests that disingenuous

self-justification was the order of the day in certain deluxe corners of the picture business.

And as soon as "see no evil; hear no evil; speak no evil" became the accepted watchwords of the Dutch wartime art market, the scene was set for Han van Meegeren to make a killing. All the stars had suddenly come into alignment for the master forger. He was a talented, hard-working crook living in a robber's El Dorado. Indeed, if Van Meegeren had strolled into a bank vault with a wheelbarrow and a shovel, he couldn't possibly have walked away with more money than he made selling fakes during the war.

Chapter Eight

Goering Gets a Vermeer

It had initially looked like a very bad sign for the forgery business when the Wehrmacht came streaming over the border in May 1940. Van Meegeren had moved back home from France in order to avoid the war, not to get caught in the middle of it. All evidence indicates that he planned to go on operating just as he had been, using Gerard Boon as a front man in the promotion of more phony old masters. In fact, almost immediately upon returning to the Netherlands, Van Meegeren had gotten Boon to sell *The Interior with Drinkers,* one of the two Bakelite Pieter de Hoochs from Roquebrune, telling the credulous politician that the picture belonged to the same collection as *The Supper at Emmaus.* The machinery of swindle was humming along just fine for Van Meegeren—until world events threw a wrench in the works. For as chance would have it, Gerard Boon and his wife were out of the country at the time of the German invasion: they spent the duration of the war in London and Canada. Van Meegeren was left scrambling to find a replacement middleman.

For lack of a better option, Van Meegeren turned to the real estate agent who had sold him the house in Laren, a man by the name

Interior with Drinkers, forgery in the
style of Pieter de Hooch, ca. 1936
(sold 1939)

The Card Players, forgery in the
style of Pieter de Hooch, ca. 1936
(sold 1941)

of Rens Strijbis. Although Strijbis did not come from the same elevated level of Dutch society as Gerard Boon, he was nonetheless a respectable figure: he had served on the Laren town council as a representative of the Liberal State Party during the 1920s and was known as an affable, honest businessman. Moreover, Strijbis was accustomed to selling valuable property on a commission basis, which made it fairly easy for Van Meegeren to raise the subject of marketing pictures on behalf of a reclusive "old family." As Strijbis later recalled, Van Meegeren invited him over for drinks one day, in or around November 1940, and asked how much a real estate agent generally made on the sale of a home. Strijbis, thinking Van Meegeren might be looking to move again, said that commissions varied: on the recent sale of a splendid 100,000-guilder home, he had earned a 1,500-guilder fee—perhaps not much in percentage terms, but a handsome sum nonetheless. Van Meegeren replied that he himself had gotten rich before the war buying and selling art, and that a flat 10-percent commission had been considered

the bare minimum in that line of trade. As if on cue, Strijbis responded, "I guess I'm in the wrong business."

From there, it was off to the races. Strijbis sold a total of four fakes for Van Meegeren over the next two years: three biblical Vermeers and the remaining Pieter de Hooch from the Roquebrune period, *The Card Players*. All of these pictures were marketed through the Hoogendijk gallery in Amsterdam, the same firm that had handled *The Supper at Emmaus*. Strijbis first introduced himself at the gallery on January 22, 1941, bringing with him a Vermeer forgery called *The Head of Christ*. Although surprised to see a stranger walk in off the Keizersgracht with an unknown Vermeer, Hoogendijk had no doubt that the picture was genuine. He showed it to Dirk Hannema and to the great connoisseur Jonkheer David Roëll, who would succeed Schmidt-Degener as director of the Rijksmuseum: both experts agreed that *The Head of Christ* was a preliminary study for *The Supper at Emmaus*. And yet, while the authenticity of the new Vermeer was never questioned, there were other factors that should have warned Hoogendijk away from the deal. Not only did Strijbis want a cool 500,000 guilders for *The Head of Christ*, but he demanded that the entire transaction be conducted off the books, with the payment to be rendered in cash. To his credit, Hoogendijk asked Strijbis point blank if the painting had been looted from a Jewish collection. When Strijbis denied it, Hoogendijk then asked if the work's anonymous owners were Nazis. "They are good Netherlanders," Strijbis replied, "just like you and me."

Hoogendijk was one of the top dealers in Amsterdam—and he was not the sort of person to do anything blatantly dishonest—but his willingness to take not one but four pictures from Strijbis under such dodgy circumstances speaks volumes about the way business got conducted during the war. The potential profits from the sale of the biblical Vermeers were simply too big to pass up, regardless of any lingering provenance questions. Getting a bit of help from

Dirk Hannema, Hoogendijk managed to place all three of Strijbis's Vermeers, as well as the Pieter de Hooch, with wealthy Rotterdam "harbor barons." In February 1941, Hoogendijk sold *The Head of Christ* for 475,000 guilders, only a tad less than Strijbis's asking price. And the much larger *Last Supper* brought in a whopping 1.6 million guilders just a few months later. The coal monopolist Daniel G. van Beuningen sold twenty genuine old masters from his collection to help finance the purchase; he then had a special chapel built on his estate so that *The Last Supper* could be housed in an appropriate setting. Hoogendijk sold the last of Strijbis's Vermeers, *Isaac Blessing Jacob,* to Van Beuningen's chief rival among Rotterdam's art collectors, the shipping magnate Willem van der Vorm, who paid 1.275 million guilders for what looks, today, like a remarkably fishy artwork. Indeed, the figures in *Isaac Blessing Jacob* bear a strong resemblance to garden gnomes, and the pictorial space is as flat as a cave painting's.

The shortcomings of *Isaac Blessing Jacob* highlight one of the paradoxes of Van Meegeren's success during the war: although

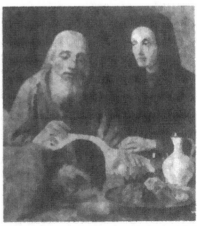

The Head of Christ, forgery
in the style of Vermeer, ca. 1939
(sold 1941)

Isaac Blessing Jacob, forgery
in the style of Vermeer,
ca. 1942

these late biblical Vermeers earned a fortune for their maker, none of them came anywhere close to *The Supper at Emmaus* in terms of grace, fluency, or art-historical intelligence. Having established the conceit behind the "lost" biblical period, Van Meegeren simply proceeded to imitate his own masterpiece in canvas after canvas. The same volkisch atmosphere is still evident in the sentimental expressions and humble settings, but there's something quite desultory about these fakes. *The Head of Christ* and *The Last Supper*— both of which Van Meegeren had made before leaving Nice—show the beginning of the downtrend with their comparatively slack execution and flaccid sense of anatomy. And *Isaac Blessing Jacob,* which was the first biblical Vermeer forgery Van Meegeren actually made back in Holland, dropped the bar even lower. With his creative attention focused mostly on the collaborationist artworks that he did under his own name, Van Meegeren seems not to have given *Isaac Blessing Jacob* his best effort. But of course, he didn't need to: unmistakably by the same hand as the famed *Supper at Emmaus,* it sold all the same.

The deteriorating quality of Van Meegeren's fake Vermeers has sometimes been seen as evidence of the forger's descent into alcoholism and other forms of physical and moral dissipation. Louche though Van Meegeren's living habits were, this explanation smacks of melodramatic fantasy. Not only was Van Meegeren sufficiently organized to pull off some of the largest art frauds the world had ever seen, but he pursued his legitimate work without any notable decline in standards. For instance, his portrait of the engineer E. A. van Genderen Stort was done at virtually the same time as *Isaac Blessing Jacob* and it confronts the viewer with an arresting image—powerful, evocative, and curiously reminiscent of *The Supper at Emmaus* in style. A longtime friend of Van Meegeren's, Van Genderen Stort provided the biographical sketch used as an introduction to *Teekeningen 1.* He was awarded a special appointment as a professor at Delft University from 1940 to 1946;

Portrait of the Engineer E. A. van Genderen Stort, ca. 1943

hence, the doctoral robes and lectern. Interestingly, although the scene in the background, with what appears to be a soldier, is highly reminiscent of several works from *Teekeningen 1*, it does not conform precisely to any extant composition by Van Meegeren and appears, in fact, to be a motif improvised by the artist for this specific portrait.

Van Meegeren's lucrative shell game with Strijbis and Hoogendijk came to an abrupt end in January 1943. Turning over a towering stack of banknotes to Strijbis after the sale of *Isaac Blessing Jacob*, Hoogendijk happened to ask if the "old family" owned anything by masters other than Vermeer and De Hooch. Echoing what he had heard from Van Meegeren, Strijbis assured Hoogendijk that the family's holdings were quite extensive, though he said he would have to ask what specific items might be available for sale. Van Meegeren opted to play along by giving Strijbis a fake Van Eyck *Annunciation* to show to Hoogendijk. The Van Eyck was not Van Meegeren's own handiwork: he had acquired it

during the 1930s, apparently from the Belgian forger Jef van der Veken, and had made an unsuccessful attempt to market it while still living in France. Hoogendijk, who had never doubted any of the biblical Vermeers, recognized at once that the Van Eyck was fake and turned it down cold. Although Hoogendijk didn't draw any conclusions about Strijbis's previous offerings on the basis of this incident, Van Meegeren preferred not to risk raising any further suspicions. He soon cut off relations with Strijbis and would not attempt to sell any more forgeries through Hoogendijk.

Van Meegeren once again needed to find a new front man, and having already painted yet another fake Vermeer—this one depicting the "fallen woman" who, as described in the Book of Luke, washes Christ's feet in the house of the Pharisee—the forger had every incentive to move quickly. Prudently, Van Meegeren avoided enlisting any of his German-friendly acquaintances, who might well have prompted questions of the sort Hoogendijk had raised about looting and possible Nazi connections in the picture's history. Instead, Van Meegeren called upon a respectable friend from more innocent times. According to his later accounts of the episode, Van Meegeren was looking through the commemorative album published on the occasion of his high school reunion when he noticed that one of his closest boyhood chums, Jan Kok, was back in the Netherlands after years of distinguished service as a colonial administrator. Although he hadn't seen Kok in decades, Van Meegeren tracked him down to the town of Zeist, outside Utrecht, and orchestrated a seemingly chance encounter. He then arranged for Kok to spend a weekend in Laren so that they could reminisce at length about their Deventer days. Soon enough, the forger launched into the usual story about the old family and the big commission to be earned selling their paintings, this time upping the proposed fee to 15 percent. Apparently, it was an offer Kok couldn't refuse.

The Footwashing,
forgery in the style of
Vermeer, ca. 1943

Van Meegeren instructed Kok, who knew nothing about the art world, to bring *The Footwashing* to the De Boer gallery in Amsterdam. Pieter de Boer was a dealer of excellent and longstanding reputation, both in the Netherlands and internationally. But during the occupation, he became known for working a bit too freely with German customers: indeed, postwar Allied investigators looking into De Boer's operations described him as "a nasty piece of work." Many of the ethical questions raised by De Boer's dealings were never really resolved after the war, but it is clear that De Boer was far more willing than most Dutch art dealers to deliver truly significant artworks into German hands. Hoogendijk, for instance, had never even considered marketing any of the biblical Vermeers to German customers, knowing that such an act would be perceived not just as profiteering but as disloyalty—selling out Holland's cultural heritage. De Boer had no such qualms. Indeed,

he thought that the most natural candidate to buy *The Footwashing* would be the so-called Führermuseum, the enormous public collection planned for Hitler's boyhood hometown of Linz, Austria, for which a virtually unlimited acquisition budget had been established by the Reich. Unfortunately for De Boer, however, when the Führermuseum's director, Hermann Voss, came to have a look at *The Footwashing,* he expressed no interest in buying it. Despite the fact that Vitale Bloch had examined the work, at De Boer's request, and ascribed it firmly to Vermeer, Voss was convinced that it was not by the master.

Next, De Boer offered *The Footwashing* to the Rijksmuseum, using the threat of an imminent German acquisition as an inducement to "keep the picture for the Netherlands." Whether De Boer owned up to the fact that Voss had rejected the picture is not known, but the rumor going around the Rijksmuseum's acquisition committee was that Hermann Goering was interested in the new Vermeer. And Goering's chief curator, Walter Andreas Hofer, was indeed after De Boer to see the picture. By all accounts, this was the pivotal factor in the committee's decision to approve the 1.3 million guilder purchase, as the painting itself excited very little enthusiasm. By far the worst of Van Meegeren's biblical Vermeers, *The Footwashing* was such a crude imitation of Vermeer's *Christ in the House of Martha and Mary* that it even prompted one committee member to blurt out the word "forgery." This highly perceptive observation was eventually shot down, though, as all of the technical evidence indicated that *The Footwashing* was of seventeenth-century origin. A. M. de Wild, the chief of conservation at the Mauritshuis—and one of the world's greatest authorities in the technical analysis of pictures—took small paint samples from various locations on the picture's surface. The results of his chemical tests confirmed that all the pigments used—ultramarine, cinnabar, lead white—were consistent with seventeenth-century methods. Indeed, De Wild

declared himself satisfied that the picture was by Vermeer, based on years of past experience examining the master's works.

In his own defense, De Wild said after the war that he had wanted to bring *The Footwashing* to The Hague to have it X-rayed, but that Pieter de Boer had adamantly refused to allow the picture to travel. Although De Boer's refusal is suggestive, X-rays wouldn't necessarily have proved very much. In painting *The Footwashing*, Van Meegeren had reused a canvas from a genuine seventeenth-century picture, just as he did with all of his biblical Vermeers. Although an X-ray image might have picked up some lingering traces of the equestrian scene that Van Meegeren had obliterated with caustic soda, this, in itself, would not have been a cause for great alarm, as panels and canvases—expensive items— were sometimes recycled even in the seventeenth century. Vermeer himself painted *The Girl with the Red Hat* over an old portrait of a man with a helmet, done by another artist, working in a completely different style. Mostly, what the X-ray would have shown was that *The Footwashing* had been painted on a surface of white lead tinted with umber, a working method typical of the period in which Vermeer lived.

Indeed, on a purely technical level, *The Footwashing* was constructed well enough to subvert virtually every method of examination likely to be deployed against it. Although there were a few esoteric chemical tests that might have given De Wild a better read on *The Footwashing*, they were not commonly used in picture analysis at that time, and performing them would have required taking very large, disfiguring paint samples. Realistically, there was only one way to determine that *The Footwashing* was fake at this point, and that was through connoisseurship, not technical analysis. But the desire to outmaneuver the Germans proved to be so powerful that it prompted the Rijksmuseum's acquisition committee to a hasty decision.

The purchase of *The Footwashing* was finalized in July 1943, with 900,000 guilders of the total purchase price coming out of state funds and the remaining 400,000 donated by Willem van der Vorm through the Rembrandt Society. Before *The Footwashing* was put away in the Rijksmuseum's bombproof underground storage depot at Paasloo, Walter Hofer was allowed to examine the new Vermeer so that he could report back to Goering about the masterpiece they had missed out on. Hofer duly informed Goering that *The Footwashing* was in poor condition and needed restoration, but that it was indisputably a genuine work by the master's hand. While in Amsterdam, Hofer also dropped in on Pieter de Boer to let the dealer know that Goering would have been willing to pay a much higher price for *The Footwashing* than the Rijksmuseum had. De Boer responded that there might still be room for hope: rumor had it that another Vermeer would soon be coming on the market. He promised to find out more about this picture and to offer it directly to Goering if and when it came into the gallery's hands.

With all of the cloak-and-dagger scheming over *The Footwashing,* Jan Kok apparently began to suspect that he had gotten himself involved in something more complex and sordid than Van Meegeren had let on. In negotiating the final terms of the sale, Kok agreed with De Boer's suggestion that a portion of the proceeds be donated to the Resistance—a laudable, patriotic gesture that hinted strongly at a guilty conscience. Purchasing "moral insurance" of this type was a fairly common gambit among people who made money in dirty ways during the occupation—Alois Miedl and his associates did it frequently—and it seems likely that the questions raised about the origins of *The Footwashing* made Kok ponder the ethics of his own activities. When Kok turned over the money from *The Footwashing* to Van Meegeren—more than ten thousand crisp new bills of the one-hundred guilder denomination—he didn't want to take immediate possession of his 15 percent commission. Not that Kok wanted to give up the money:

rather, he wanted Van Meegeren to put it in safe keeping until the coast was clear. Van Meegeren therefore deposited Kok's share in Johanna's bank account. Although Kok made occasional withdrawals, the bulk of the money remained in Johanna's possession until the end of the war. Kok never again acted as Van Meegeren's go-between.

The situation with Jan Kok illustrates two recurring problems Van Meegeren faced during the occupation: first, people realized he was up to something shady; second, handling the enormous quantities of cash resulting from the sale of his forgeries was distinctly cumbersome. At times, these two issues fed upon each other in very odd and interesting ways. In March 1943, for instance, the occupation government had recalled all thousand-guilder banknotes from circulation in a bid to stifle the black markets. Obliged to turn in more than two million guilders' worth of these bills, Van Meegeren found himself with a bit of explaining to do. The currency control board wanted to know where all the money had come from; although Van Meegeren said that he had sold a collection of pictures in France before the war, he naturally had no documentation to back up his claims. Half of the total sum was held pending an investigation, and the matter seems never to have been satisfactorily resolved. Van Meegeren had to find better ways to store his money.

Van Meegeren urgently needed to own *things*—valuable objects that could absorb his overflow of cash. He began to buy diamonds, gold jewelry, and antique furniture. He also invested in fine art, including a genuine Terborch, a genuine Willem Maris, and a genuine Frans Hals. But Van Meegeren's favorite asset by far was real estate, as it was the easiest way to put truly large amounts of money to work quickly. Van Meegeren snapped up fourteen houses and seven plots of undeveloped land in Laren; he also purchased two homes in his native Deventer. And in Amsterdam, he built an empire. By the end of the occupation, Van Meegeren owned fifty-seven individual

properties in the Dutch capital, including private houses, apartment buildings, shops, commercial structures, a garage, and even a hotel. Having neither the time nor the inclination to collect rents or fix leaky pipes, Van Meegeren employed a full-time manager to look after such practicalities, a physically imposing man from Deventer who was said to be an ex-convict.

In the midst of this real-estate-buying mania, Van Meegeren began to toy with the idea of pulling up stakes and moving permanently to Amsterdam. During the summer of 1943, an eighteenth-century mansion on the Keizersgracht was offered for sale, and the forger, badly needing a change of scenery, wanted to make it his new home. He and Johanna had worn out their welcome in Laren: Van Meegeren's political leanings hadn't gone unnoticed there, nor had his friendship with Ed Gerdes. And although the occupation had not yet reached the full height of its barbarity by 1943, being known as pro-German may well have become a growing source of worry for the couple. The Nazis were deporting thousands of Jews to death camps, summarily executing Resistance leaders, and taking prominent Dutch citizens hostage to prevent reprisals. Against that backdrop, it's hardly surprising that Van Meegeren would have found something appealing in the idea of making a fresh start someplace where no one knew anything about him.

And where better to relaunch a life than Keizersgracht 321? A sumptuous home on one of the principal canals of Amsterdam's old city, this was the sort of trophy property that seldom came on the market, at least under normal circumstances. Before the war, it had been the residence of a wealthy politician and outspoken anti-fascist by the name of Walraven Boissevain, who had represented the Liberal State Party on the Amsterdam City Council. Removed from office by the Germans, Boissevain had been obliged to leave town and sell his home during the first year of the war. The buyer, Petrus Jan Rienstra van Stuyvesande, a Nazi-friendly banker and businessman, promptly set about restoring the interior

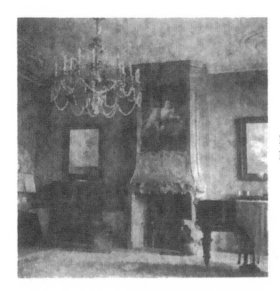

Interior of
Keizersgracht 321

of Keizersgracht 321 to its original splendor, with an eye toward a
big profit on resale. And by 1943, Rienstra was ready to cash in on
his investment. Once the abode of Boissevain, the loyal Dutch pa-
triot, Keizersgracht 321 was to become the prized possession of the
very crooked Han van Meegeren. The transformation was surely a
sign of the times.

As long as he was buying Keizersgracht 321, Van Meegeren de-
cided to purchase the slightly less grand Keizersgracht 738, about
a fifteen-minute walk away, to use as an art studio and private sex-
ual playpen. Keizersgracht 321, with its Persian rugs, grand piano,
and library filled with art books, became the province of the newly
respectable Johanna. Now past the age of fifty, she had adopted a
more demure bearing, appearing in contemporary photos wearing
matching tweed coat-and-hat ensembles complemented by sen-
sible shoes. Meanwhile, Van Meegeren spent most of his evenings
at Keizersgracht 738. There, amid the bohemian cast-off furni-
ture, he staged raucous parties known far and wide for their *zwarte
drank en lichte meisjes*—hard liquor and easy women. According

to the reminiscences of a prostitute who frequented these events, they could be quite fatiguing, but they paid well. On the way out the door, the working girls got to grab a fistful of jewels from a strongbox that Van Meegeren kept on hand just for the purpose. With all the money he was making, small expenditures of this type paled to insignificance. Had he wished to, Van Meegeren could have bought all the whores and black-market gin in Holland.

Despite this surfeit of wealth, Van Meegeren remained committed to the business of forgery. Indeed, it had been very much on his mind in purchasing Keizersgracht 321. During negotiations, Van Meegeren had learned that the seller, Rienstra van Stuyvesande, had ties, albeit loose ones, with the Goudstikker gallery. Serving as a director of Alois Miedl's Amsterdam bank, the Buitenlandse Bankvereniging, Rienstra also took a casual interest in the art trade. On occasion, Rienstra had provided customers—Germans mostly—for Miedl's pictures, and from time to time he had lent Miedl a car and driver to deliver paintings to important clients across the border, including Heinrich Hoffmann. Smelling an opportunity lurking somewhere in this scenario, Van Meegeren arranged to drop by the Goudstikker gallery one day with Rienstra, ostensibly to look at the art on offer, but more likely to gauge the depth of Rienstra's rapport with Alois Miedl. Rienstra and Van Meegeren brought their wives along for the occasion; it was all very relaxed and sociable. Van Meegeren, though, declined to buy anything at Goudstikker's, claiming that he was used to finer stuff.

It was almost immediately after this reconnaissance mission that Van Meegeren asked Rienstra to act as a front man in the sale of the biblical Vermeer known as *Christ and the Adulteress*. Van Meegeren invented one of his usual stories about why his name couldn't be mentioned in the matter: he was selling the painting on behalf of an elderly widow who needed money and wanted to remain anonymous. After taking some time to consider this tale, Rienstra agreed to bring the painting to Miedl. According to the subsequent testimony

of Miedl's German bookkeeper, a plainspoken Nazi named Schneller, Miedl was extremely excited by Rienstra's visit. "Herr Miedl called me in and told me that I would now get the chance to see a real Vermeer," Schneller recalled. "In the room where Rienstra and Miedl were standing, I saw a crate with a painting inside . . . The picture was signed in the upper left corner, 'MEER.'" Although Alois Miedl was quite certain that he could sell *Christ and the Adulteress*—indeed, he had a specific buyer in mind—there was just one problem. He needed to know where Rienstra had gotten the picture. So Rienstra told him: Han van Meegeren.

AFTER PLAYING WITH FIRE for his entire life, Van Meegeren was finally going to get burned—and badly. Rienstra, a clever man, knew that he didn't need to keep his bargain with Van Meegeren to get a cut from the sale of *Christ and the Adulteress*: he could get paid directly by Miedl. And Rienstra owed Alois Miedl complete honesty. Miedl had helped Rienstra make a great deal of money over the years; moreover, in the case of *Christ and the Adulteress*, Rienstra had specific misgivings that he wanted to bring to Miedl's attention. Rienstra had asked Van Meegeren repeatedly if the Vermeer was looted Jewish property but had never gotten a straight answer. Likewise, after talking with people around town, Rienstra had turned up a multitude of unsettling rumors concerning Van Meegeren's character. Sources said that Van Meegeren was a drunkard, that he had syphilis, that he was mad, that he was a forger. Indeed, the well-known painter and stained-glass artist Max Nauta told Rienstra that Van Meegeren had been involved in the sale of forgeries to Americans years before the war. Hence, although Rienstra didn't know enough about art to say that the Vermeer was a fake, he certainly had reason to wonder about it.

Alois Miedl, however, didn't scare so easily. Taking all of Rienstra's gossip in stride, Miedl arranged to have *Christ and the Adulteress* checked by experts, including Vitale Bloch and the Goudstikker

gallery's in-house restorer, Jan Dik. The verdict came back that the picture was indisputably genuine. Here, Van Meegeren was very fortunate that Miedl did not think to call in a chemist like A. M. de Wild to take paint samples. For by this late date in the war, Van Meegeren had run out of natural ultramarine blue, a pigment stocked by few color merchants because it is little used in the modern practice of painting, synthetic imitations being much cheaper and perfectly adequate for most purposes. With the world's primary distributor of natural ultramarine located in London, Van Meegeren had no choice but to use cobalt blue instead, a pigment not invented until the nineteenth century and easily detectible through microchemical analysis. Evidently, Miedl was not suspicious enough about the authenticity of *Christ and the Adulteress* to delve into such technical matters. And he appears to have felt no great worries over the picture's mysterious origins, either; for without further ado, he packed the new Vermeer off to Berlin so that Hermann Goering could have a look at it.

After the war, both Rienstra and Van Meegeren would claim that selling *Christ and the Adulteress* to Goering had never been in their plans. And while one hesitates to believe either of these two gentlemen, in this case, it seems that they were both telling the truth. Although selling the picture by way of Alois Miedl certainly constituted trading with the enemy, placing *Christ and the Adulteress* with a major figure in the Nazi power structure was in neither Rienstra's nor Van Meegeren's best interests. Indeed, in their initial discussions about approaching Miedl, Rienstra and Van Meegeren agreed that a Dutch buyer should be found for the picture. According to Van Meegeren's recollections, Rienstra said that he had important relations in the art trade who might be of help in placing *Christ and the Adulteress* in the Netherlands, and Rienstra did apparently have such connections through his wife's family. The way things turned out, though, Rienstra had no say whatsoever in where the picture ended up. That was entirely Miedl's call. And

although Rienstra quickly acquiesced to the idea of sending the picture to Goering, there was, in all reality, no other option—neither for Rienstra nor for Alois Miedl. Goering was Miedl's patron, and he had long been adamant that he should have the right of first refusal if Miedl ever got his hands on a Vermeer. Thus, even when Heinrich Hoffmann approached Miedl, saying that a picture as important as *Christ and the Adulteress* really ought to be reserved for the Führer, Miedl was obliged to obey Goering's prior instructions. The matter was beyond anyone's control.

Although Van Meegeren richly deserved every bit of trouble he was in, it's hard not to feel a measure of sympathy for him. With his picture swindle gone irrevocably haywire, the forger was trapped in a wide-awake version of an anxiety dream. He was out in the world, indecently exposed, and Hermann Goering would soon being staring right at him—figuratively speaking, at least. After inspecting the picture in the vault of the I. E. Meyer Bank in Berlin, Goering concluded that *Christ and the Adulteress*, with its dark Teutonic atmosphere and Italianate sense of design, was simply everything that an Axis leader could want in a picture. He therefore ordered it sent to Carinhall, where it would assume pride of place in the grand gallery. Goering loved his Vermeer—it was magnificent—and he had no intention of ever parting with it. The only catch, however, was that he refused to cough up even a single guilder until Van Meegeren revealed where the picture had come from.

Unsatisfactory though Hermann Goering was both as a human being and as a connoisseur of art, he was seldom careless in the conduct of his business affairs. He didn't suspect that *Christ and the Adulteress* was a fake, but he did realize that there was something off about its provenance. Later, just prior to his trial at Nuremberg, Goering told Allied investigators that he had been worried that the picture might have come from "a Jew, who would try to blackmail him later on." This, however, was just postwar doubletalk. Goering had no qualms about buying or receiving property

of dubious origins—pictures, carpets, furniture, tapestries—but in proper Nazi fashion, he always demanded that there be some kind of documentation to give his acquisitions a veneer of legality. A sham auction, a decree of confiscation, a sales agreement signed with a twisted arm—these were important formalities in the operations of a world-class plunderer. Given that *Christ and the Adulteress*, with its 1.65 million guilder price tag, would become the most expensive painting in Goering's collection once the sale went through—and, indeed, one of the most expensive art objects ever purchased by anyone up to that point in history—the Reichsmarschall was adamant that Van Meegeren put the Vermeer's paperwork in *korrekt* order.

This was, of course, an extremely ominous development—one with the potential to get very ugly, very quickly. Having treated the German occupation as a game for almost four years, Van Meegeren was now up against an opponent who played for keeps. Hermann Goering was not some art-world grandee like the dealers and experts who usually got duped by Van Meegeren's forgeries. He was, on the contrary, a profoundly powerful man. And while Goering was probably the most socially refined figure in the Nazi power structure, a man whose savoir faire often seemed out of place among the low-brow resentments of the Führerbau and the Reichschancellery, he was *not* someone to be toyed with. Having to write Goering a letter explaining the ownership history of *Christ and the Adulteress* was a prospect that Van Meegeren could hardly have relished. And the situation was, if anything, all the more infuriating because it was *all Rienstra's fault.*

Van Meegeren's first impulse, naturally, was to avoid writing Goering altogether, but that could only work for so much time. Soon enough, time was up. One afternoon in February 1944, Rienstra van Stuyvesande appeared on Van Meegeren's doorstep carrying a portable typewriter and a sheaf of blank paper. Alois Miedl had directed Rienstra not to leave Van Meegeren's house

without the letter Goering wanted. Put on the spot, Van Meegeren had to think quickly and clearly. Using the instincts he had honed during twenty-five years of professional double-dealing, he calmly sized up the situation, conferred with Rienstra, and then struck the perfect match between what people wanted to hear and what he wanted them to believe. There, in the lushly furnished drawing room of Keizersgracht 321, Van Meegeren formally agreed to reveal the name of the painting's mysterious owner within two years of the purchase date. Rienstra typed up the letter; Van Meegeren signed it; and Alois Miedl convinced Goering to accept the compromise.

Why was this cagey missive considered sufficient documentation for *Christ and the Adulteress*? While it's impossible to know precisely what went through people's heads, it seems fairly clear that everyone involved in the deal, except Van Meegeren, strongly suspected the picture to be stolen—perhaps looted by some low-level Nazi on the make and laundered through Van Meegeren—and Van Meegeren's letter probably went a long way toward confirming those suspicions. Yet, from Goering's point of view, as well as from Alois Miedl's, the purpose of the letter was not so much to unearth the truth as to assign any potential culpability to Van Meegeren. At the end of the day, Miedl and Goering didn't necessarily care too much about where a picture came from, so long as someone else could be blamed if uncomfortable questions came to be asked after the war. Van Meegeren simply gave them what they wanted.

On Van Meegeren's side, of course, the beauty of this gambit was that while Goering remained focused on whitewashing his latest questionable acquisition, the fact that the picture was a fraud escaped notice entirely. Van Meegeren hadn't set out to swindle the mighty Goering, but with this rather nervy piece of brinksmanship, the forger did indeed get the better of the cold-hearted German whose bombers had flattened Rotterdam.

CHAPTER NINE

The Endgame

BY DIVULGING NOTHING and making a promise he couldn't keep, Van Meegeren had earned two years' breathing room with Hermann Goering. And at the beginning of 1944, two years must have seemed like a pretty long time.

Although no one knew how the war was going to end, only the most ardent of Nazis could have denied that the Reich was in trouble. The Germans had already been defeated in North Africa; they were pinned down on the Eastern Front; and the Allies were threatening a cross-channel invasion of France. Fighting to a Continental stalemate might yet have allowed Hitler to keep some of his conquests—perhaps his native Austria, perhaps even the Netherlands—but while Axis optimists may have held out a hope for a negotiated peace, their more rational colleagues were busy preparing for other outcomes. Alois Miedl, for instance, fled to the safety of Franco's Spain just prior to the D-Day landings. Clandestine agents on both sides of the front speculated that Miedl had been dispatched to hide a portion of Goering's financial assets for use after the war—a tantalizing theory that was, unfortunately, never proved. Whatever else he may have been up to, Miedl went into

exile with consummate flair: having accumulated a vast and tainted fortune, he sat out the remainder of the war with his wife and two children in a sumptuous suite at the Hotel Ritz in Madrid.

Lacking Miedl's connections at the upper levels of the Nazi power structure, Han van Meegeren was stuck in the Netherlands for the duration. He had no chance of securing an exit visa, and even if he could have gotten one, he would have lost a bundle by leaving the country, given that the bulk of his money was tied up in domestic land and property. However, as Nazi rule degenerated into chaos during the course of 1944—with virtually all food and fuel being diverted to military purposes and reprisals against Resistance agents growing increasingly brutal and gruesome—Amsterdam became a remarkably uncomfortable place, even for a man of Van Meegeren's resources. Keeping cartons of cigarettes, tins of hard-to-get delicacies, and an extraordinary amount of liquor packed away in his storerooms, Van Meegeren didn't suffer nearly the same hardships as ordinary citizens, the poorest of whom were reduced to eating semipoisonous tulip-bulb gruel by the wintertime. But he too would have felt the pinch once the

Amsterdam, "Hunger Winter" of 1944–1945. Public canteens allotted children ½ liter of soup per day, on days when food was available.

Woman collects tree limbs for firewood.

Malnourished man collapses in the street.

authorities cut off gas and electric service in mid-December. The city came to a standstill; tram lines stopped running; normal commerce was largely abandoned; and most families were trapped in a daily struggle to procure life's necessities. Surely, looking out the tall windows of Keizersgracht 321, Van Meegeren would have noticed that all the stately oak and linden trees lining the canal had

been stripped of their bark and branches by people desperate for firewood.

Van Meegeren began to realize, during this terminal phase of the occupation, that the biggest threat to his future wasn't Hermann Goering's two-year deadline but rather the impending fall of the Reich itself. There could be no doubt that questions would be asked after the war about Van Meegeren's shady business activities and collaborationist connections. Indeed, rumors were already circulating. Upon learning via art-world gossip about Van Meegeren's involvement in the sale of *Christ and the Adulteress,* the dealer D. A. Hoogendijk started making inquiries. Evidently, by reconnecting with Rens Strijbis in Laren, Hoogendijk learned at least a sliver of the truth about Strijbis's Vermeers. "I first discovered that Van Meegeren had been involved with the Vermeers in question towards the end of 1944," Hoogendijk later recalled. "Hearing of his bad reputation, I feared then that this might be a matter involving stolen property, perhaps from outside the country."

Whether all of this was known to Van Meegeren isn't clear, but with the war's endgame playing out, the forger prudently took steps to safeguard his fortune: he divorced Johanna. Despite his rampant infidelities, Van Meegeren still loved Johanna, and their divorce was a separation in name only, a juridical fiction. The couple continued to live together at Keizersgracht 321, and to all outward appearances, nothing about their relationship changed in the least. But by having the marriage dissolved in court, Van Meegeren was able to settle a large amount of cash and property on his newly minted ex-wife, effectively placing 800,000 guilders of his ill-gotten gains outside the reach of the law.

In order to make this arrangement pass legal muster, Johanna would be obliged, when the time came, to tell the authorities that she had been completely unaware of Van Meegeren's life of crime, even as Jan Kok had used her bank account to launder his cut of

the money from *The Footwashing.* An experienced actress, Johanna would declare, in 1945, that she "never suspected" Van Meegeren of forging all the Vermeers and De Hoochs that had been in and out of her house over the years—it had been her understanding that they belonged to "an aristocratic family"—but now that she thought about it, the silver plates and earthenware vessels depicted in many of these images did resemble items on her own shelves. Never one to doubt Van Meegeren's talents or credibility, however, she conceded that he was "completely capable" of painting such masterpieces, and that "if he says that he did so," she, for one, would believe him.

With these clever preparations, Van Meegeren did a much better job of planning for the future than did the man on the other side of the Christ-and-the-Adulteress transaction, Hermann Goering. At the beginning of 1945, with the Russians bearing down on Berlin in one of the bloodiest battles in the history of the world, Goering turned his attention to a purely personal problem, one born of his own greed. Although he had constructed air-raid bunkers on the grounds of Carinhall, Goering eventually realized that all of the loot he had amassed at his estate during the past dozen years would have to be moved to a safer location farther away from the front lines. Over a three-month period, Goering's treasures were packed and loaded onto private railway trains, which were sent off on a 270-mile journey south to Nuremberg, where Goering owned a smaller property. Once his beloved Carinhall was emptied, Goering took the precaution of dynamiting the main buildings, denying the Red Army the pleasure of occupying the place.

By early April, Nuremberg was under attack. Goering therefore dispatched his art-filled trains deeper into Bavaria, to be kept under watch in a tunnel between the Berchtesgaden and Unterstein stations. Public order, however, was rapidly unraveling. Goering's guards made no attempt to intervene as crowds of people broke into the boxcars and fought over pictures, carpets, tapestries, and

other objects, which might be taken home whole or in pieces. Nonetheless, the most valuable items remained safe: a substantial cache had been walled up in an underground cavern, and Goering kept a dozen of his very best paintings in his personal possession, possibly with an eye to funding a future life in exile. On May 9, the day after Germany's unconditional surrender, Goering had these works packed into his motorcade before he set out, dressed in full regalia, with his wife Emmy and their household staff. They were heading to Schloss Fischorn, a castle near the town of Zell am See on the Austrian border, where, for reasons that remain unclear, Goering believed that he was to meet General Eisenhower. Upon arriving, though, Goering and his entourage were greeted not by the supreme commander of Allied forces in Europe but by ordinary American soldiers who placed the whole group under house arrest, later transferring Goering himself to an Augsburg stockade for interrogation.

With Goering now out of the picture, a U.S. Army captain named Harry Anderson, whose responsibilities included the recovery and protection of cultural property, confronted Emmy Goering at Schloss Fischorn to determine what might still be hidden among her belongings. After some initial protest, she turned over what Anderson later described as "six small paintings." Emmy's secretary, Fraulein Christa Gormans, however, was more forthcoming. She called Anderson aside and told him that Goering had entrusted her with the great Vermeer of Carinhall, *Christ and the Adulteress*, which had been removed from its stretchers and wrapped around a length of stovepipe to facilitate transport. Gormans recalled that when Goering had given her the picture he said that she "would never have to worry about money again." Arranging to have the canvas tacked to a piece of plywood, Anderson placed *Christ and the Adulteress* in an exhibition of Goering's art collection that, having been organized by the 101st Airborne Division, was already on view in Berchtesgaden's town hall. The

recovery of Goering's "$1,000,000 Vermeer" made headlines in the *New York Times*.

THE BIGGEST CITIES in the Netherlands were all but ignored by both sides during the fierce 1945 battle for control of Europe. Although many Dutch border towns in the south and east were liberated as the Allies cleared out German positions around the Belgian port of Antwerp, the main population centers in the west—Amsterdam, Rotterdam, Utrecht, The Hague—remained firmly in the hands of the Nazis.

With the Reich falling apart, German troops in these areas found themselves increasingly isolated and received little in the way of supplies. Left to their own devices, they began to take whatever they needed or wanted from the local people. And when, at long last, the commander of the occupying army formally capitulated to the Canadians on May 5, at the Hotel de Wereld in Wageningen, the terms of the surrender opened the door to a final rampage of unrestrained pillage. The Germans were given a twenty-four-hour grace period to head back home across the border before Allied troops entered the country. Preparing to evacuate, the Wehrmacht made off with cars, trucks, bicycles, draught animals, tractors, trains, machinery ripped out of factories, furniture, rugs, gems and jewelry stolen from decorative arts museums—essentially anything of value that they could lay their hands on.

Having no intention of occupying or governing the Netherlands, the Allies sent in only enough troops to act as symbolic liberators. There was little manpower to spare, as the pacification of Germany was going to require an intensive military presence. Moreover, interfering in the domestic affairs of a friendly nation was contrary to policy. As Canadian commanders repeatedly told their soldiers, "Remember: the Dutch are on our side." While fine in theory, this hands-off attitude did beg the question of who exactly was supposed to be in charge. With the Dutch government-

in-exile still in London, there was no central authority yet in place to take over the reins of power. And so, working under the direction of a small group of Dutch officers—the Irenebrigade—who had fought their way from Normandy with the Allies, the Resistance deputized thousands of ordinary citizens into a makeshift security force, passing out rifles and armbands to those willing and able to serve. In some areas, this transition to home rule was fairly orderly. In others it was not.

When things went badly, the treatment and mistreatment of collaborators was usually at the center of the problems. As throngs of people gathered outdoors to celebrate the Liberation in cities, towns, and villages across the country, Dutch Nazi Party members were rousted out of their homes and paraded through the streets, where they could be pummeled, hit with rocks, kicked, cursed, or spit at, before getting packed off to jail. In rounding up the "bad Dutch"—*de foute Nederlanders*—the net was cast wide. Even

The roundup of Nazi sympathizers in the Netherlands

children from German-friendly families—little boys and girls, some not even eight years of age—were forced to march about with placards around their necks saying, "My mummy and daddy are traitors to the nation." Squads of men shaved the heads of female neighbors known to have collaborated between the sheets. One woman who went through this ordeal could still remember the scene vividly decades after the fact: "They set up a sort of bandstand raised a few meters off the street, and they dragged the girls up there, hitting them with rifle-butts and belts . . . A lot of the girls ended up bleeding from their scalps because they really ripped the hair out more than cut it."

These women were called *moffenmeiden* or *moffenhoeren—mof* being an extremely crude word for a German, much worse than Kraut or Jerry, and *hoer* being exactly what it sounds like. After the ritual shaving, the *moffenhoeren* typically ended up with Hitler moustaches painted underneath their noses and swastikas or obscenities scrawled upon their clothing. Most of these women were then released, although some, usually on very thin pretexts, were led off to prison. There were no hard and fast rules about who got taken into custody and who didn't in those first days and weeks after the Liberation. Practices varied from town to town, and those who laid claim to authority—on whatever basis—generally did as they saw fit.

There were, however, some boundaries. Outright murder of collaborators was relatively rare in the Netherlands—far rarer, for instance, than in Belgium or France, where the Liberation was sporadically quite gory. This should not, however, be taken as a sign that the Dutch were either more civilized or less angry than their southern neighbors. Because the war was essentially over when so much of the Netherlands was liberated, the capture of Dutch collaborators was undertaken, for the most part, as a police action rather than as an extension of combat by other means. Reprisal killings were, as a result, much harder to justify or conceal than

The public
humiliation of the
moffenmeiden.

in areas liberated under battlefield conditions. Yet, even though there was no "day of the long knives" in Holland, the vagueness and disorder of official record keeping from this period does leave room to wonder about the way certain collaborators met their ends. For instance, Van Meegeren's friend Ed Gerdes, the occupation government's art tsar, seems to have died, quite unaccountably, on May 10. Although Gerdes had been taunted frequently enough in the Resistance press that he might have been tempted to commit suicide, other, darker possibilities also suggest themselves.

Such incidents aside, the Dutch tended to confine their acts of anticollaborationist vengeance to various forms of abuse and humiliation, most of it done behind bars. Stripping detained collaborators naked and discarding their clothes was a popular tactic, applied to men and women alike, and in many facilities the sexes were not housed separately. Beatings were common: the guards at the Hoek van Holland compound apparently employed mechanical torture devices to make the process more interesting. With tens of thousands of collaborators under arrest at hundreds of locations scattered across the country—including former Jewish internment camps like Westerbork and Vught—proper oversight was impossible. Rost van Tonningen, one of the highest profile inmates around, was subjected to repeated physical abuse by his jailors at Scheveningen. He eventually committed suicide, leaping to his death from the top of the prison stairwell.

This disorderly tableau of retribution, some of it gleeful, some of it cruel, was the backdrop against which Han van Meegeren's story unfolded in 1945. When Lt. Joseph Piller knocked on the door of Keizersgracht 321 on the misty night of May 29, the postwar era was all of three weeks old. The public mood was still raw, and people who had cozied up to the occupation government, as Van Meegeren had, now found themselves staring into a very grim future. Indeed, at the time of his arrest, Van Meegeren seems to have been far more preoccupied with the general atmosphere of

score settling than with the delicious secret of his life as an art-world crook. He would later tell friends that while he was locked away in the Weteringschans he had contemplated committing suicide. And although a simple forgery rap seems unlikely to have provoked such thoughts, being tarred as a traitor could certainly have justified some very desperate thinking.

To understand a few of the oddities of Van Meegeren's behavior in prison—for instance, his initial reluctance to confess—it is important to bear in mind that, according to the letter of the law, Van Meegeren really *was* a traitor, not just due to his general pro-German attitude but also in the light of the specific charge upon which he was arrested. For strictly speaking, Van Meegeren's decision to sell *Christ and the Adulteress* through the auspices of Alois Miedl, whether or not the picture was real, constituted war-profiteering and trading with the enemy—and Van Meegeren knew it. The Dutch government-in-exile's General Mandate of February 10, 1945, had made perfectly clear that "exploiting Occupational circumstances to enrich oneself" constituted grounds for arrest, prosecution, and imprisonment. Although the interpretation of this directive gradually softened during the months and years of the postwar criminal justice process, the question of profiteering was taken quite seriously in the direct aftermath of the occupation. Black marketeers, for instance, were treated with special harshness: branded as "plunderers," they were, in some instances, tied up outdoors to lampposts or flagpoles, pelted with stones, and then left to suffer the elements for days before being taken away to jail. Nor was it just low-level operators who had reason to fear. Practically every day, one or another of the Resistance newspapers, like *De Waarheid, Vrij Nederland,* or *Het Parool,* ran what might be called wish-fulfillment cartoons, showing businessmen in top hats and striped trousers being picked up by the hand of God and tossed behind bars for acts of "economic collaboration."

Arrested in this hostile environment and brought face to face with the uncompromising gaze of the former Resistance leader Joseph Piller, Van Meegeren understood full well that he could not get off the hook merely by admitting that Goering's Vermeer was a fake. Van Meegeren knew he would have to come up with an explanation for how the picture ended up in the very German hands of Alois Miedl in the first place. And so, when Van Meegeren finally confessed on June 12, 1945, after contemplating his options for two full weeks in jail, he didn't just say "I did it; I painted it." He also swore that selling the picture to Miedl had been entirely Rienstra van Stuyvesande's idea.

Van Meegeren denied ever having met Miedl. In fact, he denied even being familiar with the *name* Miedl. Although Van Meegeren did admit that he had asked Rienstra to market *Christ and the Adulteress* under false pretenses, that was a simple matter of fraud, a devil-may-care deception, not trading with the enemy. It was Rienstra who had gone off—unbeknownst to Van Meegeren— and sold the picture to the hated Germans. Indeed, by all rights, it was Rienstra who ought to be up on charges of collaboration, not the innocent art forger. At least, that's how Van Meegeren told it. And apparently, he told it quite well. Upon hearing this version of events, Piller immediately arrested the unlucky Rienstra, who then became Van Meegeren's neighbor, locked up side by side in Weteringschans Prison.

Undoubtedly, Van Meegeren enjoyed a measure of satisfaction in shafting Rienstra—against whom he still held a grudge for all that had gone wrong during the Miedl deal—but revenge was only a side benefit to this maneuver, not its main objective. Van Meegeren was trying to strategize his way out of trouble, using the meager material available to him as creatively as he could.

By throwing Piller a piece of red meat, Van Meegeren was not doing anything terribly unusual. Accused collaborators often sought to ingratiate themselves by informing on bigger offenders—ratting,

squealing, and turning state's evidence as if their lives depended on it, although the stakes were seldom that high. Of course, Rienstra, who had made a great deal of money during the occupation by doing business with the Germans, was just the sort of person who was likely to interest the authorities, as Van Meegeren well knew. And although the specific charge Van Meegeren leveled against Rienstra with regard to *Christ and the Adulteress* was sure to be proved false in the fullness of time—witnesses, after all, had seen Van Meegeren and Johanna visiting Alois Miedl in Rienstra's company prior to the sale of the picture—simply making the accusation helped Van Meegeren to get on Piller's good side in the short term, which was really all that mattered. Indeed, at that particular moment, Lieutenant Piller was the only person in the world who was in a position to help Van Meegeren. And Piller would help a great deal.

During the summer of 1945, Joseph Piller emerged as nothing less than Van Meegeren's friend and protector. The warm relationship that developed between these two men was a complex phenomenon, one rooted not only in Van Meegeren's ability to manipulate circumstances to his advantage but also, to a very great extent, in Piller's individual psychology and past history. Piller had spent the preceding five years battling an oppressive enemy far more powerful than himself, using guile and strategic planning to prevail, and it is no coincidence that he chose to imagine Van Meegeren's life and career in strikingly similar terms. In later interviews, Piller liked to describe the forger as an outcast, an unjustly scorned individual who had wanted to "show the world what he could really do." But with that image, Piller was, in all reality, conjuring up the story of someone much more like himself than Han van Meegeren. During the war, after all, it was Piller, not the forger, who had used deception and subterfuge to serve a noble purpose; Piller who had survived hatred and persecution; Piller who had emerged as a hero against the longest of odds. And if, in

the end, Joseph Piller came to champion Van Meegeren's cause, it was because he looked into the story of the Vermeer forgeries and perceived a reflection of his own struggles.

On the other side of the coin, there were also less attractive elements to Joseph Piller, who, despite his many noble character traits, exhibited a pronounced Machiavellian streak. As a confidential Allied report from this period noted, Piller was "disliked and mistrusted" by many of his Dutch colleagues. He was said to be "jockeying for a position" in the new order of things: hogging the attention, stepping over other people, and, in general, doing everything he could to make a name for himself so that he could land an important job once a permanent Dutch government was reestablished. How does this image square with that of Joseph Piller, the selfless stalwart of the Resistance?

Perusing the files of Allied military intelligence from the immediate postwar era, one would be hard pressed to find any other individual officer from a friendly nation who came in for such constant, withering criticism from the Allies for unprofessional, insubordinate, and completely obstructive behavior. In July 1945, for example, a British major who was working on the Miedl case came to see Piller at the Goudstikker gallery, "requesting evidence of Miedl's activities in financing German subversive organizations," as Piller "had earlier, when in his cups, alleged." Piller said that he had hidden the relevant documents away for safekeeping and that the major should "come back later." In the end, Piller never produced the evidence, despite repeated promises to do so. The truth was that, aside from a few scattered, inconclusive items, Piller had precious little with which to substantiate his overheated claims.

A lion in wartime, Joseph Piller was a menace as a peacetime bureaucrat. But in a way, that's hardly surprising: for Piller's entire claim to authority in the postwar world was, if not exactly illegitimate, then at least largely self-invented. Indeed, no one had ever asked Piller to get involved in these high-level investigations

of looting and collaboration in the first place. At the Liberation, Piller had rolled into Amsterdam with the Canadian First Army, in Dutch service, acting as the commander of an all-Dutch Field Security unit established by the Allies in preparation for turning the Netherlands over to Dutch control. Although ostensibly assigned to military policing duties, Piller had been tipped off by an old Resistance contact about the potentially more glamorous and challenging assignment at the world-renowned Goudstikker gallery. There was a claim-staking mentality in Amsterdam at the Liberation, not unlike that of a gold rush; and with its antique furniture, old-master paintings, and tales of intrigue involving Alois Miedl and Hermann Goering, Goudstikker's was a prime piece of real estate. As one of the Goudstikker heirs later described it, "A competition broke out to see who could get to the building first and a Dutch military group calling itself 'Field Security' won the race." Piller simply marched his men through the stately limestone entryway of the gallery's offices at Herengracht 458 and started rifling through the files to see if what had happened there during the war was really as bad as people said. The gallery became Piller's headquarters—and his project to investigate—because he got there first.

Piller's only problem was that long before he commandeered the premises, the Dutch government-in-exile had already assembled a team of qualified experts to investigate the Goudstikker matter, as well as wartime art looting in general. When these officially sanctioned researchers arrived in Amsterdam, they discovered to their dismay that they had to bargain with an unwelcoming Piller for space and control at the gallery. Piller could not be removed: he had sought and received ex-post-facto approval for his power grab from the Irenebrigade, who had as much authority as anyone else on the ground in Amsterdam. Brandishing a letter from the Goudstikker files in which Heinrich Himmler had commended Alois Miedl for services rendered to the German people, Piller had

spun out an elaborate theory that Miedl had been running a vast Nazi espionage ring of worldwide scope from the gallery's offices. Although this was untrue—Miedl was so greedy that even the Nazis never fully trusted him—in the climate of the times, it all seemed quite plausible, even exciting. Soon enough, Piller got promoted to the rank of captain on the strength of his initial "discoveries." His unit was even given a proper Dutch title: the ad hoc Field Security became the highly official Bureau Bestrijding Vermogensvlucht, roughly Capital Flight Control Bureau, and it was to report directly to the Ministry of Finance.

For a man who had been on the run from the Nazis just a few months earlier, these were gratifying developments. And Piller was justly proud not only of his new title but also of the skill with which he had maneuvered himself right into the thick of the action, where he could root out the truth regarding all of the dirty dealing that had gone on during the war. In fairness to Piller—and it's important to be fair to Piller—he honestly believed that he was on the right track with his investigations. The slogan of the Resistance had always been, *Wie niet tegen is, is voor*—if you're not against the Germans then you're with them. Using that binary logic as a guide, every freeloading war profiteer and collaborator in Europe might well have been part of an intricate network of evildoers. Unfortunately, while the shared burden of guilt among the Nazis and their helpers was real enough, the lines of association and culpability were somewhat more complex than Piller imagined. His approach to the Miedl case was doomed by a naive set of assumptions about the coordination of interests on the German side during the war. And his approach to the Van Meegeren case was, likewise, undermined by an all-too-simplistic notion of just who exactly Van Meegeren was and why he had done what he did.

Almost immediately, there were warning signs that Piller failed to catch. On June 22, ten days after Van Meegeren's confession—at which time the case was still a secret known only to

a select few within the provisional government—Piller finally noticed that Rienstra van Stuyvesande's version of events almost completely contradicted Van Meegeren's. In an attempt to sort out what had really happened, Piller put both men in a room and questioned them together, allowing them, at times, to confront each other directly. A typewritten transcript of this meeting survives, four sheets of onion-skin paper tucked away in the archives of the Court of Special Pleas in The Hague. Aside from capturing the earthy character of a long-ago argument in which words like "bastard," "scoundrel," and "crook" flew in all directions—*schoft, schoelje,* and *misdadiger* in the original Dutch—this eye-opening document is perhaps most noteworthy for demonstrating just how far Piller went in taking Van Meegeren's side against Rienstra on every significant issue in the case. On the question of whose idea it was to sell the picture to German interests, Piller did not press beyond the supposition that Rienstra "knew Miedl and Van Meegeren didn't," saying that any man who called Alois Miedl a "good friend," as Rienstra did, could hardly be taken seriously. When Rienstra attempted to bring up Van Meegeren's letter to Goering, Piller accused Rienstra not only of bearing false witness against Van Meegeren but of trying to lead the investigation "down a false trail." Piller repeatedly chastised Rienstra for "lying" and mocked him for amassing a fortune during the occupation. And, as soon as Rienstra began to object that he hadn't really made that much money, Piller cut him off. "Much is a matter of appreciation and taste," Piller told Rienstra with evident scorn. "You make more in a week than I do in five years."

The transcript of this June 22 meeting also highlights one of Van Meegeren's great strengths: his ability to get people to focus on minutiae and lose sight of the big picture. Playing off Rienstra's attempts at self-exculpation, Van Meegeren kept Piller's attention fixed relentlessly on a single issue, namely, how much money Rienstra made on the sale of *Christ and the Adulteress*. Rienstra,

apparently hoping to excuse himself from the charge of collaboration, claimed, at first, that he had received no money in the deal and that he had played no role in the sale of the picture after introducing Van Meegeren to Miedl. Deftly avoiding the topic of his own involvement with Miedl, Van Meegeren countered that Rienstra had taken a quarter-million-guilder cut out of the proceeds of the picture's sale, a figure seemingly invented on the spot. Under heavy questioning, Rienstra grudgingly admitted that he might have received a very small amount of money "for his trouble," but nowhere near what Van Meegeren alleged. Then, admitting that he was a bit hazy on the details, Van Meegeren backtracked a bit: perhaps it was only 150,000 or 75,000 guilders that Rienstra had gotten. Piller ultimately spent weeks tracking down witnesses and documents to get to the bottom of this matter, but because the entire transaction had been conducted in cash, it proved impossible to determine the truth. Remarkably, though, for all the effort Piller expended on this wild goose chase, he devoted exactly zero time to looking into Van Meegeren's personal background or wartime associations. But it seems clear that, on some level, Piller was not really interested in finding out the truth about Van Meegeren.

In later life, Piller would refer to the Van Meegeren case proudly as "the picture swindle of the century," almost as though he had played a part in it. And in a way he did. Wanting to get full credit for unearthing this extraordinary tale, Piller personally shepherded Van Meegeren through the bureaucracy of justice, even though it was technically not his place to do so. The crime of art forgery fell under the jurisdiction of the civilian, not the military court system, and so, on or about June 27, Piller was told to turn the Van Meegeren investigation over to the Rijksrecherche, the detective division of the newly reconstituted Ministry of Justice. Reluctant to cede control, however, Piller balked at this directive. He would later say that the civilian police remained heavily infiltrated by collaborators even after the war and that he therefore

didn't trust them—which is possible—but it appears far more likely that Piller simply wanted to make sure that the Rijksrecherche didn't steal his glory. The men of the Rijksrecherche were free to investigate all they pleased, but if they wanted to question Van Meegeren, they would have to go through Piller first. He refused to give up physical custody of his prisoner, and he refused to give anyone direct access.

Indeed, already concerned that his case might be ruined by outside meddlers, Piller can only have grown more alarmed with the passing days, as every expert witness the Rijksrecherche deposed between June 28 and July 10 claimed that Van Meegeren was lying, chief among them Dirk Hannema. During the war, Hannema had transformed himself, as loyalist art historian J. G. van Gelder put it, into "a collaborator of the most shameless variety." Installed as chief of the Dutch museum system by the occupation regime, Hannema took to signing his correspondence with "friendly National-Socialistic greetings," and to his everlasting shame, presided over the only direct transfer of artworks from the Dutch State collections to the Reich. Temporarily allowed out of the internment camp for collaborators at Hoek van Holland in order to give his testimony to the Rijksrecherche, Hannema stated that he still believed *The Supper at Emmaus* to be the work of Johannes Vermeer, citing a half dozen published authorities as evidence. Naturally, the well-known art conservator H. G. Luitwieler, who had cleaned and retouched *The Supper at Emmaus* after the Boijmans Museum purchased it in 1937, agreed with Hannema, his most important client for going on two decades. And the great A. M. de Wild, armed with the lab tests from his examination of *The Footwashing,* openly scoffed at Van Meegeren's claims of having forged the picture, calling them "pure fantasy." Whether it was by coincidence or by design that the Rijksrecherche chose to begin with these three naysayers is unclear. But when *De Waarheid*'s article appeared on July 11, announcing the discovery of the inscribed copy of *Teekeningen 1*

in Adolf Hitler's library, it probably looked to Piller very much like the fix was in against Van Meegeren.

For better or worse, by the time the story appeared in *De Waarheid,* Joseph Piller was simply far too invested in the Van Meegeren case to change his mind about it. To give Piller the benefit of the doubt, it should be noted that Van Meegeren adamantly denied having written the damning words, *"Dem geliebten Führer . . ."* The forger claimed to have signed many copies of *Teekeningen 1* when it was first published. The inscription, Van Meegeren suggested, must have been added above his name by someone else, perhaps a "German officer" or "SS member" who wanted to give Hitler the weighty tome as a present. As it happens, there was no photograph illustrating *De Waarheid*'s article, and so it was not immediately possible to verify the handwriting—but whether Piller, in his heart, truly believed Van Meegeren's far-fetched story is not known. It is, however, very clear that Piller would have looked like a fool had Van Meegeren been tarred as a collaborator. To say nothing of how sorely disappointing it would have been if "the picture swindle of the century" never came to public attention, or if it were suppressed—or, worse still, if it were written off merely as the opportunistic act of a lifelong miscreant. And so, both believing and, more importantly, *wanting to believe* that Van Meegeren was a hero, Piller resolved to make the world see the forger as a great man.

On July 12, the very next day after *De Waarheid*'s article, Piller met with Van Meegeren to draft a statement to be released to the press. This would be the first that anyone outside the investigation ever heard about the Vermeer forgeries. "Driven into a state of anxiety and depression due to the all-too-meager appreciation of my work," Van Meegeren's declaration read, "I decided, one fateful day, to revenge myself on the art-critics and experts by doing something the likes of which the world had never seen before . . ." Entering fully into the spirit of fraudulence himself, Piller staged

this event as if it were Van Meegeren's first and only admission of guilt and had it duly witnessed by two members of his staff. With this outlandish piece of stagecraft, Piller made it seem as though Van Meegeren's earlier confession simply hadn't happened. This elaborate conceit allowed Piller to pretend that his own investigation was still active, giving him a plausible excuse for going to the press behind the Rijksrecherche's back. What's more, Piller's rewriting of the historical record helped to shape the outlines of Van Meegeren's myth for public consumption.

The statement that Piller and Van Meegeren concocted on July 12 presented the world with a tidy exegesis of the forger's motives and life story while also reorienting the entire case away from collaboration. This just-for-show confession mentioned Rienstra van Stuyvesande only in passing and completely omitted any reference to the argument over whose idea it was to sell the picture to the Germans. By conveniently playing down the role of Rienstra, this less confrontational version of events also obscured Van Meegeren's wild efforts to railroad his former business associate with false and malicious testimony—an episode that neither Piller nor Van Meegeren would have wished to publicize.

Remarkably, even in this moment of jointly planned, mutually beneficial deceit, Van Meegeren still found a way to abuse Piller's trust. Subsequent to Van Meegeren's initial confession, Piller had discovered that, in addition to the six Vermeers, Van Meegeren had also sold two Pieter de Hoochs—*The Interior with Drinkers* through Gerard Boon and *The Card Players* through Rens Strijbis. During the staged reconfession of July 12, Van Meegeren claimed that these De Hoochs were genuine and that he had merely "touched up" and "strengthened" certain details. Piller, to his credit, was a bit dubious about this. By the time Piller finally allowed Van Meegeren to be deposed by the Rijksrecherche on August 10, even the forger realized that the De Hoochs were a hopeless cause. He admitted what a sophisticated battery of lab

tests would later confirm: the De Hoochs were fakes made using the same Bakelite medium as the fake Vermeers. Doomed though his lies were in this situation, Van Meegeren had every incentive for making the attempt: he had a lifetime of forgeries behind him, and the more of them he acknowledged, the less credible he would be posing as a misunderstood genius on a grand quest to mend his wounded self-esteem. In the end, Van Meegeren only admitted to the fakes that the authorities knew about: the six biblical Vermeers and the two De Hoochs, plus the unsold pieces found later in his studio in Nice.

Arguably, Piller's boldest move came immediately after his July 12 *coup de théâtre*. Piller not only announced the news of the Vermeer forgeries to the press but he also took the extraordinary step of letting Van Meegeren out of the Weteringschans, even though the forger was still a prisoner of the state and the subject of an active investigation by the Rijksrecherche. Piller set Van Meegeren up under house arrest at the Goudstikker gallery and supplied him with all the materials one would require to paint a fake Vermeer, which, over the ensuing weeks and months, Van Meegeren proceeded to do. As he put the finishing touches on *Christ in the Temple*, his new biblical Vermeer, Van Meegeren offered to give it to Piller as a gift. Piller politely declined, citing propriety. His intention had been to use the new fake as proof that he had been right to champion Van Meegeren's cause, not as a decoration for over the sofa. And as far as Piller was concerned, the matter was QED.

During this bizarre interlude, Van Meegeren became, in essence, a human mascot for Piller's Bureau Bestrijding Vermogensvlucht, a pet eccentric whose unconventional life style and weird accomplishments were met with a bit of eye rolling, but also, according to the reminiscences of one of Piller's secretaries, with genuine admiration. Van Meegeren was given an upstairs bedroom and, it seems, fairly free run of the building. He was even

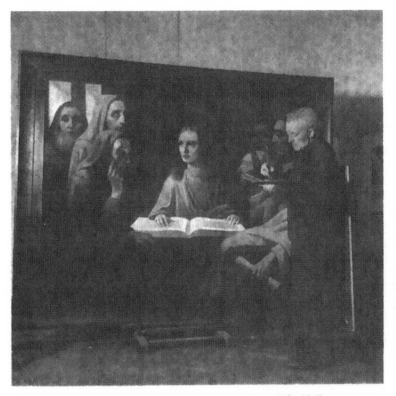

Van Meegeren at work on *Christ in the Temple*, 1945

allowed conjugal visits—not that the artist was terribly keen to spend evenings with Johanna, who had evolved, over the years, into something more like Van Meegeren's devoted companion than his playmate. Johanna was welcome to visit Van Meegeren by day, but at night he sent for a somewhat younger libertine by the name of Cootje Henning. The stylish Cootje had been married for a few years to another artist and had posed nude from time to time for Van Meegeren. Lithe, slim, and seemingly quite uninhibited, she saw to it that cases of gin and cigarettes were brought over from the cache of black market luxuries that Van Meegeren kept

on hand at Keizersgracht 738. If Piller objected to these deliveries or any other goings-on upstairs at his workplace, there's no remaining record of it.

Meanwhile, public reaction to the story of the Vermeer forgeries was predictably intense. Immediately after Piller's press conference, the headline PAINTING FORGERIES DISCOVERED—VERMEER'S EMMAUS IS FAKE drowned out such lesser news items as a dispatch from Admiral Nimitz about the progress of the still ongoing war in the Pacific and a much anticipated announcement that the weekly bread ration in Amsterdam would soon rise to three loaves per family. Prominent though the coverage was, the papers were initially unsure of what to say about the character of Han van Meegeren. Making a monkey out of Hermann Goering certainly made Van Meegeren popular with the public but naturally raised questions about Van Meegeren's collaborationist reputation. After all, why had Van Meegeren been doing business with Goering in the first place? And while these early articles had no trouble identifying the amusing and miraculous aspects of Van Meegeren's career, they also tended to include some mention of the inscription to Hitler or other comments about Van Meegeren's close association with members of the Dutch Nazi Party such as Martien Beversluis and Ed Gerdes. The beautiful fibbery of Piller's press release was, at first, only a partial success.

Soon enough, though, the tenor of the press coverage became almost uniformly positive. Within about two months, no one was really interested in hearing about Van Meegeren's Nazi connections; such matters simply didn't fit in with the delightful, Piller-inspired tale about the small man who outwitted the larger world—a narrative steadily embellished and enhanced with each retelling. Indeed, much as in the old John Ford western *The Man Who Shot Liberty Valence*, when the legend came to be accepted as fact, the papers preferred to print the legend. In a series of interviews, Van Meegeren trotted out his alibi about the "German

officer," and the matter of the inscription to Hitler was dismissed; highly exaggerated praise for the forger's artistic prowess became commonplace—"we may have lost a Vermeer but we've gained a Van Meegeren," as one commentator put it; and article after article expressed undisguised merriment at the way this clever, badly underestimated man had shown up the world's greatest art experts for a pack of fools. Van Meegeren, with Piller's help, had carried the day.

THIS PHASE OF Van Meegeren's story—his postwar emergence as a heroic figure—remains perplexing, even after sixty years. A Jewish war hero sticks his neck out to help a collaborator; an eye-catching missive to Hitler gets explained away with a fairy tale; a country embittered by the German occupation puts aside its resentments to applaud a Nazi-loving art forger—on some level, it just doesn't make any sense. People who had no readily intelligible reason to give Van Meegeren a free pass in the summer of 1945 did so, and they did it eagerly.

The Netherlands at the Liberation was a twilight zone caught between the end of Nazi tyranny and the establishment of a fully functional new order: it was, in effect, a world turned upside down. Ordinary citizens, empowered by the spirit of the moment, were free to conduct once-mighty collaborators to prison through rowdy crowds whose revelry resembled nothing so much as a medieval carnival. And just as in the carnival celebrations of old, where the accepted hierarchies of power were temporarily suspended, and the jester was hailed as king for a day, so did Van Meegeren become, in the popular imagination, the Lord of Misrule. In the hothouse atmosphere of this very strange period, Van Meegeren's talent for undermining authority, for spreading chaos in the established canons of knowledge was seen as a reflection of the wild release that the country was experiencing as a whole. And whether Van Meegeren intended to trick Goering or not, the fact that he

had actually done it made him everyone's favorite joker. His witty aperçus got snapped up by the papers, while his case, stripped of its less attractive elements, was discussed incessantly, and his narrative became inextricably linked to the national catharsis. Whether the real facts of Van Meegeren's life actually merited that kind of treatment simply didn't matter. Once Piller and Van Meegeren started the ball rolling, the public mood kept it going in the right direction.

Not that there weren't a few detractors along the way. When Jan Spierdijk, the reporter from *De Waarheid* who had found the inscribed book in Hitler's library, returned to Amsterdam at the end of the summer, he was, as he later wrote in his memoirs, shocked to discover that Van Meegeren had become such a darling of the Dutch media. By then, Spierdijk had, of course, heard the news about the forgeries—but hadn't people read about Van Meegeren's admiring words to the Führer in *De Waarheid*? As it happens, they had. And apparently they had come to the conclusion that Spierdijk was all wrong. Van Meegeren had been perfectly clear: he said that he hadn't written the inscription to Hitler. Who was Spierdijk to slander a man like the famed forger Han van Meegeren? If the story had been true, Spierdijk surely would have included a photograph of the inscription to prove his point.

Incensed at being taken for a liar—and on the word of a known criminal, no less—Spierdijk spared no effort tracking down the original signed copy of *Teekeningen 1* through two Belgian colleagues who had had been with him on the trip to the Reichschancellery. Spierdijk got a photo documenting Van Meegeren's handwritten inscription, and vindicated at last, he triumphantly published the evidence on the front page of *De Waarheid* in November. The result? Absolutely no one cared. Van Meegeren, whom Spierdijk took to calling a "human forgery," had managed to produce such a seductive image of himself and his life that people

actually preferred it to the truth even when the truth—or, rather, *De Waarheid*—was staring them right in the face.

Joseph Piller's gamble in publicizing the Vermeer forgeries paid off handsomely for Han van Meegeren. But things didn't work out quite so well for Piller himself, who had not won many friends in high places. As it became more and more obvious that his involvement in the larger investigative questions of the day—such as the Miedl case, wartime looting, and collaborationist activities in general—was both unproductive and unnecessary, the headstrong young captain found himself odd man out in the postwar power shuffle. Despite his best efforts, Piller was unceremoniously discharged from the army after roughly two years' service and never obtained the high governmental position that he had coveted. More disturbingly, his overreaching cost him proper acknowledgment of his Resistance heroism, at least within his own country. Although both the British and American militaries awarded him medals immediately after the war in recognition of his work rescuing downed Allied airmen, Piller got little more than a cold shoulder from Dutch officialdom. Indeed, it wasn't until 1951 that he received the Bronze Cross of the Netherlands, and then only as a grudging gesture. Yet, for all that, Piller was not the type to let minor slights get him down. With characteristic energy and drive, he picked up right where he had left off upon returning to civilian life, starting a mom-and-pop wholesale dress-making business, which he eventually built into a major concern. By the late 1970s, he was able to retire in quiet comfort to the island of Mallorca.

In a 1984 interview, conducted under the Balearic sunshine, Piller looked back fondly on one of his favorite moments from that brief tour of duty in government service: Han van Meegeren's media-saturated trial for art forgery. Held in Amsterdam on

October 29, 1947, the trial was something of a reunion for the two men. The recently cashiered Piller hadn't seen Van Meegeren for nearly eighteen months by the time the court date came up. The Rijksrecherche had finally wrested the forger away from the musical-comedy house-arrest arrangement at the Goudstikker gallery at the beginning of 1946: they locked him up in an internment camp for several months and then released him on his own recognizance pending trial. As soon as Van Meegeren caught sight of Piller in the courtroom, the forger smiled broadly as if the guest of honor had just arrived at a dinner party. "Oh, he was like a master of ceremonies at that trial," Piller recalled with evident delight. "He said to me, 'Joe, I've saved the best seat for you.' There were no hard feelings between us. I had helped him make a big name for himself. . . . Also I had protected him a bit."

By the time of the trial, though, the battle for Van Meegeren's reputation was long over. In the Netherlands alone, the forger's life and career had already inspired a well-received novel, a hagiographic biography, and a popular comic book titled "The Van Meegeren Matter"—*Het geval Van Meegeren*—by Ton van Tast, which made the lighter side of the story accessible to Dutch schoolchildren. A newspaper poll conducted at the beginning of 1947 found that Van Meegeren was the second most popular man in the realm: he came in just behind the newly elected prime minister and just ahead of Prince Bernhard. The Dutch simply couldn't get enough of the "genial forger"—the word "genial" having gotten stuck to his name like bubblegum to shoe leather—and they weren't alone. The French press delighted in *la farce Van Meegeren,* treating the whole spectacle like a scene from Molière. The BBC broadcast periodic reports on the case. And in America, the *Saturday Evening Post* celebrated the forger as "The Man Who Swindled Goering." Perhaps more preposterous still, the society-oriented *Town & Country* published a multipage pictorial detailing

Van Meegeren's lavish taste in home decorating. The man was nothing less than a worldwide sensation.

But Van Meegeren's apotheosis as the quirky, offbeat hero of the moment came at the trial, where, with newspaper photographers packing the galleries and the biblical Vermeers lining the courtroom's oak-paneled walls, the forger displayed his talent for comedic timing. When Van Meegeren stated for the record that he had painted *The Supper at Emmaus* merely to prove his worth as an artist, the presiding judge reminded him that money may also have played a role in the matter.

"You do admit, though, that you sold these pictures for very high prices?" the judge asked.

"I could hardly have done otherwise," Van Meegeren replied. "Had I sold them for low prices, it would have been obvious they were fake."

The newspapers ate this up, but the humorous aspects of the proceedings ran deeper than the public ever realized. Among the scientific experts giving testimony at the trial was none other than A. M. de Wild, who sang a very different tune on the witness stand than he had during the summer of 1945, when he had gone on the record stating that the very idea of Van Meegeren painting *The Supper at Emmaus* was sheer lunacy.

Preferring not to revisit that indiscreet judgment in the courtroom, De Wild instead dutifully confirmed that the Vermeers were fake. And he was in a position, by this point, to offer sound technical evidence for his reversal of opinion. Once Van Meegeren revealed that he had used Bakelite in fabricating the forgeries, De Wild—working with the forensic chemist Willem Froentjes, of The Hague crime laboratory, and Paul Coremans, head of conservation for the Belgian State Museum system—devised a specific test to identify the presence of Bakelite in the disputed pictures. The test was fairly rudimentary by today's technological standards, but

quite clever for the time: real oil paint, even when it's thoroughly dry and hard, will disintegrate when brought into extended contact with caustic agents like sodium hydroxide—the active ingredient in most drain cleaners—but Bakelite is completely unaffected by corrosives of this category. By showing that paint samples from Van Meegeren's fakes could successfully withstand the effects of sodium hydroxide while samples from real seventeenth-century pictures could not, De Wild and his colleagues were able to provide an objective demonstration of a fact that virtually everyone on the planet already knew: Van Meegeren's fake Vermeers were modern pictures, not old ones.

This technical evidence would undoubtedly have been of great importance to the outcome of the trial—if there had been

Van Meegeren at
his trial in 1947

anything to quarrel about on that festive October day in the Amsterdam District Courthouse, or anything to prove. Although Van Meegeren entered a formal plea of not guilty to open the proceedings, he freely admitted to forging the pictures. The verdict in the case was a foregone conclusion. True enough, the length of Van Meegeren's sentence still had to be determined by the judge, but an appropriate punishment could probably have been negotiated without the trouble of a public prosecution—if only the accused had been willing to pass up his moment in the limelight. That, however, was not a solution that appealed to Van Meegeren: he wanted a theatrical spectacle. And that's just what he got.

When the scientific experts finished giving their testimony, the presiding judge asked Van Meegeren if he had any comments. The forger, dressed in a blue serge suit, his silver hair combed back from his forehead, politely replied from the dock that he found all of the charts, graphs, and projected slides used by Messrs. De Wild, Froentjes, and Coremans to be breathtakingly impressive—kudos all around. He then added dryly that, from now on, the faking of old-master paintings would, of course, be impossible. This last comment, which, one senses, Van Meegeren had practiced beforehand in front of a mirror, elicited a knowing chuckle from the assembled crowd.

And for the most part, the entire trial had this same light, bantering tone. Taking the stand, Van Meegeren's old friend Jan Kok was asked if he had ever suspected something untoward might have been involved with the sale of *The Footwashing*, given all the elaborate secrecy surrounding the painting's origins. "No, certainly not," Kok replied, assuming an air of astonishment. He maintained that, as an innocent layman, he could hardly have been expected to understand such complicated affairs. The prosecutor did not pursue the issue any further.

Pieter de Boer and D. A. Hoogendijk were let off with similarly gentle questioning. And even Dirk Hannema, who had emerged

a very unpopular and discredited figure after the occupation, was treated with kid gloves. Privately, Hannema still refused to admit that his beloved *Supper at Emmaus* was not a Vermeer, perhaps conflating his failure of connoisseurship with his other, more serious lapses in judgment—the ones for which there could be no easy explanations. At the trial, Hannema was permitted to gloss over his stubborn opinions regarding the Vermeer forgeries and to state merely that other experts, such as the recently deceased Abraham Bredius, had concurred in the attribution of *The Supper at Emmaus* at the time of the painting's purchase. Interestingly, in an even more gracious gesture—and one that looks very much like favoritism on the part of the Dutch political elite—the well-regarded Gerard Boon was spared the embarrassment of testifying altogether.

Ultimately, no one was given an easier ride than Van Meegeren himself. The prosecutors, for instance, were well aware of the rumors regarding Van Meegeren's long career in art forgery, but the issue was never brought up during the trial, which hewed scrupulously to the master-forger-as-misunderstood-genius storyline. The putative Vermeer that Fritz Mannheimer had purchased back in 1932, *The Gentleman and Lady at the Spinet,* had been investigated by Froentjes, Coremans, and De Wild: they found it to be a fake of a type similar to the biblical Vermeers, but this was never mentioned publicly, nor is there any record that Van Meegeren was ever interrogated about the matter. Likewise, and perhaps more tellingly, the entire question of Van Meegeren's Nazi sympathies was studiously avoided by the crown prosecutor. And with Rienstra van Stuyvesande never being called to the stand, the disreputable collaborationist atmosphere surrounding the Miedl sale was conveniently kept out of the courtroom testimony, as was, for that matter, Van Meegeren's opportunistic denunciation of Rienstra in prison.

Indeed, the only witness who was willing to hint at the larger context of Van Meegeren's criminal enterprise was the art

historian J. G. van Gelder. One of the experts who had approved the purchase of *The Footwashing* for the Rijksmuseum in 1943, Van Gelder had worked secretly with the Resistance throughout the occupation, using his connections in the art market and museum world to keep track of the German acquisition of Dutch assets. Beneath Van Gelder's bespectacled, pipe-smoking façade lurked a very tenacious individual indeed. Asked by the prosecutor about *The Footwashing,* Van Gelder ruefully admitted to having been duped, citing his desire to keep valuable artworks out of German hands as the primary motivating factor in his thinking. Then, unprompted, he said that he ought to have known better, as he had long harbored suspicions about Han van Meegeren. Early in the war, two dodgy tax consultants had approached Van Gelder about authenticating a group of old-master paintings. After examining the pictures, Van Gelder had concluded that they were forgeries, and had "gotten a feeling" that they were in some way connected to Van Meegeren.

From the dock, Van Meegeren interrupted Van Gelder's testimony. "When exactly did you have this so-called feeling?" Van Meegeren asked.

"In 1942," Van Gelder replied.

"Then I draw the court's attention to the fact that *The Footwashing* did not even exist at that time, and yet a year later you accepted it anyway."

Although beside the point, this mocking observation drew a big laugh from the gallery. Sensing the mood in the room, Van Gelder smiled in a self-deprecating way and then wisely dropped the subject. Clearly, the day belonged to the master forger.

Appropriately, Van Meegeren, the man of the hour, was to be the final witness at his own trial. Allowed to make a statement at the end of the proceedings, just before the prosecutor's summary, Van Meegeren rose to his feet, producing a set of notes and a pair of horn-rimmed reading glasses from his breast pocket. At great

length, he informed the court that he had originally taken to forging old masters simply from a desire to pursue his artistic calling. "I had been so belittled by the critics that I could no longer exhibit my work," he claimed. "I was systematically and maliciously damaged by people who don't know the first thing about art." He stated that he had taken immense satisfaction in the chance to perfect his technique and to measure himself against the great artists of the past whom he admired. Concluding on a remorseful note, he sighed, "I didn't do it for the money, which brought me nothing but trouble and unhappiness."

It was quite a performance. And it seems to have gone over extremely well with the general public. Although people surely understood that there was a measure of flimflam involved in Van Meegeren's romanticized account of his career, flimflam was part of the man's charm. Old newspaper photos show him smiling and waving to his cheering fans as he was escorted out of the courthouse by police officers after the trial. His punishment? Van Meegeren was sentenced to one year of imprisonment—two years being the maximum term allowable under the statute for forgery. In addition, with the exception of the money settled upon Johanna during the divorce, all of Van Meegeren's assets, including the houses, the art, the jewels, and the stacks of unspent cash, were confiscated by the state, to be distributed to the parties who had lost money on the biblical Vermeers and the De Hoochs. And yet, even though Van Meegeren had to surrender the bulk of his ill-gotten loot, when all was said and done, he came away from his brush with the law smelling like a rose. He had become a folk hero—Robin Hood, the Artful Dodger, and the Man Who Broke the Bank at Monte Carlo all rolled into one.

To give him his due, he was indeed a truly brilliant fraud.

CHAPTER TEN

Swept Under the Rug

THE OBITUARY PUBLISHED in the *New York Times* on December 31, 1947, ran with the headline, PAINTER WHO FOOLED EXPERTS WITH COPIES OF MASTERS IS DEAD—APED VERMEER. Before serving even a single day of his prison sentence, Van Meegeren succumbed to heart failure, most likely as a complication of syphilis, in a police-monitored hospital ward at the Valerius clinic in Amsterdam.

Van Meegeren, the *Times* reported, had "turned to forging the works of Vermeer as the result of frustration after art critics had condemned his work while a young man." The obituary dutifully recounted how the forger had "plotted his revenge" by isolating "a blind spot of twelve years in Vermeer's life" and creating a group of paintings "to fill in that period." The *Times* dismissed the notion that Van Meegeren had been a Nazi sympathizer and all but absolved him of any ethical wrongdoing. The charge of collaboration, it declared, "did not stand up in view of the fact that he had fooled Goering completely." With his premature death, Van Meegeren not only escaped the penal servitude due to him for his

forgeries but managed to find a comfortable resting place in the realm of popular memory.

Of course, Van Meegeren wasn't the only figure whose past got conveniently swept under the rug around this time. A highly selective process of remembering and forgetting was essential to Europe's recovery after the war. And Han van Meegeren's posthumous reputation, the manner in which his forgeries were perceived, the damaging effects that his crimes had on the careers of the experts whom he had duped—these were all matters defined, to a great extent, by larger forces.

Among the first casualties in the battle between postwar optimism and postwar reality had been the hope, dear to the heart of many a Resistance fighter, of investigating and punishing everyone complicit in the Nazi takeover, from the biggest ideologues down to the lowest opportunists. Throughout Western Europe, as the justice process was forced to compete with the urgent need for physical and economic reconstruction, a kind of moral triage took place. In Germany, most of the surviving figures from the upper levels of the Nazi hierarchy received tough-minded trials and fitting penalties from the Allies: Hermann Goering, for example, was sentenced to death by hanging at Nuremberg, although, ultimately, he committed suicide with poison smuggled into his cell prior to his scheduled execution. Thousands upon thousands of lesser offenders, however, both in Germany and in the former German-occupied nations, were handled in a far more problematic fashion. When they were caught at all, they could face judgment in any of a variety of venues where differing standards and procedures yielded wildly inconsistent outcomes. Meting out equitable punishments to so many, so quickly, under such difficult circumstances was surely a challenge that no one could have gotten right. And the moral and logistical dilemmas that the process entailed left many people, both in and out of government, wishing that the whole knotty problem would just go away.

In the Netherlands, the hot phase of anticollaborationist fervor burned itself out within about a year of the war's end. Although the Dutch had richly enjoyed jailing and tormenting the Nazi sympathizers in their midst, it soon became clear that conducting proper trials for all of those detained could easily consume the better part of the nation's energy for the foreseeable future—the overall Dutch population, circa 1945, being just under eight million and the total number of collaborators requiring due process roughly 120,000. With the Dutch legal system a shambles after five years of Nazi rule, the adjudication of cases proceeded slowly, and this dilatoriness itself became a serious cause for concern. Collaborators had been thrown into the same jails and prison camps used by the Nazis, with few improvements in the overall conditions. Indeed, as news began to trickle out, in 1946, about the sometimes brutal abuse of prisoners—many of them as yet untried—there was something very much like an Abu Ghraib moment in the Netherlands, in which the public was left to wonder if the system of incarceration then in place wasn't eerily reminiscent of the very regime the war had removed.

As righteous anger against Nazi sympathizers gave way to more conflicted feelings, the legal consequences for wartime misdeeds grew steadily less severe, and the list of activities considered serious collaboration came to be radically abbreviated. Naturally, the most high-profile war criminals were dealt with first—leaders of the Dutch Nazi Party, informers, Dutch SS members. In quick succession, 138 death sentences were handed down by the Dutch courts, a remarkable outcome in a nation that did not practice capital punishment under normal circumstances. All of these cases were subject to appeal. Although the verdicts were, at first, routinely upheld, as time passed, the public mood softened, and the system slowed to a crawl. Indeed, by 1948, when Princess Juliana succeeded to the throne, a total of just thirty-six executions had taken place. And as the new queen was fundamentally opposed

Dutch collaborators interned at Kamp Vught, June 1945

to the death penalty, the remaining death row prisoners had their sentences commuted to life behind bars.

Initially, the imprisonment of collaborators was not considered nearly as controversial as execution, but attitudes began to change on this point as well. In a display of resolve, within the first eighteen months after the war's end, more than one hundred centuries' worth of prison sentences were handed down to rank-and-file Dutch Nazi Party members. Han van Meegeren's old friend Martien Beversluis, for instance, was packed off to do his time under harsh conditions at Kamp Vught, a notorious facility that had served as a Jewish internment camp during Nazi rule.

Beversluis's experience in detention, though, offers a telling illustration of the dilemmas faced by the Dutch government as it tried to weigh the needs of justice against those of basic human decency. Unable to cope with prison-camp life, Beversluis began

to exhibit pronounced symptoms of mental illness during his time at Vught. And while frailty would have earned no one any sympathy from the authorities during the occupation, in the postwar era, mercy had made a comeback. With his grip on reality becoming increasingly tenuous, Beversluis received a hardship parole and left Vught a broken man, both physically and psychologically, after serving only two years. While a somewhat extreme example, Beversluis's story was not unusual. As the will to inflict truly severe penalties for "political delinquency" began to ebb, long sentences often became short ones.

Standards changed fairly quickly in other ways as well: immediately after the war, economic collaboration was rigorously investigated, but as time passed, the prosecution of such crimes was effectively abandoned. The case of Rienstra van Stuyvesande was typical. Tried as a collaborator for trading with the enemy—for offenses unrelated to the sale of *Christ and the Adulteress,* a matter the court deemed too bizarre to delve into—Rienstra was found guilty in May 1948 and sentenced to a year in prison. Upon appeal, six months later, however, the verdict was reversed. Although certain mitigating factors did come to light at the second trial—notably that Rienstra had given a five-thousand-guilder donation to the Resistance during the occupation—the court's change of heart was based primarily on a revised understanding of what did and did not constitute treason in time of war. By selling Dutch businesses, real estate, and even a meat-packing plant to the Germans, Rienstra had not been acting in a spirit "contrary to the interests of the Dutch people," the court held, for the simple reason that it was impossible to transport such structures and entities to Germany in a physical sense; the properties Rienstra had sold to the Germans had therefore reverted to Dutch control after the war. Indeed, the court indicated that the net effect of such transactions was positive for the Netherlands, as Rienstra had, in his own small way, increased the domestic economy's supply of hard currency.

Like Lewis Carroll's White Queen, who famously declared that having jam and toast every other day meant "jam yesterday and jam tomorrow, but never, ever jam today," the court seemed to be suggesting that trading with the enemy could only have been a crime if the enemy had won. Clearly, nothing that Rienstra had sold to the Germans would have reverted to Dutch control had the outcome of the war been reversed, and there would, likewise, have been no independent Dutch economy to benefit from the influx of liquid capital. Of course, if the Nazis had won, there would also have been no way to prosecute people like Rienstra who had sold out the nation to the victorious invaders. It was a pretty paradox. Apparently, the court was not looking for convincing arguments, but rather for a pretext, even a shaky one, upon which to reverse a conviction that no longer fit in with the policy objectives of the government as a whole.

The reversal wasn't necessarily a bad or unjust decision. Although the court failed to mention it, there was actually a fairly compelling ethical rationale for giving Rienstra lenient treatment, however awkward or depressing it might have been to acknowledge: far, far bigger offenders than Rienstra van Stuyvesande had gotten off scot-free. Smart enough to escape while it was still possible, some of the most notorious war profiteers in Europe would never face any criminal charges at all—Rienstra's good friend Alois Miedl being a very notable member of this club. When Rienstra was initially convicted, it had still seemed possible that Miedl might be brought back to the Netherlands to stand trial, but by the time of Rienstra's appeal, it had become clear that no such thing was ever likely to happen.

Reasonably safe from extradition in Spain, Miedl had, in fact, been in a very sociable mood when the Allies caught up to him at the Ritz during the closing days of the war. Graciously agreeing to be questioned by U.S. Naval Intelligence, Miedl attempted to portray Dorie and himself as persecuted individuals who had

barely managed to escape occupied territory alive. Pointing to his positive actions protecting Jews in Amsterdam, Miedl argued that he deserved amnesty for any incidental offenses he may have committed while undertaking these acts of mercy, hinting broadly that he might be able to supply useful information about high-level Nazis in return. A charmer when he needed to be, Miedl nearly succeeded in this gambit. But as the nature and extent of his wartime financial operations became apparent, the Allies soon recognized that "Miedl has up till now told only part of the story." And the idea of offering him a deal was officially scotched.

No longer pretending to cooperate, Miedl then proceeded to play the U.S., Dutch, and Spanish governments against each other, successfully tying matters up in red tape until the early 1950s—by which point, Cold War anxieties left little time for anyone to worry about the fate of Hermann Goering's former banker. Ultimately, Miedl negotiated a gentleman's agreement with the Dutch authorities. He was assured that no criminal proceedings would be brought against him, but he had to surrender approximately 1.8 million guilders worth of securities and other assets that he had left behind in the Netherlands as a civil fine for his wartime misdeeds. Although this was a monumental sum, it was only a fraction of what Miedl had earned during the occupation. Thereafter, Alois Miedl was essentially in the clear, able to come and go as he pleased without any fear of arrest. Travelling often, he spent periods in Switzerland and South America, where, given his taste in friends, he quite likely ran into other figures from the Nazi era who had, like him, eluded a day of reckoning. Certainly, there was no shortage of them about. Miedl died in 1990, still quite rich and supremely unrepentant.

Asked about Miedl's case, the much disappointed Joseph Piller remarked late in life that it had always irked him to know that such a man had gotten off so easily. Piller also found it disturbing that all of the war-profiteering art dealers whom Field Security had

investigated back in the summer of 1945 similarly wound up receiving little or no punishment. "Of course, that didn't just happen with art dealers," Piller noted, "but also with much larger business interests as well. You got the sense that there was interference because it wasn't considered opportune to bring them in. But naturally, this was all tied in with matters of great economic importance for the Netherlands in the postwar period."

If questions of crime and punishment were ultimately settled in a less aggressive manner than Joseph Piller and other Resistance veterans might have liked, it was, in no small part, because the hope, the excitement, and the vast promise of the postwar era made fierce retribution an ever-decreasing priority in the eyes of most Dutch citizens. As things gradually got back to normal after the occupation, people looked around and began to realize that the genie of Nazism had been put back into the bottle; the world was safe; and it was time to celebrate.

Perhaps a matched pair of photographs can capture this sense of relief better than mere words alone. On the left, an old, beaten-up passenger train rolls into the Netherlands during the summer of 1945, loaded with Dutch forced laborers returning home from Germany, free men at last. On the right, their wives and families are lined up cheering beside the tracks. These were young, innocent people whose lives had been cruelly interrupted. And after

Dutch forced laborers being welcomed home from Germany, June 1945

all that had occurred, all the horror and grief, the chance to begin afresh must have seemed like a very sweet gift indeed.

Back in Amsterdam, once the electricity returned and emergency rations came flooding in from donors as varied as the Swedish Red Cross, the British Home Secretary, and the U.S. Army, the overall public mood steadily brightened. Soon enough, people stopped bragging about how they had shaved the heads of the *moffenmeiden* or beaten up on some German-friendly ogre who had lived down the street. All that public acrimony seemed like a matter best forgotten. And with astonishing speed, it was. Once the Allies designated Amsterdam as an R and R center for soldiers stationed in nearby Germany, the nightspots and cafés along the Prinsengracht and the Amstel began to hum with energy. And in due course, a whole generation of single Dutch women gamely learned how to boogie-woogie. Even the usually humorless editors of *De Waarheid* were inclined to crack a smile: observing a group of free-spirited Canadian troops cutting a rug with the locals, the former Resistance paper put aside its usual axe-grinding reportage to pose the immortal question, "Why do these Canadian boys dance so funny?"

As money from the Marshall Plan began to appear on the scene, late in 1947, the physical reconstruction of the country moved into high gear, and the economic situation steadily improved. Work was plentiful; the jobs generally paid well; and things, for most people, were really looking up. Under the circumstances, it's hardly surprising that the Dutch didn't feel inclined to run their nation as a prison state dedicated to the eternal punishment of collaborators.

Despite a less and less vindictive response to collaboration on an official level, former Nazi sympathizers were by no means welcome to take part in the giddiness that pervaded the Netherlands in the late forties and early fifties. Unlike France or Austria,

which sometimes allowed collaborators back into prominent public positions, the Netherlands seldom condoned such rehabilitation. The Dutch Calvinist heritage may have played some role in this: during the decades following the war, the general public actively stigmatized not just collaborators, but also the children of collaborators, and even the grandchildren of collaborators. Indeed, the practice continues to some extent even today. Everyone in the Netherlands says that with the new generation things are changing, but any Dutch person from a family that was "*fout*" during the war still tends to get whispered about upon leaving a room—and knows it.

Likewise, the Dutch government often inflicted scarlet-letter-style punishments on former Nazi sympathizers, conveniently avoiding the hassles of incarceration while still managing to damage the accused professionally. For instance, writers and artists who had derived support or preferment from the occupation government were generally forbidden from practicing their careers for a specified period of time after the war. As a result, even after Martien Beversluis was released from Kamp Vught, he was prohibited from working as a journalist for the next twenty years or from publishing any of his poetry for three years—not that there was much demand for it by that point. The length of the so-called professional ban varied according to the wartime behavior of the specific individual. To cite a less severe example, Van Meegeren's compatriot from *De Kemphaan*, Jan Ubink, whose faint-hearted collaboration consisted mostly of going along to get along, received a suspension of just one year—although even that slap on the wrist left Ubink quite upset. Apparently, Ubink had experienced a change of heart during the final phase of the war, and had even courted a measure of danger by voicing oblique anti-Nazi opinions in an occupation-government-sponsored cultural organization to which he had belonged in the town of Groningen.

Although seemingly sincere, this rather late conversion did not induce Ubink to forfeit any of the professional advantages he had gained earlier in the occupation through his amiable attitude toward totalitarian rule. So there was no free pass waiting for him after the war was over.

If Han van Meegeren had lived just a bit longer, he too would have faced a professional ban, and apparently for a much longer period than Jan Ubink. According to the recollections of Marinus van der Goes van Naters, the former chairman of the Dutch Purge Board for Artists—*De eereraad voor de kunst*—consideration of Van Meegeren's situation was postponed until the outcome of the 1947 forgery trial, presumably to avoid prejudicing those proceedings. Once the court's verdict was announced, however, the purge board reviewed Van Meegeren's wartime record and planned to serve him with a rigorous, long-term suspension—which was, of course, only natural under the circumstances. Dutch artists who had accepted direct commissions from the occupation government almost always faced punishment, as did those who had sought to exhibit their work in Germany. And Van Meegeren was in trouble on both counts. The board had also investigated Van Meegeren's disputed inscription to Hitler, concluding, on the basis of the testimony of a professional graphologist, that Van Meegeren's story about an unknown "German officer" writing the text was not even remotely credible. Although seeking an expert opinion was a prudent step, one didn't necessarily have to be a graphologist to see that Van Meegeren had been economical with the truth: not only was the entire inscription artistically laid out across the page by a single hand, but the writing—with the exaggerated tails on all the *g*s, for instance—was clearly Van Meegeren's, as a comparison with a known sample of Van Meegeren's handwriting, from a 1921 poster for the Royal Menagerie in The Hague, clearly illustrates.

A comparison with a known
sample of Van Meegeren's
handwriting leaves little
doubt about who authored the
disputed inscription to Hitler.

But in the end, no professional ban against Van Meegeren was
ever announced because the forger, with his characteristically per-
fect sense of the moment, died before it could happen. As a re-
sult, Van Meegeren's public image remained frozen in time, just as
charming as it was on the day of his trial. And the tale of the mis-
understood genius who fooled the world was left to take on a life of
its own, its meaning mutable, its symbolic importance open to di-
vergent interpretations. Indeed, the impact of the forgeries on the
reputations of the experts who had been duped by Van Meegeren
varied wildly from case to case, dependent on issues relating al-
most entirely to the war and postwar politics.

Among the surviving experts, only Dirk Hannema was truly
ruined by his gaffe, and it seems fair to say that the forgeries came

to symbolize his larger failures. Hannema, of course, had not just been wrong about the biblical Vermeers, but he had also been "wrong" in his sympathies during the occupation. Hannema's foolishness in the Van Meegeren matter made him an easy target for ridicule—and ridiculed he was. By way of contrast, the well-liked Professor J. G. van Gelder, the loyal Dutch expert who had unwisely voted in favor of acquiring *The Footwashing* for the Rijksmuseum in 1943, suffered no damaging effects to his reputation at all: he moved from strength to strength in his career, earning a prestigious chair in art history at the University of Utrecht. True, Van Gelder was, in every way, a far more capable scholar than Dirk Hannema, but more to the point, he had been on the *right* side during the war. Consequently, for Van Gelder, a regrettable mistake about a picture amounted to just that. For Hannema, however, it was a matter whose resonance was simply too powerful for anyone to ignore.

Certainly, Hannema didn't ignore it. He spent the rest of his life stubbornly refusing to admit that *The Supper at Emmaus* was a forgery—a doomed proxy for defending himself as a man in full. Hoping to prove that the biblical Vermeers, or at least the best of them, were genuine, Hannema teamed up, in the late 1940s, with an eccentric Belgian art historian named Jean de Coen in an attempt to discredit the scientific evidence that had been presented at Van Meegeren's trial. Receiving ample funding from Daniel G. van Beuningen, who still hoped that his *Last Supper* might turn out to be a masterpiece, Hannema and De Coen proceeded to organize conferences and lectures to defend their thesis, claiming, among other things, that the experts had faked the results—a tale that grew ever more conspiratorial as time went on. In 1950, De Coen published a lavishly illustrated book titled *Retour a la vérité*—"Back to the Truth"—in which he decried the "crime" perpetrated against the biblical Vermeers. And in 1955, the entire farce came to a head when Van Beuningen brought a libel suit against Paul Coremans,

one of the three experts who had analyzed the Van Meegeren fakes for the Dutch state back in 1946–1947. Van Beuningen claimed that the value of *The Last Supper* had been materially impaired by Coremans's "pseudo-scientific" condemnations.

Although he had originally undertaken the examination of the Van Meegeren fakes in partnership with Willem Froentjes and A. M. de Wild, the unlucky Coremans evidently found himself the sole target of Van Beuningen's wrath because he, unlike his colleagues, had published the technical evidence against the forgeries in the form of a book, *Van Meegeren's Fake Vermeers and De Hoochs,* which had enjoyed wide popularity. Unlike the other accounts of the case, Coremans's book presented science as the hero rather than Van Meegeren, actually a rather odd take on matters, given that, prior to Van Meegeren's confession, technical analysis had done nothing to expose the biblical Vermeer forgeries. In any event, the merits of the evidence being beyond reasonable dispute by this point, Coremans won the libel case quite easily. Indeed, the whole exercise achieved very little except to make Van Beuningen, Hannema, and De Coen look woefully misguided.

For Dirk Hannema, at least, pursuing futile obsessions was one of the few pleasures that life had left to offer. With his influential family connections, Hannema had managed to avoid a lengthy prison sentence for his wartime collaboration—serving less than nine months at Hoek van Holland—but there was no possibility of his going back to work as director of the Boijmans Museum. A disgraced figure in the Dutch museum world, Hannema spent the rest of his days in a state of limbo, alive and well, but with no real purpose. Despite his considerable personal fortune and all the comforts that money could buy, Hannema led an existence that very few could have envied.

The staff and trustees of the Boijmans Museum were, by that point, probably the only group of people in the Netherlands who were inclined to take pity on Dirk Hannema. Although he had

long been stripped of any official position, he still commanded a measure of respect for his role in bringing the museum to prominence before the war. As a courteous gesture, while Hannema was still alive, *The Supper at Emmaus* was displayed without any sort of wall label to indicate the name of its maker. Indeed, the world's most famous forgery was, in those days, intentionally hung in a hall between the modern and old-master galleries, as if there might still be some doubt about where it really belonged.

Of course, no one at the Boijmans harbored any illusions. Consigning *The Supper at Emmaus* to the discreet realm of the neither-here-nor-there was simply a way to avoid rubbing Hannema's nose in his own folly. And given that there was really nothing positive left to say about the subject, letting matters pass in silence was surely the highest form of compassion that anyone could have offered Dirk Hannema with regard to all the misjudgments of a lifetime.

ONE OF THE MOST remarkable developments after Van Meegeren's 1945 confession was that a multitude of people came forward to say that they had suspected *The Supper at Emmaus* of being a forgery all along, but for one reason or another, had neglected to speak up earlier. Most of these claims were fairly incredible. For instance, Sir Herbert Read, the editor of the *Burlington Magazine,* declared that many people at the magazine had been quite suspicious of Bredius's 1937 article announcing the discovery of the new Vermeer. In particular, Read noted that the great Roger Fry had voiced doubts about the picture's authenticity. It is difficult to give much credence to Sir Herbert's story: Roger Fry died in 1934, two years before *The Supper at Emmaus* had even been painted.

No one likes to admit a mistake, and a great many dealers, curators, and connoisseurs wanted to pretend that they had been in the know, even when they hadn't been. That said, there really were a few individuals in the trade who had entertained suspicions

236 • *The Man Who Made Vermeers*

about *The Supper at Emmaus,* and at a very early stage. For example, in 1938, the Paris-based picture scout Georges Isarlo had written an article for a French art magazine about the then recently unveiled masterpiece at the Boijmans Museum, indiscreetly noting that there were whispers circulating with regard to the picture's authenticity: "*Ce n'est pas un Vermeer. C'est un faux!*" Hedging his bets, Isarlo did not say that he personally believed *The Supper at Emmaus* to be a fake, at least not in so many words. But as Isarlo would later point out, with justifiable pride, this was the only article ever to mention *Emmaus* in the context of forgery prior to Van Meegeren's great revelation. For fairly good reasons, it was universally ignored.

Known primarily as a professional promoter of pictures, not as a scholar, Isarlo commanded little respect in the more sober precincts of the art world. Indeed, Pierre Rosenberg, director emeritus of the Louvre, once said that if he happened to agree with Isarlo about a painting, it was not because of Isarlo's opinions but rather in spite of them. Likewise, Isarlo was widely considered to be an intriguer, the sort of person who was always up to something, or as a former acquaintance of his told me, Isarlo "usually knew more than he let on." And with regard to the article on *The Supper at Emmaus,* one strongly suspects that this was the case. Isarlo, as it happens, worked very closely with the Katz gallery of the Netherlands and was on good terms with the gallery's restorer, Willy van Wijngaarden, who had more than just an inkling that *The Supper at Emmaus* was fake. It would seem that Isarlo had a uniquely insightful source of information to guide his thinking about *The Supper at Emmaus*—although, of course, he made no mention of this fact when he waved his old article around triumphantly after the war.

Another rather triumphant fellow in the art world in those days was Edward Fowles of Duveen Brothers. With Joseph Duveen and Armand Lowengard both deceased, Fowles was now the head of

the firm, fully in charge at the New York office on Fifth Avenue. When the story of Van Meegeren's confession became big news, Fowles searched through the office's correspondence files to find the telegram he had sent to Duveen, in 1937, after examining *The Supper at Emmaus*—the one that said, PICTURE A ROTTEN FAKE. Fowles sent a copy to the *New York Herald Tribune* along with a gloating letter in which he recounted how the firm had turned the picture down, noting that it was regrettable that dealers like Duveen Brothers "cannot, because of legal considerations, publicize their opinions" when such spurious items come on the market. He also stated that truly experienced dealers *never* get duped by such items.

Interestingly, Fowles neglected to point out that Duveen Brothers had, in fact, bought and sold two earlier fake Vermeers, *The Smiling Girl* and *The Lace Maker*. And by this point, it seems that Fowles knew full well what those pictures really were, mum though he remained on the subject in public. Duveen Brothers, like most of the big dealers, kept individual files for every picture they had ever handled, and in the course of the late 1940s, Fowles dutifully added a few pertinent items to the files for *The Smiling Girl* and *The Lace Maker*: copies of newspaper clippings about the Van Meegeren case, an announcement for a public lecture on the biblical Vermeer forgeries, and a review of an English-language book on Van Meegeren's life. Not only did Fowles recognize that Duveen Brothers had sold two fake Vermeers, but apparently, he also had a strong suspicion about the identity of their author.

Fowles did not choose to share any of his thoughts on this subject with the heirs of Andrew Mellon, the powerful Pittsburgh banker who had spent a tidy fortune purchasing those two putative Vermeers from Duveen Brothers. Nor, for that matter, did Fowles rush off and break the bad news to the curators at the National Gallery of Art in Washington, where the two forgeries, having been donated by the unwitting Mellon, were proudly displayed as

genuine works of the master. Of course, no intelligent business-man would have been eager to draw attention to his firm's past mistakes, and Fowles was certainly under no legal obligation to do so. Nonetheless, he does come off as a bit disingenuous in tell-ing the *Herald Tribune* how clever he had been with regard to *The Supper at Emmaus.* That was only half of the story, and not the more interesting half at that.

The National Gallery of Art did begin to wonder about its Ver-meers in the wake of the Van Meegeren court case, as did virtu-ally every museum or collector possessing examples of Vermeer's work that had come to light during the previous quarter century. A lot of careful, critical looking went on during this period, and as a result, most of the fake and misattributed works that had been jammed into Vermeer's oeuvre got excised. Indeed, one of the few indisputably positive developments to come out of the Van Meegeren case is that we now have a far better understanding of who Vermeer was as an artist. Older books on Vermeer, like the 1930 edition of Phillip Hale's monograph, for instance, now make for perplexing—indeed, almost comical—reading because they contain so many weird and unfamiliar pictures. In contrast, pick up the catalogue of the 1996 Vermeer show at the National Gallery of Art, and you'll find that the chaos has been swept away. With no more than thirty-six paintings now firmly attributed to the master, there are certainly fewer Vermeers, but Vermeer is much the better for it.

This process of art historical housecleaning did not happen all at once. Anytime the attribution of a picture is questioned, argu-ments naturally begin to fly back and forth. And even when the general direction of those arguments might be clear, there is of-ten a lingering reluctance on the part of the owner to admit that a prized possession might not be all that it once seemed. In the case of the National Gallery, it took a full twenty years for *The Smiling Girl* and *The Lace Maker* to move, step by step, down

the scale of esteem from "Vermeer" to "Follower of Vermeer" to off-the-wall-and-into-storage. In part, this was due to the technological limitations of picture analysis at the time. By the 1960s, the gallery's curators were convinced that the works were not by the master, but initial lab tests showed that all the pigments were appropriate to the seventeenth century: hence, the "Follower of Vermeer" designation. As further tests began to complicate these findings, enough suspicions were raised that an analysis not just of the pigments but of the paint's medium was authorized, a step that had been put off because it required the taking of very large, damaging paint samples. Ultimately, this was the test that turned up Theo van Wijngaarden's gelatin-glue medium, leaving virtually no doubt that the pictures were of modern manufacture. Only then were they banished from the public galleries.

The de-attribution of *The Girl with the Blue Bow,* another of Van Meegeren's early Sumatrastraat Vermeers, presents a somewhat more disturbing tale. *The Girl with the Blue Bow* had been purchased by an American collector named Charlotte Hyde, who lived in the town of Glens Falls, New York. Over the course of her lifetime, Mrs. Hyde assembled a very fine collection of European and American pictures that are housed today in the museum bearing her name, formerly her home, overlooking the still-active Hudson Valley paper mill once owned by her family. Although Mrs. Hyde generally avoided flashy acquisitions and did not have the financial resources of someone like Andrew Mellon, for the sake of her Vermeer, she had been willing to stretch her budget. At the nadir of the Great Depression, she spent $50,000 on *The Girl with the Blue Bow,* making it the most expensive picture she ever bought. Yet, had the painting been real, $50,000 would have been a bargain.

Even in the 1930s, it had been clear to astute observers like Wilhelm Valentiner that Mrs. Hyde's Vermeer was by the same hand as *The Smiling Girl* and *The Lace Maker.* At first, this had

seemed like a point in favor of the attribution of all three pictures to Vermeer; later, after the war, as the National Gallery began to undertake scientific testing, all three pictures got condemned together. Kept apprised of the research being undertaken in Washington, Mrs. Hyde authorized a similar medium analysis of her Vermeer. Upon learning that it, like the Washington pictures, was a gelatin-glue fake, she became understandably angry.

Mrs. Hyde contacted the well-known New York art dealer Hanns Schaeffer, who had sold her *The Girl with the Blue Bow*, and demanded the immediate return of her $50,000. Schaeffer replied that the original transaction had been somewhat more complicated than Mrs. Hyde understood. Schaeffer had, in fact, never owned *The Girl with the Blue Bow*: he had been acting as the agent of Nathan Katz, who often consigned pictures to the Schaeffer Gallery for sale on the American market. Unfortunately, it was no longer possible for Mrs. Hyde to get in touch with Nathan Katz. Opting not to return to the Netherlands after the war, quite likely due to the stigma he would have faced for having done business with the Nazis, Katz had remained in Switzerland, where the anti-Semitic atmosphere reportedly left him feeling ill at ease. The art market was then in very bad shape, and Katz fell into a severe depression. One day in 1949, while pacing around in his bathrobe by the swimming pool behind his chalet, he committed suicide by gunshot.

With Katz's affairs in considerable disarray and, in any event, no concern of his, Schaeffer informed Mrs. Hyde that he did not feel that he should be held personally responsible for any complaints she might have about her Vermeer. Furthermore, Schaeffer stated that the results of a laboratory test did not, to his mind, do anything to change the intrinsic beauty of *The Girl with the Blue Bow*. In consequence, he suggested that Mrs. Hyde should continue to enjoy her picture as she always had, and he made it quite clear that, under no circumstances, would he refund her money. After consulting a lawyer, Mrs. Hyde learned that it might be difficult to

obtain damages through the courts, as the attribution of a picture would be hard to define with legal precision. Likewise, there was the potential that she could expose herself to embarrassment by attempting to settle the dispute in public. Discouraged, she eventually dropped the entire matter.

Not all art dealers took the same high-handed attitude as Hanns Schaeffer with regard to the questionable Vermeers that had passed through their hands. When Baron Thyssen began to suspect that his "Greta Garbo" Vermeer was perhaps not all that it ought to be, he contacted the Feilchenfeldt family of Zurich, Switzerland, the surviving partners of the Paul Cassirer Gallery, who took the picture back, no questions asked.

Yet, while honorable people did exist in the art world, the other variety continued to thrive as well. Many of the characters from the Vermeer swindles of the 1920s carried on after the war doing what they had always done: moving dodgy merchandise around for each other in the art market. And they were endlessly resourceful individuals. Hans Wendland, arrested after the war for trading in looted art, had complained to the Allies of being old, tired, and sick; he could no longer remember the details of everything he had done; his mind wasn't what it once had been. Apparently, he got a measure of sympathy for all this, but after beating his collaboration rap in court in 1950, Wendland went on selling dubious pictures and telling whopping lies for another twenty years.

Moreover, despite Van Meegeren's tongue-in-cheek prediction at his trial, the business of art forgery did not suddenly grind to a halt after the experts showed off their chemical tests and microscopic photographs in that Amsterdam courtroom. With heightened scrutiny, it was no longer possible to pass off a fake Vermeer, but fake Rembrandts continued to show up on the market from time to time during the 1950s and 1960s; the German forger Christian Goller enjoyed a very nice run producing fake Dürers and Grünewalds during the 1970s; and until Scotland Yard recently

encouraged him to retire, John Myatt had no trouble at all duping the experts at Christie's and Sotheby's with fakes in the style of Matisse, Chagall, Gleizes, and Dubuffet. True enough, today's high-tech machinery has made it considerably easier to prove a picture fake, but generally speaking, by the time a forgery has raised enough questions to prompt scientific analysis, it has already been bought and paid for. In order to make a living, a professional forger seldom has to fool the people with the spectrometers and X-ray machines, just the starry-eyed optimist with the checkbook. In that sense, very little has changed since Van Meegeren's day.

But Van Meegeren remains unique for the way that he tampered with history. John Myatt's fake Dubuffets were painted with K-Y jelly, but stylistically they are faithful to the master, and although Goller's fake Dürers are perhaps not of the highest quality, they at least offer a close approximation of Dürer's aesthetic. Van Meegeren, though, with his biblical Vermeers, had succeeded, however briefly, in bending the past to his will.

EPILOGUE

Framing the Fake

ASIDE FROM THE immediate postwar era, the period of greatest interest in Van Meegeren's case was surely the mid-1960s. Twenty-year anniversaries tend to prompt reappraisals and retellings of past events, and a spate of books appeared on Van Meegeren in English, Dutch, and German as the milestone approached. Although these second-go-around histories were generally much better written than the earlier versions of the story, they were actually far *more* adamant in presenting Van Meegeren as completely anti-Nazi. In these books, Van Meegeren cleverly promotes his biblical Vermeer forgeries while the Second World War looms in the background, almost as a distraction. Back in 1947, the *Saturday Evening Post* had at least alluded to some of the rumors about Van Meegeren's dark leanings. But the charming narratives found in Maurice Moiseiwitsch's *Van Meegeren Mystery* of 1964, Lord Kilbracken's *Van Meegeren: Master Forger* of 1967, and Marie Louise Doudart de la Grée's *No Monument for Van Meegeren* of 1968 grippingly depict the forger as a loyal Dutchman through and through.

Significantly, though, these authors could no longer plausibly claim that Van Meegeren had proved himself the equal of Vermeer

with *The Supper at Emmaus*. No one believed that anymore. With the passage of time, Van Meegeren's masterpiece had come to look, even to his own biographers, not merely implausible as a work of Vermeer but baffling in and of itself. Chalking up the forgery's onetime success to the gullibility of Dirk Hannema and Abraham Bredius, everyone still had a good laugh. But by this point, Van Meegeren had come to be seen more as a master of deception and intrigue than of painting—a sensitive, misguided soul motivated by the unfeeling cruelty of the world around him.

It was not until 1979 that the flaws in this version of events began to show. That year saw the publication of *Een vroege Vermeer uit 1937*—"An early Vermeer from 1937"—the dissertation of a young Dutch doctoral student by the name of Marijke van den Brandhof. Combing through the Dutch state archives, Van den Brandhof had discovered, initially to her great dismay, extensive documentary evidence of Van Meegeren's wartime collaborationist

Marijke van den Brandhof
in 1979

activities. It was she who first revealed that Van Meegeren had received direct commissions from the occupation government, that he had given money to Nazi causes, and that he had sought out the patronage of the odious Ed Gerdes. An adept researcher, Van den Brandhof was able to reconstruct and evoke much of the reactionary milieu in which Van Meegeren operated, yet some details of the story eluded even her. Perhaps most notably, the nature and extent of Van Meegeren's early career in forgery and the volkisch background to his biblical Vermeers remained uncharted territory. Although never translated, *Een vroege Vermeer* is a truly outstanding book, by far the best and most rigorous one ever written on Van Meegeren. Had its author not died at a tragically early age, she would undoubtedly have continued to make original and important contributions to the field.

In 1979, though, it would still have been extremely difficult for anyone to perceive or understand the specific trends in visual culture that had suffused Van Meegeren's biblical Vermeers. For reasons of custom and propriety, the display of Nazi imagery, even in an educational context, was strenuously discouraged for decades after the war, more or less throughout the world. In Germany, due to de-Nazification decrees, it was actually illegal. But mostly, this wasn't the sort of ban that required laws to enforce it. The postwar healing process naturally meant that old copies of Heinrich Hoffmann's picture books on Hitler, as well other similar pieces of ephemera, got stowed away in the attic, where they could be forgotten along with the painful memories that went along with them.

Even today, it remains quite unlikely that any museum or gallery would wish to mount a retrospective exhibition of a middlebrow Nazi artist like Hans Schachinger, for instance. Little studied, the mode of *Volksgeist* painting practiced by Schachinger and his peers remains a lost and unlamented episode in art history. In consequence, *The Supper at Emmaus,* stripped of its frame of reference, is now like a road sign pointing to a town that got wiped

off the face of the earth. When confronted with the great forgery at the Boijmans Museum, present-day visitors tend to come away bewildered. Clearly, this picture doesn't look at all like the work of Vermeer to us anymore, but what *does* it look like? The widespread praise that *The Supper at Emmaus* once garnered now seems completely incomprehensible, and the work itself, on a very basic level, simply does not compute.

Not only do we lack the arcane pictorial knowledge required to decipher coded Nazi imagery, but the entire atmosphere that shaped the emotional appeal of *The Supper at Emmaus* has faded away to the farthest reaches of living memory. Only the very elderly can still recall how the Axis dictators, during their dramatic rise to power, began to weigh on the minds and affect the thinking even of entirely reasonable people—including those who did not necessarily share the fascist viewpoint. With their hectoring agenda, the strongmen of Europe hijacked the world stage and, in doing so, distorted the very realm of perception itself, both inspiring and allowing the fraud of *Emmaus*. To imagine a scenario in which this picture might still be accepted as a seventeenth-century masterpiece, one would have to conjure up an alternate universe where European fascism lived on and flourished; where the grandiose mythology of authoritarian culture achieved a venerable old age; where the imagery of *Emmaus*, with its puffed up sentimentality and faux Counter-Reformation drama, could have continued to pass for sheer genius. For that is the only place where this particular fake could still have cast its spell after the war—a nightmare world where Hitler won.

With that nightmare kept safely at bay, however, Van Meegeren's career has, over the years, frequently been conceived as a story of the *Hogan's Heroes* variety, one that transforms the tragedy of the Nazi era into light comedy. For instance, an anecdote, much repeated, holds that Hermann Goering, while awaiting trial at Nuremberg, was transfixed with horror when he learned that his

prized Vermeer had turned out to be a fake, "as though it were the first time he had discovered there was evil in the world." Like so many other tales that have cropped up around Van Meegeren, this one appears to be apocryphal, invented long after Goering's death.

Goering's innermost thoughts on the subject of Han van Meegeren are lost to history, but we do know a bit about Goering's ideas on deception and the twisted joys to be found in its use. During his time at Nuremberg, Goering was interviewed extensively by a psychologist named Gustave Gilbert, who was given access to the major Nazi defendants by the Allies. Hoping to gain insight into the mental processes of these individuals, who had caused pain and suffering on a truly staggering scale, Gilbert tried to draw them out on the big questions of the day—war and peace, right and wrong, innocence and guilt. On April 18, 1946, Gilbert elicited Goering's opinions about all of these subjects simultaneously, simply by making a single provocative statement. Most people, Gilbert observed, don't want war or the destruction that it causes and are not grateful to leaders who bring such things to pass. Goering, surprisingly, nodded in agreement and said that this was all quite true: most people *don't* want war, and moreover, they have nothing to gain from it. But, Goering added, there are those who know how to control the minds of men.

"The people can always be brought to the bidding of the leaders," Goering said. "That is easy. All you have to do is tell them they are being attacked and then denounce the pacifists for lack of patriotism and exposing the country to danger. It works the same in any country."

As a prisoner at Nuremberg with the prospect of the gallows looming in his future, Goering, as he himself knew, had no real influence over world events anymore. His big talk, although quite chilling, was now just empty bravado. His power, his position, his place in the scheme of things had all been based on lies, doomed,

sooner or later, to fail. And in that regard, the former head of the Luftwaffe resembled no one quite so much as his Dutch doppelganger, his victimizer, the creator of the ever-so-costly painting that had once adorned the walls of Carinhall—Han van Meegeren, the man who made Vermeers.

ACKNOWLEDGMENTS

IN GETTING TO THE BOTTOM of Han van Meegeren's story, I've been aided at every turn by generous and well-informed people who took an interest in my research and were willing to lend a hand.

I would like to offer my sincere thanks, first and foremost, to Walter Liedtke, curator of European paintings at the Metropolitan Museum of Art, who not only read and commented on preliminary drafts of the book and several articles derived from it—sharpening the arguments along the way—but also facilitated many of my contacts with Dutch museum officials and New York art dealers. What's more, Liedtke graciously put me in touch with his colleague Dorothy Mahon, head of paintings conservation at the Metropolitan, who guided me through a detailed examination of Jules Bache's two ill-fated Vermeer acquisitions, now kept in the Metropolitan's storage areas; in addition, Mahon provided a wealth of background information that has enlivened the discussion of the technical aspects of picture analysis throughout this book.

The advice and assistance of Arthur K. Wheelock Jr. have been invaluable. Wheelock, who is curator of northern Baroque

painting at the National Gallery of Art, helped me to refine the focus of my project during our discussions in Washington and also through our subsequent correspondence. My investigations into the background and professional associations of the swindler Harold Wright were initially prompted by Wheelock's 1996 essay "The Story of Two Vermeer Forgeries," which, in my opinion, is the best article ever written about fraudulent artworks. Wheelock shared with me his private research files and accompanied me to have a look at Andrew Mellon's two spurious Vermeers in the gallery's store rooms. Wheelock's colleague Anne Halpern, in the gallery's Department of Curatorial Records, has been a constant source of help and moral support throughout this project and has aided me more than I could hope to acknowledge here. Nancy Yeide, head of the Department of Curatorial Records, generously shared with me several crucial details from the research for her forthcoming catalogue raisonné of Hermann Goering's art collection. Marlene Justsen, in the gallery's archive division, was of considerable assistance, as were Lamia Doumato and John Hagood in the gallery's library.

Erin Coe, the director of the Hyde Collection in Glens Falls, New York, made my visit to that hidden gem of a museum even more delightful than it would otherwise have been through her intelligent observations on the history of the collection, her remarkable good nature, and her very obliging decision to allow me unfettered access to *The Girl with the Blue Bow* as well as to the curatorial and conservation dossiers relating to it. Barbara Rathbone, the registrar of the Hyde Collection has also been unstintingly kind. Likewise, no account of my profound debt of gratitude to American museum people would be complete without mentioning several friends at the Philadelphia Museum of Art: curator Joseph Rishel, assistant curator Lloyd DeWitt, adjunct curator Carl Strehlke, and department secretary Jennifer Vanim, all of whom assisted in my research into the infamous art dealer Leo Nardus.

Thanks also to Judy Throm at the Archives of American Art in Washington, D.C., and to Greg Bradsher and John Taylor at the National Archives and Record Administration in College Park, Maryland.

In England, Jon Whiteley, the keeper in the Department of Western Art at the Ashmolean Museum of Art and Archaeology, Oxford, was studying an antique violin with the aid of a magnifying glass when I first met him in the Ashmolean's print room. Further acquaintance only strengthened my belief that his is an intellect in the Holmesian mold. I am very much indebted to him for showing me Van Meegeren's portrait of Theodore Ward in the Ashmolean's storage rooms and for allowing me access to the records of the Ward Collection. I would also like to thank Ernst Vegelin van Claebergen, head of the Courtauld Gallery; Marijke Booth of Christie's archive division; and Annet Smit and Philippien Noordam of the Dutch Embassy in London for aiding in the British side of my research. In nearby Ireland, special thanks are due to Sue Kilbracken, widow of the late John Godley, 3rd Lord Kilbracken. It is a source of great pride to me that Lord Kilbracken expressed an interest in my project during the last year of his life and a source of terrible sadness that he did not get to see the work come to fruition. Sue's many thoughtful gestures—including sharing items from her husband's private papers—have been a genuine help and are greatly appreciated.

At the Museum Boijmans-Van Beuningen in Rotterdam, Jeroen Giltaij, head curator of old-master paintings, deserves abundant thanks not only for allowing me to inspect the four Van Meegeren forgeries stored at the Boijmans but for gamely rummaging through the museum's archival holdings with me: we turned up several items that even he was surprised to find. Jacqueline Rapmund, curator of modern art at the Boijmans, in whose department the forgeries are catalogued, was extremely helpful, as was Albert J. Elen, senior conservator of the print room. At

the Rijksmuseum, research curator Jonathan Bikker was a key source of advice; my thanks also to Dennis Kemper, the manager of the Rijksmuseum's off-site storage facility, for his help during my visit to see the five Van Meegeren forgeries held in Lelystad. At the Instituut Collectie Nederland, the director, Eric Domela-Nieuwenhuis, extended every courtesy to me during my appointment to see the two Van Meegeren forgeries stored in Rijswijk, a visit thoughtfully arranged by Yuri van der Linden. At the Groninger Museum, the director, Caspar Martens, graciously allowed me to examine *The Boy Smoking,* which was shown to me by Bert de Jonge, the storage depot manager, who then kindly escorted me back to civilization from the industrial environs of Aduarderdiepsterweg, for which I am truly grateful. Heartfelt thanks go out also to Mar Barobia, chief curator of old master paintings at the Museo Thyssen-Bornemisza, Madrid, for helping to research the history of *The Girl in Antique Costume.*

In conducting my Dutch archival research, I benefitted greatly from the expert guidance of my friends Sjoukje Atema and Paul Kempff at the Haags Gemeentearchief. Sjoukje took a keen interest in this project at a very early stage and alerted me to many intriguing possibilities for fruitful investigations in the state, municipal, and private archives of the Netherlands. She and Paul started me down the right road, and I thank them for keeping me on it straight through to the end. In the archival realm, additional thanks are due to the following individuals: J.E.A. Boomgaard, Corinne Staal, and Erik Schmitz at the Amsterdam Gemeentearchief; Eveline Kaiser and Bas van der Wulp at the Regionaal Historisch Centrum Delft; Monique van der Pal at the Internationaal Instituut voor Sociale Geschiedenis; Victor Olivier at the Koninklijke Bibliotheek; F.F.J.M. Geraedts at the Gemeentearchief Leidschendam-Voorburg; S.A.J. Faassen and Anneke Menting at the Letterkundig Museum; A.R.M. Sacher-Flaat and Liesbeth Strasser at the Nationaal Archief; René Pottkamp at the Nederlands Instituut voor

Oorlogsdocumentatie; Hans van Felius, Gerda Houweling, and Paula Someren at the Rijksarchief in Noord Holland; Fred Meijer, Rieke van Leeuwen, Sabine Craft-Giepmans, and Lidy Visser at the Rijksbureau voor Kunsthistorische Documentatie; and Carla de Glopper-Zuijderland at the Gemeentearchief van Wassenaar. Across the border in Germany, Jörn Grabowski of the Zentralarchiv der Staatlichen Museen Preußischer Kulturbesitz was of considerable assistance, as was Uwe Porten, who coordinated the Berlin phase of my work.

Some of the most gratifying research for this book consisted of interviews with private individuals who were willing to share their family histories, personal reminiscences, or particular research interests with me. The descendants of the forger Theo van Wijngaarden were especially kind in discussing the life and accomplishments of their colorful ancestor. My first contacts with the family were made through the gregarious Willem van Wijngaarden of Amsterdam. Willem then introduced me to his elderly mother, Nettie, now deceased, who could still remember "Old Theo" quite vividly. So could Willem's aunt, Adriana. A professional portraitist, Adriana is the family's matriarch, archivist, and unofficial historian; she eventually became my most significant source of information on Theo van Wijngaarden's career. Adriana's sons, Dirk and Willy Coenradi were also extremely helpful. Likewise, it was in response to Adriana's urging that I initially sought out contact with the art dealer Saam Nijstad, who had, in the days of his youth, known Adriana's father, the art restorer Willy van Wijngaarden. As it turns out, Nijstad—who may well be the most charming man I've ever met—was also acquainted with virtually everyone else in the Dutch art world of days gone by, and our conversations and correspondence have been most enlightening. I would also like to thank several other dealers, or representatives of dealers, who helped me: Walter Feilchenfeldt of the Galerie Feilchenfeldt in Zurich; Florian Eitle-Böhler and Jutta

Fianke of the Kunsthandlung Julius Böhler in Munich; and Joseph Baillio and Eliot Rowlands of the Wildenstein Gallery in New York. Further thanks are offered here to the following individuals for their assistance: Serge Nardus, Patrick Neslias, Geneviève Tellier, Jean-Luc Pypaert, Lee Richards, Jim van der Meer Mohr, Dominic Holzapfel, and Paul van Meegeren.

Many of the works reproduced in these pages belong to kindhearted collectors or private owners who welcomed me into their homes and allowed me to photograph their paintings. Leon Vosters, who has assembled probably the world's finest collection of Van Meegeren's legitimate work, allowed me to remove several of his most prized pictures from their frames in order to light them better and even provided a set of screwdrivers and wrenches for the work. Many thanks to him and Jan Uriot for their hospitality. The Vriesendorp family, many of whose older members were painted by Van Meegeren in the 1920s, gave me an astonishingly warm welcome in response to my inquiries—and, in fact, did so on both sides of the Atlantic. In America, thanks go out to Huib and Francine Vriesendorp; in the Netherlands, to Adrienne, Alexander, Bien, Frans, Gijs, Herman, Jaap, and Willem Vriesendorp, as well as to K. W. Cuperus and his son J. W. Cuperus. And a very special thanks to Mevrouw J. Dutilh-Vriesendorp, who is just as delightful to behold today as she was when Van Meegeren painted her portrait eighty-two years ago. Beyond the precincts of the Vriesendorp clan, I would like to express my gratitude to Mevrouw M. van Heeckeren van Molecaten-Van der Leeuw for her generous permission to examine the portraits that Van Meegeren painted of her late husband's family, as well as for a very pleasant and memorable afternoon of conversation. Many thanks also to Gerbert van Genderen Stort, Willem and Hanneke Avenarius, and Robert and Lous Crommelin.

This book grew out of an article published two years ago in *De Groene Amsterdammer*, where the deputy editor, Koen Kleijn, felt

so strongly about the piece that he successfully lobbied to run it as a cover story. For that and a thousand other kindnesses since, I will remain forever in Koen's debt. Other portions of the book were developed and published in the pages of *Apollo,* where the editor in chief, Michael Hall, has been a staunch supporter and ally. The book ultimately blossomed under the direction of Andrea Schulz, my editor at Harcourt. Her shrewd judgment and unerring eye for detail have helped me compose a text far stronger, sharper, and more elegant than I could ever have hoped to produce on my own. Indeed, I believe that I have learned more about writing from Andrea than I learned at Harvard—about anything. My most sincere thanks to her, to her assistant editor, Lindsey Smith, and to Harcourt's managing editor, David Hough. A special mention must also be made of my agent Rob McQuilkin: through his constant encouragement and consummate skill in shepherding this project through to completion, he has made my work virtually stress-free. Every writer should be so lucky.

Several personal friends helped in various ways during the three years of work that went into this book. In particular, I'd like to express my gratitude to Ingrid and Michael Edelson, Yolanda Gerritsen, Laela Kilbourn, Sarah Lawrence, James and Michelle Nevius, John Reardon, Ethan Robey, Maurie Samuels, Kathi Stock, and Carrie Weber. My wife Laura, to whom this book is dedicated, has intentionally been left for last in this list, but she could never be taken for least. She means everything to me. There would be no book without her. We got through this together.

Endnotes

Abbreviations Used in the Notes

AAA Archives of American Art (Washington, D.C.)
AGA Amsterdam Gemeentearchief
AHC Archives of the Hyde Collection (Glens Falls, New York)
ALIU Art Looting Investigation Unit
AM Ashmolean Museum of Art and Archaeology (Oxford)
AMG Allied Military Government
ARA Algemeen Rijksarchief (The Hague)
CHR Christie's Archive (London)
DBR Duveen Brothers Records
GTY Getty Art Research Institute (Los Angeles, California)
HDG Archief Hofstede de Groot
HGA Haags Gemeentearchief (The Hague)
JSR Jacques Seligmann Records
MMA Metropolitan Museum of Art (New York)
NARA National Archives and Record Administration (College Park, Maryland)
NGA National Gallery of Art (Washington, D.C.)
NHA Noord Hollands Archief (Haarlem)

NIOD Nederlands Instituut voor Oorlogsdocumentatie (Amsterdam)
ORION Counter-intelligence service of which ALIU was a part
RKD Rijksbureau voor Kunsthistorische Documentatie (The Hague)
RWC Records of the Ward Collection
VDB Archief Van den Brandhof
ZSMB Zentralarchiv der Staatlichen Museen zu Berlin

NOTE: To maintain consistency, the European convention of day/month/ year notation has been used throughout the endnotes. All translations of foreign language source material are by the author unless otherwise indicated.

INTRODUCTION: *A Liar's Biography*

PAGE

1 "*the* masterpiece of Johannes Vermeer of Delft": A. Bredius, "A New Vermeer," *Burlington Magazine* LXXI (1937): 211.
4 "between him and my father and mother": AM/RWC, box 1.
8 Van der Veken: Allied intelligence reports describe Van der Veken, who was closely associated with Goering's art curator, Walter Hofer, as "violently pro-German," adding that he "professed his hopes for a German victory to Hofer in writing." Van der Veken also praised "the great Germanic plan for a new Europe." See: preliminary name list for ALIU reports, NARA, M1944, reel 9. Also: NARA, RG260, box 437. Thanks to N. Yeide for this citation.
8 Icilio Joni: In his memoirs, Joni states that he was one of Mussolini's earliest followers. He also extols the fascist movement, "which has done so much to raise our dignity as a nation." See: I. F. Joni, *Le memorie di un pittore di quadri antichi* (Siena: Protagon, 2004), 307, 313.

CHAPTER ONE: *The Collaborator*

PAGE

11 Shortly after 9:00 in the evening: Details of Van Meegeren's arrest as per deposition of Joseph Piller, 21 July 1945, NHA, arch. 466/261.
12 "sold a group of Flemish Primitives": *Ibid*.
12 remained stoic and inscrutable: Van Meegeren's recollection as reported by Marie-Louise Doudart de la Grée, *Geen standbeeld voor Han van Meegeren* (Amsterdam: Nederlandsche Keurboekerij, 1964), 14–15.

14 instructing him to write down the names: Van Meegeren's recollection
 in newspaper interview, *Amersfoortse Courant*, 19 July 1946.

14 "tried to get me to talk": Doudart de la Grée, *Geen standbeeld*, 15.

14 "didn't like collaborators": Piller interviewed in A. Venema, *Kunst-
 handel in Nederland 1940–5* (Amsterdam: Arbeiders, 1984), 508.

15 "simple Jewish boy": H. A. van Wijnen, "Leider Onder de Grond,"
 NRC Handelsblad, 13 January 1998 (obit.). On Piller's wartime career:
 L. de Jong, *Het Koninkrijk der Nederlanden in de Tweede Wereldoorlog*
 (The Hague: Nijhoff, 1982), vol. 7, pt. 2, 913; *Enquêtecommisie Re-
 geringsbeleid 1940–1945* (The Hague: Staatsdrukkerij, 1950), vol. 4A,
 274–275; vol. 4C, 1320–1323; B. de Graaff, *Schakels naar de vrijheid:
 pilotenhulp in Nederland tijdens de Tweede Wereldoorlog* (The Hague:
 Sdu Uitgevers, 1995), 73; Graeme Warrack, *Travel by Dark after Arn-
 hem* (London: Harville Press, 1963), 199.

16 Alois Miedl: accounts and descriptions as per P. den Hollander, *De
 zaak Goudstikker* (Amsterdam: Meulenhoff, 1998), 65–85, 147–148.

16 front . . . for the Nazis' Abwehr: Piller's theories as per Allied intelli-
 gence report, "ORION trip to Holland 13 to 18 July 1945," and associ-
 ated correspondence in the "Netherlands" and "Miedl" files, NARA,
 M1944, reel 90. Also: N. N., "Een Nederlandsche Bankrelatie van den
 Duitschen Spionnagedienst," *Finantieel Weekblad voor den Fondsen-
 handel*, 21 December 1945.

17 "went to Van Meegeren for an explanation": Deposition of Joseph
 Piller, 21 July 1945, NHA, arch. 466/261.

17 could link him to the Vermeers through various dealers and straw-
 men: Prior to Van Meegeren's confession, Piller made contact with
 D. A. Hoogendijk, R. Strijbis, J. Kok, P. de Boer, and P. J. Rienstra van
 Stuyvesande. Piller also interviewed Van Meegeren's wife, Johanna,
 about Van Meegeren's rumored Nazi connections. See: Marijke van
 den Brandhof, *Een vroege Vermeer uit 1937* (Utrecht: Spectrum, 1979),
 144, nn. 82, 94; 145, n. 4. Also: Deposition of P. de Boer, 26 July 1945,
 NHA, arch. 466/261; and *Amersfoortse Courant*, 19 July 1946.

17 interrogation facility on the Apollolaan: Van Meegeren's recollection
 in interview with the *Amersfoortse Courant*, 19 July 1946. This was
 probably Apollolaan 7.

18 suggested that Miedl was prepared to testify: Piller's recollection
 as reported by H. A. van Wijnen, "Het Meesterwerk van Johannes

Vermeer van Delft," *Han van Meegeren en zijn meesterwerk van Vermeer* (Zwolle: Wanders, 1996), 89.

18 "he said: 'I did it.'" Piller interviewed in Venema, *Kunsthandel,* 507. The events surrounding Van Meegeren's confession are documented in greater detail in the notes for Chapter Nine, especially with regard to sequence and time frame.

18 distinctly difficult to believe: Depositions of D. Hannema, A. M. de Wild, H. G. Luitweiler, and J. van Dam, 29 June–7 July 1945, NHA, arch. 466/261.

20 "this report has expunged them": *De Waarheid,* 11 July 1945. In her otherwise excellent *Een vroege Vermeer,* Van den Brandhof states, "The earliest mention I have found of the forgery matter was in the *Knickerbocker Weekly* of 28 June 1945" (p. 13). She is mistaken. The article to which she refers appeared on 6 August and mostly repeats the accounts of *Newsweek* and *Time* from the previous week. There are no newspaper accounts of the forgery matter prior to 13 July 1945. Presumably, Van den Brandhof was working from an incorrectly labeled item in a clipping file. Piller informed Allied military intelligence of the forgeries on 12 July, probably through J. G. van Gelder: NARA, M1944, reels 40, 90.

CHAPTER TWO: *Beautiful Nonsense*

PAGE

22 only one known photograph: Photo taken by Henricus Rol ca. 1930; copy on file with the private papers of Dr. Arthur K. Wheelock Jr., NGA. On Wright generally, see: Wheelock, "The Story of Two Vermeer Forgeries," *Shop Talk: Studies in Honor of Seymour Slive* (Cambridge, MA: Harvard Art Museums, 1995), 271–275.

22 first appearance in the records of Christie's: Annotated catalogues and daybooks for sale of 25 February 1924, lots 89, 106, 139, and 140. CHR.

22 son of a Nottinghamshire iron worker: *1901 England Census,* RG 13/3198, fol. 114/20. London, Family Records Centre.

22 earning both a commendation and a temporary commission: London, National Archives, Service Medals and Award Rolls Index, WO/372/22.

23 an Amsterdam antique shop: C. Hofstede de Groot, *Jan Vermeer en Carel Fabritius* (Amsterdam: Van Holkema, 1930), suppl. II, 50.

23 as many as a hundred people each week: ZSMB, Anforderung von Gutachten, I/GG no. 290–1; Nachlass Bode, NL 415–416.

23 "still half that of a child": GTY/DBR, box 300, file 3.

23 "we shall be glad to make an exception": Letter from Bode to Wright, 31 June 1927, GTY/DBR, box 300, file 3.

24 paint company located in suburban Leidschendam: *Van Nierop & Baaks Nederlandsche Naamlooze Vennootschappen* (Amsterdam, Van Nierop & Baak, 1932), 479. That Wright was good at golf: author interview with N. van Wijngaarden, 8 August 2005.

24 Theo van Wijngaarden's atelier at Sumatrastraat 226: Accounts and descriptions of Theo van Wijngaarden, here and generally, based on author's interviews with A. van Wijngaarden, N. van Wijngaarden, W. van Wijngaarden, D. Coenradi, and W. Coenradi, various dates, April 2004 to March 2007.

24 "the city of beautiful nonsense": W. P. F. van Deventer, "Floodlights on The Hague," *Wat niet in Baedeker staat: het boek van Den Haag,* ed. H. Martin & E Veterman (Amsterdam: Strengholt, 1932), 161.

25 the third of five children in a middle-class Catholic family: The most reliable source on Van Meegeren's early life is Van den Brandhof, *Een vroege Vermeer,* 19–30; also useful on Van Meegeren's family relationships is F. Kreuger, *Han van Meegeren: Meestervervalser* (Diemen: Veen, 2004).

29 "a painter destined to walk the path of acclaim": *De Kroniek,* September 1916, quoted in Van den Brandhof, *Een vroege Vermeer,* 41.

30 "very pretty . . . a timid man": Letter from L. J. C. Boucher to M. van den Brandhof, 17 August 1979, RKD/VDB, box 1, corr. file A–G.

30 "back then it was really scandalous": Letter from P. Glazener to M. van den Brandhof, 7 February 1976, RKD/VDB, box 1, corr. file A–G.

30 Anna . . . sought the comforts of another man: Letter from N. Veenstra to M. van den Brandhof, 4 October 1975, RKD/VDB, box 1, corr. file H–Z.

30 "with a lot of zeroes in it": Letter from P. Glazener to M. van den Brandhof, 7 February 1976, RKD/VDB, box 1, corr. file A–G.

31 "various young painters at work": A. Houbraken, *De Groote Schouburgh der Nederlandsche Kunstschilders en Schilderessen* (Amsterdam), 3 vols., 1718–1721, as discussed in A. Huiberts and S. Kooistra, *Valse kunst: hoe de kunstkoper bedrogen wordt* (Amsterdam: Veen, 2003), 187.

31 Ely Sakhai: *New York Times*, 16 June 2004.

32 acted as impresarios: G. Mazzoni, "La cultura del falso," *Falsi d'autore* (Siena: Protagon/Istituzione Santa Maria della Scala, 2004), 59–79.

32 Baron Michele Lazzaroni: M. Secrest, *Duveen* (New York: Knopf, 2004), 108, 251.

32 Emile Renders: H. Verougstraete and R. van Schoute, "Vlaamse Primitieven Onderzocht," *Fake/Not Fake: Het verhaal van de restauratie van de Vlaamse Primitieven* (Gent-Amsterdam: Ludion/Groeningemuseum, 2005), 24–34. This book is also the source in this section on Van der Veken generally.

34 more often than not: Some forgeries of major Dutch masters did get sold during this period, most notably in America, but we tend to know about these items because they were fairly easy to expose once suspicions were raised. See, for example, a letter from J. Stillwell to C. Hofstede de Groot, 2 July 1910, regarding a fake Van Goyen: RKD/HDG, inventaris 61. Also: P. Eudel, *Trucs et Truqueurs* (Paris: Librairie Molière, 1907), 420–447, 451.

34 Van Ostades for sale . . . in a grocer's window: M. J. Brusse, *Knoeierijen in den schilderijenhandel* (Rotterdam: Brusse, 1926), 52–53.

35 couldn't write more than a few halting lines: *Nieuwe Rotterdamsche Courant*, 18 June 1926.

36 Nardus's has been intentionally expunged: on the art-dealing career of Leo Nardus, see J. Lopez, "Gross False Pretences," *Apollo* (December 2007): 76–83. Subsequent to the publication of the *Apollo* article, it was brought to my attention that Esmée Quodbach had discovered several documents in the Netherlands closely related to the ones I had found in Philadelphia on the Nardus matter. These were published by her in an excellent essay on Cornelis Hofstede de Groot included in the exhibition catalogue *Van Cuyp tot Rembrandt* (Groningen: Groninger Museum, 2005), 65–79. My apologies to Quodbach for my earlier oversight, which I take great pleasure in now being able to correct.

37 retiring to a seaside palace in Tunisia: E.-K. Narriman, *Léo Nardus: un peintre hollandais en Tunisie* (Carthage: L'Espace Sophonisbe, 1997), 9.

Contemporary newspaper accounts indicate that Nardus left the Netherlands sometime between 1918 and 1920 and settled first in Paris before moving to Tunisia: *Het Vaderland* (The Hague), 7 December 1920.

38 Van Wijngaarden's activities included: Brusse, *Knoeierijen*, 86–89; Wheelock, "The Story of Two Vermeer Forgeries," 273; and author interviews with the Van Wijngaarden family.

38 A. H. W. van Blijenburgh: The standard and seemingly apocryphal story is that Van Wijngaarden, upon visiting the home of Van Meegeren's landlord, was so impressed with a painting Van Meegeren had bartered to pay the rent that he immediately sought to meet the young artist. In the 1970s, Marijke van den Brandhof tracked down the landlord, who had no recollection of any such incident. See: *Een vroege Vermeer*, 67. A. H. W. van Blijenburgh won an individual bronze medal at the 1906 Olympics; Nardus won a bronze at the 1912 Olympics with the Dutch team. Nardus fenced with A. H. W. van Blijenburgh in competition in England in 1910. That Van Meegeren and A. H. W. van Blijenburgh were close is apparent from the content of Van Blijenburgh's many contributions to *De Kemphaan*.

40 family still has the book: With Van Wijngaarden's signature and handwriting inside, it is called *Handboek voor Schilders*, by P. H. Bartels, published by A. E. Kluwer in 1918, indicating that Van Wijngaarden hit upon the gelatin-glue formula after that date. Van Wijngaarden was, to some extent, refining an existing forger's trick: that of smearing an alcohol-resistant barrier of gelatin over the surface of a fake painted in oils. This earlier maneuver was, in practice, only of limited use: the softness of the underlying paint and brittleness of the gelatin generally led to flaking and adhesion problems within a short period of time; likewise the gelatin tended to leave a telltale milky haze. Leo Nardus may have used this technique: some of the pictures he sold to P. A. B. Widener developed dramatic blisters and peeling soon after purchase. Letter from Nardus to John G. Johnson, 11 November 1905, Philadelphia, Archives of the Philadelphia Museum of Art, Records of the John G. Johnson Collection, box 5, file 5.

41 the rumors center on works by Frans Hals: Kreuger, *Meestervervalser*, 175.

43 Americans, who came to Italy expressly looking for fakes: In his introduction to Joni's memoirs, G. Mazzoni notes that one of these dealers

was the well-known Frederick Mason Perkins. See: Joni, *Memorie,* Protagon ed., 6.

43 a very dubious Frans Hals *Boy with a Flute*: Listing this item as no. D 6-5, Seymour Slive states that it is "probably a modern copy"; that it was stolen from Belgium during the war; and that its present whereabouts are unknown: Slive, *Frans Hals* (London: Phaidon, 1972), vol. 3, 130. On the relationship between Nardus and Van Gelder: Lopez, "Gross False Pretences," 82.

44 incident that occurred at the baronial estate of Molecaten: Author interview with Mw. M. van Heeckeren van Molecaten, 25 August 2006. See also: Van de Brandhof, *Een vroege Vermeer,* 11.

44 belonged to the same Catholic student group: Regionaal Historisch Centrum Delft, Archief Studentenvereniging Sanctus Virgilius, arch. 352, inventaris 335.

44 a wife and five children: The couple ultimately had a total of seven children, the last two born in 1925 and 1929. Gemeentearchief Wassenaar, Bevolkingsregister 1897–1934, vol. IV, p. 8.

45 As De Haas later recalled: Handwritten notes from M. van de Brandhof's interview with De Haas, ca. 1976. RKD/VDB, box 1, nn. file.

45 home was adorned with a half dozen oil paintings: De Haas lent eight items (most made prior to 1922) to a Van Meegeren exhibition held at the Kortrijk Stadsmuseum in 1961: exhibit pamphlet, RKD/VDB, box 3.

45 30,000 guilder purchase price: Receipt of sale, RKD/HDG, inventaris 78. Account of the case from the criminal complaint, RKD/HDG, inventaris 78, and from C. Hofstede de Groot, *Echt of Onecht? Oog of chemie? Beschouwingen naar aanleiding van het mansportret door Frans Hals uit het proces Fred. Muller contra H.A. de Haas* (The Hague: Van Stockum, 1925). Where contradictions on matters of fact exist, the court documents are favored. The technical anachronisms of *The Laughing Cavalier* also included the presence of synthetic ultramarine blue, traces of cobalt blue, and the fact that machine-made, nineteenth-century nails were embedded in the panel: their entry holes had been painted over by the image, indicating it was of later vintage than the nails themselves.

48 "They should wish that they could paint that way": *Het Vaderland,* 10

June 1926. On Hofstede de Groot's visit to the Sumatrastraat: *Oog of chemie*, 13.

49 corruption . . . in the eyes of his many critics: Brusse, *Knoeierijen*, 96.

49 "I am so much wanted everywhere": Letter from Hofstede de Groot to R. F. Yeo, 20 November 1911, RKD/HDG, inventaris 81.

CHAPTER THREE: *The Sphinx of Delft*

52 "picked one of the five greatest artists": Van Meegeren's sworn statement, as read into evidence by J. Piller, 21 July 1945, NHA, arch. 466/261.

53 for all of 2½ guilders at a small auction in The Hague: A. B. de Vries, *Jan Vermeer* (Amsterdam: Meulenhoff, 1939), 84.

53 dreaming about Vermeer: M. J. Friedländer, *Kunst en kennerschap*, trans. A. Berendsen (Leiden: Stafleu, 1948), 223.

53 "not answered": Letters from A. G. H. Ward to Hofstede de Groot, 14 May 1922, 12 October 1922, 4 December 1922, 1 February 1923, RKD/HDG, inventaris 69.

54 the image disintegrated: Cable, Paris to New York, 20 November 1929, GTY/DBR, box 300, file 1.

54 was called into question by outside experts: Cable, Paris to New York, 25 November 1927, and letter, Bache to Duveen, 1 May 1929, GTY/DBR, box 300, file 5. Bache gave this picture to the MMA (cat. no. 49.7.39) with the rest of his collection in 1949. Any "saucing" or repaints that may have remained on the picture were definitively removed by the Met's conservation department in 1971. What remained was a good seventeenth-century French picture, although one with large zones of paint loss. Approximately 30 percent of the surface area (including a horizontal band across the boy's eyes) had to be inpainted. The in-paints were performed by the Met simply to complete the image and stabilize the surface. This picture is generally kept in storage, and neither it nor *The Young Woman Reading* (49.7.40) was ever exhibited by the MMA as a Vermeer from the time of the 1949 Bache bequest. Many thanks to Dorothy Mahon, of the Met's conservation department, for discussing this picture with me and allowing me to examine it on 14 December 2006.

55 "too small": Letter titled "Re: Newly Discovered Vermeer de Delft," 22 June 1925, misfiled with material on *The Smiling Girl*, GTY/DBR, box 299, file 14.

55 *The Young Woman Reading*: Duveen's decision in GTY/DBR, box 300, file 4. On the attribution, Walter Liedtke discusses his and my opinions at length in *Dutch Paintings in the Metropolitan Museum of Art* (New York: MMA, 2008), vol. 2, 902–906. As Liedtke notes, Jonkheer David Roëll, then director of the Rijksmuseum, asserted on 23 February 1954, during a visit to the Met, that the picture was "by Jef van der Veken." The reasoning behind Roëll's statement is not known. Jean-Luc Pypaert, author of the forthcoming Van der Veken catalogue raisonné, kindly gave me his opinion by private communication on 1 March 2007: "I am definitely not able to discern Van der Veken's very distinctive style in the Bache painting." Pypaert added that there is no indication that Van der Veken ever worked on canvas or ever attempted to forge works dating from after 1600.

56 bad reputation during the Second World War: L. Nicholas, *The Rape of Europa* (New York: Knopf, 1995), 101. That Bloch bought for Nazis on commission: ALIU, "Detailed Investigation Report #4," NARA, M1782.

56 Looted Jewish art was found in Bloch's private collection: For instance, a still life by Dirck van Delen stolen from the Schloss collection in Paris. Illustrated (no. 14) in J. C. Ebbinge Wubben, *Legaat Vitale Bloch* (Rotterdam: Boijmans Museum, 1978). The painting was restored to the rightful owners in May 1999.

56 peddled paintings with false . . . provenances: In 1966, it became apparent that the person cited by Bloch as the previous owner of a painting he had sold to the New York dealer Jacques Seligmann was completely unfamiliar with the work in question—or with Bloch. After learning of this matter, whose details were kept confidential, Seligmann appears never to have dealt with Bloch again. AAA/JSR, box 15.

57 "a dirty dog": S. Nijstad in interview with the author, 15 August 2006.

57 "spiritual director": Letter from A. B. de Vries to Arthur K. Wheelock Jr., 30 May 1981, Wheelock's private papers, NGA. On page 9 of *Een vroege Vermeer*, Van den Brandhof quotes a letter she received from

L. J. C. Boucher regarding a conversation he had with Bloch during the war about the biblical Vermeers. Van den Brandhof gives the impression that Boucher considered Bloch a laughable victim in the swindles. This was a tactful bowdlerization: in his original letter, Boucher suggested that Bloch was complicit. See: RKD/VDB, box 1, corr. file A–G. See also: Liedtke's comments on Bloch, *Dutch Paintings in the Metropolitan,* vol. II, 906.

57–58 When Wright was handling paperwork: Letter from Wright to Hofstede de Groot, 24 June 1925, RKD/HDG, inventaris 70. Also: ZSMB, Nachlass Bode, NL 6000.

58 ostensibly the manager of a small paint factory: Letter from A. Buchheister, Bremen, to Duveen Brothers, Paris, GTY/DBR, box 300, file 3.

58 "clever, dangerous, and tricky man": Cable, Paris to London, 11 April 1928, GTY/DBR, box 249, file 14.

58 hastily relocated to The Hague: Wright's foreign resident registration card, 20 July 1928, HGA, Vreemdelingsdienst.

58 later expanding it to a full-fledged production facility: *Van Nierop & Baak* 1932/479; *Het Vaderland,* 9 July 1938.

58 Ward had years of experience: F. Meijer, "Background to the Daisy Linda Ward Bequest," *Dutch and Flemish Still-life Paintings: The Ashmolean Museum Oxford* (Oxford and Zwolle: Waanders/Ashmolean, 2003), 10–21.

58 "They usually wear dark or grey overcoats": *Ibid.,* 18.

58 Studied for a time at Heidelberg: Undated letter from nephew of Ward's first wife, ca. 2003, AM/RWC, box 1. Ward was also a student at King's College: Meijer, "Background to the Daisy Linda Ward Bequest," 19.

58 sent artworks to Berlin for sale through local dealers: Letter from Ward to Hofstede de Groot, 8 March 1928, RKD/HDG, inventaris 73.

59 a plot to forge Bode's certificates: Documents relating to the trial of Metzenmacher and Holländer, ZSMB, Anforderung von Gutachten I/ GG no. 317.

59 A chain of German dealers that began with Hans Wendland: Duveen paid Wendland £1200 for directing the picture to the firm. The paperwork is misfiled in the dossier for *The Smiling Girl*: GTY/DBR, box

299, file 14. See also: Buchheister letter, GTY/DBR, box 300, file 3. Wendland was German by birth, although he obtained Swiss citizenship after World War I, partly for business reasons.

59 a key figure in the Nazis' art looting: ALIU, "Detailed Interrogation Report: Hans Wendland," NARA, M1782.

59 "in the German interest": ALIU, "Final Report," NARA M1782. See also: preliminary name list for ALIU reports, NARA, M1944, reel 9.

60 "big names": Meijer, "Background to the Daisy Linda Ward Bequest," 13.

61 an incident of petty theft: *Times*, 2 May 1892.

61 valued by Price Waterhouse at £53,000: *Times*, 19 June 1936.

61 Wright brought the first...to Berlin: ZSMB, Nachlass Bode, NL6000.

61 written by...Wilhelm Valentiner: Certificate, dated 1 July 1935, on file in curatorial dossier no. 1971.56, AHC.

65 first Vermeer that he had ever seen: W. von Bode, *Mein Leben* (Berlin: Reckendorf, 1930), vol. I, 27.

65 not the owner but was acting in his service: GTY/DBR, box 299, file 14. The Duveen stock card is marked "ex-Rohde, ex-Russia." Contemporary newspaper accounts also give the Russian story: *Het Vaderland*, 14 May 1926. When Bode later published the news, he said only that the picture had come from "a private collection in the lower Rhine," presumably meaning Rohde's. See: W. von Bode, "Kunsthistorische Ausbeute von dem Deutschen Kunsthandel von Heute," *Repertorium für Kunstwissenschaft* 47 (1926): 251–265.

66 cutting off dealers who displeased him: Including, briefly, Paul Cassirer and Leo Blumenreich, ZSMB, Nachlass Bode, NL0871.

67 "endorsements by him from which the date has been cut off": Letter from Hofstede de Groot to H. Blank, 14 October 1926, RKD/HDG, inventaris 70.

67 dispatched two employees to the sale: S. N. Behrman, *Duveen* (New York: Random House, 1952), 133.

68 Duveen was eager to have the picture examined: All accounts and quotations regarding the sale of *The Smiling Girl* as per GTY/DBR, box 299, file 14. See also: *Het Vaderland*, 20 July 1926.

69 a missing Vermeer that had been sold at auction in 1816: Mentioned in E. Plietzsch's certificate of expertise, GTY/DBR, box 300, file 3.

69 actually made Duveen's life more difficult: All accounts and quotations regarding the sale of *The Lace Maker* as per GTY/DBR, box 300, file 3, with the exception of the payoff to Wendland, which is misfiled in box 299, file 14.

69 fired from the Kaiser Friedrich staff in 1906: ALIU, "Detailed Interrogation Report: Hans Wendland," NARA, M1782.

70 continued to consult quietly over paintings: Bode's personal correspondence dossiers (which are incomplete) contain ten letters from Wendland during the period 1920–1929, ZSMB, Nachlass Bode.

CHAPTER FOUR: *Smoke and Mirrors*

PAGE

72 artist of choice for the . . . Liberal State Party: J. Lopez, "De Meestervervalser en de fascistische droom," *De Groene Amsterdammer* (29 September 2006): 26–29.

73 "far more motivated by . . . our principles": *Het Vaderland*, 27 January 1925.

73 chalk-striped, double-breasted suits: *Het Vaderland*, 28 July 1928.

73 "That man was a genius": Letter from R. D. L. Maduro to M. van den Brandhof, RKD/VDB, box 1, corr. file H–Z.

74 "Such brittle grace": *Het Vaderland*, 2 December 1924.

74 "Germany has to realize": *Het Vaderland*, 10 October 1933.

75 "slimy bunch of woman-haters": H. van Meegeren, "Schilderkunst en Moderne Schilderkunst," *De Kemphaan* I/7 (October 1928): 210–211.

75 "Jew with a handcart": H. van Meegeren, "Vincent van Goghfeest," *De Kemphaan* II/10 (January 1930): 295.

75 "parasites and proselytes": H. van Meegeren, "Moderne Schilderkunst II," *De Kemphaan* I/2 (May 1928): 39.

76 "shutting up any protest": *Mein Kampf*, Chapter X, author's translation, working from the original German (Munich: Verlag Franz Eher, 1925) as well as the standard Dutch translation by S. Barends (Amsterdam: Amsterdamsche Keurkamer, 1937).

78 "Here we have a truly fresh young talent": *De Nieuwe Courant*, 27 April 1917, quoted in Van den Brandhof, *Een vroege Vermeer*, 32.

81 "one must have a spiritual inclination": P. C. H. "Bijbelsche Taferelen door H. van Meegeren," *Elseviers Geïllustreerd Maandschrift* LXIV (July 1922): 66.

81 "this still-young man has mastered": *Het Vaderland,* 25 May 1922. On Havelaar's aesthetic theories: J. J. Oversteegen, *Vorm of vent* (Amsterdam: Athenaeum, 1969), 102–105.

82 Dutch League for the Promotion of Large Families: Private communication from P. van Meegeren to the author, 11 April 2006.

82 "texts of the Bible are so clear": Van den Brandhof, *Een vroege Vermeer,* 65.

82 "biblical theater for an actor": *De Groene Amsterdammer,* 1 July 1922.

83 Jacques and Pauline to live . . . in Paris: Kreuger, *Meestervervalser,* 53.

86 the resemblance was more than casual: N. N., "Vervalscher Van Meegeren: Portret in Drie Kwartier," *Het Parool,* 21 July 1945.

86 "a well-known painter from The Hague": *Nieuwe Rotterdamsche Courant,* 11 June 1926. Around this same time, a semiprofessional billiards sharp named Lolkes de Beer informed the Muller auction house that, for a small cash payment, he would be willing to testify that Theo van Wijngaarden had painted *The Laughing Cavalier* in the manner of a self-portrait, using a mirror to guide the work. Upon further questioning, Lolkes de Beer admitted that he had not actually seen Van Wijngaarden do this; rather, he had once seen Van Wijngaarden paint an ordinary self-portrait by this method and had surmised that *The Laughing Cavalier* must have been done in the same way. Muller had no interest in this testimony, but the story got picked up by the papers. Asked about these allegations by a reporter, Van Wijngaarden responded that if he were going to paint a Frans Hals, he would at least have the good sense to shut the door. *Nieuwe Rotterdamsche Courant,* 18 June 1926, 30 June 1926.

86 Not even Picasso: Immediately before the stock market crash of 1929, Picasso was routinely getting 100,000 to 125,000 old francs from dealers for major oils. This would have amounted to approximately £1000 or $5000 in the money of the time. Dealers, of course, charged higher prices to end buyers, and the secondary auction market was also higher. For Picasso prices: J. Richardson, *A Life of Picasso* (New York: Knopf, 2007), vol. 3, 384–385.

88 produced a weekly column for *De Sollicitant*: K. ter Laan, *Letterkundig Woordenboek* (The Hague: Van Goor, 1941). Details of Ubink's student years may be found in his early memoir *Testament van mijn jeugd* (The Hague: Veenstra, 1917), and in T. J. Bosman, ed., *Het gulden*

gedenkboek van de Rijkskweekschool voor Onderwijzers en Onderwijzeres-
sen te Deventer 1877–1927 (Groningen: Wolters, 1927). Also: obituary
of Van Meegeren's father written by J. Ubink: *Het Vaderland,* 11 Sep-
tember 1932.

88 closest friends joined Holland's first organized fascist party: Ubink's
mentor, the philosopher and parapsychologist K. H. E. de Jong, was
one of the founding officers of the party. HGA, Centrale Raad van het
Verbond van Actualisten, arch. 168-01.

89 shared shots of gin: Letter from A. Haighton to J. Kloos Reyneke
van Stuwe, 4 September 1929. The Hague, Letterkundig Museum,
H1650/J. Kloos Reyneke van Stuwe/B.1.

89 League of Dutch Playwrights: The story of this organization and its
Jewish dissenter, Hermann Kesnig, can be followed through the news-
paper accounts in *Het Vaderland,* 30 September 1924, 11 November
1924, 13 November 1924, 20 April 1925, 17 February 1927, 1 Decem-
ber 1928, 22 November 1929. Kesnig also wrote a letter to the edi-
tor of *De Kemphaan* (i.e., Ubink) on one occasion, complaining about
an article that had derisively described a popular Dutch-Jewish slang
word as a "Jew expression" rather than as a "Jewish expression." See:
De Kemphaan II/6, 90. On the Bond's later wartime history: *Het Vad-
erland,* 12 June 1941, 30 May 1941, 1 May 1942. On Carel de Boer and
the National Front: *Het Vaderland,* 4 November 1940.

90 "Israelites": H. van Meegeren, "Vincent Van Goghfeest," *De Kem-
phaan* II/10 (January 1930): 295.

91 "O Holland!": H. van Meegeren, "Schilderkunst en moderne schil-
derkunst," *De Kemphaan* I/7 (October 1928): 210–211.

91 "On the outside it appeared to be Calvinistic and modern": J. Ubink,
"Het theater als functie der gemeenschap," *De Kemphaan* II/4–5
(July–August 1929): 101.

92 *The False Madonna*: J. Ubink, *De valsche madonna: spel in drie bedrij-
ven* (Delft: Niessen, n.d.). First performed at the Excelsior Theater, 18
March 1931. See *Het Vaderland,* 19 March 1931.

93 "purveyors of false coins": J. Ubink, "De Ketel aan de schouwberg,"
De Kemphaan I/1 (April 1928): 1.

93 traced the descent into chaos back to Vincent van Gogh: Quotes
and descriptions as per Van Meegeren's articles, "Schilderkunst V,"
De Kemphaan I/12 (March 1929): 374; "Op de kerkhof der moderne

kunst," *De Kemphaan* I/8 (November 1928): 225–228; and "Moderne schilderkunst III," *De Kemphaan* I/3 (June 1928): 68–74.

94 Otto Wacker: Background of the Wacker case as per W. Uitert, "De dertig zoogenaamde," *De Kemphaan* I/10 (January 1929): 303–310. See also: H. Tromp, *De strijd om de echte Vincent van Gogh* (Amsterdam: Mets & Schilt, 2006), 15–134.

95 "175 fake Van Goghs": H. van Meegeren, "Vincent van Goghfeest," 294.

95 with their "art-anointing language": H. van Meegeren, "Moderne schilderkunst III," *De Kemphaan* I/3 (June 1928): 72.

96 "a bit of a lazy bones": H. van Meegeren, "Schilderkunst IV: Royal Academy, London," *De Kemphaan* I/11 (February 1929): 321.

97 "mocking fantasies": *Het Vaderland,* 23 September 1929.

97 "sharp-tongued": B. van Eysselsteyn, "Kunstenaars in Den Haag," *Wat niet in Baedeker staat* (Amsterdam: Strengholt, 1932), 71.

97 reportedly making a spectacle of themselves: Letter from P. Glazener to M. van den Brandhof, 7 February 1976, RKD/VDB, box 1, corr. file A–G.

97 "due to his biting and cynical sense of humor": J. Spierdijk, *Andermans Roem* (Amsterdam: Tiebosch, 1979), 134.

98 "a mighty leader": The account of the Kunstkring contretemps is based on minutes from the board meetings of 30 March 1932, 15 April 1932, and 24 April 1932; that Bredius was one of the main creditors, the meeting of 28 June 1932. HGA, Archief Haagse Kunstkring, arch. 253, inventaris 4. Letter accepting Van Meegeren's resignation: HGA, arch. 253, inventaris 29.

CHAPTER FIVE: *A Happy Hunting Ground*

PAGE

100 Mauclair . . . frequent praise in the pages of *De Kemphaan*: For instance, in issues I/3: 856; I/12: 382; II/1: 14–15; II/11: 351–352.

101 Harold Wright had reintroduced himself: Accounts and quotations regarding Wright's Frans Hals portrait as per GTY/DBR, box 249, file 14.

103 "unremitting vigilance": Behrman, *Duveen,* 139–40.

103 an English front man named Charles Carruthers: The account of the painting being offered to Duveen comes from a letter written by Car-

ruthers, years later, defending the honesty of his actions. Letter from
Carruthers to H. Schaeffer, 6 June 1960: AHC, dossier 1971.56.

104 likely that Theodore Ward orchestrated all of this: Annotated sales
catalogues and daybooks show Collings and various members of the
Ward family attending dozens of the same auctions during the 1920s.
Sometimes they bought each other's lots, and sometimes they deliv-
ered for-sale items to the auction house in consecutively numbered
consignments. For example: sale of 25 February 1924, lot 99; and sale
of 23 June 1922, lots 11–15, CHR.

104 Collings transferred . . . another party: Collings bought *The Girl with
a Blue Bow* from Carruthers for £504 at Christie's on 23 March 1934
(lot 62; CHR). The picture was then acquired from Collings by the
London dealer Anthony Reyre, who later sold it to the Katz Gallery of
the Netherlands. Reyre's reputation in the trade was mostly good and
his role in the swindle is unclear, but, strangely, he had once written
to Hofstede de Groot to propose a different unknown Vermeer with a
suspiciously similar back story: letter dated 29 October 1923, RKD/
HDG, inventaris 70. (Hofstede de Groot had declined to attribute that
picture.) According to a letter from Katz's New York agent, Hanns
Schaeffer, to the director of the Hyde collection, 26 December 1959,
Reyre was personally responsible for the cleaning, retouching, and
relining of *The Girl with a Blue Bow* after its "discovery" at Chris-
tie's: AHC, dossier 1971.56. See also: F. Davis, "An Auctioned 'Ugly
Duckling' Becomes a Swan," *Illustrated London News*, 20 April 1935.
Given the extreme delicacy of the gelatin-glue paint surface, Reyre's
involvement, especially in the relining of this picture, seems to raise
questions about how much he knew. Interestingly, on another occa-
sion, Reyre sold Duveen Brothers a Rembrandt self-portrait so ques-
tionable that *Punch* magazine remarked, "Sir Joseph Duveen has just
purchased a portrait of himself, by Rembrandt, for £50,000": *Punch*, 2
September 1925. Valentiner's certificate for *The Girl with a Blue Bow*,
dated 1 July 1935, is on file at the Hyde Collection. It appears to have
been provided to Reyre in preparation for the sale to Katz.

104 "Greta Garbo Vermeer": Garbo resemblance first cited by E.
Plietzsch, *Vermeer van Delft* (Munich: Bruckmann, 1939), 30. See also:
F. Kreuger, *De arrestatie van een meestervervalser* (Diemen: Veen,

2006), 133, where Kreuger expresses his opinion that this is the work of Van Meegeren. That Friedländer called the picture "splendid": R. Gimpel, *Journal d'un collectionneur, marchand de tableaux* (Paris: Calmann-Lévy, 1963), 431. That it was also accepted by other experts: R. Heinemann, ed., *Stiftung Sammlung Schloss Rohoncz* (Lugano: Stiftung Sammlung Schloss Rohoncz, 1937), vol. II, 158. Lowengard's opinion: Letter, 23 August 1930, GTY/DBR, box 30, file 6.

105 Jacques announced to the Paris press: Sepp Schüller, *Falsch oder echt?* (Bonn: Bruder Auer, 1953), 47. That Jacques sometimes made claims that were completely impossible: Van den Brandhof, *Een vroege Vermeer*, 139, n. 30. Regarding Jacques's money-making schemes: on 12 August 1951, Jacques wrote to John Godley, 3rd Lord Kilbracken, hoping to secure an advisory role in a planned movie version of Kilbracken's book on Van Meegeren, which Jacques had helped research. The movie never got made, but Jacques was eager to cut his sister, Pauline, out of the project; likewise, he was concerned Johanna might be working on a competing venture. (Many thanks to Kilbracken's widow, Sue, for sharing this information: the letter is at Killegar House with Kilbracken's private papers.) Jacques also attempted a memoir (never published) called *I Was the Son* and is rumored to have produced several forgeries of his father's legitimate work. On these latter issues: Kreuger, *Meestervervalser*, 156, 178.

105 an art book, formerly the property of Han van Meegeren: This was shown to me by the chief curator of old-master paintings, Dr. Jeroen Giltaij, during my visit to the Boijmans Museum on 16 August 2006. I would like to express my gratitude to Giltaij for his permission to reproduce this hitherto unpublished item, which is kept in box 200 in the Boijmans print room.

107 Friedländer . . . Wendland: In a letter titled "Re: Wendland" (28 September 1927, GTY/DBR, box 299, file 13), Fowles tells Duveen, "It is not advisable to offend him in any way as he is Dr. Friedländer's best friend." That Friedländer was criticized regarding his certificates: ZSMB, I/GG, no. 383. That Friedländer was Thyssen's primary advisor: Letter, dated 20 August 1930, to Seligmann from one of his European runners, who saw Thyssen's collection exhibited in Munich, AAA/JSR, box 211. Writing in German, the runner states that, with regard to Thyssens's acquisitions, "Friedländer is always directly or

indirectly involved," but hints that the advice Thyssen got in those days may not have been the best: *Die Hälfte der ausgestellten Objekte kann der liebe Mann wegwerfen.*

107 *The Gentleman and Lady at the Spinet* was made . . . with Bakelite: This fact was confirmed by pyrolysis gas chromotography performed by W. Froentjes in 1980 upon the urging of M. van den Brandhof. This technique analyzes the characteristic visual spectrum produced by a volatized sample of a given paint medium. Froentjes never published his results, but a copy of his report was sent by A. B. de Vries to Arthur K. Wheelock Jr. and is now on file with Wheelock's personal papers at the NGA: "Verslag van een natuurwetenschappelijk onderzoek van het schilderij 'Man en vrouw aan het spinet' (Mannheimer Vermeer) behorende tot Dienst Verspreide Rijkscollecties onder inv. nr. NK 3255." No trace of this report was found in the Instituut Collectie Nederland's dossier NK 3255 at the time of the author's visit to Rijswijk on 22 August 2006. A copy has since been provided to the Instituut Collectie Nederland by Wheelock.

In his sworn depositions, NHA 466/261, Van Meegeren stated that he purchased his Bakelite in the form of a commercially prepared product called Albertol, made by the Kurt Albert Corporation of Eisenbach, Germany. Subsequent biographers state that Van Meegeren got the idea from a book on the technology of paint called *Über fette Ölie* by the research chemist Alex Eibner. In his depositions, Van Meegeren alludes to a book, but does not mention its name. Eibner's book, in fact, provides little more in the way of instructions or information about Bakelite than one would have found on the side of the Albertol package itself. Whether he used Eibner as a guide or not, Van Meegeren was very likely alerted to both Bakelite and "the book" by a third party.

108–9 synthetic radio casings: *Times,* 19 June 1936.

110 a reclusive old family . . . J. Tersteeg: As per newspaper interview with Bredius, *Het Vaderland,* 19 July 1932. That the picture passed to Katz and then Mannheimer: annotated photo on file at the RKD. In all probability, Tersteeg sent the picture to Budapest at Bredius's urging, specifically in order to show it to Franz Kleinberger, who generally spent his summers there. Bredius had recently sold *The Allegory of Faith* to Kleinberger and had a good relationship attributing pictures for the Kleinberger Gallery

at this time: correspondence between Bredius and Kleinberger, various dates, GTY/DBR, ser. II, box 392, file 13. (Large portions of Kleinberger's records ended up in the possession of Duveen Brothers and are catalogued in the GTY/DBR files.) It would appear that Kleinberger then summoned his nephew and Paris office manager, Ali Loebl, to look at the picture. That both Loebl (acting for Kleinberger) and representatives of the Wildenstein Gallery turned the picture down in Budapest: cable from E. Fowles to J. Duveen, 19 October 1932, GTY/DBR box 299, file 10. Many thanks to Geneviève Tellier, who is writing a history of the Kleinberger Gallery, for the background on Kleinberger's Budapest connections and Loebl's kinship to Kleinberger.

112 "the subject is rather against it": Letter from Duveen to Hofstede de Groot, 16 November 1909, RKD/HDG, inventaris 58.

112 Bredius went public with those suspicions: A. Bredius, "An Unpublished Vermeer," *Burlington Magazine* LXI (October 1932): 144–145. All accounts and quotations of Duveen Brothers' correspondence regarding *The Gentleman and Lady at the Spinet* as per GTY/DBR, box 299, file 10.

116 "sell anything to anybody": This quote and the account of the Katz Brothers in general as per author's interview with S. Nijstad, 15 August 2006. Also: author's subsequent correspondence with Nijstad, August–December 2006.

116 None other than Theo van Wijngaarden's son: Account of Willy van Wijngaarden's career as per author interviews with the Van Wijngaarden family. See also: S. Nijstad, *Van antiquair tot kunsthandelaar* (Abcoude: Uniepers, 1990), 31.

117 a modern forgery made with *kunsthars*: M. M. Dantzig, *Frans Hals: echt of onecht?* (Amsterdam: H. J. Paris, 1937), 103–104.

118 a strangely flat and dead surface: comments based on the author's examination of these works at the Rijksmuseum storage depot, Lelystad, 10 August 2006.

120 "began with the ambition of painting ideal scenes": R. Fry, "Diana and Her Nymphs," *Burlington Magazine* XIX (July 1911): 211.

120 *The Parable of the Unmerciful Servant*: P. Hale, *Vermeer*, 2nd ed. (Boston: Hale, Cushman & Flint, 1937), 207–208.

120 perhaps intended to decorate a *schuilkerk*: P. Coremans, *Van Meegeren's Faked Vermeers and De Hoochs* (Amsterdam: Meulenhoff, 1949), 34.

CHAPTER SIX: *The Master Forger and the Fascist Dream*

PAGE

124 1936 Summer Olympics: Account as per D. Large, *Nazi Games* (New York: Norton, 2007), 190–226. See also: F. Spotts, *Hitler and the Power of Aesthetics* (New York: Overlook, 2004), 152–186.

129 should rightly go to the Führer himself: ALIU, "Detailed Investigation Report: Heinrich Hoffmann" and "Consolidated Investigation Report #2," NARA, M1782.

130 "for having been born Teutonic": J. Ubink, "Midwinter," *De Kemphaan* II/10 (January 1930): 290–293.

132 "the sort of man who liked to test the limits of what was acceptable": L. J. C. Boucher, quoted in Van den Brandhof, *Een vroege Vermeer*, 11.

132 Bertha, had tracked the artist down in 1935: Details of this chain of events as per deposition of Bertha Boon, 13 September 1945, NHA, arch. 466/261.

133 "They were confirmed anti-fascists": Deposition of G. A. Boon, 23 August 1945, NHA, arch. 466/261.

134 "It is the intention of this book to publish anew": A. Bredius, *The Paintings of Rembrandt* (London: Allen & Unwin, 1937), last page of unpaginated introduction. German version published the previous year by Phaidon Verlag, Vienna.

135 the initial attribution of *Christ in the House of Martha and Mary*: Account of this incident as per Wheelock, ed., *Johannes Vermeer*, exhib. cat. (Washington, D.C.: NGA, 1996), 90–91.

136 "This magnificent work of Vermeer . . . has been rescued": Bredius's certificate reproduced in J. van der Meer Mohr, "Bredius en zijn Emmausgangers van Vermeer: een nieuwe reconstructie," *Origine* 5 (2006): 24–29.

136 "*the* masterpiece of Johannes Vermeer of Delft": A. Bredius, "A New Vermeer," *Burlington Magazine* LXXI (1937): 211.

136 made inquiries with an attorney in The Hague: J. van der Meer Mohr, "Eerherstel voor Abraham Bredius?" *Tableau* 18/5 (1996): 39–45. Unless otherwise indicated, all accounts and quotations of Bredius's interactions with Boon, Hannema, and the Rembrandt Society are based on documents published in Van der Meer Mohr's *Origine* and *Tableau* articles.

137 "Picture a rotten fake": Accounts and quotations regarding the visit of Fowles and Lowengard to Crédit Lyonnais as per GTY/DBR, box 300, file 9.

138 friend gave Boon the name of . . . D. A. Hoogendijk: Accounts and quotations relating to Boon's interactions with Hoogendijk and Garschagen as per depositions of D. A. Hoogendijk, 11 and 13 July 1945, NHA, arch. 466/261. Boon's caginess consisted of telling Hoogendijk that the "old family" lived in France rather than Italy, where export laws would have complicated the sale.

140 Schmidt-Degener . . . second thoughts: Dirk Hannema, *Flitsen uit mijn leven als verzamelaar en museumdirektor* (Rotterdam: Donker, 1973), 110–113.

140 museum's bulletin featured an elaborate article: Jhr. J. L. A. A. M. van Rijckevorsel, "Vermeer en Caravaggio: De Emmausgangers in het Boymansmuseum," *Historia: maandschrift voor geschiedenis en kunstgeshiedenis* (July 1938): 20–24. This was the special "Boymans-Nummer" published in partnership with the museum to commemorate the exhibition.

140 Poetry was written: Poem by P. C. Boutens published in A. M. Hammacher, *De Emmausgangers: Vermeer en Rembrandt* (The Hague: De Spieghel, 1938).

140 plaudits poured forth: H. P. Bremer, *Nieuwe Rotterdamsche Courant,* 16 July 1938; V. E. van Vriesland, *De Groene Amsterdammer,* 25 June 1938; C. Veth, *Maandblad voor beeldende kunsten,* July 1938.

142 informing them that he had won the lottery: Published in the reunion album, *Gedenkboek Deventer Hogere Burgerschool 1864–1939* (Deventer: De Lange, 1939), 69–71.

142 an even grander place of their own: Lord Kilbracken, *Van Meegeren: Master Forger* (New York: Scribner's, 1968), 108–109.

Chapter Seven: Sieg Heil!

146 a pose whose grandeur and melodrama: Van Meegeren's identity documents reproduced in Kreuger, *Meestervervalser,* 111. Kreuger makes no comment on the photo.

146 "made it seem like he was no friend of the Krauts": Spierdijk, *Andermans Roem,* 134.

146 German Red Cross and the controversial Winterhulp: Van den Brandhof, *Een vroege Vermeer*, 130. Van den Brandhof notes that Van Meegeren's work was shown in the German cities of Stuttgart, Oldenburg, Osnabrück, Hagen, and Gelsenkirchen in an exhibition of contemporary Dutch art organized by Ed Gerdes. Regarding the painting dedicated to Hitler: *De Waarheid*, 17 July 1945.

146 "helps only the war": Resistance leaflet, NIOD, IP32.19/MIP076.

147 a figure roundly despised: Background on Gerdes as per Venema, *Kunsthandel*, 26–32, 332–337, 524–527. See also: biographical sketch in H. Mulder, *Kunst in crisis en bezetting* (Utrecht: Spectrum, 1979), 10.

148 Dutch Nazi Party members . . . installed as the mayors: G. Hirschfeld, *Nazi Rule and Dutch Collaboration* (Oxford: Berg, 1988), 282–286.

149 to decorate . . . the Dutch Labor Front: Van den Brandhof, *Een vroege Vermeer*, 130. On the Nederlandse Arbeidsfront: Hirschfeld, *Nazi Rule*, 51, 100, 105–109.

149 "every function has its proper role": *Het Vaderland*, 5 May 1940.

150 No grand edifices . . . constructed in the Netherlands during the occupation: Hirschfeld, *Nazi Rule*, 186–189.

152 intended the single digit on a round field to look like a *Wolfsangel*: Letter from L. J. C. Boucher to M. van den Brandhof, 6 March 1976, RKD/VDB, box 1, corr. file A–G.

153 Among those present that evening was . . . Rost van Tonningen: Van den Brandhof, *Een vroege Vermeer*, 129–133, with quote from E. Gerdes on 130. Gerdes also had a few complaints about Van Meegeren's art, particularly regarding the eroticism of the nudes. Background on Rost van Tonningen: E. Fraenkel-Verkade and A. J. van der Leeuw, eds., "Inleiding," *De correspondentie van Meinhoud Rost van Tonningen* (The Hague: Nijhoff, 1967), vol. I, 1–17; Hirschfeld, *Nazi Rule*, 327. As indicated in the notes for chap. 8, Rost van Tonningen was acquainted with additional friends of Van Meegeren: *Correspondentie*, vol. I, 250–253.

153 Nazi poet Martien Beversluis: On Beversluis, see A. Venema, *Schrijvers, uitgevers en hun collaboratie* (Amsterdam: Arbeiders, 1989), vol. II, 177–210; *Biografisch Woordenboek van het Socialisme en de Arbeidersbeweging in Nederland*, vol. 7, 13–16. Also: M. Beversluis, "Germaansche bezinning kan onze dichtkunst weer verheffen," *De Misthoorn*, 22 August 1942; and letters between Beversluis and L. P. Schreurs-de Haan,

various dates, 1955–1959, regarding Beversluis's wartime friendship with Van Meegeren. RKD, Archief Schreurs-de Haan, file 1.

155 "fiery day of reckoning": M. Beversluis, "De duivelsbel," *Han van Meegeren: Teekeningen 1* (The Hague: Boucher, 1942), p. opposite plate no. 4.

157 couldn't access the state treasury to finance his acquisitions: Account of Goering's art collecting as per Nicholas, *The Rape of Europa*, 34–37. Also: ALIU, "Consolidated Investigation Report #2," NARA, M1782; and AMG Report 145, NARA, M1944, reel 74. The number of pictures in Goering's collection as per author's correspondence with N. Yeide, whose catalogue raisonné of the Goering collection will be published in 2009.

157 Miedl, went around to . . . Jewish art collectors: Account of Miedl's activities on Goering's behalf follows Hollander, *De zaak Goudstikker*, 65–85, 147–148. That 150 Dutch Jews committed suicide in the week of the invasion: Hirschfeld, *Nazi Rule*, 16. On the birthday parties for Hitler at the Miedls' home and the fact that Alois Miedl was *sehr schlau*: comments made by Theo Gusten, one of Miedl's former employees, as noted by Allied intelligence in multiple reports of July 1945, NARA, M1944, reels 37, 40, 90, and 92.

160 Katz brothers . . . used . . . connections: Venema, *Kunsthandel,* 254–266, 492–497.

160 The Netherlands . . . lost more Jews to the death camps: L. de Jong, *The Netherlands and Nazi Germany* (Cambridge, MA: Harvard, 1990), 22.

160–61 the safekeeping of . . . Arnold van Buuren: Narriman, *Peintre hollandais en Tunisie,* 9. On Miedl's assessment of Nardus's pictures (referred to as the "Van Buuren Collection"), see interrogation reports on A. Miedl, NARA, M1944, reels 90 and 92.

161 a representative of the Nardus family: Author's telephone conversation with P. Neslias, 16 April 2006. On stolen artworks altered and overpainted, see, for example, an account of a smuggling ring operating in the American sector of postwar Berlin with an art professor named Wittkamp and the former German national boxing champion Seidler at its center: the reports, undated, reference a Wm. van de Velde painting in the subject heading, NARA, M1944, reel 10.

162 confiscated from Jewish families: General discussion of Holocaust

162 looting follows G. Aalders, *Nazi Looting* (Oxford: Berg, 2004). See especially 47, 91–95, 186–189, 196–199.

162 Seligmann spent years trying to track down: AAA/JSR, box 144, ser. 1.6.4.

162 pictures looted from the . . . Schloss family: Nicholas, *Rape of Europa*, 172–174. Item later discovered in the possession of Vitale Bloch: Dirck van Delen still-life, illustrated (no. 14) in *Legaat Vitale Bloch* (Rotterdam: Boijmans Museum, 1978).

163 Wendland was one of the biggest offenders: ALIU, "Detailed Investigation Report: Hans Wendland," NARA, M1782.

163 Rosenbergs' hiding place for their pictures: Nicholas, *Rape of Europa*, 129. On Perdoux and Boitel: preliminary name list for ALIU reports, NARA, M1944, reel 9; Paris reports, NARA, RG260, entry 400A, box 469.

163 Dutch wartime art world . . . a strange atmosphere: Aalders, *Nazi Looting*, 66–68. On the broadcasts of Radio Oranje: Aalders, *Nazi Looting*, 86.

CHAPTER EIGHT: *Goering Gets a Vermeer*

PAGE

166 Van Meegeren had gotten Boon to sell *The Interior with Drinkers*: Deposition of H. van Meegeren, 10 August 1945, NHA, arch. 466/261.

167 As Strijbis later recalled, Van Meegeren invited him: Deposition of R. Strijbis, 6 August 1945, NHA, arch. 466/261.

168 Strijbis first introduced himself: Account of Strijbis's interactions with Hoogendijk as per depositions of D. A. Hoogendijk, 11 July 1945 and 13 July 1945, NHA, arch. 466/261.

170 Louche though Van Meegeren's living habits were: It is frequently stated in the English-language literature that Van Meegeren was "a drug addict," that he was "addicted to morphine," and/or that he was "a heroin fiend." Aside from a single newspaper interview in which Van Meegeren stated that he was "in the habit of taking a sleeping preparation in order to nod off at night" there appears to be no evidence to support these claims. See: *Amersfoortse Courant*, 19 July 1946.

170 special appointment as a professor at Delft University: A. F. Kamp, *De Technische Hogeschool te Delft 1905–55* (The Hague: Staatsdrukerij, 1955). See also: E. Fraenkel-Verkade and A. J. van der Leeuw, eds.,

De correspondentie van M. M. Rost van Tonningen, vol. I, 250–253. Van Genderen Stort was an expert in steel-frame construction and author of *Staalskeletbouw* (Deventer: Kluwer, 1941).

171 The Van Eyck was not Van Meegeren's own handiwork: Deposition of H. van Meegeren, 10 August 1945, NHA, arch. 466/261. Van Meegeren stated that he had purchased the *Annunciation* from a Belgian years earlier. This picture (no. 56409 in the files of the RKD in The Hague) has been identified as the work of Jef van der Veken by Jean Luc Pypaert: private communication from Pypaert to the author, 23 February 2007. D. A. Hoogendijk stated in his NHA deposition of 13 July 1945 that he had shown the "Van Eyck" to Max Friedländer after Strijbis brought it to the shop. Friedländer remembered seeing it once before, during the 1930s, at which time it was said to have belonged to a collection in France. According to the RKD file, Van Meegeren succeeded in selling the "Van Eyck" to a Dutch private collector later during the war.

172 was looking through the commemorative album: Deposition of H. van Meegeren, 10 August 1945, NHA, arch. 466/261.

173 "a nasty piece of work": AMG Report 159, Annexure 10, "Report on the Western Provinces of Holland," NARA, M1944, reel 75. That Vitale Bloch attributed the picture: ALIU, "Consolidated Investigation Report #2," NARA, M1782. That Voss turned it down: ALIU, "Detailed Investigation Report: Hermann Voss," NARA, M1782.

174 De Boer offered *The Footwashing* to the Rijksmuseum: Account and quotations regarding the Rijksmuseum's deliberations as per depositions of D. A. Hoogendijk, 11 July 1945 and 13 July 1945, deposition of J. van Dam, 29 June 1945, and deposition A. M. de Wild, 7 July 1945, NHA, arch. 466/261. That Hofer was eager to see the picture: ALIU, "Consolidated Investigation Report #2," NARA, M1782.

175 lingering traces of the equestrian scene: A later X-ray image is in Kilbracken, *Master Forger,* plates following p. 134. That Van Meegeren used caustic soda: deposition of H. van Meegeren, 10 August 1945, NHA, arch. 466/261. That *The Girl with a Red Hat* is painted on a recycled panel: Wheelock, ed., *Johannes Vermeer,* 162–163. Due to compositional similarities, the *Footwashing* was actually referred to as "Christ in the House of Martha and Mary" during the Rijksmuseum's deliberations and also in several depositions in the NHA dossier, as though it were simply an alternate version.

176 informed Goering that *The Footwashing* was . . . genuine: This incident and Hofer's conversation with De Boer as per ALIU, "Consolidated Investigation Report #2," NARA, M1782.

176 Kok agreed . . . a portion . . . donated to the Resistance: Deposition of P. de Boer, 26 July 1945, NHA, arch. 466/261. That Kok deposited his share in Johanna's bank account: depositions of J. Kok, 25 July 1945, and J. Oerlemans (married name Van Meegeren), 4 August 1945, NHA, arch. 466/261.

177 two million guilders' worth: This incident is mentioned in the depositions of both Strijbis and Rienstra, NHA, arch. 466/261. Strijbis gives the date as March 1943.

177 real estate: Van Meegeren's holdings in Laren and Deventer were noted in an investigation by the wartime price control board: NHA, arch. 167/69608 and 167/70735.47. His fifty-seven properties in Amsterdam: AGA, Gemeentekadaster, arch 5358. (Twenty-one of these properties are listed under Johanna's maiden name of Oerlemans.) That Van Meegeren employed a Deventer ex-convict: interrogation of P. J. Rienstra van Stuyvesande, 22 June 1945, ARA, arch. 2.09.09/24716 II.

178 the residence of . . . Walraven Boissevain: AGA, Gemeentekadaster, arch. 5358/E4603. Boissevain removed from office: *Rotterdamsch Nieuwsblad*, 8 March 1941. Rienstra's renovations: *Haagsche Post*, 6 March 1943.

179 "*zwarte drank en lichte meisjes*": Spierdijk, *Andermans Roem*, 130; photo of Johanna in hound's-tooth tweed on 132. Additional reminiscences of Van Meegeren's parties at Keizergracht 738: Letter from P. Glazener to M. van den Brandhof, 3 December 1975, RKD/VDB, box 1, corr. file A–G.

180 a director of Alois Miedl's Amsterdam bank: *Het Vaderland*, 15 October 1940. Account of Rienstra's work with Miedl at the Goudstikker gallery as per depositions of J. Schneller, 27 November 1945, and A. Bovenkamp, 30 June 1946, ARA, arch. 2.09.09/24716 II. Van Meegeren's visit to the Goudstikker gallery as per Schneller and deposition of Rienstra, 27 July 1945, NHA, arch. 466/261.

181 "Herr Miedl called me in": deposition of J. Schneller, 27 November 1945, ARA, arch. 2.09.09/24716 II. Account of Rienstra's misgivings and Miedl's handling of the picture as per deposition of Rienstra, 27 July 1945, NHA, arch. 466/261.

181 Miedl arranged to have *Christ and the Adulteress* checked: Deposition of J. Dik, 4 December 1945, ARA, arch. 2.09.09/24716 II. That the picture contained cobalt blue: Coremans, *Van Meegeren's Faked Vermeers and De Hoochs*, 13.

183 "a Jew, who would try to blackmail him later on": ALIU, "Consolidated Investigation Report #2," NARA, M1782.

184 1.65 million guilder price tag: Miedl paid Van Meegeren that amount, minus a commission for Rienstra. Goering paid Miedl with a combination of cash and approximately 150 old-master paintings that Miedl accepted at a total valuation of two million guilders (according to Rienstra's depositions, ARA, arch. 2.09.09/24716 II). With the Allied invasion of France, Miedl was unable to have these pictures shipped to Spain; they remained in the Netherlands at the war's end. Approximately one third had originally been acquired by Goering through Miedl as part of the Goudstikker deal. Most of the rest were of undocumented origins and are still in the possession of the Dutch government today, as no heirs of the rightful owners have ever been identified. See: R. E. O. Ekkart et al., *Herkomst Gezocht* (The Hague: Ministerie van Onderwijs, 1998–2004), Deelrapportage 1.

184 carrying a portable typewriter: Account of Van Meegeren's letter to Goering as per interrogation of Rienstra, 22 June 1945, and deposition of H. van Meegeren, 10 July 1946, ARA, arch. 2.09.09/24716 II. Also: deposition of P. J. Rienstra van Stuyvesande, 27 July 1945, NHA, arch. 466/261.

CHAPTER NINE: *The End Game*

PAGE

186 Miedl . . . fled: Account of Miedl's activities and contemporary speculation about his mission as per intelligence reports in the subject file "Alois Miedl," NARA, M1944, reel 90; and cables in the "London" file, reel 32.

187 cartons of cigarettes . . . and an extraordinary amount of liquor: Letter from P. Glazener to M. van den Brandhof, 7 February 1976, RKD/VDB, box 1, corr. file A–G.

189 "first discovered that Van Meegeren had been involved": Deposition of D. A. Hoogendijk, 13 July 1945, NHA, arch. 466/261.

189 800,000 guilders . . . outside the reach: Kreuger, *Meestervervalser*, 123.

190 "never suspected": Deposition of J. Oerlemans (married name: Van Meegeren), 4 August 1945, NHA, arch. 466/261.

190 Goering eventually realized: Account of Goering's 1945 activities as per Nicholas, *Rape of Europa*, 318–320; 342–346. On Captain Anderson and Christa Gormans: *New York Times*, 22 May 1945. It is frequently stated in the literature that *Christ and the Adulteress* was found among the vast numbers of paintings the Nazis stored in the salt mines of Alt Aussee. This is untrue.

192 Dutch border towns in the south and east were liberated: Account of the war's end as per De Jong, *Het Koninkrijk*, vol. 10b, 1216–1300. On pillage by the occupying German forces: J. J. Boolen and J. C. van der Does, *Nederlands vijfjarig verzet* (Amsterdam: Verzetsgroep D. A. V. I. D., 1945).

192 "Remember: the Dutch are on our side": AMG Report 150, NARA, M1944, reel 74.

193 Dutch Nazi Party members . . . rousted: Film footage of these events exists. See: "WO II in amateurfilm," an episode of the Dutch documentary TV program *Andere Tijden* (VPRO), originally aired 4 May 2004, and now available online at http://geschiedenis.vpro.nl/programmas/2899536/afleveringen/17373215/.

194 "They set up a sort of bandstand": W. de Bruijn, quoted in M. Diederichs, "Moffenmeiden: Nederlandse vrouwen en Duitse militairen 1940–1945," *Jaarboek voor vrouwengeschiedenis* 20 (2000): 55.

194 Practices varied from town to town: P. Lagrou, *The Legacy of Nazi Occupation* (Cambridge: Cambridge University, 2000), 65.

194 murder of collaborators was relatively rare: On the limited nature of reprisals; torture at Hoek van Holland; and inhumane practices at other camps, see H. Mason, *The Purge of the Dutch Quislings* (The Hague: Nijhoff, 1952), 41–42, 50, 64, and 173 n. 7.

197 contemplated committing suicide: As reported in a letter from E. P. E. van der Veen-Dumont to M. van den Brandhof, 30 October 1975, RKD/VDB, box 1, corr. file H–Z.

197 "exploiting Occupational circumstances": The General Mandate, quoted in Mason, *Purge of the Dutch Quislings*, 44.

198 entirely Rienstra van Stuyvesande's idea: The original confession has disappeared, but Rienstra read portions of it into evidence while defending himself against Van Meegeren's accusations on 27 July

1945. NHA, arch. 466/261. In Rienstra's deposition the date of Van Meegeren's original statement to Field Security is noted as 12 June 1945.

198 denied ever having met Miedl: Van Meegeren stood by this claim when questioned about it further on 22 June 1945. See: ARA, arch. 2.09.09/24716 II.

198 arrested ... Rienstra: The standard version in the literature is that Piller arrested Van Meegeren and Rienstra simultaneously on 29 May, but this appears to be untrue. A contemporary newspaper article based on an interview with Piller and others in his office states, "Van Meegeren made certain claims with regard to the matter of the sale of his pictures ... Rienstra was arrested on this account a couple days later and locked up for several weeks in the Weteringschans by Field Security." *Finantieel Weekblad voor den Fondsenhandel*, 21 December 1945, as per typed transcription, ARA, arch. 2.09.09/24716 II. The article also notes that Van Meegeren "eventually had to take back what he had said."

200 "disliked and mistrusted ... jockeying for a position": Allied intelligence report, "ORION trip to Holland 13 to 18 July 1945," NARA, M1944, reel 90. In this and other comments scattered among the M1944 records (reels 32, 37, 40, 75, 90, 92), Piller is referred to variously as Lieutenant (later Captain) "Van Amstel" or "Piller-Van Amstel" or "Van Amstel-Piller." In the Resistance, Piller had been assigned the pseudonym "Van Amstel" and seems not to have stopped using it until late in the summer of 1945, as explained by De Jong, *Het Koninkrijk*, vol. 7, pt. 2, 913. Likewise, Piller's first name is frequently rendered as "Joop," the standard Dutch diminutive for Joseph. Piller's only evidence of the espionage link, apparently, was that Miedl, acting at Goering's behest, once credited the sale of certain artworks to the account of a German spy, code-named "Zantop," stationed in South America, as noted by ORION. However, the ORION reports and, especially, the *Finantieel Weekblad* article of 21 December 1945, make it clear that Piller thought there was an entire "espionage service" being funded by Miedl through the Goudstikker gallery.

201 "A competition broke out": Edward von Saher, quoted in E. Muller and H. Schretlen, *Betwist Bezit* (Zwolle: Waanders, 2002), 207.

201 Himmler had commended Alois Miedl: Himmler's letter, dated 4 July

1935; communiqué regarding Piller's theories; and handwritten notes by a U.S. intelligence officer who interviewed Piller. NARA, M1944, reel 90.

203 Piller put both men in a room and questioned them: Interrogation transcript, 22 June 1945, ARA, arch. 2.09.09/24716 II.

204 devoted exactly zero time: Prior to Van Meegeren's June 12 confession, however, Piller had done enough investigation of these matters to believe Van Meegeren to be a collaborator, making this later incuriosity all the harder to understand. See: Van den Brandhof, *Een vroege Vermeer,* 145, n. 4; and Piller's deposition of 21 July 1945, NHA, arch 466/261.

204 civilian police remained heavily infiltrated: As per H. A. van Wijnen's interviews with Piller. Van Wijnen, "Het Meesterwerk," 88.

205 "a collaborator of the most shameless variety": Van Gelder, quoted in M. Mosler, *Dirk Hannema: de geboren verzamelaar* (Rotterdam: Museum Boijmans, 1996), 52. Discussion of Hannema's collaboration as per Mosler. Testimony of Hannema, Luitweiler, and De Wild, as per their depositions: NHA, arch. 466/261.

206 must have been added above his name: Van den Brandhof, *Een vroege Vermeer,* 13. Also: Kilbracken, *Master Forger,* 160, where Van Meegeren's version of events is presented as the truth. Van Meegeren's children were among Kilbracken's primary sources.

204, 206 "picture swindle of the century": H. A. van Wijnen, "Het Meesterwerk," 88.

206 "a state of anxiety and depression": Van Meegeren's sworn statement as read into evidence by Piller on 21 July 1945, NHA, arch. 466/261. In this deposition, Piller also describes having the 12 July "confession" witnessed by two staff members, Van Meegeren's maneuvers with regard to the Pieter de Hoochs, and the decision to place Van Meegeren under house arrest at the Goudstikker gallery. See also: signed statement by Piller, 10 December 1945, regarding the creation of *Christ in the Temple*: NIOD, arch 197f/1A.

208 offered to give it to Piller: Piller's recollection in interview with A. Venema, *Kunsthandel,* 507.

208 a human mascot: There is a good account of this interlude and, especially, of Henning, in Kreuger, *Meestervervalser,* 129–133. Also: Interviews with N. van Waning, one of Piller's secretaries, conducted and

filmed by M. Edelson in 2007 in preparation for his Pacific Street Films documentary on Van Meegeren.

210 public reaction . . . was predictably intense: See, for instance, *De Volkskrant,* 17 July 1945, 19 July 1945, 21 July 1945. The standard account is that Piller held his press conference the day after Van Meegeren signed the (second) confession, i.e., 13 July 1945. Although records show that Piller presented the forgery evidence on that date to Allied investigators, who travelled from London to meet with him, judging from the news coverage, it appears that the press conference may have been held a day or two later.

210–11 "German officer": *Het Vrije Volk,* 3 August 1945; *De Spectator,* 19 August 1945.

211 "we may have lost a Vermeer": Dr. G. Knuttel, quoted in W. H. N. Baron v. Sass, "Han van Meegeren: génie ou escroc?" *Le Monde Illustré* 91 (20 September 1947): 1098–1100. The change of tone in the Dutch press was virtually complete within three months. See: *Algemeen Handelsblad,* 20 October 1945, 22 October 1945.

212 shocked . . . Van Meegeren had become such a darling: Spierdijk, *Andermans Roem,* 130–137. Photo of the dedication published in *De Waarheid,* 6 November 1945.

213 British and American . . . medals: *NRC Handelsblad,* 13 January 1998. Quotes from Piller's 1984 interview as per Venema, *Kunsthandel,* 503–508.

214 well-received novel, a hagiographic biography: These were, respectively, M. L. Doudart de la Grée, *Emmaus: roman* (Amsterdam: Bruna, 1946), and G. H. Wallagh, *De echte Van Meegeren* (Amsterdam: Strengholt, 1947).

214 second most popular man: J. Godley, *Han van Meegeren: Master Art Forger* (New York: Funk, 1951), 28. Godley later ascended to the family title of Lord Kilbracken. As Kilbracken, he reprised and updated the Funk book in a similarly titled volume published by Scribner's in 1967.

215 "You do admit, though": Accounts and quotations relating to the trial as per contemporary newspaper reports: *Algemeen Handelsblad,* 28–30 October 1947; *De Tijd,* 29–30 October 1947; *Het Parool,* 29–30 October 1947; *De Volkskrant,* 30 October 1947; *De Waarheid,* 30 October 1947. Also: G. H. Wallagh, "Het unieke schilderijenvervalsingspro-

ces tegen Han van Meegeren," *Verdacht: Veroordeeld* (Amsterdam: De Kern, 1955), 96–134; and, in some instances, Kilbracken's English version, when generally consistent with the newspapers. No official trial transcript has so far turned up in the files of the Ministry of Justice.

218 *The Gentleman and Lady at the Spinet,* had been investigated: RKD, Archief Wiarda, file 1. Confirmed by Froentjes in his report on the 1980 pyrolysis-gas chromatography analysis of the picture's Bakelite medium: report on file in the private papers of Arthur K. Wheelock Jr., NGA. The Mannheimer Vermeer was also identified as a work of Van Meegeren in the reports of Allied investigators who met with Piller: ORION report, 23 July 1945, NARA, M1944, reel 90. And again in a summary report, 8 November 1945: NARA, M1944, reel 92. The prosecution was aware of Van Meegeren's reputation as a lifelong forger through the depositions of P. J. Rienstra van Stuyvesande: NHA, arch. 466/261.

219 Van Gelder . . . to keep track: R. E. O. Ekkart et al., "Rapport van het proefonderzoek: april 1998," *Herkomst Gezocht,* 8.

220 "I didn't do it for the money": Kilbracken and Wallagh present this as an exchange with the judge; most of the newspapers as a soliloquy, although with many variations on the exact wording.

CHAPTER TEN: *Swept Under the Rug*

PAGE

221 "as the result of frustration": *New York Times,* 31 December 1947.

223 same . . . prison camps used by the Nazis: Account of conditions, punishments, and death sentences as per Mason, *Purge of the Dutch Quislings,* 50–64.

224–25 Beversluis began to exhibit . . . symptoms: *Biografisch Woordenboek van het Socialisme en de Arbeidersbeweging in Nederland,* vol. 7, 13–16.

225 The case of Rienstra van Stuyvesande: Account as per Buitenlandse Bankvereniging file, ARA, arch. 2.09.09/24716 I & II; 86941.

226 Miedl had . . . been in a very sociable mood: Account as per the subject file "Alois Miedl": NARA, M1944, reel 90, and country file for Spain, reel 92. Dorie seems to have made an especially good impression on the U.S. Naval Intelligence officer who conducted the initial interrogations, Lt. Theodore Rousseau, later curator of European paintings at the MMA. Preserved in the NARA files is a handwritten 1945 note

from Dorie to Rousseau, saying, in German, "You can hardly imagine how much my husband and I enjoyed spending the evening with you. We have not had the opportunity of meeting people of your caliber for a long time." Judging from his later published comments, in which he stated that Alois Miedl had been "in the Resistance," Rousseau either continued to believe the Miedls' side of the story after the war or else did not wish to acknowledge the extent to which he had been misled: T. Rousseau, "The Stylistic Detection of Forgeries," *Metropolitan Museum of Art Bulletin* 26 (February 1968): 247–252.

227 Miedl negotiated a gentleman's agreement: Hollander, *De zaak Goudstikker*, 83–84; 128–129; and 231, n. 17. That Miedl died on 4 January 1990: printed death announcement, Amsterdam, Internationaal Instituut voor Sociale Geschiedenis, Archief Cees Wiebes, box 1, folder 1.

228 "didn't just happen with art dealers": Piller as interviewed by Venema, *Kunsthandel,* 505.

230 forbidden from practicing their careers for a specified period: Mason, *Purge of the Dutch Quislings,* 116–118.

230 Jan Ubink . . . received a suspension of just one year: Venema, *Schrijvers, uitgevers en hun collaboratie,* vol. 3A, 309. On Ubink during the war: B. Tammeling, *De krant bekeken: de geschiedenis van de dagbladen in Groningen en Drenthe* (Groningen: Nieuwsblad van het Noorden, 1988), 162–164; L. H. Hajema, "De glazenwassers van het bestuur: lokale overheid, massamedia, burgers en communicatie, Groningen in landelijk perspectief 1945–2001," (dissertation, Groningen University, 2001), 121–125. By the end of 1943, Ubink's evolving attitude was viewed as "National–Socialistically speaking, more negative than positive" by one of his hard-core Nazi colleagues in Groningen, who wanted to see Ubink reprimanded: correspondence, various dates, November–December 1943, NIOD, Archief Nederlandsche Kultuurkamer, arch. 104/36.00. After affirming his allegiances, Ubink received no reprimand and seems to have steered clear of further problems.

231 Marinus van der Goes van Naters: *NRC Handelsblad,* 20 September 1974.

234 Van Beuningen claimed: It is only because of this 1955–1956 court case that so many of the depositions from Van Meegeren's original

Rijksrecherche dossier remain intact: the latter were appended as exhibits to the former. NHA, arch. 466/261. The original 1945–1947 dossier has gone missing. On the Coremans-Van Beuningen case: Kilbracken, *The Master Forger,* 110–123; J. de Coen, *Retour à la vérité: deux authentiques Vermeers* (Rotterdam: Donker, 1951). Van Beuningen died in the midst of the trial preparations, but his heirs decided to proceed anyway.

234 no possibility of his going back to . . . the Boijmans: Mosler, *Dirk Hannema: de geboren verzamelaar,* 51.

235 displayed *The Supper at Emmaus* without any . . . label: Author interview with J. Giltaij, 16 August 2006.

235 Sir Herbert Read . . . declared: *Burlington Magazine* CII (November 1960): 465. There were other questionable recollections. Sir Ellis Waterhouse, director of the Scottish National Gallery, would later claim that he had recognized *The Footwashing* as a forgery when he inspected it at the newly liberated Pasloo depot on 29 April 1945. Perhaps he did, but, if so, he kept his opinions to himself at the time. His report on that trip (AMG 150, NARA, M1944, reel 74), which is filled with other gossip, makes no mention of the Vermeer. Likewise, his subsequent AMG, ALIU, and ORION dispatches give the impression that he found out the facts of the case after 12 July, just like everyone else. Interestingly, Marijke van den Brandhof's dissertation advisor, H. L. C. Jaffé, had accompanied Waterhouse on the Pasloo visit. When asked by Van den Brandhof about what had really happened, Jaffé declined to confirm or deny Waterhouse's version of events, saying he couldn't remember. Jaffé referred Van den Brandhof to Waterhouse, who repeated the Pasloo claim, adding, as a corroborating detail, that he could recall examining the illustrations in Van Meegeren's book *Teekeningen 1* in April 1945 and that he had concluded that they were by the same hand as *The Footwashing.* See: RKD/VDB, box 1, corr. file H–Z. According to his own intelligence reports from the time, Waterhouse examined *Teekeningen 1* in July. See: ORION summary report, 8 November 1945: NARA, M1944, reel 92. One suspects that Waterhouse may have felt private doubts about *The Footwashing* in April and then conflated them with the public revelations of July to concoct, consciously or not, an amusing war story.

236 *"C'est un faux!"*: G. Isarlo, "Evénements artistiques en Hollande: Les achats sensationnelles du musée Boymans à Rotterdam," *Beaux Arts* 75 (20 May 1938): 1.

236 if he happened to agree with Isarlo: Letter from P. Rosenberg to T. Rousseau, 7 February 1975. MMA, curatorial dossier 49.7.39. That Isarlo "usually knew more than he let on": author interview with S. Nijstad, 15 August 2006. Nijstad added that Isarlo was "not very honest."

237 "cannot . . . publicize their opinions": *New York Herald Tribune*, 25 November 1947.

237 Fowles . . . added a few pertinent items: GTY/DBR, box 300, file 3.

238 National Gallery . . . took a full twenty years: Wheelock, "The Story of Two Vermeer Forgeries," 275.

239 most expensive picture she ever bought: Author interview with Dr. Erin Coe, director of the Hyde Collection, 28 April 2006.

240 Mrs. Hyde contacted . . . Hanns Schaeffer: Correspondence between Schaeffer, Mrs. Hyde, and Joseph J. Dodge, director of the Hyde Collection, various dates 1954–1960: AHC, dossier 1971.56. Account of Katz's death as per author interview with S. Nijstad, 15 August 2006. That Katz reportedly found the atmosphere in Switzerland anti-Semitic: *De Gelderlander,* 13 October 2007.

241 contacted the Feilchenfeldt family: According to a private communication from Walter Feilchenfeldt to the author, 4 October 2005, the old Paul Cassirer commission stock-card for this picture (no. 20314) is annotated "returned." The return would appear to have occurred sometime after 1959. Thyssen had attempted to sell the picture to J. Seligmann in that year. Seligmann declined, noting that the picture was no longer accepted by experts as a Vermeer: AAA/JSR, box 211. According to communications in 2005 between the author and Mar Barobia, head curator of old masters at the Museo Thyssen Borne-misza, Madrid, the current whereabouts of the picture are unknown. Should it ever turn up, it would merit scientific analysis: conceivably, Van Meegeren could have laid claim to a picture he didn't paint.

241 Wendland . . . telling whopping lies: See J. Seligmann's correspondence with Wendland regarding pictures Wendland had sold with dubious provenance information, various dates 1969–1970, AAA/JSR, box 101.

241 fake Rembrandts . . . during the 1950s: M. Porkay, *Die Abenteuer zweier unechter Rembrandts* (Munich: Lama, 1963). On Christian Goller: Hoving, *False Impressions*, 246–248. On John Myatt: *Guardian*, 13 and 16 February 1999.

EPILOGUE: *Framing the Fake*

PAGE

247 "The people can always be brought to the bidding of the leaders": H. Goering, quoted in G. M. Gilbert, *Nuremberg Diary* (New York: Farrar, Straus & Giroux), 278.

SELECT BIBLIOGRAPHY

———

BOOKS AND ARTICLES

Aalders, Gerard. *Berooid: De beroofde joden en het Nederlandse restitutiebeeld sinds 1945*. Amsterdam: Boom, 2001.

———. *Nazi Looting*. Translated by Arnold Pomerans and Erica Pomerans. Oxford: Berg, 2004.

———. *Roof: De ontvreemding van joods bezit tijdens de Tweede Wereldoorlog*. The Hague: Sdu Uitgevers, 1999.

Adam, Peter. *The Art of the Third Reich*. New York: Abrams, 1992.

Ainsworth, Maryan W. "Caveat Emptor: An Early Twentieth-Century Workshop for Flemish Primitives." *Apollo* (June 2001): 20–29.

Arnau, Frank. *The Art of the Faker*. Translated by J. Maxwell. Boston: Little Brown, 1961.

Artists' Pigments: A Handbook of Their History and Characteristics. Edited by Robert J. Feller and Ashok Roy. 3 volumes. Cambridge and Washington, D.C.: Cambridge University Press in association with the National Gallery of Art, 1986–1997.

Aspects of Art Forgery: Papers read by H. van de Waal, Th. Würtenberger, and W. Froentjes at a Symposium Organized by the Institute of Criminal Law and Criminology of the University of Leiden. The Hague: Nijhoff, 1962.

Avermaete, Roger. "Naweeën van het geval Van Meegeren." *Mededelingen van de koninklijke academie voor wetenschappen letteren en schone kunsten van België* XXXVI (1974): 189–201.

Backes, Klaus. *Hitler und die bildenden Künste: Kulturverständnis und Kunstpolitik im Dritten Reich.* Cologne: DuMont, 1988.

Baesjou, Jean. *De alchemist van Roquebrune.* Antwerp: Vink, 1954.

Barnouw, David. *Rost van Tonningen: fout tot het bittere eind.* Amsterdam: Walburg, 1994.

Barnouw-de Ranitz, Louise. "Biographie van Abraham Bredius." In *Museum Bredius: catalogus van de schilderijen en tekeningen,* ed. Albert Blankert, pp. 10–38. The Hague: Museum Bredius in association with Waanders Uitgeverij, 1991.

Bauer, Anthony. "The Double Dealers." *Art in America* LVI (July-August 1968): 58–69.

Bauer, Victor, and Helmuth Rinnebach. "L'Examen des peintures aux rayons X," Mouseion 5, no. 1 (1931): 42–69.

Bayard, Emile. *L'art de reconnaître les fraudes.* Paris: R. Roger et F. Chernoviz, 1914.

Beck, Andreas. *Original-Fälschung? Bildgebende Verfahren bei der Diagnostik von Kunstwerken.* Konstanz: Schnetztor, 1990.

Behrman, S. N. *Duveen.* New York: Random House, 1952.

Beissel, Stephan. *Gefälschte kunstwerke.* Freiburg: Herder, 1909.

Beversluis, Martien. "De Duivelsbel." In *Han van Meegeren: Teekeningen 1,* opposite plate 4. The Hague: Boucher, 1942.

———. "Germaansche bezinning kan onze dichtkunst weer verheffen." *De Misthoorn* (22 Aug. 1942): 2.

———. "Waarom ik toetrad." *De Weg* (11 May 1940): 9.

———, trans. *Wij hebben den Führer gezien! Jongens en meisjes vertellen van de grootste gebeurtenis in hun leven.* Amsterdam: Volksche Uitgeverij Westland, 1944.

Biografisch woordenboek van Nederland. Edited by Johannes Charité. 5 volumes. The Hague: Nijhoff, 1979–2001.

Biografisch woordenboek van het socialisme en arbeidersbewegingen in Nederland. Edited by P. J. Meertens. 9 volumes. Amsterdam: Internationaal Instituut voor Sociale Geschiedenis, 1986–2003.

Blankert, Albert. "The Emmausgangers Reconsidered." In *In his Milieu: Essays on Netherlandish Art in Memory of John Michael Montias,* ed. Amy Golahny, Mia Mochizuki, and Lisa Vergara, pp. 47–57. Amsterdam: Amsterdam University, 2007.

———. *Johannes Vermeer van Delft 1632–1675.* Utrecht: Spectrum, 1975.

Blankert, Albert, John Michael Montias, and Gilles Aillaud. *Vermeer.* Paris: Hazan, 1986.

Bloch, Vitale. "Die 'Kleine Briefleserin' des Vermeer." *Cicerone* 20 (1928): 357–360.

————. "Van Meegeren: Faussaire de Vermeer." *L'amour de l'art* 8 (1946): 9–13.

Bode, Wilhelm von. "Kunsthistorische Ausbeute von dem Deutschen Kunsthandel von Heute." *Repertorium für Kunstwissenschaft* 47 (1926): 251–265.

————. *Mein Leben.* 2 volumes. Berlin: Reckendorf, 1930.

Bode, Wilhelm von, and M. J. Binder. *Frans Hals, sein Leben und seine Werke.* Berlin: Photographische Gesellschaft, 1914.

Bodkin, Thomas. *The Paintings of Jan Vermeer.* London and New York: Phaidon in association with Oxford University Press, 1940.

Boer, Carel Hendrik de. "Nieuwe stroomingen in de hedendaagsche schilderkunst: H. van Meegeren." *De Cicerone* 3 (1918): 89–96.

————. *De Schilderkunst.* The Hague: De Schouw [Uitgeverij van de Nederlandse Kultuurkamer-Departement Volksvoorlichting en Kunsten], 1942.

————. "Vormen van het bovennatuurlijke en wonderbaarlijke in de kunst." *De Cicerone* 4–5 (1918): 126–133; 167–176.

Boolen, J. J. and J. C. van der Does. *Nederlands vijfjarig verzet.* Amsterdam: Verzetsgroep D. A. V. I. D., 1945.

Borenius, Tancred. "At the Vermeer Gallery." *Burlington Magazine* LIV (1935): 298.

————. "Vermeer's Master." *Burlington Magazine* XLII (1923): 37–39.

Bosman, T. J., ed. *Het gulden gedenkboek van de Rijkskweekschool voor Onderwijzers en Onderwijzeressen te Deventer 1877–1927.* Groningen: Wolters, 1927.

Brandhof, Marijke van den. "Het geval Van Meegeren." In *Knoeien met het verleden,* ed. Z. R. Dittrich, B. Naarden and H. Renner, pp. 153–162. Utrecht: Spectrum, 1984.

————. *Een vroege Vermeer uit 1937: Achtergronden van leven en werken van de schilder/vervalser Han van Meegeren.* Utrecht: Spectrum, 1979.

Bredius, Abraham. "A New Vermeer." *Burlington Magazine* LXXI (1937): 211.

————. "Nog een woord over Vermeers Emmausgangers." *Oud Holland* LV (1938): 97–99.

————. *The Paintings of Rembrandt.* London: Allen & Unwin, 1937.

————. "Een prachtige Pieter de Hoogh." *Oud Holland* LVI (1939): 126–127.

————. "An Unpublished Vermeer." *Burlington Magazine* LXI (1932): 144–145.

Brière-Misme, Clothilde. "L'affaire des faux Vermeers ne fait que commencer." *Beaux-arts, littérature, spectacles* no. 163 (23 April 1948): 3.

————. "La fin d'une affaire sensationnelle—Van Meegeren." *Beaux-arts, littérature, spectacles* no. 141 (21 November 1947): 1.

Broos, Ben. "Un célèbre peintre nommé Vermeer." In *Johannes Vermeer,* ed. Arthur K. Wheelock Jr., pp. 47–56. Washington: National Gallery of Art in association with the Mauritshuis (The Hague) and Yale University Press, 1995. Exhibition catalogue.

———. "Malice and Misconception." In *Vermeer Studies,* ed. Ivan Gaskell and Michiel Jonker, pp. 19–34. Washington: National Gallery of Art in association with Yale University Press, 1998.

Brusse, M. J. *Knoeierijen in den schilderijenhandel.* Rotterdam: W. L. & J. Brusse, 1926.

Burroughs, Alan. *Art Criticism from a Laboratory.* Boston: Little Brown, 1938.

———. "X-Raying the Truth about Old Masters," *The Arts* 9 (1926): 325–333.

"Carel Hendrik de Boer als schilder, kunstcriticus, en essayist." *Kunst en kunstleven* 1 (August 1949): 1–2. Obituary.

Catalogus van de hoogst belangrijke kunst-, antiek- en inboedelveiling, alles afkomstig uit de nalatenschap van wijlen den kunstschilder H. A. van Meegeren in zijn huis aan de Keizersgracht no. 321. Amsterdam: P. Brandt, 1950. Auction catalogue.

Ciliberto, Enrico, ed. *Modern Analytical Methods in Art and Archaeology.* New York: Wiley, 2000.

Coremans, Paul. "Les Rayons ultra-violets, leur nature, leurs applications en technique museographique." *Bulletin des Musees Royaux d'Art et d'Histoire, Brussels* 8 no. 3 (1936): 50–55.

———. *Van Meegeren's Fake Vermeers and De Hoochs: A Scientific Examination.* Amsterdam: Donker, 1949.

Correspondentie van M. M. Rost van Tonningen. Edited by E. Fraenkel-Verkade and A. J. van der Leeuw. 2 volumes. The Hague: Nijhoff, 1967–1993.

Dalla Vigna, Pierre. *Opera d'arte nell'età della falsificazione.* Milan: Mimesis, 2000.

Dantzig, M. M. van. *Frans Hals: Echt of onecht?* Amsterdam: H. J. Paris, 1937.

———. *Johannes Vermeer, de "Emmausgangers" en de critici.* Leiden: Sijthoff, 1947.

Davis, Frank. "An Auctioned Ugly Duckling Becomes a Swan." *Illustrated London News* 187 (20 April 1935): 660–661.

Deblaere, A. "Het geval Van Meegeren." *Katholiek cultureel tijdschrift* 7 (1950): 31–40.

Decoen, Jean. "Encore Van Meegeren." *Beaux-arts, littérature, spectacles* no. 177 (6 August 1948): 3.

———. "Les faux Vermeers de Van Meegeren sont-ils de faux Meegeren?" *Beaux-arts, littérature, spectacles* no. 81 (23 August 1946): 1, 4.

————. *Retour à la vérité: deux authentiques Vermeer.* Rotterdam: Donker, 1951.

————. *Vermeer-Van Meegeren, scandale ou vérité?* Knokke-Le Zoute: privately published, 1968.

Deventer, W. P. F. van. "Flood Lights on The Hague." In *Wat niet in Baedeker staat: Het boek van Den Haag,* ed. Hans Martin and Eduard Veterman, pp. 158–164. Amsterdam: Strengholt, 1930.

Diederichs, Monique. "Moffenmeiden." *Jaarboek voor Vrouwengeschiedenis* 20 (2000): 41–64.

Donath, Adolph. *Wie die Kunstfälscher arbeiten.* Prag: Dr. E. Grégr a syn, 1937.

Doudart de la Grée, Marie Louise. *Emmaus: roman.* Amsterdam: Bruna, 1946.

————. *Het fenomeen: Gedramatiseerde documentaire over het leven van de kunstschilder Han van Meegeren.* The Hague: Omniboek, 1974.

————. *Geen standbeeld voor Han van Meegeren.* Amsterdam: Nederlandsche Keurboekerij, 1966.

Dutton, Denis, ed. *The Forger's Art.* Berkeley and Los Angeles: University of California Press, 1984.

Ebbinge Wubben, J. C. *Legaat Vitale Bloch.* Rotterdam: Boijmans Museum, 1978. Exhibition catalogue.

Eibner, Alex. "L'examen microchimique d'agglutinants," *Mouseion* 6, no. 4 (1932): 5–22.

————. "L'examen microchimique des tableaux et décorations murales." *Mouseion* 5, no. 1 (1931): 70–92.

————. "Les rayons ultra-violets appliqués a l'examen des couleurs et des agglutinants," *Mouseion* 7, no. 1 (1933): 32–68.

————. *Über fette Ölie: Leinölersatzmittel und Ölfarben.* Munich: Heller, 1922.

Ekkart, R. E. O., et al. *Herkomst Gezocht.* The Hague: Ministerie van Onderwijs, 1998–2004.

Enquêtecommissie Regeringsbeleid 1940–1945. Compiled by the War Inquest Committee of the Dutch Parliament, lower chamber. 8 volumes. The Hague: Staatsdrukkerij, 1949–1956.

Eudel, Paul. *Trucs et Truqueurs.* Paris: Librairie Molière, 1907.

Faille, J. B. de la. *Les faux Van Gogh.* Paris and Brussels: Van Oest, 1930.

Fakes and Forgeries. Edited by Samuel Sachs. Minneapolis: Minneapolis Institute of Art, 1973. Exhibition catalogue.

Fake? The Art of Deception. Edited by Mark Jones. London: The British Museum in association with the Berkeley Art Museum and the Univ. of California Press, 1990. Exhibition catalogue.

Feliciano, Hector. *The Lost Museum.* New York: Basic Books, 1997.

Fernhout, Ellen, ed. *De Haagse Bohème op zoek naar Europa: Honderd jaar Haagse kunstkring*. Zutphen: Walburg Pers, 1992.

Feulner, Adolf. "Das Emmausbild von Vermeer." *Zeitschrift für Kunstgeschichte* VII (1938): 345–347.

Fleming, Stuart J. *Authenticity in Art: The Scientific Detection of Forgeries*. New York: Crane-Russack, 1976.

Franits, Wayne, ed. *The Cambridge Companion to Vermeer*. Cambridge and New York: Cambridge University Press, 2001.

Frans Hals: Tentoonstelling, Haarlem, 1937. Edited by G. D. Gratama. Haarlem: Frans Hals Museum in association with Bohn N.V., 1937. Exhibition catalogue.

Friedländer, Max J. *Die altniederländische Malerei*. 14 volumes. Berlin: Cassirer, 1924–1937.

———. *Echt und unecht: aus den Erfahrungen des Kunstkenners*. Berlin: Cassirer, 1929.

———. *Kunst en kennerschap*. Translated by A. Berendsen (Leiden: Stafleu, 1948), 223.

———. *De niederländischen Maler des 17. Jahrhunderts*. Berlin: Cassirer, 1926.

Froentjes, W. "Criminalistic Aspects of Art Forgery." In *Aspects of Art Forgery*, pp. 39–53. The Hague: Nijhoff, 1962.

Froentjes, W., and R. Breek. "Application of Pyrolysis Gas Chromatography on Some of Van Meegeren's Fake Vermeers and De Hoochs." *Studies in Conservation* 20 (1975): 183–189.

———. "Een nieuwe onderzoek naar de identiteit van het bindmiddel van Van Meegeren." *Chemisch Weekblad* (Nov. 1977): 583–589.

Froentjes, W., and A. M. de Wild. "A Forged Frans Hals." *Burlington Magazine* XCII (1950): 297.

———. "De natuurwetenschappelijke bewijsvoering in het proces Van Meegeren." *Chemisch Weekblad* (23 April 1949): 269–280.

Fry, Roger. "The Artist as Critic." *Burlington Magazine* LXIV (February 1934): 78–80.

———. "The Authenticity of the Renders Collection." *Burlington Magazine* L (May 1927): 261–263, 267.

———. "Diana and her Nymphs." *Burlington Magazine* XIX (July 1911): 211–213.

Gaskell, Ivan, and Michiel Jonker, ed. *Vermeer Studies*. Studies in the History of Art 55: Center for Advanced Study in the Visual Arts, Symposium Papers XXXIII. Washington: The National Gallery of Art in association with Yale University Press, 1998.

Gelder, H. E. van. *Levensbericht van Dr. C. Hofstede de Groot.* Leiden: Brill, 1931.

Genderen Stort, E. A. van. "Voorwoord." In *Han van Meegeren: Teekeningen 1,* pp. 5–10. The Hague: Boucher, 1942.

Gier, G. J. G. de. *Alfred Haighton: Financier van het Fascisme.* Amsterdam: Sijthoff, 1988.

Gilbert, G. M. *Nuremberg Diary.* New York: Farrar, Straus & Giroux, 1947.

Gimpel, René. *Journal d'un collectionneur, marchand de tableaux.* Paris: Calmann-Lévy, 1963.

Godley, John. See: Kilbracken, Lord.

Goedhart, I. E. *Uit mijn 50 jarige loopbaan als kunsthandelaar en expert in oude kunst.* Amsterdam: Van Holkema & Warendorf, 1918.

Goll, Joachim. *Kunstfälscher.* Leipzig: Seemann, 1962.

Gowing, Lawrence. "Forger Versus Critic." *The Cornhill Review* 990 (1951): 390–395.

————. *Vermeer.* New York: Harper, 1970.

Graaff, Bob de. *Schakels naar de vrijheid: Pilotenhulp in Nederland tijdens de Tweede Wereldoorlog.* The Hague: Sdu Uitgevers, 1995.

Gräff, Walter. "L'examen des peintures et les moyens optiques," *Mouseion* 3, no. 1 (1931): 21–41.

————. "Die Sprungbildung als Beweismittel bei Fälschungen alter Bilder," *Pantheon* 7 (1931): 32–36.

"Greatest Art Swindle of Modern Times." *The Knickerbocker Weekly* 5 no. 24 (6 August 1945): 6–7.

H., P. C. "Bijbelsche tafereelen door H. van Meegeren bij Biesing." *Elseviers Geïllustreerd Maandschrift* LXIV (1923): 66–67.

Hale, Philip L. *Vermeer.* 2nd Edition. Boston and New York: Hale, Cushman & Flint, 1937.

Hammacher, A. M. "De Emmausgangers van Johannes Vermeer en Rembrandt." *Beeldende Kunst* 26, no. 4 (1938): 5–6.

————. *De Emmausgangers: Vermeer en Rembrandt.* The Hague: De Spieghel, 1938.

Hannema, Dirk. "De Emmausgangers van Johannes Vermeer." *Jaarverslag Vereniging Rembrandt* (1938): 12–17.

————. *Flitsen uit mijn leven als verzamelaar en museumdirekteur.* Rotterdam: Donker, 1973.

Hannema, Dirk, and Arthur van Schendel Jr. *Noord- en Zuid-Nederlandsche schilderkunst der zeventiende eeuw.* Amsterdam: Bigot & Van Rossum, 1936.

Hannema, Frans. "Han v. Meegeren." *Maandblad der Nederlandsch-Duitsche Kultuurgemeenschap* (December 1943): 1–5.

Han van Meegeren. Kortrijk: Stadsmuseum, 1961. Pamphlet to accompany exhibition.

Han van Meegeren. Edited by Pieter Hofnagels. Slot Zeist: Zeistsmuseum, 1984. Exhibition catalogue.

Han van Meegeren en zijn meesterwerk van Vermeer. Zwolle: Waanders in association with the Kunsthal, Rotterdam, and the Museum Bredius, The Hague, 1996. Book of essays to accompany exhibition.

Han van Meegeren: Teekeningen 1. The Hague: Boucher, 1942.

Hasse, Günter. *Die Kunstsammlung des Reichsmarschalls Hermann Göring: eine Dokumentation.* Berlin: Edition Q, 2000.

Heaps, Leo. *The Grey Goose of Arnhem.* London: Weidenfeld and Nicholson, 1976.

Hedquist, Valerie. "Religion in the Art and Life of Vermeer." In *The Cambridge Companion to Vermeer,* ed. Wayne Franits, pp. 111–130. Cambridge and New York: Cambridge University Press, 2001.

Hinz, Berthold. *Die Malerei im deutschen Faschismus: Kunst und Konterrevolution.* Munich: Hanser, 1974.

Hirschfeld, Gerhard. *Nazi Rule and Dutch Collaboration: The Netherlands under German Occupation 1940–1945.* Translated by Louise Willmot. Oxford and New York: Berg, 1988.

Hitler, Adolf. *Mein Kampf.* Munich: Verlag Franz Ehrer Nachfolger, 1925.

———. *Mijn Kamp.* Translated by S. Barends. 2nd edition. Amsterdam: Amsterdamsche Keurkamer, 1939.

Hofstede de Groot, Cornelis. *Beschreibendes und kritisches Verzeichnis der Werke der hervorragendsten holländischesn Maler des XVII Jahrhunderts.* 14 volumes. Esslingen and Paris: P. Neff and F. Kleinberger, 1906–1928.

———. *Echt of Onecht? Oog of chemie? Beschouwingen naar aanleiding van het mansportret door Frans Hals uit het proces Fred. Muller contra H. A. de Haas.* The Hague: Van Stockum, 1925.

———. "Frans Hals as Genre Painter." *Art News* XXVI no. 28 (14 April 1928): 45–46.

———. *Jan Vermeer en Carel Fabritius.* 3 volumes. Amsterdam: Scheltema & Holkema, 1907–1930.

———. *Kennerschaft: Erinnerungen eines Kunstkritikers.* Berlin: Grotes'sche, 1930.

———. "Some Recently Discovered Works by Frans Hals." *Burlington Magazine* XLV (1924): 84–87.

Hollander, Pieter den. *De zaak Goudstikker.* Amsterdam: Meulenhoff, 1998.

Holzapfel, Rudolf M. *The Autobiography of Rudolf Melander Holzapfel.* Dublin: Sunburst Press, 1999.

Houbraken, Arnold. *De Groote Schouburgh der Nederlandsche Kunstschilders en Schilderessen.* 3 volumes. Amsterdam: privately published, 1718–1721.

Hoving, J. W. "Tact." In *Gedenkboek Deventer Hogere Burgerschool 1864–1939,* pp. 67–68. Deventer: De Lange, 1939.

Hoving, Thomas. *False Impressions.* New York: Touchstone, 1997.

Huiberts, Ard, and Sander Kooistra. *Valse kunst: hoe de kunstkoper bedrogen wordt.* Amsterdam: Veen, 2003.

Isarlo, Georges. "Evénements artistiques en Hollande: Les achats sensationnelles du musée Boymans à Rotterdam." *Beaux Arts: chronique des arts et de la curiosité* 75, no. 281 (20 May 1938): 1, 3.

Johannes Vermeer. Edited by Arthur K. Wheelock Jr. Washington, D.C.: National Gallery of Art in association with the Mauritshuis (The Hague) and Yale University Press, 1995. Exhibition catalogue.

Jong, Louis de. *De Bezetting.* 5 volumes. Amsterdam: Querido, 1961–1965.

———. *Het koninkrijk der Nederlanden in de tweede wereldoorlog.* 14 volumes. Amsterdam: Nederlands Instituut voor Oorlogsdocumentatie in association with M. Nijhoff Uitgeverij, 1969–1990.

———. *The Netherlands and Nazi Germany.* Cambridge, MA: Harvard University Press, 1990.

Jonge, A. A. de. *Crisis en critiek der democratie: Anti-democratische stromingen en de daarin levende denkbeelden over de staat in Nederland tussen de wereldoorlogen.* Utrecht: H. E. S. Uitgevers, 1984.

Joni, Icilio Federico. *Le memorie di un pittore di quadri antichi.* Siena: Protagon, 2004.

Joosten, L. M. H. *Katholieken en Fascisme in Nederland 1920–1940.* Hilversum: Brand, 1964.

Kamp, A. F. *De Technische Hogeschool te Delft 1905–55.* The Hague: Staatsdrukerij, 1955.

Keisch, Bernard. "Dating Works of Art Through Their Natural Radioactivity." *Science* 160 (April 1968): 413–415.

Kilbracken, Lord (John Godley). *Han van Meegeren: Master Art Forger.* New York: Wilfred Funk, 1951.

———. *Van Meegeren: Master Forger.* New York: Scribner's, 1967.

Knuttel, W. P. C. *De toestand der Nederlandsche katholieken ter tijde van de Republiek.* 2 volumes. The Hague: Nijhoff, 1892–1894.

Kok, Johannes Antonius de. *Nederland op de breuklijn Rome-Reformatie: numerieke aspekten van protestantisering en katholieke herleving in Noordelijke Nederlanden 1580–1880.* Assen: Van Gorcum, 1964.

Koomen, Pieter. "De teekenaar Van Meegeren." *Maandblad voor beeldende kunsten* XIV (January 1942): 12–17.

————. "Teekeningen van Han van Meegeren." In *Han van Meegeren: Teekeningen 1*, pp. 20–31. The Hague: Boucher, 1942.

Kraaipoel, Dirk. "Een Vermeer met diepgang." In *Han van Meegeren en zijn meesterwerk van Vermeer*, pp. 23–64. Zwolle: Waanders in association with the Kunsthal, Rotterdam, and Museum Bredius, The Hague, 1996. Book of essays to accompany exhibition.

Kraus, H. F. "Die Galerie der Fälschungen." *Kroniek van hedendaagsche Kunst en Kultuur* 3 (June-July 1938): 270–272.

Krueger, Frederik. *De arrestatie van een meestervervalser*. Diemen: Veen, 2006.

————. *Het bedrog*. Diemen: Veen, 1999.

————. *Han van Meegeren: Meestervervalser*. Diemen: Veen, 2004.

Kühn, Hermann. "A Study of the Pigments and Grounds Used by Jan Vermeer." *Reports and Studies in the History of Art* 2 (1968): 154–202.

Kurz, Otto. *Fakes*. New Haven: Yale Univ. Press, 1948.

Laan, Kornelis ter. *Letterkundig woordenboek*. The Hague: Van Goor, 1941.

Lagrou, Pieter. *The Legacy of Nazi Occupation*. Cambridge: Cambridge University Press, 2000.

Large, David Clay. *Nazi Games*. New York: Norton, 2007.

Laurie, A. P. "Crackle and Forgeries of Primitives." *Connoisseur* 81 (1928): 157–161.

————. "Examination of Pictures by Ultra-Violet and X-rays." *Museums Journal* 28 (February 1929): 246–247.

————. "The Forger and the Detective." *Burlington Magazine* LI (July 1927): 50–52.

————. "The Identification of Forged Pictures." *Burlington Magazine* L (June 1927): 342–344.

————. *New Light on Old Masters*. New York: Macmillan, 1935.

————. "Old Masters and Modern Forgeries." *Analyst* 59 (1934): 657–664.

Lavachery, Henri. *Vermeer-Van Meegeren: faux et authentiques, un temoignage*. Brussels: Weissenbruch, 1954. Offprint of conference paper, delivered 7 December 1954.

Lavallée, Pierre. "Un tableau inconnu de Vermeer." *Revue de l'art ancien et moderne* 47 (May 1925): 323–324.

Liedtke, Walter. *Dutch Paintings in the Metropolitan Museum of Art*. New York and New Haven: Metropolitan Museum of Art in association with Yale University Press, 2008.

————. "Toward a History of Dutch Genre Painting II: The South Holland Tradition." In *The Age of Rembrandt: Studies in 17th Century Dutch Painting, Papers in Art History from the Pennsylvania State University*, volume 3, ed.

R. E. Fleischer and S. S. Munshower, pp. 92–131. University Park: Pennsylvania State University Press, 1988.

———, ed. *Vermeer and the Delft School*. New York: Metropolitan Museum of Art in association with the National Gallery (London) and Yale University Press, 2001. Exhibition catalogue.

———. "Vermeer Teaching Himself." In *The Cambridge Companion to Vermeer*, ed. Wayne Franits, pp. 27–40. Cambridge and New York: Cambridge University Press, 2001.

———. *A View of Delft: Vermeer and His Contemporaries*. New Haven: Yale University Press, 2001.

Lopez, Jonathan. "The Early Vermeers of Han van Meegeren." *Apollo* (July-August 2008): 22–30.

———. "Gross False Pretences." *Apollo* (December 2007): 76–83.

———. "De meestervervalser en de fascistische droom: Hitler en Van Meegeren." *De Groene Amsterdammer* (29 Sept. 2006): 26–29.

———. "Valse biographie." *De Groene Amsterdammer* (29 Sept. 2006): 57.

Lucas, E. V. *Vermeer of Delft*. London: Methuen, 1922.

Luger, J. "Weerzien met den gevallen meester." *De Groene Amsterdammer* (20 October 1945).

Mak van Waay, S. J. *Lexicon van Nederlandsche schilders en beeldhouwers 1870–1940*. Amsterdam: Veilinghuis Mak van Waay, 1940.

Mann, Klaus. "The Double Life of Han van Meegeren." *Town and Country* (February 1948): 88–89.

Marceau, Henri. "Photographic Aids and Their Uses in Problems of Authenticity in the Field of Paintings." *Proceedings of the American Philosophical Society* 97 no. 6 (16 December 1953): 686–712.

Martens, Didier. "Les frères Van Eyck, Memling, Metsys et alii, ou le répertoire d'un faussaire éclectique." *Wallraf-Richartz Jahrbuch* LXIV (2003): 253–284.

Martin, Hans, and Eduard Veterman, ed. *Wat niet in Baedeker staat: Het boek van den Haag*. Amsterdam: Strengholt, 1930.

Martin, Wilhelm. *Alt-Holländische Bilder*. Berlin: Schmidt, 1918.

———. *De Hollandsche schilderkunst in de zeventiende eeuw*. Amsterdam: Meulenhoff, 1935–1936.

Mason, Henry L. *The Purge of the Dutch Quislings*. The Hague: Nijhoff, 1952.

Mazzoni, Gianni, et al. *Falsi d'autore*. Siena: Istituzione Santa Maria della Scala in association with Protagon, 2004. Exhibition catalogue.

Meegeren, Han van. "Beeldhouwkunst." *De Kemphaan* II/8 (1929): 225–229.

———. "Beschouwing Jungfraujoch." *De Kemphaan* I/4–5 (1928): 97–99.

————. "Geheelonthoudsdelirium." *De Kemphaan* III/9 (1930): 257–260.

————. "Linsesoep." *De Kemphaan* II/9 (1929): 275–276.

————. "Moderne schilderkunst I." *De Kemphaan* I/1 (1928): 6–9.

————. "Moderne schilderkunst II." *De Kemphaan* I/2 (1928): 37–41.

————. "Moderne schilderkunst III." *De Kemphaan* I/10 (1928): 289–292.

————. "Moderne schilderkunst: Zijn eminentie aestheticus." *De Kemphaan* II/9 (1929): 261–265.

————. "Op het kerkhof der moderne schilderkunst." *De Kemphaan* I/8 (1928): 225–228.

————. "Parabelen en sprookjes." *De Kemphaan* I/7 (1928): 216–217.

————. "Parabelen en sprookjes: Cauchemar." *De Kemphaan* II/8 (1929): 255–256.

————. "Schilderkunst en moderne schilderkunst." *De Kemphaan* I/7 (1928): 207–211.

————. "Schilderkunst I." *De Kemphaan* I/4 (1928): 97–101.

————. "Schilderkunst II." *De Kemphaan* I/6 (1928): 161–163.

————. "Schilderkunst III." *De Kemphaan* I/10 (1928): 289–292.

————. "Schilderkunst IV." *De Kemphaan* I/11 (1929): 321–325.

————. "Schilderkunst V." *De Kemphaan* I/12 (1929): 370–377.

————. "Schilderkunst VI." *De Kemphaan* II/2 (1929): 33–36.

————. "Sonate quasi una fantasia." In *Gedenkboek Deventer Hogere Burgerschool 1864–1939*, pp. 69–71, Deventer: De Lange, 1939.

————. "Vincent van Goghfeest." *De Kemphaan* II/10 (1929): 295–298.

Meesterwerken uit vier eeuwen. Rotterdam: Museum Boijmans, 1938. Exhibition catalogue.

Meer Mohr, Jim van der. "Bredius en zijn 'Emmausgangers' van Vermeer: Een nieuwe reconstructie." *Origine* 5 (2006): 24–29.

————. "Eerherstel voor Abraham Bredius? Hoe Han van Meegeren en G. A. Boon de 'Emmausgangers' verkochten; een reconstructie aan de hand van ongepubliceerde brieven." *Tableau* 18/5 (1996): 39–45.

————. "Meestervervalser van Vermeer." *Kunstwerk* (April 1996): 32–33.

Meijer, Fred. *Dutch and Flemish Still-life Paintings: The Ashmolean Museum Oxford.* Oxford and Zwolle: Ashmolean Museum in association with Waanders Uitgeverij, 2003.

Mendax, Fritz. *Aus der Welt der Fälscher.* Stuttgart: Kohlhammer, 1953.

Mihan, George. *Looted Treasure: Germany's Raid on Art.* London: Alliance, 1944.

Moisewitch, Maurice. *The Van Meegeren Mystery.* London: Barker, 1964.

Montias, John Michael. "Art Dealers in the Seventeenth-Century Netherlands." *Simiolus* 18 (1988): 244–256.

———. *Vermeer and His Milieu: A Web of Social History.* Princeton: Princeton University Press, 1980.

———. "Vermeer's Clients and Patrons." *Art Bulletin* 69 (1987): 68–76.

Mosler, Mireille. *Dirk Hannema: De geboren verzamelaar.* Rotterdam: Museum Boijmans-Van Beuningen, 1995.

"Mrs. Randall, fille de Van Meegeren soutient que Les Disciples d'Emmaüs et La Cène sont bien de son père." *Beaux-arts, littérature, spectacles* no. 175 (16 July 1948): 1.

Mulder, Hans. *Kunst in crisis en bezetting: Een onderzoek naar de houding van de Nederlandse kunstenaars in de periode 1930–1945.* Utrecht: Spectrum, 1978.

Muller, Eelke, and Helen Schretlen. *Betwist Bezit: De Stichting Nederlands Kunstbezit en de teruggave van roofkunst na 1945.* Zwolle: Waanders, 2002.

Narriman, El-Kateb. *Léo Nardus: un peintre hollandais en Tunisie.* Carthage: L'Espace Sophonisbe, 1997. Exhibition catalogue.

Nash, John M. *Vermeer.* London: Scala, 1992.

Neave, Airey. *Saturdays at MI-9: A History of Underground Escape Lines in North-West Europe in 1940–5.* London: Hodder & Stoughton, 1969.

Nebehay, Christian Michael. *De goldenen Sessels meines vaters.* Vienna: Brandstätter, 1983.

"Een Nederlandsche bankrelatie van den Duitschen spionnagedienst," *Finantieel Weekblad voor den Fondsenhandel* (21 December 1945): 1, 3.

Neuburger, Albert. *Echt oder Fälschung? Die Beurteilung, Prüfung und Behandlung von Altertümern und Kunstgegenständen; ein Handbuch für Museumsleiter, Sammler, Liebhaber, Händler, und Chemiker.* Leipzig: Voigtländer, 1924.

Nicholas, Lynn H. *The Rape of Europa.* New York: Knopf, 1994.

Nicholaus, Knut. *Gemälde: untersucht, entdeckt, erforscht.* Braunschweig: Klinkhardt Biermann, 1979.

Nijstad, Saam. *Van antiquair tot kunsthandelaar.* Amsterdam: Van Gennep, 1996.

Oversteegen, J. J. *Vorm of vent.* Amsterdam: Athenaeum, 1969.

Pauw, J. L. van der. *De Actualisten: De kinderjaren van het georganiseerde Fascisme in Nederland.* Amsterdam: Sijthoff, 1987.

Plaut, James S. "Loot for the Master Race." *The Atlantic Monthly* (September and October 1946): 57–64, 73–78.

Plietzsch, Eduard. *Vermeer van Delft.* Munich: Bruckmann, 1939.

Porkay, Martin. *Die Abenteuer zweier unechter Rembrandts.* Munich: Lama, 1963.

Posthumus, N. W., ed. "The Netherlands During German Occupation." Special issue, *The Annals of the American Academy of Political and Social Science* 245 (May 1946).

Quodbach, Esmée. "De eerste Amerikaanse reis van Cornelis Hofstede de Groot." In *Van Cuyp tot Rembrandt: De verzameling Hofstede de Groot,* ed. Luuk Pijl, pp. 65–79. Gent and Groningen: Groninger Museum in association with Uitgeverij Snoeck. Exhibition catalogue.

———. "The Last American Versailles: The Widener Collection in Lynnewood Hall." *Simiolus* 29, no. 1 (2002): 42–96.

Renders, Emile. "Cracks in Flemish Primitives." *Burlington Magazine* LII (February 1928): 58–61, 64–65, 67.

Ricci, Seymour de. "Le quarante-et-unième Vermeer." *Gazette des Beaux-Arts* 16 (1927): 305–310.

Richardson, John. *A Life of Picasso.* 3 volumes. New York: Random House/Knopf, 1991–2007.

Riessen, H. van, et al. *Het grote gebod: gedenkboek van het verzet in LO en LKP.* 2 volumes. Kampen: Kok, 1951.

Rijckevorsel, Jhr. J. L. A. A. M. van. "Vermeer en Caravaggio: De Emmausgangers in het Boymansmuseum." *Historia: maandschrift voor geschiedenis en kunstgeshiedenis* (July 1938): 20–24.

Rorimer, James J. *Ultra-violet Rays and Their Use in the Examination of Works of Art.* New York: Metropolitan Museum of Art, 1931.

Rousseau, Theodore. "The Stylistic Detection of Forgeries." *Metropolitan Museum of Art Bulletin* 26 (Feb. 1968): 247–252.

Roxan, David, and Ken Wanstall. *The Rape of Art: The Story of Hitler's Plunder of the Great Masterpieces of Europe.* New York: Coward-McCann, 1965.

Russell, John. "La farce Van Meegeren." *L'oeil* 14 (February 1956): 5–11.

Sass, W. H. N. Baron von. "Han van Meegeren: génie ou escroc?" *Le Monde Illustré* 91 (20 Sept. 1947): 1098–1100.

Schama, Simon. *The Embarrassment of Riches: An Interpretation of Dutch Culture in the Golden Age.* New York: Knopf, 1988.

Scheen, Pieter A. *Lexicon Nederlandse beeldende kunstenaars.* 2 volumes. The Hague: Kunsthandel Scheen, 1969.

Scheffer, F. E. C. "L'examen chimique des tableaux." *Mouseion* 5 no. 1 (1931): 93–103.

Schirach, Henriette von. *Der Preis de Herrlichkeit.* Munich: Herbig, 1975.

Schüller, Sepp. *Falsch oder echt? Der Fall Van Meegeren.* Bonn: Brüder Auer, 1953.

Schneider, Arthur von. *Caravaggio und die Niederländer.* Marburg & Lahn: Verlag des Kunstgeschichtlichen, 1933.

Secrest, Meryle. *Duveen.* New York: Knopf, 2004.

Shirer, William. *The Rise and Fall of the Third Reich.* New York: Simon & Schuster, 1960.

Slatkes, Leonard. "Utrecht and Delft: Vermeer and Caravaggism." In *Vermeer Studies*, ed. Ivan Gaskell and Michiel Jonker, pp. 81–92. Washington: National Gallery of Art in association with Yale University Press, 1998.

Slive, Seymour. *Frans Hals*. 3 volumes. The National Gallery of Art: Kress Foundation Studies in the History of European Art. London and New York: Phaidon, 1974.

Smyth, Craig Hugh. *Repatriation of Art from the Collecting Point in Munich after World War II*. Gerson Lecture. The Hague: Sdu Uitgevers, 1988.

Speer, Albert. *Inside the Third Reich*. New York: Macmillan, 1970.

Spencer, Ronald, ed. *The Expert Versus the Object: Judging Fakes and False Attributions in the Visual Arts*. New York: Oxford University Press, 2004.

Spierdijk, Jan. *Andermans Roem*. Amsterdam: Tiebosch, 1979.

Spotts, Frederic. *Hitler and the Power of Aesthetics*. New York: Overlook, 2007.

Stiftung Sammlung Schloss Rohoncz. Edited by Rudolf Heinemann. Lugano: Stiftung Sammlung Schloss Rohoncz, 1937.

Tammeling, Bert. *De krant bekeken: de geschiedenis van de dagbladen in Groningen en Drenthe*. Groningen: Nieuwsblad van het Noorden, 1988.

Tast, Ton van. *Het geval van Meegeren*. The Hague: Kompas, 1946. Comic book.

Tentoonstelling van bijbelsche tafareelen door H. van Meegeren. The Hague: Kunstzaal Biesing, 1922. Exhibition catalogue.

Tentoonstelling van portretten, schilderijen en teekeningen door H. van Meegeren. Deventer (NL): Sociëteit de Hereeniging, ca. 1930. Exhibition catalogue.

Tentoonstelling van schilderijen, acquarellen, en teekeningen door H. A. van Meegeren. The Hague: Kunstzaal Pictura, 1917.

Thoré, Théophile. "Van der Meer de Delft." *Gazette des Beaux-Arts* 21 (1866): 297–330, 458–470, 542–575.

Tietze, Hans. *Genuine and False: Copies, Imitations, Forgeries*. London: Parrish, 1948.

Tromp, Henk. *De strijd om de echte Vincent van Gogh: De kunstexpert als brenger van een onwelkome boodschap 1900–1970*. Amsterdam: Mets & Schilt, 2006.

Ubink, Jan. "De Ketel aan de schouwberg." *De Kemphaan* I/1 (April 1928): 1–4.

———. "Midwinter." *De Kemphaan* II/10 (Jan. 1930): 289–293.

———. "De onsterfelijke schaakpartij als beeld van het heelal." *Haagsch Maandblad* (March 1943): 124–132.

———. Sage en feit uit oorlogstijd. Leiden: Batteljee & Terpstra, 1946.

———. *Het testament van mijn jeugd—De school aan Houbrakenstraat*. Groningen: Wolters, 1950. Reprint.

———. "Het theater als functie der gemeenschap." *De Kemphaan* II/4–5 (July–Aug. 1929): 101–108.

————. *De valsche madonna: spel in drie bedrijven.* Delft: Niessen, n.d.

————. "Wit en zwart, een beschouwing van den kunstenaar Van Meegeren." *Haagsch Maandblad* (May 1942): 242–248.

Valentiner, Wilhelm R. *Frans Hals des Meisters Gemälde in 322 Abbildungen.* Stuttgart: Deutsche Verlag, 1923.

————. "A Newly Discovered Vermeer." *Art in America* 16 (1928): 101–107.

————. *Pieter de Hooch des Meisters Gemälde in 180 Abbildungen.* Stuttgart: Deutsche Verlag, 1929.

————. *Rembrandt des Meisters Gemälde in 643 Abbildungen.* Stuttgart: Deutsche Verlag, 1908.

————. *Rembrandt wiedergefundene Gemälde (1910–1922).* Stuttgart: Deutsche Verlag, 1923.

————. "Zum 300 Geburtstag Jan Vermeers." *Pantheon* X (Oct 1932): 305–324.

Vals of echt? Amsterdam: Stedelijk Museum, 1950. Exhibition catalogue.

Van Nierop & Baaks Nederlandsche Naamlooze Vennootschappen. Amsterdam: Van Nierop & Baak, 1932.

Venema, Adriaan. *Kunsthandel in Nederland 1940–1945.* Amsterdam: Arbeiderspers, 1986.

————. *Schrijvers, uitgevers, en hun collaboratie.* 4 volumes. Amsterdam: Arbeiderspers, 1988–1992.

Vermeer and the Delft School. Edited by Walter Leidtke. New York: Metropolitan Museum of Art in association with the National Gallery (London) and Yale University Press, 2001. Exhibition catalogue.

Vermeer: Oorsprong en invloed. Rotterdam: Museum Boijmans, 1935. Exhibition catalogue.

Verougstraete, Hélène, and Roger van Schoute, et al. *Fake/Not Fake: Het verhaal van de restauratie van de Vlaamse Primitieven.* Gent and Amsterdam: Groeningemuseum in association with Ludion, 2005. Exhibition catalogue.

Veth, Cornelis. "Meesterwerken uit vier eeuwen." *Maandblad voor beeldende kunsten* XL (July 1938): 195–204.

Vries, A. B. de. *Jan Vermeer van Delft.* Amsterdam: Meulenhoff, 1939.

————. "Noch einmal Vermeer und Caravaggio." *Pantheon* XXII (1938): 286–287.

Waal, Henri van de. "Forgery as a Stylistic Problem." In *Aspects of Art Forgery,* pp. 1–14. The Hague: Nijhoff, 1962.

Wallace, Irving. "The Man Who Swindled Goering." *The Saturday Evening Post* 219 (11 January 1947): 18–19, 124–126.

Wallagh, G. H. (Bob). *De echte Van Meegeren.* Amsterdam: Strengholdt, 1947.
———. *Verdacht . . . Veroordeeld!* Amsterdam: Strengholdt, 1955.
Walsh, John Jr., and Hubert von Sonnenburg. "Vermeer." *Metropolitan Museum of Art Bulletin* XXXI (Summer 1973): 7–53 of unpaginated original.
Warmbrunn, Werner. *The Dutch under German Occupation 1940–1945.* Stanford, CA: Stanford University Press, 1963.
Warrack, Graeme. *Travel by Dark After Arnhem.* London: Harville Press, 1963.
Werness, Hope. "Han van Meegeren fecit." In *The Forger's Art,* ed. Denis Dutton, pp. 1–58. Berkeley and Los Angeles: University of California Press, 1984.
Wheelock, Arthur K. Jr. "The Appreciation of Vermeer in Twentieth Century America." In *The Cambridge Companion to Vermeer,* ed. Wayne Franits, pp. 161–182. Cambridge and New York: Cambridge University Press, 2001.
———. *Jan Vermeer.* New York: Abrams, 1981.
———, ed. *Johannes Vermeer.* Washington: National Gallery of Art in association with the Mauritshuis (The Hague) and Yale University Press, 1995. Exhibition catalogue.
———. "St. Praxedis: New Light on the Early Career of Vermeer." *Artibus et Historiae* 7 no. 14 (1986): 71–89.
———. "The Story of Two Vermeer Forgeries." In *Shop Talk: Studies in Honor of Seymour Slive,* ed. C. P. Schneider, W. W. Robinson, and A. I. Davies, pp. 271–275. Cambridge, MA: Harvard Art Museums, 1995.
———. *Vermeer and the Art of Painting.* New Haven: Yale University Press, 1995.
———. "Vermeer's Craft and Artistry." In *The Cambridge Companion to Vermeer,* ed. Wayne Franits, pp. 41–53. Cambridge and New York: Cambridge University Press, 2001.
Wild, A. M. de. *The Scientific Examination of Pictures.* Translated by L. C. Jackson. London: G. Bell & Sons, 1929.
Wijde, Inge. *Kluchten en drama's in den kunsthandel.* Leiden: Nederlandsche Uitgeversbedrijf van Wetenschappelijke Uitgaven, 1946.
Wijnen, H. A. van. "Het meesterwerk van Johannes Vermeer van Delft." In *Han van Meegeren en zijn meesterwerk van Vermeer,* pp. 65–92. Zwolle: Waanders in association with the Kunsthal, Rotterdam, and Museum Bredius, The Hague, 1996. Book of essays to accompany exhibition.
———. "Leider onder de grond: Joseph Piller 1914–1998." *NRC Handelsblad* (13 January 1998): 8. Obituary.
Wright, Christopher. *The Art of the Forger.* New York: Dodd & Mead, 1985.
———. *Vermeer.* London: Oresko, 1976.

Würtenberger, Thomas. "Criminological and Criminal-law Problems of the Forging of a Painting." In *Aspects of Art Forgery,* pp. 15–38. The Hague: Nijhoff, 1962.

Wynne, Frank. *I Was Vermeer.* London and New York: Bloomsbury, 2006.

Zaal, Wim. *De Nederlandse Fascisten.* Amsterdam: Wettenschappelijke Uitgerij, 1973.

PERIOD NEWSPAPERS AND MAGAZINES

Algemeen Dagblad
Amersfoortse Courant
Berliner Tageblatt und Handels-Zeitung
Elsevier
De Gelderlander
De Groene Amsterdammer
Haagsche Courant
Haagsche Post
Haagsche Maandblad
Haagsche Vrouwenkroniek
De Kemphaan
Knickerbocker Weekly
De Kroniek
Illustrated London News
Le Monde
Le Monde Illustré
Newsweek
New York Herald Tribune

New York Times
De Nieuwe Courant
Nieuwe Rotterdamse Courant
NRC Handelsblad
Het Parool
Punch
De Standaard
De Telegraaf
De Tijd
De Volkskrant
Time
Times of London
Town & Country
Uitkijk
Het Vaderland
Vrij Nederland
De Waarheid

UNPUBLISHED MATERIALS

PUBLIC COLLECTIONS

Archives of American Art, Washington, D.C.
———. Records of the Jacques Seligmann Gallery.
———. Schaeffer Gallery Records (1936–1937).
Christie's Archive, London.
———. Annotated sales catalogues.
———. Daybooks.

Gemeentearchief Amsterdam.
———. Archief Familie Boissevain.
———. Bevolkingsregister.
———. Kadastraalregister.
Gemeentearchief Wassenaar.
———. Bevolkingsregister.
———. Personeelsdossiers Gemeente Wassenaar (1930–1960).
Getty Research Institute, Los Angeles.
———. Records of the Duveen Brothers Gallery.
———. Records of the Schaeffer Gallery.
Groninger Museum, Groningen.
———. Curatorial Records.
Haags Gemeentearchief, The Hague.
———. Bevolkingsregister.
———. Centrale Raad van het Verbond van Actualisten.
———. Haagse Kunstkring.
———. Haags Politie.
———. Pulchri Studio.
———. Vreemdelingsdienst.
Hyde Collection, Glens Falls, New York.
———. Curatorial Records.
Internationaal Instituut voor Sociale Geschiedenis, Amsterdam.
———. Archief K. H. E. de Jong.
———. Archief Cees Wiebes.
Letterkundigmuseum, The Hague.
———. Brievencollectie.
Metropolitan Museum of Art, New York.
———. Curatorial Records. Department of European Painting.
———. Conservation Records. Department of Paintings Conservation.
Museum Boijmans-Van Beuningen, Rotterdam.
———. Curatorial Records, Afdeling Moderne Schilderkunst.
———. Curatorial Records. Afdeling Oude Nederlandse Schilderkunst.
———. Special Collections, Prentenkabinet.
Nationaal Archief (Algemeen Rijksarchief), The Hague.
———. Centraalarchief Bijzondererechtspleging.
———. Ereraad voor de Kunst.
———. Stichting Nederlands Kunstbezit.
National Archives, London.
———. Family Records Centre.
———. Service Medals and Award Rolls Index.

National Archives and Record Administration, College Park, Maryland.
———. Record Group 59. Records of the Fine Arts and Monuments Advisor, 1949–1960.
———. Record Group 59. General Records of the Department of State. Decimal Files, 1940–1944, 1945–1949.
———. Record Group 239. Records of the American Commission for the Protection and Salvage of Artistic and Historic Monuments in War Areas.
———. Record Group 260. Records of the United States Occupation Headquarters. World War II. Ardelia Hall Collection: Records of the Collecting Points.
National Gallery of Art, Washington, D.C.
———. Archive. Edith Standen Papers.
———. Archive. John Walker Papers.
———. Archive. Widener Collection Records.
———. Curatorial Records.
———. Library. Rare Books and Manuscripts Section.
Nederlands Instituut voor Oorlogsdocumentatie, Amsterdam.
———. Bureau Bestrijding Vermogensvlucht.
———. De Nederlandse Kultuurkamer.
———. Departement Volksvoorlichting en Kunsten.
Noord Hollands Archief (Rijksarchief in Noord Holland), Haarlem.
———. Parket van de Procureur-generaal te Amsterdam.
———. Prijsbeheersing inspectie.
Regionaal Historisch Centrum Delft.
———. Bevolkingsregister.
———. Studentenvereniging Sanctus Virgilius.
Rijksbureau voor Kunsthistorische Documentatie, The Hague.
———. Archief Van den Brandhof.
———. Archief Hofstede de Groot.
———. Archief Scheurs de Haan.
———. Archief Wiarda.
———. Krantenknipsels.
———. Mappen. Afdeling oude schilderijen.
Rijksmuseum, Amsterdam.
———. Curatorial Records.
Zentralarchiv der Staatlichen Museen Preußischer Kulturbesitz, Berlin.
———. Archives of the Kaiser Friedrich Museum.
———. Nachlass Bode.

PRIVATE RESOURCES

Archives of the Kunsthandelung Julius Böhler, Munich.
Paul Cassirer Gallery Archives (Galerie Feilchenfeldt), Zurich.
Papers of John Godley, 3rd Lord Kilbracken, Carrigallen, Ireland.
Van Wijngaarden family archives, Amsterdam and Zutphen, the Netherlands.
Papers of Arthur K. Wheelock Jr., Washington, D.C.
Wildenstein Gallery Archives, New York.

INTERVIEWS AND CORRESPONDENCE

Willem and Hanneke Avenarius
Dirk Coenradi
Willy Coenradi
Adriana Coenradi-Van Wijngaarden
J. Dutilh-Vriesendorp
Robert and Lous Crommelin
Gerbert van Genderen Stort

M. van Heeckeren van Molecaten
Paul van Meegeren
Serge Nardus
Patrick Neslias
Saam Nijstad
Nettie van Wijngaarden
Willem van Wijngaarden

PICTURE CREDITS

PAGE

4 Interior view of Ward's home. The Records of the Ward Collection, box 1, Ashmolean Museum, Oxford. Photo of this archival material by J. Lopez.

4 *Portrait of Theodore W. H. Ward.* Photo: Ashmolean Museum, Oxford.

5 Imitator of Johannes Vermeer, *The Lace Maker.* Andrew W. Mellon Collection (1937.1.54). Image courtesy of the Board of Trustees, The National Gallery of Art, Washington, D.C.

9 *The Supper at Emmaus.* Photo: Museum Boijmans-Van Beuningen, Rotterdam.

12 Exterior view of Keizersgracht 321. Photo: K. Raucamp/ANEFO/Het Nationaal Archief, The Hague.

13 Van Meegeren smoking cigarette. Photo: George Rodger/Time & Life Pictures/Getty Images.

15 Joseph Piller and wife with Dick Kragt, ca. 1944. Photo: Collection Driessen, the Netherlands.

19 Ruins of the Reichschancellery, 1945. Photo reproduced by permission of the Trustees of the Imperial War Museum, London.

20 *Dem geliebten Führer . . .* Photo: *De Groene Amsterdammer.*

25 Van Meegeren, ca. 1918. Photo: Haags Gemeentearchief.

26 Portrait drawing of Willem van Konijnenburg. Photo: Haags Gemeentearchief.

27 Party at the Haagse Kunstkring. Photo: Haags Gemeentearchief.

27 Anna van Meegeren, ca. 1919. Photo: H. Berssenbrugge/Haags Gemeentearchief.

29 Johanna de Boer, ca. 1920. Photo: Haags Gemeentearchief.

35 Leo Nardus, ca. 1914. Published in F. Marshall, *Marshall's Chess Swindles* (New York: 1914).

39 Theo van Wijngaarden, *Self-Portrait.* Collection Willem van Wijngaarden, Amsterdam. Photo: J. Lopez.

41 *The Boy Smoking.* Collection the Groninger Museum, Groningen, the Netherlands, Hofstede de Groot bequest. Photo: John Stoel.

45 *Portrait of Eric Baron van Heeckeren van Molecaten.* Private collection, the Netherlands. Photo: J. Lopez.

45 *Portrait of E. W. Baron van Heeckeren van Molecaten.* Private collection, the Netherlands. Photo: J. Lopez.

46 *The Laughing Cavalier.* Current whereabouts unknown. Photo: Archief Hofstede de Groot, inventaris no. 78, Rijksbureau voor Kunsthistorische Documentatie, The Hague.

48 Oil portrait of Cornelis Hofstede de Groot by an unknown artist. Photo: Rijksbureau voor Kunsthistorische Documentatie, The Hague.

55 Attributed to Sébastien de Bourdon, *Portrait of a Young Boy.* The Metropolitan Museum of Art, Jules Bache Collection, 1949 (49.7.39). Image © The Metropolitan Museum of Art, New York.

56 Style of Johannes Vermeer, *The Young Woman Reading.* The Metropolitan Museum of Art, Jules Bache Collection, 1949 (49.7.40). Image © The Metropolitan Museum of Art, New York.

63 Imitator of Johannes Vermeer, *The Girl with a Blue Bow,* ca. 1925. Aqueous medium over old oil paint on old canvas, 13 × 9⅞ inches. (1971.56.) The Hyde Collection, Glens Falls, New York. Photo by Joseph Levy.

63 Johannes Vermeer, *The Girl with the Pearl Earring.* Royal Painting Cabinet, The Mauritshuis, The Hague. Photo: akg-images, London.

63 *Portrait of Cornelia Françoise Delheʒ.* Collection Huib and Francine Vriesendorp, New York. Photo: J. Lopez.

64 Imitator of Johannes Vermeer, *The Smiling Girl.* Andrew W. Mellon Collection (1937.1.55). Image courtesy of the Board of Trustees, The National Gallery of Art, Washington, D.C.

65 Johannes Vermeer, *The Girl with a Glass of Wine.* Herzog Anton Ulrich Museum, Braunschweig. Photo: akg-images, London.

67 Joseph Duveen, ca. 1920. Photo: George C. Beresford/Hulton Archive/Getty Images.

67 Wilhelm von Bode, ca. 1914. Published in the *Berliner Tageblatt,* 5 February 1914.

73 *Hertje. (Teekeningen 1.)*
74 Gerard A. Boon, ca. 1930. Photo: J. Matz/Haags Gemeentearchief.
77 *Interior of the St. Laurens Church. (Teekeningen 1.)*
80 *Christ Preaching in the Temple.* Private collection, the Netherlands. Photo: J. Lopez.
80 *The Tribute Money.* Collection Leon Vosters, Amsterdam. Photo: J. Lopez.
85 *Portrait of Marie Vriesendorp.* Private collection, the Netherlands. Photo: J. Lopez.
88 *De Kemphaan.* Collection the author.
88 Jan Ubink, ca. 1910. Photo: Haags Gemeentearchief.
106 Printed reproduction of *The Girl in Antique Costume* with Van Meegeren's handwritten annotations. Storage box 200, the print room, Museum Boijmans-Van Beuningen, Rotterdam. Photo of this archival material by J. Lopez.
108 *The Gentleman and Lady at the Spinet.* Instituut Collectie Nederland. Photo: Tim Koster, ICN, Rijswijk/Amsterdam, the Netherlands.
112 Abraham Bredius, ca. 1925. Photo: Dewald/Haags Gemeentearchief.
113 Johannes Vermeer, *Allegory of Faith.* The Metropolitan Museum of Art, New York. Photo: Bridgeman Art Library.
118 *Woman Playing the Lute.* Photo: © Stichting Het Rijksmuseum, Amsterdam.
119 *Malle Babbe.* Photo: © Stichting Het Rijksmuseum, Amsterdam.
120 Johannes Vermeer, *Christ in the House of Martha and Mary.* The National Gallery of Scotland, Edinburgh. Photo: Bridgeman Art Library.
122 *The Supper at Emmaus.* Photo: Museum Boijmans-Van Beuningen, Rotterdam.
123 Albrecht Dürer, *Self-Portrait at Age Twenty-Eight.* Alte Pinakothek, Munich. Photo: akg-images, London.
127 *Mealtime at the Farm.* Photo: George Rodger/Time & Life Pictures/ Getty Images.
127 Liselotte Orgel-Köhne, *Mutterkreuzträgerin mit ihrer Familie.* Deutsches Historisches Museum, Berlin (Orgel-Köhne 5227/10).
128 *Christ and the Adulteress.* Instituut Collectie Nederland. Photo: Tim Koster, ICN, Rijswijk/Amsterdam, the Netherlands.
128 Hans Schachinger, *Abschied.* University Library of Augsburg, Germany, Photo Collection Erika Groth-Schmachtenberger; documentary photo of the Große Deutsche Kunstausstellung in the Haus der deutschen Kunst, Munich, 1942 (Photo-Sign. 130/LB 21000G878-15a, No. 98).
129 *Jugend um Hitler.* Photo: Nederlands Instituut voor Oorlogsdocumentatie, Amsterdam.

131 *Portrait of Theo van der Pas.* Photo: Haags Gemeentearchief.

131 Hitler at Walhalla, 1937. Photo: Lebrecht Music & Arts Library, London.

138 Dirk Hannema. Photo: Nederlands Instituut voor Oorlogsdocumentatie, Amsterdam.

141 *Emmaus,* installation view. Photo: Museum Boijmans-Van Beuningen, Rotterdam.

144 Goering salutes. Photo reproduced by permission of the Trustees of the Imperial War Museum, London.

144 RAF Leaflet with Goering's face. Collection Lee Richards. Photo: psywar .org.

147 Ed Gerdes in his office. Photo: Nederlands Instituut voor Oorlogsdocumentatie, Amsterdam.

150 *Arbeid. (Teekeningen 1.)*

151 Dutch farmers led away by German soldiers. Photo: Nederlands Instituut voor Oorlogsdocumentatie, Amsterdam.

152 *Teekeningen 1,* cover design. *(Teekeningen 1.)*

152 *Wolfsangel* insignia. Collection the author.

153 Martien Beversluis. Photo: Willem van de Poll/Het Nationaal Archief, The Hague.

154 *Grain, Petroleum, Cotton. (Teekeningen 1.)*

155 *Snake and Fawn. (Teekeningen 1.)*

158 Alois Miedl, ca. 1940. Photo: RG 239, entry 73, box 80, National Archives and Record Administration, College Park, Maryland.

167 *Interior with Drinkers.* Present whereabouts unknown. Photo: Rijksrecherche dossier 1945/1A, Fotoarchief Leon Vosters, Amsterdam.

167 *The Card Players.* Photo: Museum Boijmans-Van Beuningen, Rotterdam.

169 *The Head of Christ.* Photo: Museum Boijmans-Van Beuningen, Rotterdam.

169 *Isaac Blessing Jacob.* Photo: Museum Boijmans-Van Beuningen, Rotterdam.

171 *Portrait of the Engineer E. A. van Genderen Stort.* Private collection, the Netherlands. Photo: J. Lopez.

173 *The Footwashing.* Photo: © Stichting Het Rijksmuseum, Amsterdam.

179 Interior of Keizersgracht 321. Photo: © Cok de Graaff/Nederlands Fotomuseum.

187 Dutch children at public canteen. Photo: © Cas Oorthuys/Nederlands Fotomuseum.

188 Woman collects firewood. Photo: © Charles Breijer/Nederlands Fotomuseum.

188 Man collapses in the street. Photo: © Cas Oorthuys/Nederlands Foto-
museum.

193 Roundup of Nazi sympathizers. Photo: Regionaal Historisch Centrum
Limburg, fotocollectie G. A. Maastricht.

195 *Moffenmeisje* being shaved. Photo: © Bert Haanstra/Nederlands Foto-
museum.

195 *Moffenmeisje* smeared with grease paint. Photo: Nederlands Instituut voor
Oorlogsdocumentatie, Amsterdam.

209 Van Meegeren painting *Christ in the Temple*. Photo: George Rodger/Time
& Life Pictures/Getty Images.

216 Van Meegeren at his trial. Photo: Yale Joel/Time & Life Pictures/Getty
Images.

224 Collaborators at Kamp Vught. Photo: Elsevier/ANEFO/Het Nationaal
Archief, The Hague.

228 Dutch forced laborers return from Germany. Photo: © Cees N. Jongkind/
Nederlands Fotomuseum.

228 Onlookers welcome Dutch forced laborers home from Germany. Photo:
© Cees N. Jongkind/Nederlands Fotomuseum.

232 *Dem geliebten Führer . . .* Photo: *De Groene Amsterdammer.*

232 Van Meegeren's poster for the Royal Menagerie. Photo: Haags Gemeente-
archief.

244 Marijke van den Brandhof, 1979. Photo: Van Dijk/ANEFO/Het Nation-
aal Archief, The Hague.

INDEX

Note: Italicized page numbers indicate photographs.

Abschied (Schachinger), *128*

Action Française, 90

age crackle, 40–41

alcohol test for forgeries, 33–34, 36, 39–40, 43, 47, 54, 108, 263

Allegory of Faith (Vermeer), 111–114, *113*
 purchased by Bredius, 111–113, 135
 sold to Kleinberger gallery, 112, 275–276

Amstel Hotel (Amsterdam), 16

Amsterdam
 Apollolaan interrogation facility, 17–18
 De Boer gallery, 173–177
 Goudstikker gallery, 16, 18, 158, 159–160, 180, 181–182, 200–202, 208–210, 214
 Hoogendijk gallery, 168–169, 189
 HvM in Weteringschans Prison, 11–14, 196–208
 HvM real estate investments in, 177–180
 HvM residence at Keizersgracht 321, 11–12, *12*, 178–180, *179*, 185, 188–189, 196–197
 HvM residence in suburban Laren, 145–148, 153, 166–167, 172, 178
 HvM trial for art forgery, 213–220
 Jews in World War II, 14, 147, 156–165
 Liberation of the Netherlands and, 1, 191–197, 200–201, 211
 Nazi occupation of, 156–157, 186–189
 Rijksmuseum, 68, 87, 102, 168, 174–176, 214, 218–219, 233

Anderson, Capt. Harry, 191

Annunciation (forgery in the style of Van Eyck), 171–172

Apollolaan interrogation facility (Amsterdam), 17–18

Arbeid (Van Meegeren), 149–151, *150*

Arntzenius, Floris, 78

art fraud, 2–10. *see also* forgery
 gentleman amateurs and, 32–34, 43
 laundering Holocaust assets, 3, 56–57, 59–60, 156–165

art fraud (*continued*)
 Leo Nardus and, 36–37, 42, 43, 45, 49
 nature of, 2–3
 selling imitations, 31–32
 signed authentications and, 23, 42–43,
 53–54
Aryan mother worship, 126, *127*
Ashmolean Museum (Oxford)
 Ward collection donated to, 3, 4, 60
Asscher-Koetser gallery, 116
Astronomer (Vermeer), 121, 156–157,
 159
Aus der Fünten, Ferdinand Hugo, 16

Bache, Jules, 113, 163
 purchases *Portrait of a Young Boy*,
 misattributed to Vermeer, 54
 purchases *Young Woman Reading*
 forgery, 55–56, *56*, 114
Bakelite, 107–110, 117–118, 119, 208, 216
Behrman, S. N., 103
Belgian State Museums, 215–216
Berenson, Bernard
 Icilio Joni forgeries and, 43
 Leo Nardus fraud and, 37, 42
 Pre-eminence of, 42
Berlin
 as Babylon on the River Spree,
 21–22
 German Reich Art Exhibition,
 124–125
 HvM visits (1936), 124–132
 hyperinflation, impact of, 21–24
 Kaiser Friedrich Museum, 22–24, 53,
 69–71, 104, 140
 in the mid-Weimar period, 21–24
 Olympics (1936), 9, 124, 132
 Paul Cassirer Gallery, 105, 241
 prostitutes in, 21–22, 66
 Reichschancellery ruins (1945), *19*,
 19–20
 rumors about fake art in, 114
 Russians in, 190

Theodore Ward contacts in, 22,
 58–59, 61
Bernhard, H. R. H., Prince of the
 Netherlands, 214
Berssenbrugge, H., *27*
Beuningen, Daniel G. van, 169, 233–234
Beversluis, Martien, *153*
 background of, 153–155
 at Kamp Vught, 224–225, 230
 Teekeningen 1 (with Van Meegeren),
 19–20, 151–156, 170–171,
 205–206, 210–213, 231
Beyeren, Abraham van, 3
Biesing gallery on Molenstraat (The
 Hague), 79–83, 126–128
Blakeney, Sir Percy, 86–87
blender brush, 109
Blijenburgh, A. H. W., 38
Bloch, Vitale
 art fraud, links to, 56–57, 59–60,
 266–267
 Christ and the Adulteress forgery and,
 181–182
 Footwashing forgery and, 174
 Holocaust art and, 56–57, 162
 Young Girl Reading forgery and,
 56–57
Blumenreich, Leo, 69
Bode, Wilhelm von, *67*
 authentication of art works, 42, 53,
 56, 57, 59, 64–71, 111, 120
 Vitale Bloch and, 56
 inflation of 1921 and, 66–67
 at the Kaiser Friedrich Museum
 (Berlin), 23, 61, 65, 66, 68–71
 rejection of art works presented to,
 61–62, 64, 103
 Hans Wendland and, 69–70
 Harold Wright and, 42, 59
Boer, Carel Hendrik de
 fascist National Front Party and, 89
 friendship with HvM, 29–31
 wife marries HvM, 30–31, 89

Boer gallery, De (Amsterdam), 173–177

Boer, Johanna de. *see* Meegeren, Johanna van (wife of HvM)

Boer, Pieter de, 173–177, 217–218

Boijmans Museum (Rotterdam)
"Greta Garbo Vermeer" documentation and, 105–106, 274
Hannema as director of, 234–237, 244
Supper at Emmaus forgery and, 1, 10, 128, 137–142, *141*, 145, 205, 234–237, 243–244, 245–246

Boissevain, Walraven, 178–179

Boitel, Achille, 163

Bond van Nederlandse Toneelschrijvers, 89, 149, 271

Boon, Bertha, 132–133

Boon, Gerard A., *74*, 132–139
absence from the Netherlands during occupation, 166
anti-fascist beliefs of, 74–75, 133–134
Liberal State Party of the Netherlands and, 74–75, 132–134, 167
sale of *Interior with Drinkers* forgery, 166, 207
sale of *Supper at Emmaus* forgery, 133–139, 142, 218

Bosboom, Johannes, 76–77

Bourgeois Frères, 36

Boy Smoking (forgery in the style of Hals), *41*, 41–42, 45

Boy with a Flute (rumored forgery in the style of Hals), 43

Brandhof, Marijke van den, *244*, 244–245

Bredius, Abraham, *112*, 134–140
authentication of *Gentleman and Lady at the Spinet* forgery, 111–115, 134–135
authentication of *Supper at Emmaus* forgery, 1, 99, 134–137, 139–140, 218, 235, 244

purchases *Allegory of Faith* (Vermeer), 111–113, 135

Bruckner, Anton, 130, *131*

Burlington Magazine, 112–113, 136, 235

Buuren, Arnold van, 160–161

Calvinism, 91, 230

Caravaggio, Michelangelo da, 121, 140

Card Players (forgery in the style of De Hooch), 118–119, 166, *167*, 168, 207–208

Carinhall (Goering's estate), 157, 183, 190–192, 248

Carruthers, Charles, 103–104

Christ and the Adulteress (forgery in the style of Vermeer), *128*, 126–128, 180–185
authentication of, 181–182
in exhibition of Goering's art collection, 191–192
investigation of sale to Goering, 16–20, 197–204, 214–215, 225–226
provenance letter, 183–185
removal from Carinhall, 190–192
sale to Goering, 1–2, 8, 12, 17, 18, 126, 128–129, 182–185, 189–192, 196–204, 214–215, 221–222, 225–226
Volksgeist imagery and, 126–128

Christie's, 3, 22, 58, 241–242

Christ in the House of Martha and Mary (Vermeer), 119–120, *120*, 122, 135, 174

Christ in the Temple (forgery in the style of Vermeer), 208, *209*

Christ Preaching in the Temple (Van Meegeren), 79, *80*

Christus, Petrus, 33

Coen, Jean de, 233

Coremans, Paul, 217, 218, 233–234

Credit Lyonnais, 137, 138

cubism, 80

Dadaism, 125
Delft
HvM in, 76
Delhez, Cornelia Françoise, 62, *63*
Diana and Her Companions (Vermeer),
119–120, 135
Dik, Jan, 181–182
Dongen, Kees van, 94
Doudart de la Grée, Marie Louise, 243
Dresselhuys, H. C., 73
Dürer, Albrecht, 122–123, 132,
241–242
Self-Portrait at Age Twenty-Eight, 123
Dutch Golden Age
Catholic influence on, 91–92, 130
forgery of paintings from, 3, 31–51
significance of, 90–94
Dutch Labor Front, 149
Dutch League for the Promotion of
Large Families, 82
Dutch National Socialist Party. *see*
Dutch Nazi Party
Dutch Nazi Party, 133, 148, 152–154,
193–194, 223–224, 230
HvM association with, 17, 146–147,
149, 152–153, 178, 189, 205–206,
210, 218, 244–245
moffenmeiden and, 194–196, *195*, 229
Dutch Purge Board for Artists (*Eereraad
voor de kunst*), 231
Dutch Resistance
agents tortured and murdered by
Nazis, 14, 178, 187
attitude of toward economic
collaboration, 164, 197, 222, 225,
228
Joseph Piller in, 15–16
De Waarheid (The Truth), 19–20,
205–206, 212–213, 229
Dutch Trade Unions, 149
Duveen, Sir Joseph, 42–43, *67*, 163, 236
purchases *Girl with a Kitten* forgery,
54

purchases *Lace Maker* forgery, 5, 53,
54, 59, 61, 70, 75, 86, 101, 139
purchases *Smiling Girl* forgery, 54, 61,
67–69, 112–113, 115, 237–240
Frans-Hals-style portrait and, 5,
101–103
rejects *Allegory of Faith* (Vermeer),
112
rejects *Girl with the Red Hat*
(Vermeer), 55
rejects *Supper at Emmaus* forgery,
137–140, 236–237

egg tempera medium, 33–34
Eisenhower, Dwight, 191
Erasmus, Kurt, 116
Eyck, Jan van, forgeries in the style of,
8, 33, 171

"fake up," 33–34
False Madonna (play by Jan Ubink),
92–93
fascism
affinity of art forgers for, 8, 258
Kemphaan (Fighting Cock) magazine
and, 90–97
Jan Ubink and, 88–90, 149–150,
153–154
fauvism, 80
Feilchenfeldt family, 241
Flemish Primitives, 12, 32–33, 42,
104–105
Footwashing (forgery in the style of
Vermeer), 172–177, *173*
authentication by Bloch, 174
authentication by de Wild, 174–175,
205
portion of sale proceeds hidden by
Johanna van Meegeren, 177,
189–190
sold to the Rijksmuseum, 174–176,
218–219, 233
trial of HvM and, 217, 218–219

forgery. *see also* art fraud
 age crackle and, 40–41
 alcohol test for, 33–34, 36, 39–40, 43,
 47, 54, 108, 263
 Bakelite medium and, 107–110,
 117–118, 119, 208, 216
 egg tempera and, 33–34
 Dutch old masters and, 31–51
 gelatin-glue medium and, 40, 47–48,
 104, 107–109, 239, 240, 263
 Han van Meegeren and. *see* Meegeren,
 Han van, forgeries
 hyperrestorations, 32–33, 40–42,
 116–117
 kunsthars (synthetic paint) and, 117
 K-Y jelly medium and, 242
 milk-based casein paint medium and,
 40
 signed authentications and, 23, 42–43,
 53–54
 technical evidence for, 174–175, 182,
 215–217, 234, 242
 top forgers, circa World War II, 8,
 258
 Van Gogh and, 94
 Vermeer and. *see* Vermeer, Johannes,
 forgeries in the style of
 water test for forgeries, 47–48
 X-rays and, 175, 242
Fowles, Edward, 68, 69, 103–104, 112,
 113–115, 137, 139, 236–237
Frank, Anne, 14
Friedländer, Max, 42, 53
 authentication of "Greta Garbo
 Vermeer," 104–105, 107,
 274–275
 at the Kaiser Friedrich Museum
 (Berlin), 104–105
Froentjes, Willem, 215–216, 217, 218,
 234
Fry, Roger, 36–37, 119–120, 235
Führermuseum (Linz, Austria), 174
Fyt, Jan, 34

Garschagen, Oscar, 138–139
Gauguin, Paul
 denounced in *De Kemphaan,* 93–95
gelatin-glue medium, 40, 47–48, 104,
 107–109, 239, 240, 263
Gelder, J. G. van, 205, 218–219, 233
Gelder, Michel van, 43
Genderen Stort, E. A. van, 170–171, *171*
Gentleman and Lady at the Spinet
 (forgery in the style of Vermeer),
 107–117, *108*
 authentication by Bredius, 111–115,
 134–135
 Bakelite medium and, 107–110
 "precisionist" technique and, 109–112
 sale to Katz Gallery, 115–117
 trial of HvM and, 218
Gerdes, Ed, *147*
 anti-Semitism of, 147
 death of, 196
 as Nazi art tsar, 146–147, 149,
 152–153, 178, 245
Germany. *see also* Berlin; Nazis;
 Nuremberg
 de-Nazification decrees, 245
 Dutch forced laborers in, 228–229
 surrender of, 191
Geval Van Meegeren, Het (Ton van
 Tast), 214
Gilbert, Gustave, 247
Girl Asleep (Vermeer), 121–122
Girl in Antique Costume. see "Greta
 Garbo Vermeer"
Girl with a Blue Hat. see "Greta Garbo
 Vermeer"
Girl with a Glass of Wine (Vermeer),
 64–65, *65*
Girl with a Kitten (forgery in the style of
 Vermeer), 54
Girl with the Blue Bow (forgery in the
 style of Vermeer), 61–64, *63,*
 85, 273
 authentication by Valentiner, 61, 104

Girl with the Blue Bow (*continued*)
 de-attribution of, 239–241
 Katz Gallery and, 117
Girl with the Pearl Earring (Vermeer),
 53, 62, *63*, 68
Girl with the Red Hat (Vermeer), 53, 55,
 104, 175
Godley, John, 3rd Lord Kilbracken, 247,
 251, 274
Goering, Emmy, 191
Goering, Hermann, *144*
 art collecting habits of, 156–158,
 183–184
 bombing of Rotterdam, 143–145
 buys *Christ and the Adulteress* forgery,
 1–2, 8, 12, 17, 18, 126, *128*,
 128–129, 182–185, 189–192,
 196–204, 214–215, 221–222,
 225–226
 Carinhall (estate), 157, 183, 190–192,
 248
 death sentence at Nuremberg, 222,
 246–248
 described, 157
 Dutch art collections and, 16, 18,
 156–165
 exhibition of art collection after war,
 191–192
 Footwashing forgery and, 174, 176
 under house arrest, 191
 investigation of sale of *Christ and the
 Adulteress* forgery to, 16–20,
 197–204, 214–215, 225–226
 Alois Miedl as financial advisor to,
 16–18, 157–160, 176, 227
 moves property from Carinhall,
 190–192
Goes van Naters, Marinus van der, 231
Gogh, Vincent van
 denounced in *De Kemphaan*, 93–95
 forgeries in the style of, 94–95
Goller, Christian, 241–242
Gormans, Christa, 191

Goudstikker, Jacques, 158
Goudstikker gallery (Amsterdam), 16,
 18, 158, 159–160, 180, 181–182,
 200–202, 208–210, 214
Goupil gallery (Paris), 110
Grain, Petroleum, Cotton (Van
 Meegeren), *154*, 154–155
Great Depression
 appeal of Hitler and, 141
 Vermeer-mania and, 114
"Greta Garbo Vermeer," 104–107, *106*
 authentication by Max Friedländer,
 104–105, 107, 274–275
 connections to Van Meegeren,
 105–107
 sold to Heinrich Thyssen, 105–106,
 107
 returned by Thyssen family, 241, 292
Groene Amsterdammer, De, 82–83, 254
Groote Schouburgh, De (The Great
 Stage), 31

Haagse Bluf, 25, 72–73
Haagse Kunstkring, *27*
 Bredius and, 111
 described, 28
 HvM and, 28, 97–99
Haas, H. A. de, 44–47, 50
Hague, The
 Biesing Gallery on Molenstraat,
 79–83, 126–128
 as center of art forgery, 34, 37–45
 Court of Special Pleas Archive, 203
 described, 24–25
 Haagse Kunstkring, *27*, 28, 97–99,
 111
 Heeregracht, 49–50
 HvM base of operations in, 24–31,
 38–42
 HvM solo shows, 78–83, 126–128,
 152–153
Kemphaan (Fighting Cock) magazine
 and, 75, 86–97

Mauritshuis, 34, 68, 76, 104–105, 135
 in the 1920s, 24–31
 Theo van Wijngaarden's operations in, 37–61, 83–99, 117
Haighton, Alfred, 88–89
Hale, Phillip, 238
Hals, Frans, 53, 177
 forgeries in the style of, 5, 34, 39
 Boy Smoking, *41*, 41–42, 45
 Boy with a Flute, 43
 Laughing Cavalier, 44–52, *46*, 61, 85–86, 107, 117
 Malle Babbe, 118, *119*
 portrait, 101–103
 HvM's stylist affinity for, 41–42, 86
Hannema, Dirk, *137*
 as director of the Boijmans Museum, 138–141, 234–237, 244
 Head of Christ forgery and, 168–170, *169*
 investigation of HvM and, 205, 217–218, 287
 as Nazi collaborator, 205
 postwar career, 232–235
 Supper at Emmaus forgery and, 137–140, 205, 217–218, 232–235
Havelaar, Just, 81
Head of Christ (forgery in the style of Vermeer), 168–170, *169*
Heeckeren van Molecaten, E. W. Baron van, 44, *45*
Heeckeren van Molecaten, Eric Baron van, 44, *45*
Heeckeren van Molecaten, Walraven Baron van, 44
Henning, Cootje, 209–210
Hertje (Van Meegeren), *73*, 73–74, 155–156
Himmler, Heinrich, 201–202
Hitler, Adolf
 aesthetic theories of, 75–76, 125

Boon's opposition to, *74*, 74–75
Dutch Nazi Party and, 133
Führermuseum (Linz, Austria), 174
Haagse Kunstkring and, 98
Hoffmann as photo-biographer of, 128–130
Holocaust art and, 156–157, 159, 160
HvM support for, 2, 8, 19–20, *20*, 75–76, 90, 125, 145–156, 165, 205–206, 210–212, 231
invasion of Poland, 142
Mein Kampf, 8, 75–76, 124, 125
Netherlands capitulation to, 145
official photographs of, *129*, 129–130, *131*
Reichschancellery ruins (1945), *19*, 19–20
Teekeningen 1 (Van Meegeren and Beversluis), 19–20, *20*, 205–206, 210–213, 231
Hoek van Holland internment camp, 196, 234
Hofer, Walter Andreas, 174, 176
Hoffmann, Heinrich, 128–130
 as admirer of Vermeer's "biblical period," 128–129
 as art advisor to Hitler, 180, 183
 Christ and the Adulteress forgery and, 128–129
 official photographs of Hitler, *129*, 129–130, *131*
 picture books on Hitler, 245
Hofstede de Groot, Cornelis
 authentication of art works, 42, 43–44, *45*–51, 53–54, *54*, 66–67, 111
 "Eye or Chemistry, The" (*Oog of chemie*), 47
 Laughing Cavalier fraud and, 45–50, 61, 85–86
 Leo Nardus fraud and, 36–37, 42, 43, 45, 49

Hofstede de Groot, Cornelis (*continued*)
 portrait of, *48*
 as target of forgers and swindlers,
 50–51
Holocaust
 laundering assets of, 3, 56, 59–60,
 156–157, 159, 160, 162
Hooch, Pieter de, forgeries in the style of
 Card Players, 118–119, 166, *167,* 168,
 207–208
 Interior with Drinkers, 118–119, 166,
 167, 207–208
Hoogendijk, D. A., 138–139, 140,
 168–169, 171–173, 189, 217–218
Hoogendijk gallery (Amsterdam),
 168–169, 189
Hopper, Edward, 80
Houbraken, Arnold, 31
House of Muller, 45–49
Hyde, Charlotte
 Girl with the Blue Bow forgery and,
 239–241
hyperrestorations, 32–33, 40–42,
 116–117

Interior with Drinkers (forgery in the style
 of De Hooch), 118–119, 166, *167,*
 207–208
Irenebrigade, 193, 201
Isaac Blessing Jacob (forgery in the style
 of Vermeer), *169,* 169–171
Isarlo, Georges, 116, 236, 292
Israëls, Jozef, 147
Italian Primitives, forgeries of, 8, 40

Jews
 in Amsterdam, 14, 147, 156–165
 looting of artworks from, 3, 56–57,
 59–60, 156–165
 transport to death camps, 14, 16, 159,
 160, 161, 178
Joni, Icilio
 art fraud of, 8, 43, 258

Juliana, H. R. H., Princess of the
 Netherlands, 73–74, 155
 as Queen, 223–224

Kaiser Friedrich Museum (Berlin)
 Wilhelm von Bode at, 23, 61, 65, 66,
 68–71
 Max Friedländer at, 104–105
 "Greta Garbo Vermeer" and, 104–107
 Lace Maker forgery and, 22–24, 53,
 69–71, 140
 Smiling Girl forgery and, 64–71
 Young Woman Reading forgery and, 56
Kalf, Willem, 3
Kamp Vught, *224,* 224–225, 230
Kantzow, Carin von, 157
Katz, Benjamin, 115–117, 160, 236
Katz, Nathan, 115–117, 138, 160, 236,
 240
Keizersgracht 321, Amsterdam, 11–12,
 12, 178–180, *179,* 185, 188–189,
 196–197
Kemphaan (Fighting Cock) magazine,
 75, 86–97
 clique surrounding, 88–90
 cover illustration, *88*
 designated enemies of, 93–95
 funding for, 100–101
 Hitler and, 125
 Liberal State Party of the Netherlands
 and, 96–97
 masters of the Dutch tradition and,
 95–96
 objectives of, 90–94, 130–131
 Jan Ubink as editor of, 87–99,
 130–131, 149, 230–231
Kilbracken, Lord. *see* Godley, John, 3rd
 Lord Kilbracken
Kleinberger gallery
 Allegory of Faith (Vermeer) and, 112
 rejects *Gentleman and Lady at the
 Spinet* forgery, 110–111,
 275–276

Knoedler & Co., 42–43, 55, 68
Kok, Jan, 172–173
 sale of *Footwashing* forgery and,
 176–177, 189–190, 217
Konijnenburg, Willem van, 78
 portrait drawing of, *26*, 28
Korteling, Bartus, 76
Kragt, Dick, 16
kunsthars (synthetic paint), 117
Kunstkring. *see* Haagse Kunstkring
K-Y jelly medium, 242

Lace Maker (forgery in the style of
 Vermeer), *5*, 6, 85
 authentication by Bode, 22–24, 59,
 69–71
 de-attribution of, 238–240
 at the Kaiser Friedrich Museum,
 22–24, 53, 69–71, 140
 sold to Duveen, 5, 53, 54, 59, 61, 70,
 75, 86, 101, 139
 sold to Andrew Mellon, 54, 103,
 237–238
Last Supper (forgery in the style of
 Vermeer), 169, 170, 233–234
Laughing Cavalier (forgery in the style of
 Hals), 44–52, *46*, 107, 117
 Hofstede de Groot authentication of,
 45–50, 61, 85–86
 sold by House of Muller, 45–49
Lazzaroni, Michele, 32, 33, 40, 43
League of Dutch Playwrights (*Bond van
 Nederlandse Toneelschrijvers*), 89,
 149, 271
Leonardo da Vinci, 53
Liberal State Party of the Netherlands,
 72–75, 84, 87, 96–97, 132–134,
 155–156, 166–167, 178
London. *see also* Ward, Theodore
 Dutch government in exile, 192–193,
 197
 HvM visits Ward in, 3–5, 102
 rumors about fake art in, 112, 114

Lowengard, Armand, 68, 70, 102–105,
 137, 139, 236
Luitwieler, H. G., 205
Lynnewood Hall art fraud, 36–38, 42,
 49

Maduro, Tettie, 73
Malle Babbe (forgery in the style of
 Hals), 118, *119*
Mannheimer, Fritz, 110, 115, 218
Maris, Willem, 177
Marshall Plan, 229
Martin, Wilhelm, 34, 68, 104–105,
 135
Mauclair, Camille, 100, 272
Mauritshuis (The Hague), 34, 68, 76,
 104–105, 135
Mazzoni, Gianni, 32
Mealtime at the Farm (Van Meegeren),
 125–126, *127*, 146
Meegeren, Anna van (wife of HvM)
 background of, 26
 children of, 26–28, 83–84, 105
 divorces HvM, 30, 83–84
 high life in The Hague and, *27*,
 28–29
 marriage to HvM, 26–30
Meegeren, Han van
 in 1918, *25*
 in 1945, *13*
 in 1947, *216*
 affection for the Bible, 79–83
 alcohol problems of, 6, 97, 170
 anachronisms in works of, 6, 10,
 104–107
 at Apollolaan interrogation facility,
 17–18
 association with Theo van
 Wijngaarden, 24–25, 34–36,
 38–51, 57–61, 117
 background of, 25–28
 Berlin trip (1936), 124–132
 children of, 26–28, 83–84, 105

Meegeren, Han van (*continued*)
 as collaborator, 3, 17, 146–147, 149,
 152–153, 178, 189, 205–206, 210,
 218, 244–245
 death of, 221–222, 232
 in Delft, 76
 described, 76
 divorce from wife, Anna, 26–30,
 83–84
 divorce from wife, Johanna, 189–190,
 220
 donations to German Red Cross and
 Winterhulp, 146–147
 Dutch Nazi Party and, 17, 146–147,
 149, 152–153, 178, 189, 205–206,
 210, 218, 244–245
 education of, 25–26, 76–78
 extramarital affairs of, 28–31, 89,
 189
 forgeries by. *see also* Meegeren, Han
 van, works
 Bakelite medium and, 107–110,
 117–118, 119, 208, 216
 "biblical" Vermeers, 9–10, 17, 57,
 117–142, 166–176, 180–185, 245
 confesses to, 7, 18–20, 202–203,
 207, 213–220
 deteriorating quality of, 170
 Hitlerism and, 2, 8, 19–20, *20*,
 75–76, 90, 125, 145–156, 165,
 205–206, 210–212
 investigation of, 196–214
 political-intellectual purpose of,
 92–93
 public reaction to announcement
 of, 210, 213, 214–215, 237,
 243–248
 sold to Hermann Goering, 1–2, 8,
 12, 17, 18, 126, *128*, 128–129,
 182–185, 189–192, 196–204,
 214–215, 221–222, 225–226
 technical evidence for, 215–217
 trial in Amsterdam for, 213–220

Meegeren, Han van (*continued*)
 grandstanding mode after World War
 II, 50
 Haagse Kuntskring and, 28, 97–99
 in The Hague, 24–31, 38–42
 Cootje Henning and, 209–210
 as heroic figure, 210–220, 246–247
 Hitlerism of, 2, 8, 19–20, *20*, 75–76,
 90, 125, 145–156, 165, 205–206,
 210–212, 231
 house arrest at Goudstikker Gallery,
 208–210, 214
 Kemphaan (Fighting Cock) magazine
 and, 75, 86–97
 Liberal State Party of the Netherlands
 and, 72–75, 84, 87, 96–97,
 132–134, 155–156, 166–167,
 178
 marries Johanna de Boer, 30–31, 89
 marries Anna de Voogt, 26–30,
 83–84
 metamorphosis from painter to forger,
 7–8, 30–31, 78–79
 Nazi collaborationist artworks, 17,
 148–156
 Joseph Piller and, 18–20, 199–213
 portraits, 84–86. *see also* Meegeren,
 Han van, works under own name
 real estate investments in Amsterdam,
 177–180
 residence at Keizersgracht 321,
 Amsterdam, 11–12, *12*, 178–180,
 179, 185, 188–189, 196–197
 residence in Laren, 145–148, 153,
 166–167, 172, 178
 residence Roquebrune, on the French
 Riviera, 99, 100–101, 117–123,
 132–133, 142
 returns to Amsterdam, 142, 145,
 148–156
 solo show at Biesing Gallery on
 Molenstraat (The Hague, 1922),
 79–83, 126–128

Meegeren, Han van (*continued*)
 solo show at Pictura exhibition hall
 (The Hague, 1917), 78
 solo show in Mesdag Panorama (The
 Hague, 1942), 152–153
 trial for art forgery, 213–220
 Volksgeist themes and, 9, 124–132,
 141, 148–149, 245–246
 wealth of, 100–101, 142, 146–147,
 177–180, 189–190, 220
 in Weteringschans Prison
 (Amsterdam), 11–14, 196–208
 wins gold medal for drawing of St.
 Laurens Church (Rotterdam),
 76–77, *77*, 79–80
 works, forgeries confessed to in 1945
 Card Players (style of De Hooch),
 118–119, 166, *167*, 168, 207–208
 Christ and the Adulteress (style of
 Vermeer), 8, 12, 16–20, 126,
 128, 128–129, 182–185, 189–192,
 196–204, 214–215, 221–222,
 225–226
 Christ in the Temple (style of
 Vermeer), 208, *209*
 Footwashing (style of Vermeer),
 172–177, *173*, 189–190, 205,
 217–219, 233
 Head of Christ (style of Vermeer),
 168–170, *169*
 Interior with Drinkers (style of De
 Hooch), 118–119, 166, *167*,
 207–208
 Isaac Blessing Jacob (style of
 Vermeer), *169*, 169–171
 Last Supper (style of Vermeer), 169,
 170, 233–234
 Malle Babbe (style of Hals), 118, *119*
 Portrait of a Man (style of
 Terborch), 118
 Supper at Emmaus (style of
 Vermeer), 1, 9–10, 18, 92, 99,
 117, 121–124, *122*, 132–142, *141*,

 145, 168, 170, 178, 205, 215–218,
 233–238, 243–246
 Woman Playing the Lute (style of
 Vermeer), 118, *118*
 Woman Reading Music (style of
 Vermeer), 118
 works, forgeries here attributed to
 Boy Smoking (style of Hals), *41*,
 41–42, 45
 Gentleman and Lady at the Spinet
 (style of Vermeer), 107–117, *108*,
 134–135, 218
 Girl with the Blue Bow (style
 of Vermeer), 61–64, *63*, 85,
 103–104, 117, 239–241, 273
 Lace Maker (style of Vermeer), *5*,
 6, 22–24, 53–54, 59, 61, 69–71,
 75, 85–86, 101, 103, 139–140,
 237–240
 Laughing Cavalier (style of Hals),
 44–52, *46*, 61, 85–86, 107,
 117
 Smiling Girl (style of Vermeer),
 54, 59, 61, *64*, 64–71, 86,
 94–96, 103, 112–113, 115,
 238–240
 works, rumored forgeries, possibly by
 Boy with a Flute (style of Hals), 43
 Girl in Antique Costume. see "Greta
 Garbo Vermeer"
 Girl with a Blue Hat. see "Greta
 Garbo Vermeer"
 "Greta Garbo Vermeer," 104–107,
 106, 274–275
 works, under own name
 Arbeid, 149–151, *150*
 Christ Preaching in the Temple, 79,
 80
 Cornelia Françoise Delhez, 62, *63*
 Grain, Petroleum, Cotton, *154*,
 154–155
 *E. W. Baron van Heeckeren van
 Molecaten*, 44, *45*

Meegeren, Han van (*continued*)
 works, under own name (*continued*)
 *Eric Baron van Heeckeren van
 Molecaten*, 44, *45*
 *Walraven Baron van Heeckeren van
 Molecaten*, 44
 E. A. van Genderen Stort, 170–171,
 171
 Hertje, *73*, 73–74, 155–156
 Kemphaan (cover illustration),
 88
 Willem van Konijnenburg, *26*, 28
 Mealtime at the Farm, 125–126,
 127, 146
 Theo van der Pas, 130, *131*
 Portrait of Bertha Boon's mother
 mentioned, 132–133
 St. Laurens Church (Rotterdam),
 76–77, *77*, 79–80
 Snake and Fawn, 155, *155*
 Teekeningen 1 (book), 19–20,
 151–156, *152*, 170–171, 205–206,
 210–213, 231
 Tribute Money, 79, *80*
 Marie Vriesendorp, 84, *85*
 Theodore W. H. Ward, *4*, 4–5, 102,
 105
Meegeren, Jacques van (son of HvM),
 26–28, 83–84, 105
Meegeren, Johanna van (wife of HvM),
 29, 30–31
 alcohol problems, 97
 divorce from Carel de Boer, 30
 divorce from HvM in name only,
 189–190, 220
 marries HvM, 30–31, 89
 proceeds of *Footwashing* sale hidden
 by, 177, 189–190
 residence at Keizersgracht 321,
 Amsterdam, 178–180, *179*
 residence in Roquebrune, on the
 French Riviera, 99, 100–101,
 117–123, 132–133, 142

 as respectable matron, 179, 209
 returns to Amsterdam, 142
Meegeren, Pauline van (daughter of
 HvM), 26–28, 83–84
Meijer, Fred, 60
Mein Kampf (Hitler), 8, 75–76, 124, 125
Mellon, Andrew, 2, 54–55, 237–239
 purchases *Girl with the Red Hat*
 (Vermeer), 55
 purchases *Lace Maker* forgery, 54,
 103, 237–238
 purchases *Smiling Girl* forgery, 54,
 103, 237–238
 donates collection to National Gallery
 of Art (Washington, D.C.), 54,
 237–240
Metropolitan Museum of Art (New
 York), 60, 121–122
Michelangelo, 53
microchemical analysis, 174, 182
Miedl, Alois, *158*
 flees to Spain, 16–18, 186–187,
 226–227
 as Goering's financial advisor, 16–18,
 157–160, 176, 227
 Goudstikker gallery and, 16–17, 158,
 180, 201–202
 Jews protected by, harmed by,
 158–159
 questioned by U.S. Naval
 Intelligence, 17–18, 226–227,
 289–290
 sale of *Christ and the Adulteress* forgery
 and, 180–185, 197–204, 213
 wealth of, 187, 226–227
Miedl, Dorie Fleischer, 158–159,
 226–227, 289–290
milk-based casein paint medium, 40
Mistress and Maid with a Letter
 (Vermeer), 140
moffenmeiden, 194–196, *195*, 229
Moiseiwitsch, Maurice, 243
Mondrian, Piet, 94

Muller, Frederik, 45–49
Music Lesson (Vermeer), 121–122
Mussert, Anton, 153
Mussolini, Benito, 132, 133
Mutterkreuz, 126, *127*
Myatt, John, 241–242

Nardus, Leo, *35*, 35–38
 art collection in Amsterdam, 160–162
 background of, 36
 business practices of, 43–44, 48
 retires to Tunisia, 37, 160–161
 in the U.S, 36–37
 Widener fraud accusations and, 36–37, 42, 43, 45, 49
 Wijngaarden as restorer for, 35–38
National Gallery of Art (Washington, D.C.)
 de-attribution of Vermeer forgeries, 238–240
 Mellon collection donated to, 54, 237–238
 Vermeer show (1996), 238–239
 Widener collection donated to, 37
Nauta, Max, 181
Nazis. *see also* Dutch Nazi Party; Goering, Hermann; Hitler, Adolf
 Abwehr espionage ring, 16
 art looting apparatus, 3, 56–57, 59–60, 156–165
 downfall of Third Reich, 186–189, 191
 financial operations of Third Reich, 16–17
 HvM collaborationist paintings, 148–156
 HvM interest in, 2, 8, 83, 100, 124–132, 145–156, 218
 Luftwaffe bombing campaigns, 143–145
 occupation of the Netherlands, 145–165, 186–189

symbolism of, 151, 152, *152*
Volksgeist themes, 9, 124–132, 141, 148–149, 245–246
Volksgemeinschaft, 149–150
Wehrgemeinschaft, 149–150
Netherlands. *see also* Amsterdam; Delft; The Hague; Rotterdam
 Dutch forced laborers in Germany, 228–229
 government in exile in London, 192–193, 197
 Liberal State Party of the Netherlands, 72–75, 84, 87, 96–97, 132–134, 155–156, 166–167, 178
 Liberation of, 1, 191–197, 200–201, 211
 Marshall Plan and, 229
 Nazi occupation of, 145–165, 186–189
 Nazi Party of. *see* Dutch Nazi Party
 persoonsbewijs program, 145
 status during battle for control of Europe (1945), 192–197
Nietzsche, Friedrich, 8, 93, 95
Nieuwe Courant, 78
No Monument for Van Meegeren (Doudart de la Grée), 243
Nuremberg
 Goering escapes to environs of, 190–191
 Nuremberg Rallies, 125
 Nuremberg trials, 183–184, 222, 246–248

Orgel-Köhne, Liselotte, 126
Orphen, William, 84
Ostade, Adriaen van, 34

Parable of the Unmerciful Servant (incorrectly ascribed to Vermeer), 120

Paris
 Goupil gallery, 110
 Rothschild collection, 159–160
 Schloss collection, 162
 Seligmann gallery, 162
Pas, Theo van der, 130, *131*
Paul Cassirer Gallery (Berlin), 105, 241
Perdoux, Yves, 163
Picasso, Pablo, 86
Piller, Joseph, 11–20, 196–214
 admiration for HvM, 18–20, 199–213
 arrests HvM, 11–14, 196–208
 arrests Rienstra van Stuyvesande,
 198, 207, 286
 background of, 14–16, *15*
 Christ in the Temple forgery and, 208,
 209
 criticized by Allies, 200, 286
 discharge from army, 213
 Goudstikker gallery and, 16,
 200–202, 286
 HvM confesses forgeries to, 18–20,
 202–203, 207
 at HvM trial for art forgery, 214
 joins the Dutch Resistance, 15–16
 Dick Kragt and, 16
 Alois Miedl and, 227–228
 as peacetime bureaucrat for the Dutch
 army, 11–14, 16–20, 196–214
 retires to Mallorca, 213–214
 transfers HvM to Apollolaan
 interrogation facility, 17–18
pointillé highlights, 115, 121
Portrait of a Man (forgery in the style of
 Terborch), 118
Portraits of HvM. *see* Meegeren, Han
 van, works under own name
Price Waterhouse, 61

Radio Oranje, 164
Read, Sir Herbert, 235
Reichschancellery ruins (1945), *19*,
 19–20

Rembrandt, 52, 53–54, 60, 120, 134
 forgeries in the style of, 34, 241
Rembrandt Society, 139, 140, 176
Renders, Emile, 32–33
Resistance. *see* Dutch Resistance
Riddersgezelschap, 44
Riefenstahl, Leni, 125
Rienstra van Stuyvesande, Petrus Jan,
 178–185
 arrested by Piller, 198, 207, 286
 Christ and the Adulteress forgery and,
 180–185, 198–199, 203–204, 207,
 225–226
 residence at Keizersgracht 321,
 Amsterdam, 178–179
 trial as collaborator, 225–226
 trial of HvM and, 218
 in Weteringschans prison, 198–199
Rijkskweekschool voor Onderwijzers,
 87
Rijksmuseum (Amsterdam), 68, 87, 102,
 168, 214
 purchases *Footwashing* forgery,
 174–176, 218–219, 233
Rijksrecherche, 204–207, 214
Roëll, Jonkheer David, 168
Rohde, Walter Kurt, 59, 65, 68–69
Rosenberg, Pierre, 236
Rosenberg family, 163
Rost van Tonningen, Meinoud, 153, 196
Rothschild paintings, 159–160
Rotterdam
 Boijmans Museum. *see* Boijmans
 Museum (Rotterdam)
 HvM drawing of St. Laurens Church,
 76–77, *77*, 79–80
 Luftwaffe bombing of, 143–145

St. Laurens Church (Rotterdam)
 HvM drawing of, 76–77, *77*, 79–80
Sakhai, Ely
 art fraud of, 31–32
Sargent, John Singer, 84

Saturday Evening Post, 243

Schachinger, Hans, 126, 245
 Abschied, 128

Schaeffer, Hanns, 240, 241

Schindler, Oskar, 159

Schloss family, 162

Schmidt-Degener, Frederik, 68–69,
 70–71, 102, 104–105, 115,
 137–140, 168

Self-Portrait at Age Twenty-Eight
 (Dürer), *123*

Seligmann, Jacques, 162, 266–267,
 274–275

Siennese Primitives, 8, 43

Smiling Girl (forgery in the style of
 Vermeer), *64,* 64–71, 86, 94,
 95–96
 authentication by Bode, 59, 64–66
 Bredius on authenticity of, 112–113,
 115
 as forgery, 238–240
 sold to Joseph Duveen, 54, 61, 67–69,
 112–113, 115, 237–240
 sold to Andrew Mellon, 54, 103,
 237–238

Snake and Fawn (Van Meegeren), 155,
 155

Sollicitant, De
 Jan Ubink and, 87–88

Sotheby's, 3, 241–242

Spain
 Miedl flees to, 16–18, 186–187,
 226–227
 Spanish Civil War, 143

spectrometers, 242

Spierdijk, Jan, 19–20, 21, 212–213

Strijbis, Rens, 166–169, 171–172, 189,
 207

Sumatrastraat forgery business in The
 Hague, 24, 37–61, 83–99, 117

Supper at Emmaus (forgery in the style
 of Vermeer), *9,* 9–10, 117,
 121–123, *122,* 168, 170
 authentication by Bredius, 1, 99,
 134–137, 139–140, 218, 235, 244
 background of, 121
 Berlin Olympics (1936) and, 9, 124,
 132
 at the Boijmans Museum (Rotterdam),
 1, 10, 128, 137–142, *141,* 145,
 205, 234–237, 243–244, 245–246
 as forgery, 18, 137–140, 215, 233,
 235–237, 238, 243–244
 Dirk Hannema and, 137–140, 205,
 217–218, 232–235
 HvM begins work on, 132
 HvM confesses to painting, 215
 politico-intellectual program behind,
 92
 sale of, 133–139, 142, 218
 sources of inspiration, 122–124,
 124–132, 148–149
 trial of HvM and, 217–218

Tast, Ton van, 214

Teekeningen 1 (Van Meegeren and
 Beversluis), 151–156, 170–171
 HvM inscription to Hitler and, 19–20,
 20, 205–206, 210–213, 231

Terborch, Gerard, 177
 Portrait of a Man (forgery in the style
 of), 118

Tersteeg, J., 110–111

Third Reich
 Berlin Art Exhibition (1936),
 124–125
 downfall of, 186–189, 191
 financial operations of, 16–17

Thoré, Théophile, 53

Thyssen, Heinrich, 2
 buys and returns "Greta Garbo
 Vermeer," 105–106, 107, 241

Titanine, 24

Tombe, A. A. des
 buys *Girl with the Pearl Earring*
 (Vermeer), 53

Town & Country magazine, 214–215
Tribute Money (Van Meegeren), 79, *80*
Triumph of the Will (Riefenstahl), 125
tronie, 62, 64
Tunisa
 Leo Nardus retires to, 37, 160–161

Ubink, Jan, *88*
 background of, 87–88, 91, 110
 column for *De Sollicitant*, 87–88
 as editor of *De Kemphaan*, 87–99,
 130–131, 149, 230–231
 False Madonna (play), 92–93
 and the fascist movement, 88–90,
 149–150, 153–154
 Haagse Kunstkring and, 97–99
 investigation of collaborationist
 activities, 230–231
 and League of Dutch Playwrights, 89,
 149, 271
 at Rijkskweekschool voor
 Onderwijzers, 87
 as HvM's idea man, 92–93
United States
 Hyde Collection (Glens Falls, New
 York), 239–241
 Metropolitan Museum of Art (New
 York City), 60, 121–122
 Leo Nardus in, 36–37
 National Gallery of Art (Washington,
 D.C.), 37, 54, 237–240

Valentiner, Wilhelm, 239–240
 authentication of *Girl with the Blue
 Bow* forgery, 61, 104
 Leo Nardus fraud and, 36–37
Van Meegeren: Master Forger
 (Kilbracken), 243
Van Meegeren Mystery, The
 (Moiseiwitsch), 243
Veken, Jef van der, 8, 33, 55, 171–172
Verbond van Actualisten, 88, 110
Vermeer, Johannes
 Catholicism and, 130

 exhibition at the National Gallery of
 Art (1996), 238–239
 forgeries and reputed forgeries in the
 style of
 "biblical" Vermeers, 9–10, 17, 57,
 117–142, 166–176, 180–185, 245
 Christ and the Adulteress, 8, 12,
 16–20, 126, *128*, 128–129,
 182–185, 189–192, 196–204,
 214–215, 221–222, 225–226
 Christ in the Temple, 208, *209*
 Footwashing (style of Vermeer),
 172–177, *173*, 189–190, 205,
 217–219, 233
 Gentleman and Lady at the Spinet,
 107–117, *108*, 134–135, 218
 Girl in Antique Costume. see "Greta
 Garbo Vermeer"
 Girl with a Blue Hat. see "Greta
 Garbo Vermeer"
 Girl with a Kitten, 54
 Girl with the Blue Bow, 61–64,
 63, 85, 103–104, 117, 239–241,
 273
 "Greta Garbo Vermeer," 104–107,
 106, 274–275
 Head of Christ, 168–170, *169*
 Isaac Blessing Jacob, *169*, 169–171
 Lace Maker, *5*, 6, 22–24, 53–54, 59,
 61, 69–71, 75, 85–86, 101, 103,
 139–140, 237–240
 Last Supper, 169, 170, 233–234
 Smiling Girl, 54, 59, 61, *64*, 64–71,
 86, 94–96, 103, 112–113, 115,
 238–240
 Supper at Emmaus, 1, 9–10, 18, 92,
 99, 117, 121–124, *122*, 132–142,
 141, 145, 168, 170, 178, 205,
 215–218, 233–238, 243–246
 Woman Playing the Lute, 118, *118*
 Woman Reading Music, 118
 Young Woman Reading, 55–56, *56*,
 114, 266
 lack of disciples, 54

Vermeer, Johannes (*continued*)
 modern rediscovery of, 52–53
 oeuvre of, 53, 64–65, 96, 238–239
 pictures misattributed to
 Parable of the Unmerciful Servant,
 120
 Portrait of a Young Boy, 54
 works by
 Allegory of Faith, 111–114, *113,* 135
 Allegory of Painting, 156–157
 Astronomer, 121, 156–157, 159
 Christ in the House of Martha and
 Mary, 119–120, *120,* 122, 135,
 174
 Diana and Her Companions,
 119–120, 135
 Girl Asleep, 121–122
 Girl with a Glass of Wine, 64–65, *65*
 Girl with the Pearl Earring, 53, 62,
 63, 68
 Girl with the Red Hat, 53, 55, 104,
 175
 Mistress and Maid with a Letter, 140
 Music Lesson, 121–122
 Woman with a Balance, 53
Volksgeist themes, 9, 124–132, 141,
 148–149, 245–246
Volksgemeinschaft, 149–150
Vondel, Joost van den, 91, 92
Voogt, Anna de. *see* Meegeren, Anna
 van (wife of HvM)
Vorm, Willem van der, 169, 176
Voss, Hermann, 174
Vries, A. B. de, 57
Vriesendorp, Marie, 84, *85*
Vroege Vermeer uit 1937, Een (An early
 Vermeer from 1937; Van den
 Brandhof), 244–245

Waarheid, De (The Truth), 19–20,
 205–206, 212–213, 229
Wacker, Otto, 94
Ward, Albert
 gallery in London, 58

 requests for signed authentications,
 53–54
Ward, Rudolf
 gallery in London, 58
 operations in Paris, 59
Ward, Theodore
 background of, 60–61
 Bakelite medium and, 108–109
 as collector of old masters, 3
 described, 60
 donates collection to Ashmolean
 Museum (Oxford), 3, 4, 60
 employment of Harold Wright, 5, 22,
 24, 57–61, 71
 Finchley Road townhouse (London),
 3–4, *4,* 22
 HvM visits in London, 3–5, 102
 paint company, 24, 57–58, 61, 261
 portrait of, *4,* 4–5, 102, 105
 as private dealer, 58–59
 requests for signed authentications,
 53–54, 104
Wehrgemeinschaft, 149–150
Wendland, Hans, 59–60, 69–70, 107,
 163, 241, 274–275
Weteringschans Prison (Amsterdam)
 HvM in, 11–14, 196–208
 Rienstra van Stuyvesande in,
 198–199
Widener, P. A. B.
 Leo Nardus fraud against, 36–38, 42,
 49
Wijngaarden, Theo van
 association with HvM, 24–25, 34–36,
 38–51, 57–61, 117
 association with Harold Wright,
 24–25
 as restorer for Leo Nardus, 35–38
 background of, 34–35
 Bakelite medium and, 109
 business practices of, 43–47, 50–51
 gelatin-glue medium and, 40, 47–48,
 104, 107–109, 239, 240
 Self-Portrait, 39

Wijngaarden, Theo van (*continued*)
 Sumatrastraat forgery business in The
 Hague, 37–61, 83–99, 117
Wijngaarden, Willy van
 as art restorer, 116–117, 236
 "biblical" Vermeers of HvM, opinion
 of, 117, 138
 rejects work as art forger, 38–39
Wild, A. M. de, 174–175, 182, 205,
 215–218, 234
Wildenstein, Nathan, 42–43, 114–115
Wildenstein & Co., 110–111
 buys and sells *Young Woman Reading*
 forgery, 55, 114
Windsor Castle, 121–122
Wolfsangel, 152, *152*
Woman Playing the Lute (forgery in the
 style of Vermeer), 118, *118*
Woman Reading Music (forgery in the
 style of Vermeer), 118
Woman with a Balance (Vermeer), 53

Wright, Harold
 arrives in Berlin, 22, 61
 association with Theodore Ward, 5,
 22, 24, 57–61, 71
 association with Theo van
 Wijngaarden, 24–25
 described, 22
 end of career as front man, 101–103,
 107
 relocates to The Hague, 58
 sells *Lace Maker* forgery, 5, 53, 54, 59,
 61, 69–71, 75, 86, 101

X-rays, 175, 242

Young Woman Reading (forgery in the
 style of Vermeer), 55–56, *56*,
 114, 266

Zwart, Willem de, 78

Made in the USA
Columbia, SC
25 August 2022

66090888R00212